ALLISON LEVY is Digital Scholarship historian educated at Bryn Mawr College the UK. Allison has published widely o Italy and serves as General Editor of the b *1300–1700*, published by Amsterdam Univ

"With *House of Secrets*, Allison Levy presents an enthralling tour through an extraordinary Florentine palazzo, complete with romance, murder, lives of the rich and famous, and layer upon layer of history ranging from the heart of the Renaissance to yesterday. A scholarly thriller that is virtually impossible to put down."

Ingrid Rowland, author of
From Pompeii: The Afterlife of a Roman Town

"In this provocative and lively account, Allison Levy deftly mingles scholarship and personal history to tell the story of a building that is also the story of a family, a city, a country and a continent over the course of several tumultuous centuries. Essential reading for lovers of Florence, *House of Secrets* will join Shirley Hazzard's *Greene on Capri*, Jan Morris's *Venice*, and Edith Templeton's *The Surprise of Cremona* on the shelf that I reserve for those rare books that tell us something new—and true—about Italy."

David Leavitt, author of *Florence, A Delicate Case*

"With the delicious happenstance of securing her lodging in a grand Renaissance Florentine palazzo (otherwise quite off limits to the public), the author weaves together a lively—dare one say sexy?—personal narrative with a chronicle of several hundred years in the life of the city's nobility. We meet not only the very multi-colored Rucellai family, but also a whole cast of other characters. There is hardly a bold-face name in the Italian Renaissance who doesn't get to play at least a cameo role. As we absorb a flood of delightful anecdotes from past and present, we slowly come to realize that we are in the hands of a scholar who is teaching us a great deal about a vibrant episode in the European past. The book is a triumph of both story-telling and history-telling."

Leonard Barkan, author of *Michelangelo: A Life on Paper*

"Art Historian Allison Levy has written a delightful, fascinating, and riveting yarn about a palazzo, a family, and a city across time. In her tale, scandals, orgies, murders, and love affairs (including her own) mingle with the creation of extraordinary architecture, art, and patrimony. Her cast of characters is rich, from Leon Battista Alberti to Cy Twombly, from Nannina de' Medici to Lysina Rucellai. At once highly entertaining, profound, and enlightening, Levy's account succeeds in making the walls of the Palazzo Rucellai sing."

Jenny McPhee, author and translator of Natalia Ginzburg's *Family Lexicon*

"Florentine Renaissance palazzi are so well-known that it seems little can be said about them afresh. Allison Levy manages that rare feat in her personal and behind-the-scenes exploration of Palazzo Rucellai, bringing on stage its inhabitants over the past six centuries and fleshing out the dreams and dramas that unfolded inside the building. The story she weaves is rich in history and anecdote, scholarly erudition and private experiences. The resulting book is as layered and multi-dimensional as the palazzo itself."

Marina Belozerskaya, author of *The Medici Giraffe*

HOUSE
of
SECRETS

THE MANY LIVES
OF A FLORENTINE PALAZZO

Allison Levy

TAURIS PARKE
Bloomsbury Publishing Plc
50 Bedford Square, London, WC1B 3DP, UK
1385 Broadway, 5th Floor, New York, NY 10018

BLOOMSBURY, TAURIS PARKE and the TAURIS PARKE logo are trademarks
of Bloomsbury Publishing Plc

First published in Great Britain 2019
This edition published 2020

Copyright © Allison Levy, 2019

Allison Levy has asserted her right under the Copyright, Designs and
Patents Act, 1988, to be identified as Author of this work

All rights reserved. No part of this publication may be reproduced or transmitted in any form or
by any means, electronic or mechanical, including photocopying, recording, or any information
storage or retrieval system, without prior permission in writing from the publishers

A catalogue record for this book is available from the British Library

ISBN: HB: 978-1-7883-1360-5; PB: 978-1-7883-1755-9; eBook: 978-1-7867-2571-4

2 4 6 8 10 9 7 5 3 1

Typeset in Arno by Tetragon, London
Printed and bound in Great Britain by CPI Group (UK) Ltd, Croydon CR0 4YY

To find out more about our authors and books visit www.bloomsbury.com
and sign up for our newsletters

*To the memory of my father,
my cornerstone*

A building has at least two lives—the one imagined by its maker and the life it lives afterward—and they are never the same.

REM KOOLHAAS

i am what is around me.

women understand this.
one is not duchess
a hundred yards from a carriage.

these, then are portraits:
a black vestibule;
a high bed sheltered by curtains.

these are merely instances.

WALLACE STEVENS, "THEORY"

CONTENTS

Map of Florence	x
List of Illustrations	xi
Timeline of principal events	xv
Author's Note	xxiv
Preface	xxv
Prologue	1
Piano Terra	6
Chapter One: The Merchant	15
Primo Piano	30
Chapter Two: The Opportunists	39
Secondo Piano	76
Chapter Three: The Heir Aberrant	85
Terzo Piano	126
Chapter Four: The Suicide Bride	135
Quarto Piano	154
Chapter Five: The Salonnière	162
Quinto Piano	195
Chapter Six: The Tenant	205
Sesto Piano	225
Epilogue	233
Acknowledgments	239
Text Permissions	240
Notes	241
Bibliography	253
Index	265

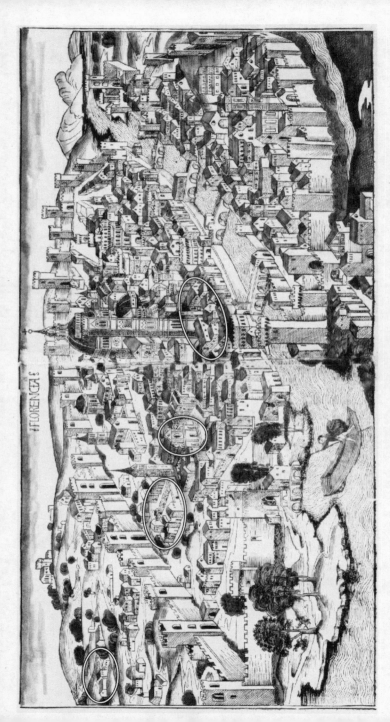

From the *Nuremberg Chronicle* (1493), indicating Rucellai properties and Rucellai-sponsored ecclesiastical projects (l–r): Lo Specchio, the Orti Oricellari, Santa Maria Novella, and the San Pancrazio/Palazzo Rucellai complex.

LIST OF ILLUSTRATIONS

COLOR PLATES

PLATE 1 Palazzo Rucellai, Florence, mid-fifteenth century. Oblique view of facade, designed by Leon Battista Alberti, from Via della Vigna Nuova, c.1865. Alinari/Art Resource, NY.

PLATE 2 Geri da Settignano (workshop), coat of arms of the Rucellai family, c.1450–80. Detroit Institute of Arts, USA/Gift of anonymous donor/Bridgeman Images.

PLATE 3 Francesco Salviati (attributed), *Portrait of Giovanni di Paolo Rucellai*, c.1540. Florence, Private collection.

PLATE 4 Leon Battista Alberti, Temple of the Holy Sepulchre, San Pancrazio, Florence. Detail of inlay with personal emblem of Giovanni Rucellai. 1467. Photo: Author.

PLATE 5 Leon Battista Alberti, winged eye, from Alberti, *Philodoxeos fabula*, Modena, Biblioteca Estense Universitaria Cod. Lat. 52, c. 6v., c.1437. Reproduced by permission of the Ministero dei beni e delle attività culturali e del turismo.

PLATE 6 Church of Santa Maria Novella, Florence. Completed 1470. Detail of facade, designed by Leon Battista Alberti. Courtesy Scott Gilchrist/archivision.com.

PLATE 7 Botticelli, *The Story of Nastagio degli Onesti (Scene II)*, 1483. © Museo del Prado/Art Resource, NY.

PLATE 8 Marco del Buono Giamberti and Apollonio di Giovanni di Tomaso, *The Story of Esther*, c.1460–70. Metropolitan Museum of Art, New York. Rogers Fund, 1918.

PLATE 9 Pontormo, *Portrait of a Youth in a Pink Cloak*, c.1525. Pinacoteca Nazionale di Palazzo Mansi, Lucca, Italy. Scala/Ministero dei beni e delle attività culturali e del turismo/Art Resource, NY.

PLATE 10 Pietro Torrigiano (attributed), *Portrait of Palla Rucellai*, c.1506. Detroit Institute of Arts, USA/Gift of Mrs. Ralph Harman Booth/Bridgeman Images.

LIST OF ILLUSTRATIONS

PLATE 11　Giuseppe Bezzuoli, *Portrait of Marianna Rucellai*, nineteenth century. Palazzo Rucellai, Florence. Universal Images Group/Art Resource, NY.

PLATE 12　Gian Domenico Ferretti, *Mnemosyne with the Muses*, 1752. Fresco, *piano nobile*, Palazzo Rucellai, Florence. Photo: Author.

PLATE 13　Filippino Lippi, *The Virgin and Child with Saints Jerome and Dominic*, c.1485. © National Gallery, London/Art Resource, NY.

PLATE 14　Bernardo Daddi (follower), *Madonna and Child with Saints*, c.1340. The New Orleans Museum of Art: The Samuel H. Kress Collection, 61.60.

PLATE 15　Cover of Bant Singer, *Delaney, abbi pazienza* (*Delaney, Be Patient!*), published by Mondadori, January 1955. Photo: Lindsay Elgin.

PLATE 16　Caravaggio, *St. Jerome Writing*, c.1605. Rome, Galleria Borghese. Scala/Ministero dei beni e delle attività culturali e del turismo/Art Resource, NY.

FIGURES

FIGURE 1	Palazzo Rucellai, Florence. Detail of facade, showing family emblems and coat of arms. Photo: Author.	3
FIGURE 2	Palazzo Rucellai, Florence. Detail of facade, showing built-in bench. Photo: Author.	4
FIGURE 3	Palazzo Rucellai, Florence. Main portal, 18 Via della Vigna Nuova. Photo: Author.	5
FIGURE 4	Palazzo Rucellai, Florence. Side portal, Via dei Palchetti. Photo: Author.	7
FIGURE 5	Palazzo Rucellai, Florence. Service stair. © Raffaello Bencini/Alinari Archives, Florence.	13
FIGURE 6	Theodoor van Thulden, *The Discovery of Purple*, 1636. Image © Museo del Prado/Art Resource, NY.	16
FIGURE 7	Mirabello Cavalori, *The Wool Factory*, 1570–2. Studiolo of Francesco I, Palazzo Vecchio, Florence. Photo: Scala/Art Resource, NY.	22
FIGURE 8	Boccardino il Vecchio (workshop), bartering scene, from Filippo Calandri, *Trattato di Aritmetica*, late fifteenth century. Biblioteca Riccardiana, Firenze, Ricc. 2669, c. 66r. Reproduced by permission of the Ministero dei beni e delle attività culturali e del turismo.	25
FIGURE 9	Donato Costanza, books drying in the courtyard of Palazzo Strozzi, 1966. Reproduced by permission of Gabinetto Scientifico Letterario G. P. Vieusseux, Florence.	33
FIGURE 10	Jean-Baptiste Carpeaux, *Ugolino and His Sons*, 1865–67. Metropolitan Museum of Art, New York. Purchase, Josephine Bay Paul and C. Michael Paul Foundation Inc. Gift, Charles Ulrick and Josephine Bay Foundation Inc. Gift, and Fletcher Fund, 1967.	37

LIST OF ILLUSTRATIONS

FIGURE 11 Palazzo Rucellai, Florence. Plan of ground floor with houses numbered in order of acquisition, c.1846. Photo from *Giovanni Rucellai ed il suo Zibaldone, II: A Florentine Patrician and His Palace*, ed. F. W. Kent et al. (London: Warburg Institute, 1981), pl. 5. Photo: Lindsay Elgin. 47

FIGURE 12 Palazzo Rucellai, Florence. Elevation along Via dei Palchetti (1994). Photo from Simonetta Bracciali, ed. *Restaurare Leon Battista Alberti: Il caso di palazzo Rucellai* (Florence: Libreria Editrice Fiorentina, 2006), p. 142, fig. 126. Photo: Lindsay Elgin. 56

FIGURE 13 Cross-section of houses belonging to the Gaddi family of Florence, c.1560. Gabinetto dei Disegni e delle Stampe degli Uffizi, Florence. Reproduced by permission of the Ministero dei beni e delle attività culturali e del turismo. 62

FIGURE 14 Loggia Rucellai, Florence, 1460s. Scala/Art Resource, NY. 71

FIGURE 15 Leon Battista Alberti, Temple of the Holy Sepulchre, San Pancrazio, Florence, 1467. Scala / Art Resource, NY. 73

FIGURE 16 Leon Battista Alberti, *Self-portrait*, c.1435. Samuel H. Kress Collection 1957.14.125. Courtesy of National Gallery of Art, Washington. 75

FIGURE 17 David Seymour, *Portrait of Bernard Berenson*, 1955. © David Seymour/ Magnum Photos. 83

FIGURE 18 Unknown, *The Ship of Fortune*, c.1460–70. © Trustees of the British Museum. 104

FIGURE 19 Anthony Frederick Sandys, *Rosamund, Queen of the Lombards*, 1861. Norwich Castle Museum and Art Gallery. 117

FIGURE 20 Francesco di Neri, called Sellaio, conjoined twins, identified as monsters, from the facade of the Hospital of San Martino in Florence (now lost). c.1317. San Marco Museum, Florence. Reproduced by permission of the Ministero dei beni e delle attività culturali e del turismo. 119

FIGURE 21 Emilio Burci, *Colossus of Polyphemus*, 1832. © Victoria and Albert Museum, London. 121

FIGURE 22 Palazzo Rucellai, Florence. View of courtyard, showing columns with metal braces. Photo: Author. 127

FIGURE 23 Marc Dalessio, *Portrait of Allison Levy*, 2007. Private collection. 129

FIGURE 24 Palazzo Rucellai, Florence. View of courtyard, c.1920–30. Alinari/Art Resource, NY. 136

FIGURE 25 Palazzo Rucellai, Florence. Detail of facade, showing biforate window and coat of arms, c.1890. Alinari/Art Resource, NY. 138

FIGURE 26 Loggia Rucellai, Florence, 1460s. View c.1920–30. © Alinari Archives-Brogi Archive, Florence. 141

FIGURE 27 Church of Santa Maria Novella, Florence. View with east cloister c.1890. Alinari/Art Resource, NY. 152

LIST OF ILLUSTRATIONS

FIGURE 28 Palazzo Rucellai, Florence. Details of facade, showing carved glyphs. Photo: Colby Anderson. 155

FIGURE 29 Ludwig Johann Passini, *Portrait of Sir Austen Henry Layard*, 1891. © National Portrait Gallery, London. 165

FIGURE 30 Udo J. Keppler, "The Magnet." Editorial cartoon from *Puck* magazine, New York, 21 June 1911. The Morgan Library & Museum. ARC 2650. 169

FIGURE 31 Palazzo Rucellai, Florence, mid-fifteenth century. Facade, designed by Leon Battista Alberti, view c.1890. Alinari/Art Resource, NY. 171

FIGURE 32 *Portrait of Lysina Rucellai*, n.d. Photo from Marcello Vannucci, *L'avventura degli stranieri in Toscana. Ottocento e novecento: fra cronaca e storia* (Aosta: Musumeci, 1981), fig. 73. Photo: Lindsay Elgin. 174

FIGURE 33 George Wright, *Portrait of Sir Harold Acton*, 1989. National Portrait Gallery, London. © George Wright. 180

FIGURE 34 Ruth Orkin, *American Girl in Italy, 1951*. © 1952, 1980 Ruth Orkin. 183

FIGURE 35 Thayaht modeling the *tuta*, 1920. Courtesy of Sandro Michahelles. 188

FIGURE 36 Earrings of Marie Antoinette. Washington, D. C., Museum of Natural History. Image Credit: Chip Clark, Smithsonian Institution. 190

FIGURE 37 *Gabriele D'Annunzio in the Nude*, 1880. © Mondadori Portfolio/Getty Images. 194

FIGURE 38 Giuseppe Guzzi, *Portrait of Leon Battista Alberti*, 1837. Private Collection. 199

FIGURE 39 Milton Gendel, *Portrait of Alvise di Robilant*, 1976. © Milton Gendel. 208

FIGURE 40 Clifford Coffin, *Portrait of Countess Gabriella di Robilant, Vogue 1946*. © Clifford Coffin/Condé Nast Collection/Getty Images. 210

FIGURE 41 David Lees, *Portrait of Cy Twombly (r) with patron Giorgio Franchetti*, 1958. Photo: David Lees/The LIFE Images Collection/Getty Images. 223

FIGURE 42 David Lees, *Portrait of Cy Twombly, 1958*. Photo: David Lees/The LIFE Images Collection/Getty Images. 224

FIGURE 43 Palazzo Rucellai, Florence. Detail of facade, showing unfinished edge. Photo: Author. 230

FIGURE 44 Heather Anne Campbell, *Looking over the Arno*, 2012. © 2018 Heather Anne Campbell. 238

TIMELINE

*Principal events in the histories
of Florence and the house of Rucellai*

Neolithic period	Arno River valley first settled
9th–8th century BCE	Etruscans establish a settlement (Viesul, now known as Fiesole) on a hill above the valley
59 BCE	Julius Caesar establishes a Roman colony for retired soldiers on the northern bank of the Arno (Florentia, now known as Florence)
2nd century CE	Population: c.10,000
393	City's first Christian basilica, San Lorenzo, consecrated as its cathedral by Saint Ambrose
405	Siege of Florence, part of a succession of Gothic invasions of the Roman Empire
5th century	Church of Santa Reparata constructed within the Roman walls on the site of the present cathedral
Late 6th century	City falls to the Lombards, becoming part of the Lombardic Duchy of Tuscany
774	City conquered by Charlemagne; Carolingian era ushers in a period of urban revival
Late 8th century	City walls expanded
978	Badia Fiorentina, a Benedictine Abbey, founded by Willa, widow of Uberto, Margrave of Tuscany
996	First Ponte Vecchio built near the site of the Roman-era bridge
1018	Mercato Nuovo built on the site of the old Roman forum
	Basilica of San Miniato al Monte built on highest point in Florence
	Population: c.5,000
1115	Florence achieves de facto self-government with the establishment of a *comune* (confirmed by the Holy Roman Emperor in 1183)

TIMELINE

- **1128** Construction finished on the Baptistery, built on the site of a sixth- or seventh-century octagonal structure, itself built on a structure dating to the Roman period
- **c.1150** Arte di Calimala (cloth merchants' guild) established
- **1212** Arte della Lana (wool merchants' guild) established
 Population: c.30,000
- **1216** Murder of Buondelmonte de' Buondelmonti seen as inaugurating quarrel between the Guelph faction (supporters of the papal cause) and the Ghibellines (supporters of the Holy Roman Emperor)
- **c.1246** Construction of the church of Santa Maria Novella by the Dominicans begins
- **c.1250 Alamanno discovers *Roccella tinctoria* (the dye source for "poor man's purple") in an eastern Mediterranean market**
- **1252** Gold florin first minted
- **1255** Construction begins on Palazzo del Popolo (now known as the Bargello), the first monumental civic building, built for the commander of the civic militia
- **1261 Alamanno matriculates in the Arte della Lana**
- **1265** Dante born in Florence
- **1269** Flood
- **1288** Ospedale di Santa Maria Nuova founded by Folco Portinari, the father of Dante's Beatrice
- **1293** Ordinances of Justice institute office of *gonfaloniere*
- **1294** Construction of the church of Santa Croce by the Franciscans begins
- **1296** Foundation stone of new cathedral laid on the site of Santa Reparata (rededicated to Santa Maria del Fiore in 1412)
- **c.1299** Construction begins on Le Stinche, considered the first purpose-built prison in Europe
- **1299** Palazzo della Signoria (now known as Palazzo Vecchio), seat of the government, constructed on the site of the old Roman theater
- **1300** City walls expanded
 Population: c.100,000, making Florence one of the five largest cities in Europe
- **1302 Nardo di Giunta, first member of the family to hold public office, named prior of the Signoria (gonfalonier of justice in 1308); the family would give a total of 85 *priori* and 14 *gonfalonieri* to the city**
 Dante exiled
- **1304** Fire destroys hundreds of houses

TIMELINE

- 1312 Siege of Florence, part of the Wars of the Guelphs and Ghibellines
- 1315–17 Famine
- **1318** **Bingeri, a captain in the Florentine militia, suppresses the revolt of the Tolomei in Siena; rewarded with an addition to the family blazon: a silver lion rampant against a red background**
- 1321 University of Florence founded
- 1330 Ufficiali delle donne, degli ornamenti e delle vesti (Officers for Women, Ornaments and Clothes) established
- 1333 Flood kills more than 3,000 people
- 1334 Giotto appointed *capomaestro* of cathedral complex; foundations of campanile laid
- 1345 Ponte Vecchio rebuilt
 Bardi and Peruzzi banking families declare bankruptcy
- 1348 Black Death results in a 60 percent decline in the population
- c.1349–53 Boccaccio at work on the *Decameron*
- **1355** **Cenni di Nardo builds a chapel dedicated to Saint Catherine of Alexandria in the church of Santa Maria Novella**
- 1360 Giovanni di Bicci de' Medici born in Florence
- 1374 Death of Petrarch
- 1376 Construction of the Loggia dei Lanzi begins
- 1378 Revolt of the Ciompi begins
- 1389 Cosimo "il Vecchio" de' Medici born in Florence
- 1397 Medici Bank established
- **1403** **Giovanni Rucellai born in Florence**
- 1404 Leon Battista Alberti born in exile in Genoa
- 1406 Florence conquers Pisa, signaling the final defeat of the Ghibellines and giving Florence control of an important seaport
- 1417 Poggio Bracciolini rediscovers Lucretius' *De rerum natura*
- **1421** **Giovanni Rucellai occupies his father's townhouse on Via della Vigna Nuova**
- **1423** **Giovanni Rucellai matriculates in the Arte del Cambio (bankers' guild); made a partner in the fourth-largest bank in Florence**
- c.1425 Brunelleschi reinvents one-point perspective
- 1427 *Catasto* (property tax survey) begins
 Population: c.37,000
- **1428** **Giovanni Rucellai marries Iacopa Strozzi; buys second house**
 Alberti family exile lifted
- 1432 Ufficiali di notte (Officers of the Night) established to adjudicate acts of sodomy
- **1433** **Giovanni Rucellai buys third house**
 Cosimo de' Medici exiled

TIMELINE

- **1434** Cosimo de' Medici returns from exile; becomes unofficial ruler of Florence, or Pater Patriae
 Palla Strozzi exiled
 Leon Battista Alberti re-enters Florence in the curia of Pope Eugenius IV
- **1435** Leon Battista Alberti writes *On Painting*
- **1436** Brunelleschi's dome completed; Duomo consecrated
- **1439** General Council of Greek Orthodox and Roman Catholic churches held in Florence
- **1440s** **Three Rucellai cousins commission a white marble pulpit, designed by Brunelleschi, for the church of Santa Maria Novella**
- **1440** Donatello completes his *David*; installed in courtyard of Palazzo Medici
- **1443** Leon Battista Alberti begins *On the Art of Building*
- **1445** **Giovanni Rucellai at the helm of his own bank, one of the largest in Florence, with branches in Pisa, Rome, Lyon, and Constantinople; buys fourth, fifth, and sixth houses**
- **1449** Lorenzo "il Magnifico" de' Medici born in Florence
- **c.1450** **Leon Battista Alberti designs palace facade for Giovanni Rucellai**
- **1452** Ghiberti completes bronze casting of east doors (also known as the Gates of Paradise) for the Baptistery
- **1454** Amerigo Vespucci born in Florence
- **1456** **Pandolfo Rucellai marries Caterina Pitti**
- **1457** **Giovanni Rucellai begins his *zibaldone* (commonplace book)**
- **1458** **Giovanni Rucellai becomes third-richest man in Florence; buys seventh house**
- **1460s** **Leon Battista Alberti designs loggia for Giovanni Rucellai**
- **1464** Death of Cosimo "il Vecchio" de' Medici
- **1466** **Bernardo Rucellai marries Nannina de' Medici**
 Leonardo enters the workshop of Florentine painter Andrea del Verrocchio as an apprentice
- **1467** **Leon Battista Alberti designs burial chapel, modeled after the Holy Sepulchre in Jerusalem, for Giovanni Rucellai**
- **1469** Lorenzo de' Medici succeeds his father, Piero "the Gouty"
 Niccolò Machiavelli born in Florence
- **1470** **Leon Battista Alberti designs facade of the church of Santa Maria Novella for Giovanni Rucellai**
- **1474** **Giovanni Rucellai declares bankruptcy**
- **1478** Pazzi Conspiracy wounds Lorenzo de' Medici and kills his brother Giuliano (26 April)

TIMELINE

- **1480s** **Bernardo Rucellai begins to develop newly acquired suburban property, naming it the Orti Oricellari**
- **1481** **Death of Giovanni Rucellai**
 Savonarola arrives in Florence
- c.1485 Botticelli paints the *Birth of Venus*
- 1487 Giraffe presented to Lorenzo de' Medici by al-Ashraf Qaitbay, the Sultan of Egypt
- 1489 Foundation stone of Palazzo Strozzi laid
- **1492** **First legal and physical division of Palazzo Rucellai**
 Death of Lorenzo de' Medici
- 1494 French king Charles VIII invades city to lay claim to the Kingdom of Naples; Medici driven from the city
- **1495** **Bernardo Rucellai's *De bello italico commentarius* published**
- **1496** **Bernardo Rucellai's *De urbe Roma* published**
- 1497 Bonfire of the Vanities organized by supporters of Savonarola (7 February)
- 1498 Savonarola burned at the stake for heresy (23 May)
 Machiavelli appointed secretary to the committee overseeing military matters and foreign affairs
- 1504 Michelangelo completes his *David*
- 1512 Return of the Medici
- 1513 Machiavelli's *The Prince* in circulation
- **1516** **Giovanni di Bernardo Rucellai's *Rosmunda*, the earliest extant Italian tragedy, first performed in the Orti Oricellari for Pope Leo X**
 Death of Bernardo Rucellai
 Giovanni de' Medici, second son of Lorenzo "il Magnifico," enters Florence as Pope Leo X; later excommunicates Martin Luther
- **1519** **Niccolò Machiavelli begins *The Art of War* in the Orti Oricellari**
- **c.1520** **The madrigal is developed in the Orti Oricellari**
- 1523 Cardinal Clement VII (born Giulio de' Medici) becomes Pope, two years after the death of his cousin Pope Leo X
- 1527 In the wake of the Sack of Rome, Medici rule is overthrown and Republic of Florence is established
- 1528 Baldassare Castiglione's *Book of the Courtier* published
- **1529** **Death of Camilla Rucellai, ardent follower of Savonarola**
 Siege of Florence, part of the War of the League of Cognac, begins
- **1531** **Second legal and physical division of Palazzo Rucellai**
- 1532 Republic ends; Alessandro de' Medici named Duke of Florence
- **1536** **Dissection of a "monster" takes place in the Orti Oricellari**
 Holy Roman Emperor Charles V visits city

TIMELINE

1550 Giorgio Vasari publishes first edition of his *Lives of the Artists*
1557 Flood (September)
1558 Giovanni Della Casa's conduct book *Galateo* published, addressed to Annibale Rucellai
1560 Vasari begins construction on Palazzo degli Uffizi to house the offices of the city magistrates
1563 Accademia delle Arti del Disegno established
1564 Death of Michelangelo
1565 Cosimo I instructs Vasari to build a private passageway (now known as the Vasari Corridor) linking Palazzo Vecchio and the Uffizi to the new Medici residence, Palazzo Pitti, on the south side of the Arno
1569 Cosimo I proclaimed Grand Duke of Tuscany
1571 Jewish ghetto created
1573 Orti Oricellari sold by the Rucellai
1580 Official rules of *calcio fiorentino*, an early form of football played in Piazza Santa Croce, published
1583 Accademia della Crusca founded
1600 Wedding ceremony of Maria de' Medici and Henry IV of France takes place in the Duomo (5 October); as part of the celebration, *Euridice*, the earliest surviving opera, written by Jacopo Peri, is performed at Palazzo Pitti (6 October)
1604 Birth of Orazio Ricasoli Rucellai, philosopher, scientist, and leading member of the Accademia della Crusca
1610 Galileo appointed Chief Mathematician and Philosopher to Grand Duke Cosimo II
1654 Descendants of Giovanni Rucellai acquire eighth house
1656 Teatro della Pergola, considered the oldest opera house in Italy, opens as a private court theater for the Grand Dukes of Tuscany (until 1718); premieres of Donizetti's *Rosamund of England* (1834) and Verdi's *Macbeth* (1847)
1668 Cavaliere Giulio Rucellai murdered by del Benino in a duel in Via dei Tintori (17 July)
1677 Rucellai loggia bricked in (not reopened until the 1960s)
Early 18th century Multiple mezzanine floors added to Palazzo Rucellai; a Rucellai daughter hurls herself into the courtyard on the eve of her wedding
1723–37 Reign of Cosimo III's son, Gian Gastone
1737 Francis, Duke of Lorraine installed as Grand Duke
1740–86 Sir Horace Mann serves as British envoy at Florence
1743 Under Giulio Rucellai, Minister for Ecclesiastical Affairs for the Habsburg-Lorraine dynasty, Palazzo Rucellai undergoes

TIMELINE

 extensive renovation campaign, including the decoration of the *piano nobile* to celebrate Rucellai's marriage to Teresa de' Pazzi
 Death of the last Medici, Gian Gastone's sister, Anna Maria, who bequeaths Medici treasures to the House of Lorraine on condition that none is removed from Tuscany

- 1765 Death of the Grand Duke Francis; succeeded by his younger son, Peter Leopold
- **1768 Facade of Santa Maria Novella begins to crumble; Rucellai family threatened with legal action for neglecting their responsibility as custodians of the facade**
- 1784 Galleria dell'Accademia established; Michelangelo's *David* installed there in 1873
- 1790 Grand Duke Peter Leopold becomes Emperor of Austria; appoints his second son Ferdinand III Grand Duke of Tuscany
- 1799 French occupation begins; Jewish ghetto abolished
- 1801 Tuscany becomes part of Napoleon Bonaparte's Kingdom of Etruria
- 1808 Antonio Meucci, inventor of the first telephone device, born in Florence
 Deconsecration of the church of San Pancrazio
- 1814 French occupation ends; Jewish ghetto reinstituted
- 1820 Florence Nightingale, founder of modern nursing, born in Florence
- 1824 Death of Ferdinand III and succession of his son Leopold II as Grand Duke
- **1826 Giuseppe Rucellai rents *piano nobile* of Palazzo Rucellai to the Layard family of England**
- 1826 Carlo Collodi, author of *The Adventures of Pinocchio*, born in Florence
- 1827 English Cemetery established
- 1844 Flood
- 1848 Santa Maria Novella railway station opens
 Jewish ghetto abolished
- 1859 Demonstrations in Florence in support of a united Italy drive Leopold II from city, making him effectively last Grand Duke of Tuscany
 La Nazione newspaper first published in Florence
- 1860 People of Tuscany vote for unification of former Grand Duchy with constitutional monarchy of Victor Emmanuel II, King of Piedmont
- 1861 Death of Elizabeth Barrett Browning in Florence
- 1862 Teatro Comunale opens; home to the annual music festival Maggio Musicale Fiorentino (since 1933)
- 1865 Florence becomes capital of the recently established Kingdom of Italy
 Population: 150,864

TIMELINE

1869 Piazzale Michelangelo built on a hill on the south bank of the Arno
1871 Capital of Italy relocated to Rome
 Gothic-style facade added to the Duomo
1874 Construction begins on the Tempio Maggiore Israelitico (Great Synagogue of Florence)
1881 Guccio Gucci born in Florence
1884 Mercato Vecchio and part of the former Jewish ghetto demolished to make way for Piazza della Repubblica on the site of the old Roman forum
1890 Giulio Rucellai marries Elizabeth Pilar von Pilchau in a Russian Orthodox ceremony in Paris; occupies the *piano nobile* of Palazzo Rucellai in 1906
1895 Cosimo Rucellai marries Edith Bronson in Venice in 1895; occupies the second floor of Palazzo Rucellai in 1909
1901 *Population: 236,635*
1914 Facade of Palazzo Rucellai stoned and fire set at rear of house during Red Week (June)
 Emilio Pucci born in Florence
1915 Italy enters World War I
1920 Futurist artist Thayaht unveils the *tuta* on *piano nobile* of Palazzo Rucellai (July)
1922 Mussolini named Prime Minister of Italy by Victor Emmanuel III
1923 Film director Franco Zeffirelli born in Florence
1929 Journalist Oriana Fallaci born in Florence
1931 *Population: 304,160*
1932 Santa Maria Novella railway station rebuilt under Mussolini
1935 Italy invades Ethiopia
1936 Writer Dacia Maraini born in Fiesole
1938 Hitler visits Florence; spends several hours in the Uffizi (9 May)
 Racial laws introduced (September)
1940 Mussolini declares war on France and Great Britain (10 June)
1943 German occupation of Florence begins
 Allied bombing kills 215 civilians and destroys buildings (25 September)
1944 All bridges except Ponte Vecchio bombed by German forces (3 August)
 German occupation of Florence ends (11 August)
1946 Umberto II, last king of Italy, abdicates the throne; Italy officially becomes a republic (2 June)
1954 UFO mass sighting during football match at Florence stadium (27 October)

TIMELINE

1961 Population: 436,516
1966 Flood (4 November)
1968–85 Monster of Florence murders seven couples in the hills of Florence
1977 Florence–Rome high-speed railway begins operating
1982 Historic center of Florence designated UNESCO World Heritage site
1986 Gran Caffè Doney closes
Late 1990s **Palazzo Rucellai undergoes extensive renovation campaign**
1991 Population: 403,294
1993 Terrorist attack carried out by Sicilian Mafia in Via dei Georgofili kills five people, damages the Uffizi, Vasari Corridor, and Palazzo Vecchio, and destroys numerous works of art (27 May)
1997 **Alvise di Robilant found murdered in Palazzo Rucellai (16 January)**
2002 European Social Forum held in Florence (November)
2013 Population: 383,083 *(over 1.5 million in metropolitan area)*
2018 Population: 413,953 *(projected)*

AUTHOR'S NOTE

House of Secrets is a work of creative nonfiction. The subject of my story, Palazzo Rucellai, is an icon of Western art; it is also a private home. I have been fortunate to experience this building in both capacities. As an art historian of early modern Italy on the eve of a yearlong sabbatical in Florence, I was well versed in the work and writing of Leon Battista Alberti, the fifteenth-century architect of Giovanni Rucellai's palace. But only when I rented an apartment *behind* its famous facade did my subject come into focus. Over the course of my sabbatical residency, I discovered a different history. Or, rather, I began to see history differently. I saw people, not pilasters; I saw lives. I listened. And I soon learned that Palazzo Rucellai had a personality all its own.

In writing this book, I wished to give the denizens of Palazzo Rucellai, ancient and modern, a voice, so that we might hear what this storied house meant to each of them, how that edifice structured—and confounded—the lives they lived. Many tell us in their own words: Giovanni Rucellai, Bernardo Rucellai, Nannina de' Medici, Austen Henry Layard, Lysina Rucellai, Harold Acton … Add to this list my own voice—or, rather, voices. For I join the conversation both as an art historian and as a former tenant. As such, the story I tell is, at once, a history of Palazzo Rucellai and an account of how I let myself be consumed by that history.

While this work is based on actual persons and events, certain names and identifying details have been changed to protect the privacy of the individuals portrayed. For the purposes of narrative coherence, I have modified certain conversations and events.

Unless otherwise indicated, all translations are my own; I have modernized spelling and punctuation and have adapted certain phrases and expressions for the sake of readability in English.

PREFACE

House of Secrets is a book about memory and desire, about the stories that structures hold and the stories that we invent to fill those structures. It is about the sharing of space, the tracing of footsteps, the overlapping of lives ... palazzo as palimpsest. It is about the willingness to lose oneself behind the facade, to live between past and present, to slip between the cracks of history and the crevices of our own imagination. *House of Secrets* is also a lively history of Florence from the Renaissance to the present day, the universally beloved city that produced literary and artistic genius on an incomparable scale and played host in the fifteenth century to what was arguably the most dramatic artistic boom in the history of Western civilization.

The impetus for the writing of this book was my sabbatical residency in the fifteenth-century Palazzo Rucellai (Rü-che-ˈlī, Roo-cha-LIE), an icon of Western art, a structure that has for so long defined me professionally, and that I would not have ever in my wildest dreams occupied. Yet a serendipitous discovery of an apartment for let within the palazzo lands me in the vortex of history. Immediately upon moving in, I am lost deep inside of this building I thought I knew. My one-room apartment, called Archivio, is wedged between the top two floors—between stories—on what is called a "hidden floor." It is from this literal and figurative platform, as I seek to get a foothold in Palazzo Rucellai, that my account of this storied house unfolds.

Far from another architectural history, for countless tomes have been published on the building and its architect, *House of Secrets* provides the reader with a character-driven historical narrative of Palazzo Rucellai, the first of its kind. Over the course of six chapters, one for every century the house of Rucellai has persevered, the disparate yet closely linked lives of those enmeshed in the history of the house will amass, presenting a single portrait of the edifice itself

and a palimpsest of history. Right from its earliest days, the palace has witnessed endless drama. It was built piecemeal by Giovanni Rucellai, the third richest man in Florence in the mid-fifteenth century (buttressed by his ancestor's discovery of a precious dye, "poor man's purple"), and Leon Battista Alberti, the celebrated architect responsible for putting a strong public face on Rucellai's physical and emotional labyrinth, before being abandoned by Pandolfo and Bernardo, the house's first heirs, and having its interiors butchered in the sixteenth century by their heirs. In the eighteenth century, Bianca, a Rucellai daughter and the house's specter, is rumored to have hurled herself into the courtyard on the eve of her wedding, and just before World War I broke out, Lysina Rucellai, a twice-widowed Cossack countess with fascist leanings, hosted champagne-fueled orgies and tango teas in the palace. Even as late as 1997, exactly ten years before my own residency in the house, Alvise di Robilant, an aristocratic art dealer, was bludgeoned to death on the third floor; his murder remains unsolved to this day. Behind each story there is a theme: origin and identity; ambition and arrogance; manners and deception; selective memory and purposeful forgetting; otherness; and doubleness. Running throughout this portrait of place, as well, are larger questions: how we project our own ideals and fantasies onto buildings; and how buildings, in turn, both do and do not comply.

In an attempt to answer these questions from a slightly different angle, interspersed among the residents' portraits are a series of fluid episodes from the present day, musings on instances from my own palace idyll. This complementary narrative serves to introduce the history of the house while also examining my place within it—and, by extension, my relationship with history itself. In this world where identity is inextricably bound to the seeming permanence of architecture, I eventually come face-to-face with my own fictions. For the more I come to understand this storied structure, the more, paradoxically, it escapes me. Or could it be that the more real *it* becomes, the less real *I* feel to myself? Either way, my occupancy proves a turning inside out for both of us. Like the house, I am transformed through time and experience. And in the end, my response to Palazzo Rucellai is informed as much by my education as by my residency, as much by the sense of desire giving way to disappointment as by a sense of denial that soon enough must succumb to truth.

Buildings—like the people who inhabit them—come with a lot of baggage. And if we step *deep* inside, we discover that some walls do, indeed, have ears—not to mention eyes and even a set of pursed lips or two with which to whisper. *Saxa loquuntur*. Stones speak. It would be hard to think of a building richer in

illuminating stories than Palazzo Rucellai; perhaps it has just been waiting for the right tenant to take note.

"It often happens that we ourselves, although busy with completely different things, cannot prevent our minds and imagination from projecting some building or other." Leon Battista Alberti, the fifteenth-century architect of Palazzo Rucellai, understood well the lure of architecture—a pull so strong, in certain instances, that mind has no sway over matter, that we cannot but propel ourselves to occupy, as best we can, the structure, the space, the story that has so seduced us.

What we might call "house lust" or "shelter porn" is hardly a modern phenomenon. Earlier escapists were equally compelled to "drive by," to see for themselves, to scrutinize. Architectural voyeurism, in fact, was not only encouraged but was also aligned with the workings of nature by the Florentine chancellor Leonardo Bruni, writing in 1404:

> If there is someone who would like to experience [the homes of the private citizens], let them come here and walk through the city. But don't let him pass through like a temporary guest or a hurrying tourist. Rather, he should pause, poke around, and try to understand what he is seeing [...] the beauty of Florence cannot be appreciated unless seen from the inside [...] just as blood is spread throughout the entire body, so fine architecture and decoration are diffused throughout the whole city.

There is, indeed, much more to these Renaissance palaces than good bones and a handsome face. Those who do "pause" and "poke around," as Bruni prescribes, will discover that Florence behind the facade is a place where history is never past, where age-old dramas continue to play out and centuries-old personalities are ever-present. Perhaps this in-betweenness is precisely what we desire most, and why Florence and its architecture stay under our skin.

The performativity of architecture, or how buildings interact meaningfully with people and place, has been the subject of recent research by architectural and cultural historians eager to collapse the distinctions between space, actor, and spectator, preferring instead to see built structures as social partners, equal players in the theaters of life and death. This action-oriented focus foregrounds situations, experiences, and relationships—in the moment and over a long duration. Thus, in considering the rich narrative of life that we attach to architecture, we must also consider the life—or, rather, lives—of architecture

itself, understanding the built structure as a sentient being with a soul and a memory, a capacity to adapt, and a will to survive. In the pages that follow, the biggest personality—the main protagonist—is Palazzo Rucellai itself, a living and breathing character throughout my story. The house has night sweats, body odor, and cracking joints. Its marble slabs have veins. The palace witnesses sex and violence; it bleeds, but it bites its lip. It blushes and weeps; it shudders at the idea of anyone passing through its portal. Yet for more than half a millennium, Palazzo Rucellai has both humored and haunted those who have lived and died behind its noble facade. *House of Secrets* is my story about the power of a building to shape lives as well as survive them.

PROLOGUE

Fresh out of graduate school, I'd landed a tenure-track teaching position at a small liberal arts college outside of Boston, which looked great on paper—as such positions always do—but soon turned out to be a nightmare. Between rampant grade inflation and potluck faculty suppers, the campus bloat was asphyxiating.

Five years in, I badly needed a break. It had all become so routine, so quickly. I could write conference papers in my sleep. My syllabi looked exactly the same. Even my pronunciation of the word *contrapposto* sounded tired. I wasn't just burned out. I was profoundly unhappy. But why? Hadn't I been the one to orchestrate this overly disciplined career in art history? The Italian Renaissance had rescued me once before. Why was it failing me now?

Decades earlier, growing up in New Orleans, bound by Southern conventions, I was never truly able—or willing—to fit in. Dolls and dresses gave me hives; seersucker and the occasional pink piece I wore, albeit from Brooks Brothers Boys. In high school, I took up daydreaming, not dating, avoiding my classmates' debutante balls like the plague. In this light, I couldn't *but* feel misplaced. Only when I found myself in a darkened classroom, in the company of sympathetic images flickering upon a flat vinyl screen, did I finally feel comfortable in my own skin.

Art history has long privileged Renaissance bodies, and my university introductory course was no exception. One such body, however, spoke volumes to me: Donatello's bronze *David*. Measuring a mere 62 inches—my exact height—I saw much of myself in the highly polished surface of this fifteenth-century youth. As the lecturer described David's pose, I stared at my doppelgänger: dutiful but dying of boredom, composed but pushing the limits, both of us burdened by stubborn orthodoxy. The minute class ended, I marched straight to the dean's office and declared my major. Italian Renaissance art would set me free.

Yet here I was, 20 years later, looking for an escape all over again. As a demoralized assistant professor, I threw myself into my work—my writing, not my teaching. I took a hands-off approach to student advising; "Do what you love," I preached, my delivery growing increasingly halfhearted with every new semester. I avoided the faculty dining room and its insipid gossip, instead eating alone in my office. I eventually bought a dorm-sized refrigerator and kept it fully stocked: late nights on campus had gradually replaced evenings out with an ever-diminishing circle of friends. I was lost. And I knew it.

Relief finally came in the form of a generous fellowship: a year's salary, with no strings attached, to finish my book in Florence. The topic—Renaissance tomb sculpture—may have been dismal, but the destination was a dream come true.

As the snow and ungraded papers continued to pile up in bleakest New England, I began the search for my sabbatical home. The Florentine offerings in my price range ran the gamut from "charming" to "sunny" to "perfect for students" (tiny, sweltering, loud). On a whim, I decided to see how the other half lived, clicking on the luxe real estate site Windows on Tuscany, merely to dream. These grandiose properties slept up to 12, excluding staff, with names to match: Isabella d'Este, Maria de' Medici, Eleonora di Toledo. And then, amid all of this beautiful excess, a single word caught my eye, appropriately humble, daring one to hope: Archivio.

The description was discreet: "Living room–bedroom with stone fireplace and wood-beam ceiling. Antique terracotta floor. Fully equipped kitchen, bathroom with tub. Tastefully and elegantly furnished. Third floor with elevator service [...] located in the famous Palazzo Rucellai."

I had to read it twice to make sure it wasn't a figment of my imagination. For this wasn't just any building. This was the structure that started it all. Centuries of cognoscenti had idolized the palace—and rightly so: Palazzo Rucellai was the first private building, with its groundbreaking facade, to establish the vocabulary of Renaissance classicism. I, by comparison, had worshiped the palace a mere 20 years, ever since that fateful semester back in 1987 when, as a newly declared art history major, I enrolled in a seminar on its architect, Leon Battista Alberti, the archetypal "Renaissance Man"—yet my devotion could hardly be paralleled.

I knew the palace intimately. That is, I knew it as well as any art historian *could* know it. I'd even seen it in person, quite a few times, actually—each visit a transcendental experience. From the far corner of the tiny piazza opposite the palace on Via della Vigna Nuova, I would stand transfixed. Without fail, Palazzo

Rucellai, on my every pilgrimage, delivered exactly what I was looking for—or, rather, what I'd been trained to look for:

- ✓ the three stories of imposing yet accessible height, divided by two friezes intricately carved with family emblems;
- ✓ the pilasters of varying classical orders, an application echoing the elevation of the Colosseum in Rome;
- ✓ the rounded arches and biforate windows in between—only those in the third and sixth bays slightly wider and taller than the other five;
- ✓ the smooth masonry, a refined departure from the heavy rustication of the medieval period;
- ✓ the built-in bench, fronting the street and running the full length of the facade, with its erudite mimicry of ancient Roman brickwork;
- ✓ the bold cornice, at once crown and tamper, bestowing grandeur and gravitas in one broad stroke.

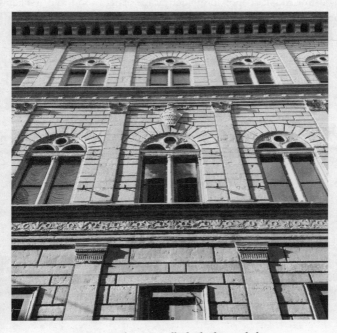

Figure 1. Palazzo Rucellai bathed in sunlight.

All there—nothing superfluous, nothing unexplained. It had come to serve as a sort of Confirmation of the Rule, this checklist, a reaffirmation of my faith in Art, Beauty, and the Ideal. With its promise of deliverance, the facade of Palazzo Rucellai continued to beckon, and I, ever faithful, never ceased to heed the call of its architect, that

> one's gaze might flow freely and gently along the cornices, through the recessions […] so that anyone who saw it would imagine that he could never be satiated by the view, but looking at it again and again in admiration, would glance back once more as he departed.

Because I'd always lingered longer than necessary, I knew, too, that the stones blushed at sunset and that the cornice wept during torrential downpours. That only 11 of what had once been 14 torch holders remained hammered into the seven window frames on the *piano nobile*, and that each and every one of those wrought-iron rods cast upon the golden facade, at high noon, a grim shadow—a temporal stain resembling a noose already taut around a traitor's neck. And the glass panes hanging within those gallows, I'd observed long ago, shook with

Figure 2. The built-in bench of the palace facade.

every passing city bus. Far below, the built-in bench accommodated an ever-changing huddle of Florentines wearily awaiting transport elsewhere. I'd often perched on that pockmarked surface myself—not waiting to leave, but rather wishing to stay. Reclining on the hard, unyielding seat until my shoulders awkwardly attached to the cool sandstone, I would slouch there and stare out into the piazza before me, breathing in the building at my back as the cellar exhaled moist air against my dangling ankles. On one such occasion, glued as I was to the facade, I turned my face parallel to the palazzo and noticed that a certain T. Bartlett had left his autograph to the right of the main portal in 1868 and that that same door, not surprisingly, was lacking a knob. I even knew what the place looked like on garbage night—the only time this handsomest of facades appeared at all compromised.

But I'd never crossed the threshold. I'd never even tried. Because, for me, Palazzo Rucellai had always remained a venerable *exterior*—a massive wall of sandstone, there to be admired at a remove. The palace was still in family hands, after all, closed to the masses. End of story.

Until, that is, I fell upon the contessa's advertisement.

I couldn't afford it, really. Not even with my stipend, which had been earmarked for research purposes, not palatial living. I promptly booked it anyway. I'd be back on campus before I knew it, with not another leave in sight for at least five years. There'd be plenty of time to recoup my losses.

To live *inside* Palazzo Rucellai ... This surely would be the highlight of my year. If not my life.

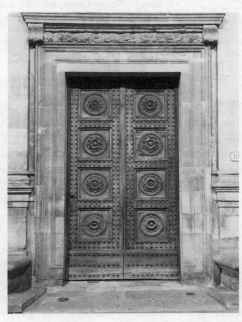

Figure 3. The main portal of Palazzo Rucellai, 18 Via della Vigna Nuova.

Piano Terra

In another moment down went Alice after it, never once considering how in the world she was to get out again.

Lewis Carroll, *Alice's Adventures in Wonderland*

Palazzo Rucellai sits quietly in the middle of the narrow Via della Vigna Nuova, today a commercial street in the heart of ancient Florence. As a passerby, I'd long admired the stoicism of its posture, the severity of its sandstone face, the snobbery of its chiseled features. Now here I stood, curbside with my luggage, staring down the aloof neighbor that was soon to become my private abode.

I'd been instructed by the agency to ring at the side entrance. Dragging my suitcases behind me, I walked around the corner and into a narrow alley jammed with metal bicycle racks and blue plastic trash bins. After just a few steps on the stone pavement, I landed on a wobbler, sending my foot into a gulch filled with the previous night's runoff. I shook the sludge from my loafer and continued along the plaster sidewall of the palace, a montage of barred windows, blind arches, and jerry-rigged drainpipes—by Florentine standards, an anonymous everyday stretch of beige covered in a small army of shiny aluminum placards: PROPRIETÀ PRIVATA, VIETATO L'ACCESSO, DIVIETO DI SOSTA. I smugly scoffed. "No trespassing" no longer applied to me here.

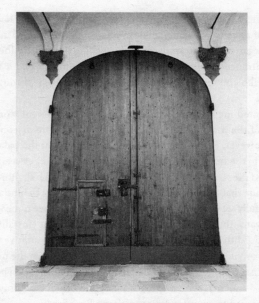

Figure 4. A secondary threshold, safeguarded by four locks, opens up from the side street onto the palace courtyard.

As my eyes scrolled over the colossal entryway, seeking a way in, a little man suddenly appeared in the door. And I do mean *in* the door; for a hatch not much larger than my overstuffed Samsonites had been cut out of the lower quarter of the wooden *portone*. The idea had been to make passage from one side to the other easier, but the effect was peculiar. As was the gatekeeper himself.

Niko, whose size nearly matched that of the diminutive trapdoor, wore a long canvas sculptor's smock that blotted out any hint of a body beneath, leaving in full view only a big, round jack-in-the-box head, his clownish appearance heightened by tufts of white curls, a bushy mustache, and Coke-bottle glasses. The elderly Greek man with the impeccable British accent—and, I'd soon learn, a very short temper—apparently had been expecting me. "Just in time," he announced. "I'm about to take my break."

I, on the other hand, was caught completely off guard. I hadn't anticipated having to shimmy my way into Palazzo Rucellai. Nevertheless, I maneuvered my body, most unceremoniously, through the wicket. Hardly the ideal entrance. But then, as I untucked myself and stood up straight, Alberti's courtyard opened

up around me. It was nothing short of perfection: a vision in chalk white and cool gray *pietra serena*, without a single cypress in sight. I walked into the center and slowly began to spin around, carefully keeping time with Alberti's slinking arches, so entranced I might have continued indefinitely had it not been for the grunts Niko emitted as he struggled to get my luggage through the rabbit hole after me.

Niko pointed me upstairs, where I discovered a different story—a quirky assemblage of the magnificent and the misfit. Even more disconcerting than the décor, however, was the apartment's position within the palace. Archivio was situated in the front corner of the building—wedged between the top two floors. It faced the street, but there was no view and not the slightest suggestion from the facade that there might be a hollow space hiding behind and between Alberti's carefully set windows. Access to the rest of the palace came via an antique birdcage elevator that opened directly into the apartment (installed in 1928 by "Cosimo and Edith of the Rucellai Counts," its commemorative brass plaque announced) or via its own secret stairway, an offshoot from the main staircase originating just above the second-floor landing, eerily concealed behind a door within a wall—much like the surprise door within a door that, only a short time before, had served as my gateway into Palazzo Rucellai.

Just as soon as I'd gotten my bearings, Niko rang. "I need you to come downstairs!" he barked. "Contessa is here now."

Was I being summoned? How oddly exciting, I thought.

I tucked in my T-shirt and headed down to meet the dowager of my dreams. But when I re-entered Alberti's cortile, prepared to curtsy, or whatever it was one did, I found a very different picture: the serene space I'd just passed through was now dominated by a tall young woman making a futile effort to discipline three brats kicking one of the courtyard's weathered columns as though it were a mangy old dog. This must be the daughter-in-law, I reasoned. Or the daughter-in-law's *nanny*?

Alas, this was the contessa.

Everything about her clashed with my fantasy of the Italian nobility. I'd imagined something along the lines of Bona Frescobaldi—with maybe a bit of an aging, bespectacled Sophia Loren thrown in for good measure: assisted skin, mannequin hair, heavy gold, dressed for an audience in a nubby knit dress, her imminent arrival announced by the steady click-clack of Ferragamo grosgrain ribbon-adorned patent-leather pumps and the intoxicatingly sweet waft of Santa Maria Novella vapors. In other words, a daunting matriarch.

Instead, my contessa would turn out to be nothing more than a meddling Emma Woodhouse, a boring throwback with an acerbic demeanor that already suggested to me a profound bitterness, a simultaneous loving and loathing of the role to which she'd ascended. I let my imagination run wild: her husband had given her a title and little else. Don't get me wrong—the name was priceless, but perhaps it no longer paid the bills. And so, I fantasized, the ever artful contessa, forced to downsize to a suburban villa, had begrudgingly converted the former servants' quarters into apartments, letting the rent she collected each month serve as a salve upon the humiliation of it all.

I stood, as silent and stoic as the abused column at my back, and tried to take her in. Her words, like her gestures, were quick and stiff. Upon completion of a rather officious lecture on the importance of locking up, she declared with brusque determination, "Now, we'll *have* to find you an Italian husband!"

I cringed, and blushed. Or blushed, then cringed. I don't remember in which order, exactly; I became undone. The only thing I know for sure is that I was flustered by her mandate, and all the more so by its delivery. Back home, I had ways of dealing with this sort of thing, but here, in this milieu, I was rather at a loss. Where I come from, we pry politely. Declarative sentences are simply not used in New Orleans—and don't even think about using the imperative. Criticism is deployed only in the very softest of tones, and preferably in the form of an invitation: "Would you *like* to find a husband?" (Not that Italian culture isn't at least as duplicitous and, considering the millennia propping it up, rather well rehearsed. Even to a fifth-generation New Orleanian, this would pose a challenge over the ensuing months. But, in time, I would come to recognize the difference between the two courts: whereas southern manners serve to *cover up*, Italian formality functions to *reveal* and, crueler yet, to *remind*.)

Never one to forget my manners, I simply smiled and responded to the matrimonial agenda she'd just laid out: "Contessa, you don't think I'm here to find a *husband*, do you?"

No, I was there to find something else entirely. I had come to Florence to write Renaissance history. And I was moving into Palazzo Rucellai to *live* it, to lose myself in my muse.

A week into my stay and I was still tripping over the impedimenta of the nobility. It was a far cry from the anemic housing I'd had as an academic. A mammoth armoire painted with saccharine scenes of frolicking shepherdesses loomed over me. Smaller, though no less haunting, was the pair of *rosso rubino* marble-topped

tables that, mimicking the ruby-red color of dried blood and flanking my headboard, contributed to many a restless night. But the real monstrosity in the room was a great ebony sideboard, its upper half resembling one of those creepy curiosity cabinets, its dozens of tiny drawers filled with freakish specimens, like monkey thumbs or two-headed rats. Such *Wunderkabinette* were popular from the mid-sixteenth century through the so-called Age of Reason and up to the early Age of Enlightenment. I was at once disappointed and relieved to find these drawers empty for our current age.

The lower half of this baroque albatross, resembling a proper credenza, offered a great deal of practical storage space. One afternoon, in an effort to make a home for my books there, I unearthed a badly chipped but complete vintage set of Richard Ginori china in the Italian Fruit pattern. Now this *was* a wonder! Clearly, the contessa had overlooked it when collecting her booty. Never mind that the delicate pattern of ripe *susine*, *albicocche*, and *fragoline* competed with Murano glass goblets of deep amethyst hue and medieval proportion; I kept the full service proudly displayed on the long walnut banquet table, as though I had a standing dinner date with Cosimo de' Medici.

Illuminating the room were silver-plated candelabra the size of small lemon trees, which cast fitful shadows over cracked plaster walls. The latter were covered with less than mediocre landscape paintings, made-up scenes of the "School of" variety; still, they kept me reasonably elegant company. Overhead, a medieval truss of squared-off elephantine tree trunks obtruded upon my already squat quarters. And the situation underfoot was no less menacing, the original terracotta pavement being in such poor condition that the contessa had rolled out one of those cheap sisal mats from IKEA, over which she'd scattered an array of threadbare antique rugs. I must admit it worked, aesthetically; but the pile of the rugs was so badly worn that one could feel the prick of modern fibers poking right up through the weave. Hence my daily sisal splinter, a harsh reminder of egalitarianism, modernity, globalization—all those ideas that had enabled my present adventure and yet, with every new piercing, tempered the thrill of my palace idyll.

Suffice it to say, the contessa had dumped so much aristocratic detritus into the room that only 15 percent of the 540-square-foot floor plan was even navigable. There was simply no way to move the couch upholstered in burnt orange chenille; that whale wouldn't budge. Similarly permanent was the gigantic "antique" wine barrel—Tuscan kitsch I could have done without. Any remaining space was swallowed up by an inconceivable number of Victorian rosewood

balloon-back dining chairs—truly lovely, taken individually, but, as a herd, burdensome beyond belief. Then there were the several gilded rococo mirrors disconcertingly multiplying and magnifying the gaudy splendor.

Yes, I was living large among orphaned heirlooms, quietly nestled in this repository of Rucellai disinheritance. To be sure, the apartment had been aptly named. But Archivio stored more than just cast-off furniture and chipped china. It was also, I began to perceive, a guardian of secrets, a keeper of memories, a confidant who had heard it all. As an outsider invited in, I found myself living between floors, between centuries, between lives. Or so I mused when I should have been unpacking my books.

Wallowing in my newfound residence, I leaned back on the chenille couch and popped a Baci into my mouth. As the chocolate hazelnut kiss slowly melted away, I unfurled the love note lining the foil wrapper to see what Perugina had prophesied for me that afternoon:

> *Messaggio d'amore n. 132:*
> *"Nei sogni, come in amore, non ci sono cose impossibili."*

"In dreams, as in love, all is possible"—a sentiment I would take to heart.

As I was the sole tenant—Niko had let this slip on day two—I'd been enjoying myself immensely, having effectively the run of the house. Niko lived there, too, but only Sunday evening through Friday evening, and he slept in an alcove just off the courtyard; well past retirement age, the "guard" was safely tucked in every night by 8:00 p.m. That's when, as a morgue-like hush fell over the palace, I would roam the halls, knocking on blind archways, daring the ghosts to wake. I took great delight in swishing down the marble staircase, bowing to battered portrait busts of adopted forefathers at every dusty landing. I even took the liberty of sorting through the family mail, which still passed through a slender slot carved to resemble a foreshortened Roman sarcophagus—or a parted mouth. Though I knew that Florentines had long made a habit of recycling family names, standing there in the vestibule, fingering a certain Giovanni's correspondence, took my breath away.

I also went behind the scenes—and between the walls. I drew back curtains in quarters that were not mine to enter, enjoying views of the city that only Rucellai eyes, I liked to imagine, had taken in. I discovered in a rear corner of the *piano nobile*, tucked not too far from a tiny rectangular chapel, itself barely wide

enough to hold a pair of prie-dieux, a disquietingly narrow spiral service stair which ran, unilluminated, from the tip-top of Palazzo Rucellai to rock bottom. Adding to the sense of peril was the absence of a central solid axis: In lieu of a supporting pole, let alone a railing of any sort, was a brittle rope, knotted at regular intervals and suspended some 70 feet. With steady steps, I began the ascent, my left hand tightly grasping the knuckles of the fiber pendulum as my right hand trailed flatly along the enclosing wall. I didn't manage to complete a single revolution before I seized up with fear—*if the contessa found out* ...

Rather than lose my footing in the dark, I returned to the front of the palace and jimmied my way into the ballroom. I entered easily enough, only to discover that the enormous square room, with its white-on-white wedding-cake styling, was already occupied. Gamboling overhead was a gaggle of gauze-draped maidens, in varying degrees of undress. I kept my head cocked back for a good five minutes, titillated by the risqué fresco, its sensuality heightened by a *sorbetto*-tinged palette. Perfectly besotted with these rococo beauties, I floated up to join them on top of the world.

Enchanted, I remained.

What was I looking for, breaking and entering my way through Palazzo Rucellai after hours? There was the novelty of the address, undeniably; that I now possessed a key to the front door of Alberti's magnum opus exhilarated me. But my stealth meanderings through the house weren't merely of an academic nature. There was also something achingly personal about my movements: the way I fingered the mail, for example, or the way I cupped doorknobs, even the way I sank into and petted the upholstered furniture—all of these gestures betrayed a dire and unapologetic covetousness on my part. For what I'd finally found in this house, I believed, was a home.

I grew up not in a Greek Revival townhouse in the Lower Garden District, nor in a Creole cottage in Faubourg Marigny, but in a two-story, four-bedroom tract house on the west bank of the Mississippi River. My parents were stylish people who knew good architecture, but they were also new business owners—my venturesome father had given up his professorship in mathematics for a second career in the retail school supply industry when I was seven years old. Hence their 1975 purchase of the ten-year-old suburban cookie cutter, a decision driven by cost and convenience. Admirable priorities these—sensible ones, too, for we spent most of our waking hours at the store. Three miles away, in the middle of a strip shopping center anchored by a kosher-Cajun deli on one end and a

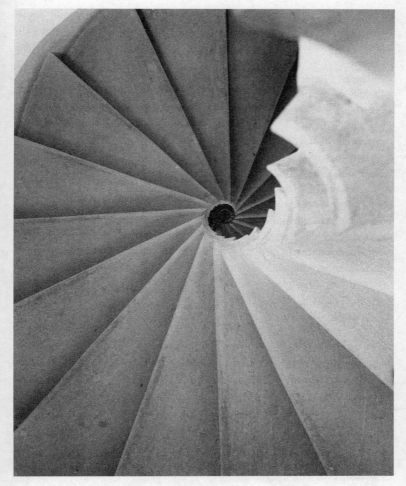

Figure 5. A secret stair, dating to the fifteenth century, found at the rear of the palace.

fabric store on the other, our unconventional family life played out. Friends and relatives visited during business hours. My brothers raced hand trucks—with me on board—between Oldsmobiles in the parking lot. Scolding took place in the back room. We held our birthday parties at the store; I lost teeth at the store. When a hurricane threatened, we slept on preschool rest mats piled high

on the mezzanine; and several times a week—no matter the weather—dinner came from the deli five doors down. Even our dog, either tethered behind the front counter or left to his own devices in the attached warehouse, called the store home.

Meanwhile, our house, on the corner of Copernicus and St. Nick, sat empty, a "home" as incongruous as the sound of its coordinates. From the outside, 4400 resembled every other brick-and-wood siding split-level in the young neighborhood: the dominant concrete driveways, the yawping garage doors, the short shutter-less windows, the unremarkable front entries—the houses could have been transplants from any large suburban development. Here, though, in Walnut Bend, the dullness of the design was enlivened, to some degree, by hot pink azaleas and fragrant magnolias. Still, our house, for all its Southern suburban conformity, was pretty much a soulless shell.

Given that our lives revolved around the business, my parents had outfitted the house only with those pieces of furniture deemed essential—a couch, sadly, hadn't made the cut, for the large rectangular living room, which accounted for a good quarter of the house's total footprint, served as our satellite warehouse. I spent my evenings playing among the boxes, carving out forts from cases of chalk. Other nights, I'd rearrange the backstock into convoluted mazes, then voluntarily lose my way; I'd have no choice but to climb up from my cardboard trenches and skydive down onto the shag carpet below, a synthetic sea of baby blue that stretched from one sheet-paneled wall to the next.

From my perspective, the rest of the house came up short. Sure, empty or sparsely furnished rooms promised endless adventure—and made the house seem larger than it actually was. But this vacuous feeling extended well beyond the physical confines of the four walls; it also magnified the significance of the few material flourishes we did possess: an antique grandfather clock, an olive-wood chess set, a pewter teapot. The sobriety of this interior was merely a matter of circumstance, my parents kept repeating, a means to an end.

But the couch never came.

And there was no alternative nest: my father didn't believe in joining private social organizations, so we didn't belong to a country club. Nor were we members of a carnival krewe. And given that we were both secular *and* quiet, the Jewish Community Center, too, was out of the question. My Saturday morning art classes, held at the local elementary school, were the closest I'd come to attaining membership—in anything.

—CHAPTER ONE—
The Merchant

Looking at a very handsome woman—not born to the purple, but giving an excellent imitation.

Screenplay, *The Woman in Green* (1945)

"CLOTTED BLOOD"

Over the ages, purple has meant many things to many people. In Ancient Rome, it signified power; to the early Christians, sin; but for the Rucellai, purple would be the color of money.

The original shade was deep and dark and rich. Think of shiny pomegranate arils or of a succulent Super Tuscan wine or, as Pliny the Elder observed, of "clotted blood." So esteemed was the precious hue that classical mythology assigned its discovery to Hercules. According to legend, the god-hero went for a stroll one day along the eastern Mediterranean coast with his dog and a beautiful nymph named Tyrus. When his faithful friend, who had been frolicking in the shallow water nearby, returned to the couple sporting a crimson muzzle, Tyrus fell in love with the peculiar shade and promised to marry her suitor, but only if he could present her with a robe of the same novel color. Determined to win the girl, the god-hero followed the dog's path to the water's edge, where he found the unlikely key to his lover's heart: spiny sea snails. He eventually extracted enough

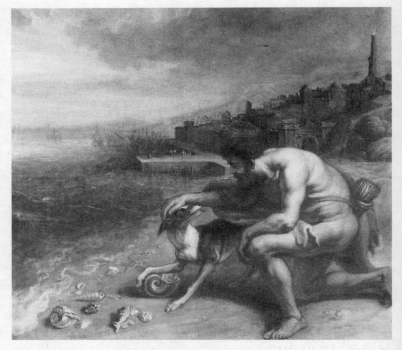

Figure 6. Hercules discovers the color purple.

dye from the tiny glands of the mollusks—by crushing them completely—to purpurate the nymph's gown, to her delight. And thus the god-hero's conquest would imbue the color with power and passion down to the present day.

For almost 2,000 years, the manufacture and trade of Tyrian purple, also known as "royal purple" or "imperial purple," played a major social, political, and economic role throughout western Eurasia. Though the Phoenicians are credited with the commercial production and distribution of the precious dye around 1600 BCE, recent archaeological findings on the island of Crete point to a Minoan dye industry, albeit on a smaller scale, several centuries earlier. Indigenous to the Levantine littoral, the dyestuff, mollusks of the genus *Murex*, was prevalent—at first; but overharvesting, combined with the laborious process of extraction, soon made the purple dye the most expensive in the ancient world, worth its weight in gold under the emperor Diocletian.

So coveted were purple textiles, so rampant the conspicuous consumption, that sumptuary laws had to be enacted to control the peacocking. As early as the ninth century BCE, the prevalence of purple bed linens, for instance, prompted Lycurgus, the legendary Spartan lawmaker, to ban such "needless splendor." (Spartan warriors did, however, wear purple on the battlefield in order to camouflage bloodstains, thereby appearing invulnerable to the enemy.) Despite such censure, materially minded citizens found ingenious ways around luxury legislation, dyeing just undergarments or hemlines, for example, in the prohibited color. But as the public became more emboldened, politicians became more draconian. According to Suetonius, the Roman biographer, "when [Nero] saw a matron in the audience at one of his recitals clad in the forbidden colour he pointed her out to his agents, who dragged her out and stripped her on the spot." The emperor clearly lacked the cultural tolerance of Pliny: "Let us be prepared to excuse this frantic passion for purple," counseled the first-century naturalist, "even though at the same time we are compelled to enquire why it is that such a high value has been set upon the produce of this shellfish."

And in Byzantium, where use of the color was limited to the imperial court, purple symbolized power as much as privilege. Only emperors, bedecked in purple boots, could sign edicts in purple ink from upon a purple throne. Such entitlement, in fact, began at birth. A child "born in the purple"—far superior to being born with a proverbial silver spoon in one's mouth—was considered preordained to rule. The distinction, Porphyrogenitos, was reserved only for those born to a reigning emperor and his empress in the Porphyra, or imperial birthing chamber, in the Great Palace of Constantinople. A purple birth was, thus, a label of legitimacy.

But as a symbol of the elite, purple could also stand for excess, a vice frowned upon by the early Christian church despite the practice of outfitting their own cardinals in the color they had denounced as decadent. "All such vanity," wrote Clement of Alexandria, "is but a puff of wind." Those who clothe themselves in luxury, he admonished, rest in "the palaces of earth, those which crumble away, where vanity and vainglory and sycophancy and error dwell." Women, this third-century church father believed, posed a particular threat to society insofar as their purple dress could be linked directly to moral decay: "If I could but wring the purple out of all the veils," he exclaimed, "that passersby might not turn to catch a glimpse of the face behind it!" Women, Clement insisted, "make everything purple to inflame lusts." He

further bemoaned the fact that such clothing was more valuable than the body underneath:

> A covering, it seems to me, should make what it covers more conspicuous than itself, as the temple does the statue, the body the soul, and the clothing the body. Now, everything is just the opposite. If these women sold their bodies, they would get scarcely a thousand Attic pieces, yet they pay ten thousand talents for one garment, proving that they are less valuable and profitable than their clothes [...] The foolish eagerly seek what seems to be good, rather than what is really good, like the insane who believe that black is white.

Despite all the preaching against purple, consumers continued to flock to the superficial. For it was precisely the cover-up—what Clement regarded as sin—that the masses saw as their salvation.

It was only a matter of time before this ultimate status symbol, as hotly debated as it was desired, fell victim to the laws of supply and demand. By the third century CE, the intense harvesting of natural resources had led to a significant decline in purple dye manufacture (discarded shell piles, some measuring 130 feet in height, still exist in present-day southern Lebanon), and for the nearly 1,000 years following, there is virtually no mention of the industry in historical sources. True, between the fall of Rome and the fall of Constantinople, the Byzantine emperors and the highest echelons of the church hierarchy did have access to the precious dye, but even *they* had to scramble to maintain what was merely a satisfactory supply.

And then, out of the blue, purple resurfaced in Florence, of all places; this time, however, the domain of a single family. So how did the Rucellai get their hands on it?

"POOR MAN'S PURPLE"

Legend has it that an ancestor was traveling in the Levant, as part of a crusade led by the Emperor Frederick II, when nature called. Dismounting his horse, he wandered off the beaten path, where relief gave way to disbelief as his urine turned the earth a deep, dark crimson. It seems the shrewd Christian's thoughts quickly jumped from papal allegiance to personal profit, for he gathered up as

much of the mysterious plant at his feet as he could carry and then hurried back to Florence, where, in short order, he was flush.

The story makes for a colorful foundation myth. But there was, in fact, no such serendipitous stream of urine, no eureka moment, no divine intervention, the true story being a bit more prosaic: Sometime around 1250, an enterprising merchant-adventurer named Alamanno set out along the eastern Mediterranean trade routes, determined to find the Next Big Thing. What he got was the Next *Best* Thing. For what the Florentine merchant had managed to get his hands on was *Roccella tinctoria*, a small, dry, drab-colored lichen (a symbiosis between a fungus and an alga), a most unassuming agent which yielded not "royal purple" per se, but something far more valuable: "poor man's purple."

The lichen—and the color derived from it—had been known and exploited for millennia before Alamanno ever laid eyes on it. From the outset, with 12,000 *Murex* shellfish yielding only 1.4 grams of dye (less than half a teaspoon), just enough for the trim of a single garment, there simply wasn't enough Tyrian purple to go around. The mollusk population now on the brink of extinction, manufacturers were pressed to find a substitute, an imitation purple dye that could satisfy an insatiable public.

At first, the lichen dye was used simply as a base dye to stretch out the extraordinarily expensive and increasingly rare original, though some Egyptian clerics went so far as to engage in flat-out forgery, passing off the lichen purple as the real "royal" variety. Oddly enough, however, the ersatz color was soon heralded "far more beautiful," according to Theophrastus, writing around 320 BCE, "than the purple dye [of Tyre]." But this, too, would all but disappear, for if overharvesting and slow regrowth didn't decimate the lichen supply, the secrecy surrounding the source reserves and techniques nearly did. Until, that is, an ambitious and tenacious Alamanno unearthed *Roccella* in an urban market—perhaps in Constantinople or Antioch or Alexandria, amid silks and spices and semiprecious stones—and returned to Florence, recipes and spores in hand, prepared to cash in on the promise of purple.

And so it was that the revival of "poor man's purple," a knockoff, made the Rucellai name—literally. From *oricella*, the Italian word for the lichen dye, the family became known as the "Oricellariis," the orchil dyers, a Latinized form that would eventually morph into the vernacular Rucellai. For almost a century, the family held a monopoly on lichen dye manufacture, exporting *oricella* throughout the greater Mediterranean. Purple was, again, the symbol of the elite. And since everybody wants to be somebody, the streets were suddenly awash in purple,

lining the pockets of the Rucellai with a different color altogether: gold. The dynasty was established.

ON THE FIXED AND THE FUGITIVE

The role of the cloth industry in the commercial revolution of late medieval Tuscany should not be underestimated. And in a city like Florence, where process was tightly interwoven with politics, those involved in the wool industry were, in essence, the warp and woof of the commune.

From the early thirteenth century, Florence was structured by a rigid guild system, a hierarchy of 21 organized trade unions that controlled all aspects of economic life. The seven *arti maggiori*, or "major guilds," included the Arte della Lana (wool merchants), Arte di Calimala (cloth importers, refinishers, and merchants), Arte della Seta (silk weavers), Arte del Cambio (bankers), Arte dei Giudici e Notai (judges and notaries), Arte dei Medici e Speziali (physicians and pharmacists), and Arte dei Vaiai e Pellicciai (furriers). Members of these guilds held considerable political power. They didn't simply wield influence; they were also guaranteed participation in the government: six of the nine priors of the Signoria, the governing body of Florence, hailed from the major guilds, while only two representatives could be sent from the lesser guilds (bakers, shoemakers, innkeepers, and the like). The *Priori*, for the duration of their two-month appointment, resided inside Palazzo della Signoria, now known as Palazzo Vecchio; they dressed in ermine-lined crimson robes and ranked only second in power below the chief magistrate of the city. Apart from the prestige the position carried, the job provided a powerful voice on the city's trade laws, taxes, and levies. As such, these selected officials effectively served as their own lobbyists.

It almost goes without saying, then, that the vast majority of wealth in medieval Florence was concentrated among the industrialists and bankers, or mercantile elite, of the *arti maggiori*. Indeed, as Giovanni Villani brings to light in his fourteenth-century *Chronicle*, the city's economy was booming—and its staple commodity was none other than wool. So enmeshed was civic identity with wool commerce that Saint John the Baptist (and his unshorn lamb) served as patron saint for both the city and the Arte della Lana. In 1338, according to Villani, the Arte della Lana oversaw 200 or more workshops, which produced annually between 70,000 and 80,000 bolts of woolen cloth worth a total of 1.2 million gold florins. (The *fiorino d'oro* was worth 3.5 grams, or 0.1125 troy

ounces, of gold; coined in Florence from 1252, it was the dominant trading coin in Western Europe.) These impressive figures reflect a seismic shift that had occurred decades earlier: with the importation of English wool, combined with Florentine know-how and wherewithal, the local cloth industry had gone from one of mass-produced mediocrity (*panno bastardo*, for example, was the name given to cloth made of native wool) to one of highly specialized luxury goods.

No one was better positioned to profit from that opportunity than the "Oricellariis," exclusive purveyors of "royal purple." Without a doubt, as demand for luxury fabrics rose, only they could deliver the defining ingredient. But this was hardly happenstance. Upon discovery of both agent and process in the mid-thirteenth century, a farsighted Alamanno and his kinsmen sourced the lichen from the Levant, the Aegean, and the Mediterranean. Then, using the age-old recipes of the Eastern dyers, which the clan itself managed to keep secret for almost a century, the family manufactured the dyestuff in Florence. With no competition in sight, they alone exported *oricella* to every major textile center in Europe and beyond, controlling the manufacture and commercial trade of *Roccella* purple until the end of the fourteenth century.

The intrepid Alamanno may have single-handedly reestablished the lichen dye industry, but his success was largely dependent upon an extensive and intricate network of suppliers, shippers, and laborers. As a wool merchant-manufacturer (unequivocal documents link Alamanno to the Arte della Lana as early as 1261) he was, above all, a producer, responsible for organizing and underwriting the entire enterprise: purchasing and transporting bales of wool from the Cotswolds via Calais, in spite of war, pirates, and plague; sending the raw material out to be worked locally, once it had made its way through the receiving ports of Pisa or Genoa; and, finally, selling the finished cloth outside of Italy, mainly in Spain, North Africa, and the Levant. Given the logistics, a healthy amount of capital, efficient management, and strict quality control were crucial to any successful operation. So, too, was patience: from start to finish, the whole transaction could take up to three and a half years to complete.

Matters on the domestic front were no less hairy; the manufacture of cloth alone was a complicated process, involving at least 26 different operations by countless hands over a period of six months. According to the "Trattato dell'arte della lana," a fifteenth-century set of guidelines issued by the Florentine wool merchants' guild, the five major steps of wool manufacturing included preparing the wool, spinning, weaving, dyeing, and finishing. The work force ranged from unskilled manual laborers to highly trained artisans. Men assumed either the

physically demanding work, such as beating, washing, and carding the fleece, or the more profitable advanced work of napping, shearing, pressing, and folding. Women—mothers, widows, nuns, and prostitutes—were responsible for all of the spinning and some of the weaving, with children working as apprentices from the age of ten. Though the gender division of labor was sharp, the sexes often came together in the popular imagination. Spinning, for example, was historically associated with female virtue and industry, but in the medieval period and beyond it could also be linked to sexual appetite. Indeed, the image of the sexy spinster, balancing an upright distaff in her open lap, proved stiff competition for Eve and other "bad girl" types.

Depending upon the stage of manufacture, operations were carried out in workshops across the city, on the banks of the Arno, in convents or private homes in town, or in the Tuscan countryside. Wages, too, were all over the map: carders received low daily wages, while weavers tended to be paid on a piece-rate basis; the majority of laborers, working independently or within large establishments, received compensation on an irregular schedule, whereas a regional supervisor might receive a fixed weekly salary. Furthermore, every stage of cloth manufacture was heavily regulated by guilds that had been organized for the benefit of the merchants, not for the *sottoposti*, the lowest rank of workers in the textile industry. This disenfranchised group found itself at the complete mercy of the guildsmen, who set wages, established industry standards, and dealt out harsh sanctions. A spinner who didn't reach quota, for example, could be threatened

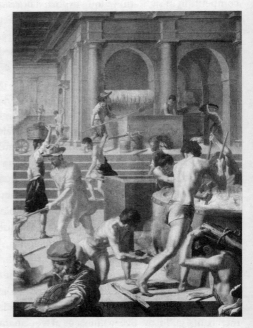

Figure 7. *The Wool Factory* captures the hard, gendered labor of cloth manufacture.

with excommunication. Cloth not dyed up to par would be burned and the dyer fined; he might also have his hand cut off. Meanwhile, a small group of savvy entrepreneurs, like the Rucellai, were making money hand over fist. Finally, in 1378, fed up with regulation without representation, skilled and unskilled *sottoposti* joined forces and took to the streets of Florence. "Strip us totally nude and you would see us as equal; reclothe us in your dress and you in ours," they dared, "and we would, without a doubt, seem noble and you base; because only poverty or riches makes us unequal." The uprising, known as the Revolt of the Ciompi (named for the clogs worn by the poorest workers), led to the creation of three new minor guilds, including one for the dyers—notorious rabble-rousers, known for their "dangerous tendencies to independence."

Dyers were, indeed, a dicey lot. Well aware of the pivotal role they played in cloth manufacture, wool dyers had tremendous leverage. Already by the end of the thirteenth century, they had formed their own autonomous confraternity dedicated to Saint Onufrius, or Humphrey, the fourth-century Egyptian hermit who, according to popular belief, had been born a girl but miraculously became a man in order to stave off losing her virginity. And in the following century, buttressed by their newly formed guild, the Arte dei Tintori, some dyers were able to negotiate partnerships with their dyestuff suppliers, resulting in economic mobility for a good number of them. The group had become so specialized, in fact, that by the fifteenth century there were seven different words for "dyer." In short, the aggressive, independent spirit of the *tintori* kept them a league apart, even as they maintained their core position within the industry.

But if, for these reasons, dyers were treated with kid gloves, they also were kept at arm's length. Since antiquity, dyers—because of the materials and methods of their craft—had been viewed with disinclination and suspicion. "The finger of a dyer," it was pejoratively recorded in the ancient Egyptian "Papyrus Anastasi," "has the smell of rotten fish. His eyes are red from fatigue. His hands are red [...] like those of a man covered with blood." The stench over the ages in all likelihood stemmed from the use of urine in large quantities, as called for in this recipe from 1548:

> Take one pound of *oricella*, moisten it with a little urine [...] let it sit for twelve days, stirring twice daily [...] add a little more urine, let it remain another eight days, continuing to stir [...] afterwards add a pint and a half of stale urine. Wait eight days [...] add a quarter ounce of arsenic; it will then be fit for use.

The source of all of this urine? We know from archaeological excavations in Pompeii, for instance, that fullers kept pots outside of their shops, encouraging passersby to leave donations. (The ancients preferred the urine of children who had not yet reached the age of puberty, perhaps because children's urine was believed to have mystical properties.) And in eighteenth-century Britain, the urban poor saved their urine, selling it to dye factories in order to keep food on the table; urine collectors then delivered the "urinous volatile spirit" to the even worse off—workers who held the unsavory job of filtering the fetid liquid. Perhaps the Rucellai had a similar modus operandi. The cloudy origin of the *orina* supply aside, secret formulas and mysterious admixtures further contributed to the popular belief that dyers, because they changed the appearance of things, were dabblers in magic and alchemy. There may very well be some logic, then, to the choice of the transsexual Saint Onufrius as the patron saint of the medieval dyers' guild, if transmutation was the crux of their trade.

Yet color is merely an illusion—a visual effect caused by reflected light—and thus a trick of the eye rather than of the dyer. "Any body may be made to appear of any colour," observed Sir Isaac Newton, whose seventeenth-century investigations into the refraction of light propound that objects themselves do not generate color, "but ever appear of the colour of the light cast upon them." Medieval and even Renaissance theoreticians may not have had such a sophisticated understanding of optics, but what early colorists—and consumers—did see with crystal clarity was the power of color to convince otherwise.

If dyers were a shadowy bunch, so, too, were their dyestuffs. Lichen purples, for example, lack the same stability and fastness as mollusk purples, causing them to fade over a relatively short amount of time. From the consumers' point of view, the fear of fading—both sartorially and socially—made dressing very costly; because purple was always popular, wearing last season's washed-out shade was unthinkable. But from a business perspective, the fleeting character of *oricella* wasn't necessarily a bad thing; accelerated wear and tear meant steady demand.

Not everyone was in a position to assume a new and improved identity, to be sure. Still, everybody had a role to play in the comedy of riches that was early modern Florence. Accordingly, dyers became the enablers for the upstarts who were fast to flaunt their elevated social status—no matter how fugitive the impression.

SCARLET FEVER

Paradoxically, in Florence, a city whose fortune had been founded on luxury cloth, the wearing of extravagant dress was practically prohibited by the commune. Early sumptuary legislation, largely enacted by the guildsmen, was resolutely democratic, "designed less to keep down the upstart than to fetter the aristocrat." But over time, as the rising rich began to acquire refined tastes, the old codes were reconfigured to regulate the new elite.

The vast majority of these laws imposed limits on the size and style of a woman's wardrobe. She could own no more than four gowns, for example, only one of which could be dyed crimson; trains, sleeves, and plunging necklines were not to exceed a certain length, width, or depth; belts, buckles, and buttons were all subject to regulation, as were fur hems and head ornaments. Even men's dress fell under scrutiny: excessive ruffles or pleats were deemed effeminate and, therefore, offensive. In short, the overdecorated aristocratic body—male or female, bona fide or bogus—was banned from the streets of Florence, at least in theory.

Despite extreme measures, such as the establishment of the first modern "fashion police," the Ufficiali delle donne, degli ornamenti e delle vesti, efforts to enforce sumptuary legislation proved futile: "In spite of all these strong ordinances," Giovanni Villani opined in 1338, "outrages remained; and though one could not have cut and figured cloth, they wanted

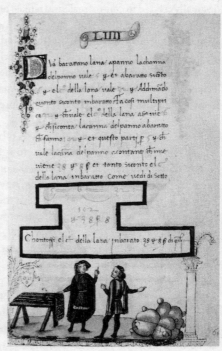

Figure 8. A didactic image from an arithmetic book shows two merchants bartering in an open market: a single length of crimson-colored wool is worth several bolts of undyed cloth.

striped cloth and foreign cloth, the most that they could have, sending as far as Flanders and Brabant for it, not worrying about the cost." Moralists, too, tried to crack down on the frenzy, but to no avail. The threat of mortal sin notwithstanding, Saint Bernardino of Siena's admonition that "there is great danger in being puffed up with pride and in wearing crimson overgarments" did little to slow the spread of scarlet fever.

If class difference had been anxiety-inducing, imagine the threat of class confusion—the uncertainty of knowing who and/or what lay beneath the cloth. It was precisely this ambiguity that would further unravel the conservative powers that be. By the early Quattrocento, for example, prostitutes and Jewish women were dressing like "honorable" women—and vice versa. The Ufficiali di notte, originally created to control male and female prostitution and other dark-of-night activities, soon had their work cut out for them; before long, because of their shared taste in fashion, women of all ages and stations were under surveillance.

But under certain circumstances, luxurious dress was permitted—even expected—so long as it imparted honor to the city. Take, for example, this 1480s description, written by the Florentine bookseller and biographer Vespasiano da Bisticci, of Leonardo Bruni, chancellor of Florence and quintessential "new man":

> There was, about Messer Leonardo, a most solemn aspect. He was not tall, but of medium height. He used to wear a full-length scarlet woolen gown with sleeves that were lined at the openings, and over his gown, he wore a full-length rose-colored cloak, open at the sides. On his head, he wore a rose-colored hat, at times with the fabric hanging down on one side. He used to walk through the street with the greatest seriousness.

For the *uomo nuovo*, the secret to dressing for success was refined restraint—in everything from choice of fabric to comportment. This "look," of course, was as affected as any other; but what set these poseurs apart from the *pavoni*, or peacocks, was their mastery of *sprezzatura*: the art of faking it without trying too hard, or the erasure of any evidence of effort. Knowing just how much—or how little—to reveal was key. When in doubt, Cosimo de' Medici famously advised, "Dress in red, and don't talk."

This unqualified *rosso*, like Rucellai purple, ranged in shade from pomegranate to raspberry. By the time of Cosimo's adage, the variety and availability of dyestuffs had expanded significantly since the thirteenth century. Remarkably, Alamanno and his kin were able to maintain their monopoly on *oricella* until

explorations of the Canary Islands in c.1400 yielded a nearby supply source; subsequently, other Italian merchant-manufacturers began dyeing with the *Roccella* lichen. Throughout the Quattrocento, *oricella* remained a prized commodity (it was the cornerstone of the burgeoning litmus industry), though it would eventually share the stage with other sources of the favored crimson shade, from kermes, or grana, to lac, vermilion, brazilwood, and cochineal. What mattered most, however, was not the source of the color, but its sustained symbolism—wealth writ large.

SURFACE BRUISE

Purple may have paved the way for Alamanno to catapult himself into the mercantile elite, but the family fortune was secured on the black.

Taking advantage of an international network of commerce and banking, the shrewd Alamanno dealt not only in goods but also in foreign-exchange transactions. Neither moneylender nor money changer, the merchant banker occupied an ambiguous position in the world of medieval finance. Usury, the taking of interest from a loan, was considered a cardinal sin; but because the profit made on the purchase and sale of bills of exchange was based on fluctuating and thus unpredictable prices, the church turned a blind eye to such transactions, thereby absolving the Christian merchant bankers from any wrongdoing.

Fleecing was rampant; it was also rewarding. Such disguised dealings earned Alamanno and his clan a significant family seat, of sorts, in the heart of the city. Having originally settled in Campi, an ancient settlement located about ten miles northwest of Florence, the family had strategically repositioned itself by the end of the thirteenth century in the established neighborhood of San Pancrazio, "where two of Florence's oldest professions—wool and prostitution—met." Built up along the northern bank of the Arno and lying just south of the church of Santa Maria Novella, the preexisting parish of San Pancrazio (its founding ascribed to Charlemagne) constituted the nucleus of Lion Rosso, one of 16 *gonfaloni*, or districts, in the medieval city.

Each *gonfalone* had its own unique character, dictated by geography as much as by genealogy. The tendency for households of large families to cluster together, combined with the camaraderie of these enclaves, or *consorterie*, resulted in a nearly unbreakable sociopolitical network. Loyalty to kith and kin was unspoken law. Thus, having settled into Lion Rosso, Alamanno and his clan gained both a

collective friend and a foothold in Florentine politics, for the *gonfalone* served as a mediator between the citizen and the commune, as well as a training ground for "new men" wishing to join the city's ruling group.

Still, the family never forgot their roots. Giovanni, who would expand the family fortune exponentially, waxed nostalgic in the fifteenth century about his forefathers' contributions: "Our ancestors were orchil dyers, and in that period there was no one else in Florence, nor in all of Italy, who knew how to die with orchil […] and this," the proud descendant boasted, "was the beginning of great wealth and good living for our family."

Indeed, Alamanno may have reeked of "rotten fish," but his descendants would enjoy the sweeter smell of success. The first member of the family to play an important role in the government of the Florentine Republic was Bernardo (called Nardo) di Giunta, named prior of the Signoria in 1302 and gonfalonier of justice in 1308. (The family would give a total of 85 *priori* and 14 *gonfalonieri* to the city.) By this time, the "Oricellariis" clan had acquired a simple coat of arms to go with their surname: a blue kite shield, or inverted teardrop, decorated with gold horizontal zigzag lines.

The next generation would rack up more than just political appointments. Bencivenni (called Cenni di Nardo) was elected prior an impressive six times before serving as gonfalonier of justice in 1328. But his most significant mark would be made as an intercessor of a different sort. A staunch defender of the Republic, he fought successfully against local factions and tyrant forces; when his son was beheaded in a siege in 1342, he sought refuge as a novice in the nearby convent of Santa Maria Novella and prayed there for the salvation of the city. He also built a chapel, in the transept to the right of the high altar, dedicated to Saint Catherine of Alexandria. In gratitude, the *popolani* coined a saying: "God can save thee, or Cenni di Nardo can."

Cenni's brothers continued to score accolades. Andrea, for example, was knighted for his service to France in the wars against England. But it was Berlinghieri (called Bingeri) who would bring a more material laurel to the family. A captain in the Florentine militia, Bingeri helped to suppress the revolt of the powerful Tolomei family in Siena and was rewarded by the people of that city, in 1318, with an addition to the family blazon: a silver lion rampant against a red background.

In the second half of the fourteenth century, in the wake of the Black Death, Rucellai sons—survivors against the odds—continued to serve the city, following in the footsteps of their forefathers. During this period, however,

philanthropic projects took center stage, from decorating their parish church of San Pancrazio to underwriting the completion of Giotto's bell tower for the cathedral complex. As patrons of art and architecture, they were making their mark all over town.

The Rucellai, it seems, had finally arrived. Within a century of Alamanno's discovery of "poor man's purple," the family had accrued a surname, a coat of arms, military honors, and political and financial successes. Alas, the house of Rucellai had everything *but* that critical claim in Renaissance Florence: the house.

Primo Piano

*She has seen it and knows that she is
without it and wants to have it.*

Sigmund Freud

After a full day of luxuriating in Palazzo Rucellai, I geared up to leave the building. Even from the ground floor, no fewer than three locked doors stood between me and the street. And these weren't just any locks; they were 300 years older than the Liberty Bell, with a set of hopelessly unwieldy keys to match. This antediluvian mechanism of simple warded lock and crude bit key offered minimal security and maximum stress. It took longer for me to exit the palazzo, for example, than it did to zigzag to my favorite *enoteca*, an elegant wine bar tucked away in a ground-floor room, just off the courtyard of a family palace to rival the one I was living in.

We go way back, this venerable Florentine house and I, their entry-level blend having been my weekend red of choice throughout graduate school. Though no oenophile, I knew that the family had been making wine for just about forever. And it came in the most handsome bottle on the Chianti shelf, the label an engraving of a Tuscan villa set within a formal garden of cypress, olive, and clipped boxwood—the perfect house red for an Italian Renaissance art historian in the making. Then, years later, on a trip to Florence for doctoral

thesis research, I made the link between the winery and this family palace and began drinking *in situ*. Now, as a professor with a cushy fellowship, I could even afford to take an occasional meal here.

On my first night back, Francesco, the perfectly seasoned manager, standing squarely behind the wood and copper bar, its semimatte countertop handsomely scarred by decades of bottle dings, slowly began to polish the bright surface in front of him. When he asked where I was living, I assumed he'd be impressed with my reply.

"*Palazzo Rucellai?*" he asked. "Why on earth would you want to live *there?*"

As Francesco poured, I proceeded to summarize for him the merits of Alberti's architecture. But still he was unpersuaded—less of my lecture on the facade, it seemed, than of my decision to reside behind it.

"*Vediamo,*" he said with a wry smile—*we'll see*—and slipped into the kitchen.

We'll see *what*, I wondered. I took a long sip and began to swirl. Did this layman know something I didn't?

The next morning, indulging my curiosity about the palace's local reputation, spurred by the prospect that there just might be something more to Palazzo Rucellai, I headed out, reader's cards in hand.

Florence has no shortage of research libraries, in all shapes and sizes of bureaucracy. I preferred the rusty, romantic ones, hallowed establishments that called out to me like a siren, inviting me to enter and experience the chanciness of discovery. This desired outcome was contingent upon the right combination of faith and patience, for Italian libraries and archives operate in a catch-as-catch-can system, with oddball opening times and a long-winded admissions policy. But once you've been granted a *tessera*, left an identification card at the entry desk, crammed your belongings into a locker, and found a seat in the reading room, the magic begins to happen.

The oldest of my favorites was an illustrious institution founded in 1583, the Accademia della Crusca. With a sieve as its symbol, the Accademia is dedicated to separating the fine flour from the bran (*crusca*), or preserving the Italian language in its purest form, as exemplified by Dante, Petrarch, and Boccaccio. In 1612, the organization published the first Italian language dictionary, the *Vocabolario*, itself an institution now in its fifth edition. Housed today in the Medici villa of Castello, about a 30-minute train ride outside of Florence, the Accademia della Crusca, the oldest linguistic academy in the world, proudly displays in its Sala delle Pale 153 wooden baker's shovels, dating from the sixteenth

and seventeenth centuries, each painted with a member's emblem, motto, and nickname. Walking past these symbolic portraits on the way to the library was always, to me, something of a mental strain, knowing that only the most refined thoughts were allowed here.

Back in the *centro*, on the same street as Palazzo Medici, sits the Biblioteca Marucelliana, one of Florence's oldest public libraries, its place in history vouched for by brass plaques affixed at regular intervals to the bookcases of its eighteenth-century reading room: NON SPUTARE!! The double exclamation point makes clear the severity of the threat on the next line: SPITTING SPREADS TUBERCULOSIS! Is this why the books, I often wondered, had been locked behind chicken wire—quarantined? If so, the permeable screen did little to quell my anxiety. Nevertheless, I always took my chances, sitting for hours on end at one of the nine long tables that filled the small room like jammed railroad cars. But the most disconcerting curiosity at the Marucelliana I encountered upon leaving. Each of the four corners of the room curved inward. Every time I pulled open one of the convex wooden doors, and then closed it behind me, I couldn't but think I'd stepped into a time capsule. Stuck in that liminal space, if only for a few seconds, I often wondered how far back I could go.

The membership registers of the Gabinetto Scientifico Letterario G. P. Vieusseux, a Victorian lending library, are a veritable Who's Who of nineteenth-century Florence: Schopenhauer, Stendhal, Leopardi, Longfellow, Emerson, Liszt, Ruskin, Browning, Dostoyevsky, James, Sargent, Twain, Zola, Gide, D'Annunzio. Imagine my delight, then, in adding my own name to the readers' list. Since its inauguration in 1819 the Vieusseux has changed location numerous times, palazzo-hopping along Via Tornabuoni. In the early twentieth century, the library moved into a suite of rooms on the ground floor of Palazzo Strozzi. When the flood of 1966 ravaged Florence, approximately 90 percent of the collection, stored in the palace basement, was buried in mud. For months, waterlogged volumes were left to dry out in the courtyard. The Vieusseux eventually reopened, in the same location; and some books, although bloated and stained with Rorschach-like watermarks, can still be requested and read. Sitting in this reading room 40 years after Florence's great deluge, and one year after Hurricane Katrina devastated New Orleans, I felt a sudden sense of urgency, a race against time, to unearth what I could about Palazzo Rucellai. For as I sat in these vestiges of Florence old and began poring over the literature, I quickly realized how little I actually knew about the building I now called home. Mortified, I put my

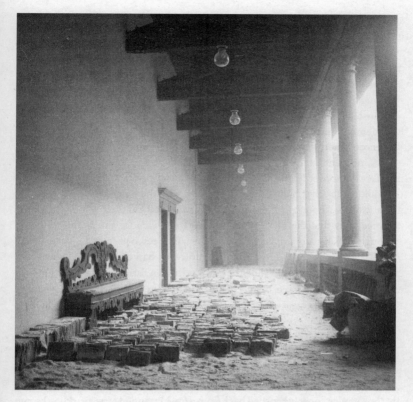

Figure 9. Books from the collection of the Gabinetto Vieusseux, damaged in the historic flood of 1966, blanket the courtyard of Palazzo Strozzi.

sabbatical book project on hold and devoted my library visits entirely to P. R., as I'd affectionately come to call my palace idol.

Practically overnight, the house became my own private laboratory, a testing ground for all of the competing theories I read about. Imagine cramming all day in the stacks, trying to unlock the mysteries of a topic, and then finding the key upon returning home. All of my findings, however, were pedantic in nature—questions of attribution, dating, masonry. None of this was even remotely shocking, let alone sordid. So I returned to the *enoteca* to interrogate Francesco's insinuation that Palazzo Rucellai had a dark side. Only this time I got much more than the tight-lipped manager.

The lunch crowd was different from the evening one I was by now used to. Instead of a convivial *cantina*, the dining room was packed with fast-talking Italian industrialists—hardly my speed. The bar, on the other hand, was vacant. I took my usual seat at the far end, beneath the framed emblem of the medieval vintner's guild, a monstrous web-footed goblet. Francesco was there, of course, but instead of playing Gregory Peck to my Audrey Hepburn, as he usually did, he seemed almost perturbed by my presence and took to polishing the bar with a nervous energy bordering on the neurotic. *Something* was up.

A moment later, side-glances and whispers began bouncing off of every surface. Whoever had just walked in was causing quite a stir. I took my turn at looking, too, but hadn't the foggiest idea who the older gentleman was. He was *someone*, though—a few of the suits were now on their feet. It struck me immediately that the mystery man didn't quite care for the attention; polite enough, he kept moving. As he approached, Francesco prepared a place setting at the far-left end of the bar. The man, however, had other ideas. I spied him gesturing to Francesco to slide the place setting in the opposite direction—in *my* direction. Francesco obliged, but only by two spaces. The man gestured again, this time his wave much more emphatic. I spun around fast and took a long sip of *rosso*.

I let him take his seat directly next to mine and then turned, nonchalantly, and gave him a polite but abbreviated "'*Giorno*," accompanied by a quick, short nod, which implied that I had no intention of disturbing his lunch. That's when I got a closer look: late fifties/early sixties; thick head of chestnut hair, graying at the temples, loosely brushed back from a freshly tanned face; sparkling brown eyes; and a slight underbite that suggested vintage genes. The man's lips were a bit thin, but he had a mischievous smile, I noticed immediately, that would have melted Mont Blanc. A delectable mix of Robert Redford, Roman Polanski, and Prince Ernst of Hanover with his smiling eyes, fluffy hair, and hand-in-the-cookie-jar pursed mouth, he was, in short, dangerously adorable.

I promptly introduced myself.

"And *I* am LO·REN·ZO," he rather proclaimed by way of response. How bizarre, I thought.

And yet, he wanted to know all about me. Surely I was on vacation, he surmised; or was I a study-abroad student? When corrected, he gasped, "A *PRO·FES·SOR?*" I could tell by his wide naughty grin and by his inflection that he was somehow titillated by my title. He seemed to put a stress on the syllables

of the things he liked. By which key, I'd so far gleaned that he liked himself, and he liked me (*Professor* me)—in that order. He also liked to talk—incessantly.

In the 45 minutes that ensued, I learned that he was "a little bit psychic"; that he had been born in Florence, but that his father, "a very demanding man," had sent him away to boarding school at the age of 12; that he'd "only once" ended up in jail—during his obligatory military service. He nudged closer to tell me the details: "I was stationed in Rome, working in a mailroom—something my mother had arranged with the archbishop—and, well, it was the year of *La Dolce Vita* … So I asked my *comandante* if I could take the weekend off—'to go home,' I said, 'to help with the harvest.' A week later, he saw me on the pages of a tabloid—dancing with a STAR-LET!"

As we both laughed off his youthful antics, I managed to do a full-body scan. He had an athletic build, with broad shoulders; he was tall in stature—not exactly a towering figure, but unmistakably a presence. Below the waist, cinched with a navy- and-green-striped web belt, he wore a well-broken-in pair of Levi's and scuffed blucher moccasins that, with those yellow-and-brown braided laces, could only have come from L.L. Bean. On top, he wore a light-blue long-sleeved polo, with one sleeve pushed all the way up to the elbow and the other left alone; this seemed deliberate, as the bared right arm displayed two tattoos, one all but hidden beneath an IWC watchband, and the other, a coiled serpent, all gray, etched into the middle of his inner forearm.

I could reconcile neither his American prep school style with his body art, nor his irresistible boyish charm with his intoxicating old-world scent of fresh cedar, nor his innocent puppy-dog eyes with his come-hither red-blooded voice.

At that moment, as if on cue, Francesco reappeared to top off our glasses, which is when the raconteur really opened up, telling me that he'd lived in L.A.—he'd dated Faye Dunaway "circa *Chinatown*"—but had been forced by his father, now described as "a dictator," to shelve his cinematography aspirations for viticulture; and that, consequently, he had "a couple of places" on the Tuscan coast, but was "on the market" for a palazzo in town.

Francesco had left a bottle of the house red within reach, and, groping for a suitable response to Lorenzo's most intriguing backstory, my eyes landed upon it. I figured it was my turn to divulge something personal, though I knew I could never compete with Lorenzo's past. So I professed my sappy grad school story, the one about my love of the label, which then prompted Lorenzo to share *his* sentimental link to the bottle.

"I was born in *that* room," he said, pointing out a window on the second floor of the engraved villa. "It was during the war, just my mother and a nurse. They said I came into this world like a bomb—*KA-BOOM!*" He threw up both of his hands, mimicking the explosion like a schoolboy soldier, his tabletop theatrics triggering a rascally little smile, which, within seconds, turned sour. "We don't own it anymore. My father sold it when I was twelve years old—to buy back this palazzo."

"'Buy *back*'?" I asked, half choking on the realization of whose company I'd been keeping for the last half hour.

"This palazzo hasn't always been in the family," he disclosed. "Well, it's only been in *our* family since the 1950s. Another branch owned it. Then they lost it— after, what, 400 years? My father wanted it so badly ..." Lorenzo's voice trailed off as he picked up the bottle and stared at the label. It seemed the only way he could possess the villa now was by holding the bottle in his hand. "I *never* forgave him for selling the house I was born in!" He placed the bottle back on the bar, with the label facing him squarely, before turning toward me. "And then, if you can imagine *anything* worse, my father left this palazzo to my brother. *Everyone* in Florence was scandalized!"

All of a sudden, Lorenzo was on his feet. A man had just approached—not to fawn, as the others in the dining room had done a short while earlier, but to announce that he'd finished his work "at the apartment in the Oltrarno." Lorenzo introduced the man as "Mr. Cantova—my architect." I offered an enthusiastic *salve!*, though I felt nothing but contempt for the interloper.

Within seconds, my impromptu lunch date was over. The whirlwind was out the door, but not without having first slipped me a paper napkin, scribbled with his number, which he'd tagged simply "LORENZO." I folded the napkin into my wallet and headed home.

Research was my middle name, I reminded myself. Surely I'd be able to flesh out the who, what, when, where, how, and why of "Lorenzo" in no time. I sat down at my computer, pushed up a single shirtsleeve, and got to work. Hours—and dozens of creative Boolean searches—later, I'd pieced together an impressive portrait. Lorenzo wasn't simply the younger brother of the public face of the venerable wine house; he'd also made a name for *himself* in the wine world, landing on the cover of more *Wine Spectator* issues than I had ISBNs under my belt. He was the real thing, all right.

One biographical detail, however, gave me pause: Lorenzo, whose family dated back to the eleventh century, was a direct descendant of Ugolino of

Donoratico, the thirteenth-century count consigned to Hell by Dante, reputed to have eaten his own children:

> "When a little ray had entered our dolorous prison,
> and I perceived on four faces my own appearance,
> both my hands I bit for rage; and they, thinking
> that I must be doing it out of a desire to eat,
> suddenly stood up
> and said: 'Father, it will be much less pain for us
> if you eat of us: you clothed us with this wretched
> flesh, so do you divest us of it.'
>
> and I,
> already blind, took to groping over each of them,
> and for two days I called them, after they were dead.
> Then fasting had more power than grief."
> When he had said that, with eyes askance he took
> the wretched skull in his teeth again, which were
> strong against the bone, like a dog's.

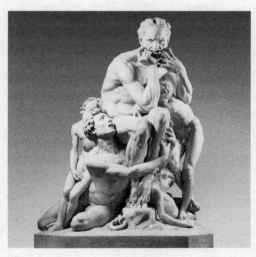

Figure 10. Jean-Baptiste Carpeaux's *Ugolino and His Sons*, 1865–67, depicts the moment when Ugolino, accused of treason and imprisoned, contemplates cannibalism.

A direct descendant of Ugolino! The historian in me was over the moon. But was I ready to be devoured myself? I refolded the napkin and filed it away in one of the tiny drawers of my *Wunderkabinett*. Tempting as Lorenzo seemed, I had my own aristocratic trappings to explore.

—CHAPTER TWO—

The Opportunists

God creates men, but they choose each other.

Niccolò Machiavelli

P icture a diptych—a double portrait—loosely hinged, the fissure in between a metaphor for the void that defines both halves, even as it binds them: two native sons displaced by trauma, stigmatized by separation, determined to go home again, to rise.

Giovanni Rucellai was born in 1403, the eldest of five sons. Just three years later, his father died, leaving a very young widow with no choice but to move back home. Rucellai, then, was raised across town with his maternal kin, the erudite Pandolfini. And he would not be reintegrated with his paternal clan until the age of 18. The reunion must surely have been a bittersweet moment for Rucellai as "home" was no prestigious palazzo, but, rather, a modest town house—only a small portion of today's block of real estate—on the corner of Via della Vigna Nuova and Via dei Palchetti, in the heart of Lion Rosso. Earning considerable wealth from the purple dye business, the family had assumed a comfortable place among those of the merchant class. Several family members had held prestigious political posts; others had earned fame as mercenary soldiers. Yet for all their successes, the Rucellai had nothing—at least not in significant material

terms—to show for it. When Giovanni and his brothers returned to Lion Rosso, in 1421, there were 23 Rucellai households but no one house, let alone palazzo, to stand as monument, as testament, to the greatness of this family.

Born in Genoa just one year later than Rucellai, in 1404, Leon Battista Alberti was the first of two illegitimate sons born to a father exiled from Florence a few years earlier. Alberti's mother, a Grimaldi widow, died two years later of plague. Then, when Alberti was 16, his father died, prompting unscrupulous relatives to withhold his inheritance; by the time the family exile was finally lifted and he entered Florence for the first time, Alberti was a poor and sickly 24-year-old. At least he had received a superior education, with a doctorate in canon and civil law under his belt—and a passion for architecture worn rather boldly on his sleeve. The Alberti, who hailed from the Santa Croce neighborhood, had been successful merchant bankers, serving the papacy and, necessarily, heavily involved in local Guelph politics. They had certainly made their mark—how else does one account for a 30-year exile? But when the clan came home, the bastard Battista was shut out. His patrimony having been stripped from him on account of his illegitimate birth, Alberti could lay no claim to the family property, a not insignificant palazzo built by his grandfather in the 1370s.

GLASS EYES

How must Florence have appeared through the impressionable eyes of the young Rucellai and Alberti when each reconnected with his family seat—or, more to the point, for each of these young men: his lack thereof?

In the first quarter of the fifteenth century, Florence had a population of 37,000—down by more than 60 percent from its pre-plague peak of 100,000 just a century earlier—but was still one of the largest and most important cities in Europe. Despite a substantially diminished populace, the city was thriving both economically and culturally. With a banking industry and a textile trade of international renown, not to mention a wellspring of talent, Florence was host to what was arguably the most dramatic artistic boom in the history of Western civilization.

Already in 1404, the humanist Leonardo Bruni had lauded the virtues of the city, particularly its magnificent and splendid buildings and the collective impact the architecture of Florence had on visitors:

As soon as they have seen the city and inspected with their own eyes its great mass of architecture and the grandeur of its buildings, its splendor and magnificence, the lofty towers, the marble churches, the domes of the basilicas, the splendid palaces, the turreted walls, and the numerous villas, its charm, beauty, and decor, instantly everyone's mind and thought changes so that they are no longer amazed by the greatest and most important exploits accomplished by Florence. Rather, everyone immediately comes to believe that Florence is indeed worthy of attaining dominion and rule over the entire world.

By the time Rucellai and Alberti came of age, 20 years later, Bruni's boastful survey of "exploits" on display would have expanded to include Ghiberti's first set of bronze doors for the Baptistery; Donatello's monumental marble statues of Saint Mark and Saint George, installed in external niches at Orsanmichele; and the dramatic renderings by Masolino and Masaccio of, respectively, the *Temptation* and *Expulsion* in the Brancacci Chapel fresco cycle. But, hands down, the most convincing case for world domination would have been the erection of Brunelleschi's colossal cupola for the cathedral of Santa Maria del Fiore, the Duomo. Rising well above an already impressive skyline, the dome, with its crowning lantern bedecked with gilded orb, would serve as a beacon in more ways than one. In short, the city of Florence was flourishing—and its future looked even brighter.

Reinsertion into the highest reaches of the Florentine establishment demanded reinvention, a metamorphosis abetted by the introduction of an *impresa*, or personal emblem. In late medieval Florence, pretty much anyone with a last name had a coat of arms. Then again, no more than one in eight Florentines had a surname in 1347; and though there would be a steady increase in the adoption of family names, the percentage of households using a surname, in the first quarter of the fifteenth century, hovered just around 35 percent. Rarer still was the invention of a personal device—not to mention one that would be employed for public effect. Giovanni, keen to ride the swell, contrived for himself a complex allegory of Fortune in the guise of Opportunity as the mast of a merchant ship in full sail. This was a curious motif, and gesture, insofar as the Rucellai family had had a coat of arms since the early fourteenth century. Nonetheless, the Rucellai family owed much to Fortuna, and this budding patriarch wasn't in the least ashamed to admit that much.

Alberti, too, had weathered his share of luck—most of it bad—and knew very well that survival in the city, let alone success, would depend not just upon skill but serendipity as well. "Like sailors tossed amid stormy events and rocky circumstances," he counseled, "we must be cautious argonauts." Coinciding with his reentry, he had invented his own emblem: an open eye—ripped from its socket, nerves still quivering—surmounted by a pair of eagle's wings, this oracular device augmented with a laurel wreath and accompanied by the intrepid motto QUID TUM? ("What Next?"). Alberti may have presented himself as an omniscient opportunist, but his detached organ, artificially puffed up with aquiline pinions, also reveals a deep-rooted fear of deflation, of impotence—or, rather, of civic castration. For he would also, at this time, add Leone to his birth name, Battista Alberti. For an exiled son, his choice was not surprising. Leone, referring to the heraldic lion that had symbolized Florence for centuries, carried unmistakable civic overtones. (As early as 1259, the city kept a lion pen, located first in Piazza della Signoria and then, by the fifteenth century, behind Palazzo Vecchio in the street still named Via dei Leoni.) Moreover, for an anxious orphan, the adopted name did double duty, compensating for the fate of his namesake, John the Baptist (Giovanni Battista), the patron saint of Florence, who had lost his head.

The trauma of separation, the embarrassment of noninheritance, the stigma of starting from scratch: for both Rucellai and Alberti, their iconographic and onomastic gestures may have gone some way to quell the anxiety of inclusion, but these wounded sons would never fully heal. Together, however, the pair would embark upon a grandiose building program, with architecture acting as a sort of suture upon it all—a public proclamation of what they regarded as their due and a personal promise to fill an even deeper void. Palazzo Rucellai would serve as more than a mere residence for these two orphans on the make, even more than a status symbol; the palace would stand as lost paternal referent, as palimpsest, as phoenix for both patron and architect.

NUTS AND BOLTS

Some built from the ground up, in a single campaign; take, for instance, Palazzo Medici, Palazzo Pitti, or Palazzo Strozzi, all of which were built *ex novo*. Rucellai, instead, with his father's modest medieval town house as his starting point, went about it from the inside out, over a span of 30 years. The final impression may

have been cutting-edge, but the philosophy and process operating behind the facade were steeped in tradition—and trauma.

During the volatile and rapidly expanding period of the thirteenth century, extended family groups, or *consorterie*, had a tendency to cluster, building their homes close together around tall towers. In addition to providing protection on a practical level, these fortified multifamily tenements symbolically proclaimed the strength and solidarity of the clan (still today, *casa*, or house, can be used to refer to either the building structure or the family). So powerful, in fact, had these complexes become that already by 1250 city officials were pressed to pass legislation limiting private tower height; anyone caught adding to the resultant stumps would have had both hands amputated. Shortly after this, as the city began to enjoy greater, if temporary, peace and prosperity, construction began on a new town hall, Palazzo della Signoria, and an expanded cathedral. These large-scale urban renewal projects prompted intense feelings of civic pride, inciting Florentines to finally see beyond the narrow confines of the *consorteria*.

But if, by the early fourteenth century, there was an increase in the construction of independent dwellings (masonry structures less dependent upon the clan buttress), restraint remained the rule. Austere simplicity defined exterior and interior alike. This intentional lack of style was dictated as much by mendicant ideology—"too great and unseemly a desire to build," warned the pseudo-Bernardine, "invites the revenge of the buildings themselves"—as by neighborhood jealousy. And if anything, these moral and social concerns further anchored the ancestral home in the psyche as well as the substructure. It was not uncommon, for example, to incorporate *spolia* (walls, doors, stairs) from older structures into the new family seat. But this conservative approach would gradually give way to a more autonomous attitude toward building.

Writing in 1381, the Florentine chancellor Coluccio Salutati referred to the prevalence of "splendid palaces" going up all around him. Without question, the last decades of the fourteenth century saw the rise of numerous impressive edifices, including that of the prosperous Alberti family. This surge in building would continue, with houses becoming increasingly grand in both size and sumptuousness. By the turn of the century, for instance, Leonardo Bruni extolled "the homes of the private citizens, which were designed, built, and decorated for luxury, size, respectability, and especially for magnificence [...] Even if I had a hundred tongues, a hundred mouths, and a voice of iron," he wrote in his "Panegyric to the City of Florence," "I could not possibly describe all the magnificence, wealth, decoration, delights, and elegance of these homes." Just as

the owners tried to outshine one another so, too, did the opinionists: "Nowhere in the world," lauded the silk merchant Gregorio Dati, "are there royal palaces that outdo these."

If all of this building was, indeed, worthy of encomia, it was also true that the rapid expansion of domestic architecture could wreak havoc on daily life. Luca Landucci, who owned an apothecary a short distance from the rising Palazzo Strozzi, seemed at once enthralled and yet perturbed by the spectacle unfolding—or, rather, swelling—before his very eyes. A diary entry from 1489, one of 12 on the subject, describes the scene:

> And they were continually tearing down houses, with a great number of masters and workers; and all the streets around were filled with mountains of stone and rubble, with mules and asses which were hauling things away and bringing gravel; so that there were difficulties for anyone passing through these streets. And the rest of us artisans were forever engulfed in dust and bothered by people who stopped to watch and by men with loaded animals who could not get through.

As Landucci's commentary confirms, such assertive—if not downright aggressive—building campaigns did not leave everyone merely impressed. So "splendid" was Palazzo Medici, for example, that an angry neighbor threw a bucket of blood onto the facade in protest, an incident indicative of the pulse of the *popolani* and colorfully recounted by the anti-Medicean chronicler Giovanni Cavalcanti:

> The multitude of citizens, no less than the plebeian horde, directed their wrath, full of bitterness and inclined to evil-doing, against the more distinguished citizens [...] and united in accursed envy of the infinite riches of Cosimo: for which iniquitous reasons many complained of his magnificent buildings; and many said: In his hypocrisy, full of pride in the church, our purses are emptied to pay for them in the name of taxes [...] And now that there is nothing more to build for the friars, he has begun on a palace, by comparison with which the Roman Colosseum will appear to disadvantage. And others said: Who would not build magnificently, being able to spend money that is not his? And thus throughout the city there was much odious gossip, and everything was turned angrily against Cosimo [...] Whence under cover of night, his threshold was all

covered with blood: about this grievous significance there was the greatest murmuring throughout the city.

The source of Cosimo's riches aside, it is well worth discussing the economics of palace building, an extravagant endeavor that represented a major redistribution of wealth in fifteenth-century Florence. It is estimated, for instance, that the median cost of a palace was between 5,000 and 10,000 florins, approximately the entire capital of two very large wool firms. (To put this cost in further perspective, Brunelleschi earned 100 florins per year as foreman of the Duomo building project.) Filippo Strozzi, then one of the wealthiest men in Florence, is said to have invested more than one third of the value of his entire estate into his. On the flip side of the coin, however, the building of a major palace could lead to the creation of up to 400 jobs for an entire year. At the Strozzi site, "every Saturday," it was reported, "100 florins are paid to workmen of all sorts, leaving aside materials." Whichever way you look at it, palace construction was big business.

HOUSE OF CARDS

Despite Giovanni Rucellai's bold and purposeful vision, his foray into palace building was, by circumstance, slow and systematic. By his own account, "there are two important things man must do in life: the first is to procreate, the second is to build."

By the time Rucellai came of age, in 1421, his patrimony was considered not insubstantial. His father, Paolo, had left a small urban town house, a discreet villa in the Florentine suburb of Quaracchi, several local farms, and an investment of 2,000 florins. And though the complete estate was a joint patrimony intended to support the fraternal family of five, the nest egg must also have served as a psychological safety net for the 18-year-old Giovanni. Already by the age of 20, the precocious young man had matriculated in the Arte del Cambio, or bankers' guild, and was made a partner in the fourth-largest bank, out of 72, in Florence. With this promotion came a substantially improved socioeconomic position, enabling him, just several years later, to pull off his biggest coup yet: at the age of 25, Giovanni Rucellai married the daughter of the wealthiest man in town. Palla Strozzi provided his daughter with a sizeable dowry of 1,200 florins; Iacopa, in turn, gave her husband seven children; it was now up to Rucellai to deliver.

Soon after coming into his inheritance, Rucellai had begun hoarding houses. At the age of 18, he had moved back into his father's modest medieval town house on the corner of Via della Vigna Nuova and Via dei Palchetti with his mother and four brothers (an elder sister, Camilla, had married in 1416). Even by fifteenth-century standards, that building, with its plain plastered front and wooden shutters, was small, and its two-story, seven-room composition must have provided cramped living quarters for the fraternal family. But size, for Rucellai, mattered less than location. Lion Rosso wasn't the most affluent district, mind you; a discontented neighbor, for example, felt "compelled to rent [his house] out because the Jews and wool beaters made it such a wretched neighborhood." Rather than vacate, however, Rucellai was determined to validate the diverse *gonfalone*. In the year of his marriage, 1428, he and his brothers bought a second house, an adjacent property along the side street. Five years later, the siblings acquired a third house, this one flanking the original on Via della Vigna Nuova; joining those two houses on the main street doubled not only the extended family's living space but also its exposure to the passing pageant outside. The ubiquitous medieval town house was, typically, a multifamily dwelling. For Giovanni Rucellai, then, to have accumulated three such houses by the age of 30, albeit with the support of a shared patrimony, suggests that he was already enjoying an unusually comfortable domestic life and was well on his way to obtaining his dream home.

Much of the credit for Rucellai's accelerated ascent must go to his wealthy and powerful father-in-law, Palla Strozzi, who had groomed the young man for a successful career in banking. The comfortable position his marriage afforded, however, would all too soon be put in jeopardy.

Things were going swimmingly up until 1434. The previous year, Strozzi had even managed to send his archrival, Cosimo de' Medici, into exile, clearing the way for still more political and financial gain for himself and his inner circle. But when Cosimo returned just one year later, as, once again, de facto ruler of Florence, he wasted no time in sending Strozzi into exile—in the latter's case, for life. Not being a blood relative, Rucellai himself was spared. Even so, with Palla Strozzi in exile, the 31-year-old found himself, once again, without a father. For the next 27 years, he was, in his own words, "not accepted but suspected." All the more remarkable, then, that, despite this "period of adversity," during which he had "to navigate with precision," Rucellai managed not only to avoid exile but also to dramatically increase his wealth. He achieved this by courting favor with, of all people, Cosimo de' Medici, a change of party that was frowned

upon both socially and politically. Eventually, however, this altered allegiance paid off—and then some.

Within a dozen years, at the age of 42, Giovanni Rucellai was at the helm of his own bank, one of the largest in Florence, with branches in Pisa, Rome, Lyon, and Constantinople. Other business ventures included partnerships in wool-manufacturing firms, as well as intercontinental trading in silk, skins, leather, and slaves. The time was ripe for Rucellai to make his move. Aided by an amicable split of the joint patrimony just a few years earlier, Giovanni already had full possession of all three houses. Then, in a single year, he managed to purchase three additional properties from his cousins, extending his turf all the way to the rear edge of the city block. (This piecemeal acquisition of property

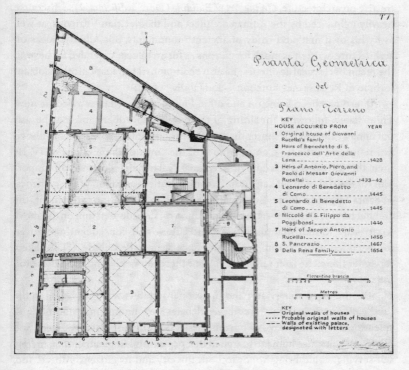

Figure 11. Plan of the ground floor of Palazzo Rucellai, c.1846, with houses numbered in order of acquisition date and original owners identified.

would also stretch his wallet; coinciding with Rucellai's colonizing practice was the introduction of the *catasto*, or property tax, the first of its kind in Western Europe.) "From eight houses I made one," Rucellai would later brag. But for now, he had amassed an impressive six—and that was just enough contiguous real estate to summon an architect, someone who could turn this house of cards into a proper palace.

CURB APPEAL

No one was better prepared for the job than Leon Battista Alberti, who had recently completed what would soon be heralded as the definitive Renaissance treatise on architecture, *On the Art of Building* (*De re aedificatoria*), a discourse heavily influenced by the Roman architect and theoretician Vitruvius, as well as by his own firsthand study of ancient monuments. But Alberti's ideas on architecture, written as much for patrons as for architects, extended far beyond the realm of classical aesthetics; he also championed the adaptation of ancient form to fit Renaissance function—and family fiction.

Alberti had been living on and off in Florence for well over a decade now. Immediately following the lifting of the family ban, Alberti, busy as he was pursuing a career in the church, had visited the city only briefly, in all likelihood not returning until 1434, as a member of the court of Pope Eugenius IV. By then, the 30-year-old was enjoying ecclesiastical benefices that would support him for the rest of his life, including an appointment as canon of the cathedral of Santa Maria del Fiore. But even with his plum Florentine assignment, the architectural projects Alberti embarked upon on the side kept him on the move to cities like Rimini, Mantua, Ferrara, and Urbino and, consequently, removed for extended periods from the city he once again called home. ("I am like a foreigner there," he later reflected. "I went there too rarely, and lived there too little.")

Still, the papal abbreviator and occasional architect was well versed in the local culture, particularly the complex debates surrounding magnificence and splendor. Borrowing heavily from the classical writings of Aristotle, Cicero, and others, Renaissance humanists argued that private building, rather than merely self-serving, could bring honor to both the city and its citizens. Alberti, too, believed that "great pleasure and joy" could be derived from the sight of "some other person's building":

Need I mention here not only the satisfaction, the delight, but even the honor that architecture has brought to citizens at home and abroad? Who would not boast of having built something? We even pride ourselves if the houses we live in have been constructed with a little more care and attention than usual. When you erect a wall or portico of great elegance and adorn it with a door, columns, or roof, good citizens approve and express joy for their own sake, as well as for yours, because they realize that you have used your wealth to increase greatly not only your own honor and glory, but also that of your family, your descendants, and the whole city.

One could read this, and similar texts, as little more than an erudite justification of conspicuous consumption. Yet Alberti also advocated propriety in the design of domestic architecture: "The greatest glory in the art of building," he wrote, "is to have a good sense of what is appropriate."

So crucial to Alberti was the matter of decorum in private building that he devoted an entire book of his architectural treatise to the subject. "Any person of sense," he advised, "would be careful not to incite envy through extravagance or ostentation." Striking the right balance was paramount—and for more reasons than one: "On the other hand," Alberti reasoned, "no sensible person would wish that anyone else should surpass him." But with his keen appreciation of the psychosocial purpose—and power—of architecture, Alberti also understood the importance of first impressions: "It is preferable," he wrote, "to make the parts that are particularly public or are intended principally to welcome guests, such as the facade, vestibule, and so on, as handsome as possible." To this end, he called for "the severest restraint [...] although," he conceded, "a certain license is often possible."

It should come as no surprise, then, that for Palazzo Rucellai, Alberti—decorous yet competitive—would put his best face forward: a perfectly symmetrical five-bay, single-entrance facade. Fronting Via della Vigna Nuova, the revetment of golden-brown *pietra forte*, an indigenous sandstone, consists of three stories of imposing yet accessible height divided by two friezes intricately carved with family emblems: A *vela gonfiata*, or windblown sail, runs the full length of the upper frieze, while the imagery of the lower frieze alternates between a *mazzocchio*, a chaplet ornamented with three ostrich plumes, and a point-cut diamond ring floating against a pair of feathers. Pilasters of different orders, echoing the elevation of the Colosseum in Rome, divide the three stories into five bays—the third bay is slightly wider than the other four to accommodate the door, above

which, on the second story, appears the Rucellai coat of arms. Centered within each bay are the windows. Those on the ground floor are small and square, while those on the upper floors are biforate and framed by rounded arches. The spandrels are filled with another family emblem: three interlocking diamond rings—Borromean links bedecked with point-cut diamonds. The masonry on every level is smooth, a refined departure from the heavy rustication of the medieval period. A built-in bench and accompanying backrest, or *spalliera*, with its clever mimicry of ancient Roman *opus reticulatum* brickwork, forms the base. A projecting cornice crowns the whole.

More than an exemplum of modesty in private building, Alberti's design for the facade of Palazzo Rucellai—the perfect balance of horizontal and vertical elements—represents his bottom line: *pulchritudo*, or beauty, "that reasoned harmony of all the parts within a body, so that nothing may be added, taken away, or altered, but for the worse." There was room for neither error nor negotiation, as far as this perfectionist was concerned: "No one," he insisted, "can look at something shameful, deformed, or disgusting without immediate displeasure and aversion." Instead, the artist must imitate nature, Alberti emphasized, in order to improve upon it. To this end, in what may be considered a preventive measure, Alberti had already penned *On Painting* (*De pictura*) and *On Sculpture* (*De statua*), two treatises that outline the rules of perspective and the methods for calculating precise proportions. With *On the Art of Building*, Alberti expanded his mandate beyond the arts of painting and sculpture to include architecture. Dictated by what he called *concinnitas*, "the absolute and fundamental rule in Nature [...] the spouse and soul of reason," *pulchritudo*, he argued, must be "the main object of the art of building." For beauty itself is "the source of her dignity, charm, authority, and worth."

But this "handsome" front was just that—an idealized portrait masking an anguished anima within. By the time Alberti's facade was installed, in the mid-1450s, Giovanni Rucellai had been a resident of Lion Rosso for more than three decades, and yet this orphaned son was still seeking acceptance from his paternal kin, his neighbors in the *gonfalone*, and the Florentine community at large. Addressing his sons in 1457 in his *zibaldone*, or commonplace book, a mishmash of information and opinions that Rucellai himself described as "a salad of mixed greens," he counseled them on the importance of being "favored and liked by citizens, family and friends," and he stressed a need "to be loved and honored." Similarly, Alberti wrote at this time of his "own longing" for "fame and favor and reputation." In his treatise *On the Family* (*Della famiglia*), he lays bare a life

marked by exile and alienation: "If I might," he contemplates, "stand honored, loved, and adorned with dignity and the respect of my fellow citizens in my own country, I would never shun this." It is perhaps no coincidence that these deeply personal reflections emerged just as Rucellai's long-brewing architectural plans were finally being realized. For building, both men believed, was the only means to this end: love, honor, and legitimacy.

Indeed, architecture seemed to offer all the answers; in the preface to his architectural treatise, Alberti asked:

> How many respected families, both in our own city and in others throughout the world would have totally disappeared, brought down by some temporary adversity, had not their family hearth harbored them, welcoming them, as it were, into the very bosom of their ancestors?

Despite the risk of ruin, either environmental or human, to the built structure, the concrete presence of an established family residence could provide security *and* continuity—a framework, both physical and psychological, notably lacking for both men. Suffice it to say, now more than ever, Alberti and Rucellai, well into middle age, longed for a proper homecoming.

We might better understand this nuanced relationship between body and building, or the ways in which human beings identify with the built environment at the psychological level, by turning to Sigmund Freud's theory of the death drive, which he regarded as one of the fundamental impulses of human behavior. His theory foregrounds the conflict between love and death, or between life instincts (Eros) and death instincts (Thanatos). For Freud, the death drive originates at the very moment of birth, a violent trauma that disrupts the pleasure of the time spent in the womb: a period and locus of serenity and refuge. Though birth irreparably upsets that prelapsarian state of bliss, memory of it remains, and subsequent life is dominated by a desire to return to that lost paradise; this regressive compulsion—the drive to return to the womb—is known as the nirvana principle. But the death instinct, understood in these terms, is less about self-destruction and more about self-preservation insofar as the desired outcome is not finality or absence of life, but resolution of conflict and return to equilibrium.

On a basic level, we can identify an obvious parallel between these principles of Freudian psychoanalytic theory and those of Renaissance architectural theory outlined previously: the continuous drive toward pleasure and reconciliation,

the quest for beauty through proportion—a common striving for harmony, both emotional and aesthetic. But there is also a compelling correlation between Freud's "womb" and the "bosom" that Alberti kept coming back to, again and again, in his treatise on architecture. For that seemingly safest of harbors, the place of origin, is also, as a point of premature expulsion or forced weaning, the cruelest. And if, as Freud suggests, the only remedy is reunion, then the primal habitat becomes beginning *and* end, womb *and* tomb.

Of course, memory, conditioned as it is by deep-rooted desire, is prone to manipulation. And the inscription of that desire, upon both body and building, has the potential to rewrite history. By stoning over the plain plastered fronts of the medieval town houses lined up along Via della Vigna Nuova, Alberti effectively provided himself—and his patron—with a *tabula rasa*, a blank slate upon which the *preferred* public face of the house of Rucellai could finally be projected and, in the process, the ancestral home enshrined. It was to this emotionally charged surface that Alberti added the revetment of golden-brown *pietra forte*, the indigenous sandstone so indicative of Florentine taste and tradition, of sobriety and toughness, an application that immediately lent an air of legitimacy to Rucellai's asynchronous assemblage.

Both men, however, would go well beyond materials in order to nail down their message. In his *zibaldone*, Rucellai compared himself to Gnaeus Octavius, a Roman citizen who had gained "great honor […] on account of his building a most beautiful palace […] renowned for its dignity and for its good and measured proportions." With this invocation of Cicero's *On Obligations*, Rucellai exposed his overarching objective: honor *of* the house, the family, *through* the house. In other words, following in ancient Roman footsteps, Rucellai hoped to gain a foundation precisely by laying down a foundation—or at least the illusion of one. To this end, the abundance of classical citations both in Rucellai's writing and on Alberti's *all'antica* facade bestows upon Palazzo Rucellai and its inhabitants an ancient pedigree.

This would not be the only distortion. Because Rucellai prioritized location above all, Alberti was hindered by the unlikely site, which, set as it was in the middle of a long and very narrow street, posed real scenographic challenges (even today, Via della Vigna Nuova measures less than 20 feet wide). Without the benefit of a piazza opening in front of it, the palazzo could only be viewed close-up or obliquely, two disadvantageous perspectives that prevented the facade from being seen in its entirety—in fact, skewing it completely. Alberti compensated for these visual constraints by adjusting the facade pictorially,

deliberately incorporating several deceits into his design to make the most of multiple viewing positions and, in so doing, achieve the effect of grandeur. By wrapping the facade ever so slightly around the corner of Via dei Palchetti, for example, Alberti gave the structure a more three-dimensional—and thus more substantial—appearance. By exaggerating the height and width of the pilasters on the upper stories, he provided the elevation with a seemingly perfect set of proportions. And by stretching the space above the windows, he made them appear taller and more generously distributed. These amendments, subtle deviations from his own guidelines on building and ornament, were as carefully calculated as the rigid rules he was now forced to bend.

Illusionism had been of primary importance to the Renaissance artist. Around 1425, Brunelleschi reinvented one-point perspective to this end, making him the first person since antiquity to create the illusion of three-dimensional space on a two-dimensional surface. Standing a few feet inside the central doorway of the cathedral and facing out, he painted exactly what he saw in front of him—the Baptistery and surrounding sky. But rather than paint static clouds, he affixed burnished silver leaf to the surface of the square panel in order to reflect the natural sky. Then, to demonstrate the accuracy of his image, he devised a self-check viewing system: returning to the exact spot where he had painted the picture, he held the panel up to his eye with the painted side facing away from him and stared through a peephole he had drilled at the center. In his other hand, he held a mirror at arm's length in front of and facing the panel, so that what he saw through the peephole was actually a reflection of his painting. With precise alignment, moving the mirror from his field of vision revealed no disconnect between reality and representation—an illusion aided by animated clouds in either scenario.

Brunelleschi's experiment in virtual reality would revolutionize artistic practice—but not until Alberti codified these early explorations in perspective construction, which he did in his groundbreaking treatise, *On Painting*. Successfully fusing art theory with step-by-step instruction, this philosophical how-to was both daring and deeply influential. (The short book remains required reading today for any serious student of art.) The most fundamental—and far-reaching—tenet of Alberti's theory of painting was his conception, pre-Microsoft, of the picture plane as a window. To demonstrate the laws of perspective, he first drew a rectangle. Along its base, or groundline, he marked equidistant intervals. At the center of the frame and directly opposite the artist's viewpoint, he established a central point. From this, also known as a vanishing point, he drew connecting

lines, called orthogonals, toward the groundline intervals. Next, using the same scale, he added horizontal lines, or transversals, which ran parallel to the groundline. This mathematical construction, which resembled a checkerboard receding in space, provided the artist with a linear framework for the rational placement of figures, objects, and buildings in space.

In order to accurately represent those components, Alberti invented the *velum*, or veil, a device "loosely woven of fine thread," he explained, "divided up by thicker threads into as many parallel square sections as you like, and stretched on a frame." This grid was to be positioned "between the eye and the object to be represented, so that the visual pyramid passes through the loose weave of the veil," enabling the artist to "see any object that is round and in relief, represented on the flat surface of the veil." From this, the artist could fix "the position of the outlines and the boundaries of the surfaces," which could then be worked up into a shaded drawing or painting. So equipped, the artist could convincingly copy exactly what he saw before him—with results so precise as to render the creator, in the words of Alberti, "another God."

Having judged himself divine, Alberti was now ready to up the ante—inventing the means not merely to replicate reality but to enhance it:

> Later on, by means of this very art of painting, [Alberti] also created effects that had not been heard of and were deemed unbelievable by the viewers. These pictures, which were contained in a small closed box, he exhibited through a tiny aperture. There you would have seen very lofty mountains and broad landscapes embracing a huge bay of the sea, and in addition regions very far removed from sight, so remote as not to be seen clearly by the viewer. He called these things 'demonstrations,' and they were such that experts and laymen contended that they were looking not at pictures but at the true natural objects themselves.

This passage from the *Vita di Leon Battista Alberti*, an unsigned text widely understood as a disguised autobiography, describes the impact of the illusion-making instrument, but the science behind it is equally important: Alberti's optical chamber, a precursor to the camera obscura, relied on magnifying crystals to project an image that had been painted on a translucent material and backlit for dramatic effect; monocular vision, combined with the isolation of the image in a dark box, must have made for a psychedelic viewing experience for "experts and laymen" alike.

If buildings could be surveyed and amended in this way for the sake of illusionistic painting, could not the same be done for architecture itself? In order to compensate for the physical and visual constraints of the building site on Via della Vigna Nuova, Alberti relied on a combination of techniques and tools, from Brunelleschi's mirror to his own *camera ottica*, to correct the unsatisfactory effects of ocular deception. By moving an angled mirror to and fro, for example, he could ascertain the adjustments required to augment his design. Of course, without the benefit of these viewing devices, the casual observer is none the wiser, easily fooled by the fictions of Palazzo Rucellai.

The facade, it must be reiterated, is merely a screen—and a shallow one at that, the revetment of *pietra forte* measuring in some places no more than an inch or two deep. The very thinness of this fifteenth-century magnum opus throws into question the solidness and heftiness we typically ascribe to monuments, not to mention the meaning of architecture itself. Moreover, the masonry consists of fewer and larger "blocks" than the surface design indicates. For example, some pieces are carved with intermediate channels that give the illusion of individual blocks of stone laid side by side and stacked in alternating courses; in other cases, portions of the pilasters spread into the adjacent field. The structural components, then, are anything but. Even the shield above the entrance door, that noble signpost magnified and mounted to mark a family's territory, is something of a sham; for at the house of Rucellai, the "shield" is nothing more than a blister on the surface, an integral part of the sandstone skin upon which it appears affixed.

There are still other illusions at play on Alberti's artful facade, these less corrective, perhaps, than cryptic. Positioned to the far left on the middle story, there is an open window. But no one can peer in—or out. The window is *finta*, fake. Or is it? Frescoed onto the face of the house that once belonged to Giovanni Rucellai's father, does this virtual window, partly ajar, allude to the ghost of occupants past? Does it provide an escape for the soul—or an invitation to reenter? If architecture can be said to have an afterlife, its past haunting its present, this curious little gesture is emblematic of palace as palimpsest: upon its spackled surface, a succession of tenants, traces of lives once lived, centuries of pentimenti crusting to a calloused skin.

Perhaps not surprisingly, there is a pronounced disconnect between exterior and interior at Palazzo Rucellai—a disjointedness due, in large part, to the fact that the facade was added *after* the sprawling medieval mess behind it had already been compounded to form a single family dwelling. Nor did Alberti's rational veneer compensate for this amalgamation, as evidenced by what is a

cacophonic side elevation along Via dei Palchetti, a warped plaster wall riddled with a haphazard placement of windows and a spasmodic roofline. Rather, the stolid mask imposed itself serenely—and if at the expense of some part of the interior, then so be it.

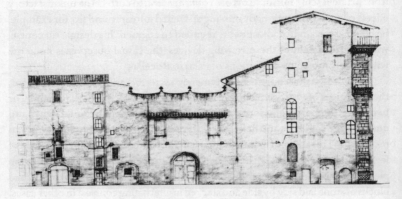

Figure 12. The side elevation of Palazzo Rucellai suggests a chaotic and irrational interior.

HOME ECONOMICS

We might, indeed, think of the Renaissance palace as "a kind of coagulant," as one economic historian has suggestively put it, "that reduced the fluidity of medieval urban life." Certainly, the Florentine palazzo reflects the early modern phenomenon of the dissolution of the clan and the emergence of the conjugal family. (More often than not, that is, a fifteenth-century palace housed an immediate, rather than an extended, family; a typical group might consist of the paterfamilias, his mother, wife, and children—even married sons or widowed daughters—but rarely members from other branches of the family.) And it undeniably signals a new age of consumerist competition. But the patrician palace also represents a more inward-looking domestic organization, a desire to withdraw into a world of privacy, a realm into which the public can no longer so easily seep.

Of course, our notion of privacy today is vastly different from whatever it might have been in Quattrocento Florence. And with this, some social historians have rejected the reading of the palace as a world of fragmentation, alienation, and detachment, advancing instead the proposition that the Renaissance *casa*

was a decidedly sociopolitical space, planned and decorated with a constant circulation of visitors in mind. Granted, Alberti did pose the following: "If the city is like some large house, and the house is in turn like some small city, cannot the various parts of the house [...] be considered miniature buildings?" This reasoning surely implies sociability over isolationism; but in a different passage, on the reality of everyday living patterns, he is far more explicit: "In houses, as in towns, some parts are public, others restricted to the few, and others for single persons."

The Renaissance palace, therefore, might best be thought of as a multifaceted microcosm, a single building trying to be all things to all people, now as much as then. In filling these various voids—civic pride, family honor, self-worth—the palazzo, I propose, functions as surrogate, standing in for something lost, missing, or inadequate. Thus, if Giovanni Rucellai could hide his fractured self behind Alberti's seemingly faultless facade, *his* turning inward prompts us to do the same, to peer inside the structural and psychological cocoon that is Palazzo Rucellai, to penetrate those spaces, public and private, that have for so long sheltered its scarred inhabitants.

In 1458, the head of household listed nine *bocche*, or mouths, in his tax report. There was Giovanni himself; his wife, Iacopa; and their seven children: Pandolfo, Bernardo, Maddalena, Alessandra, Margarita, Caterina, and Marietta. Giovanni's mother, Caterina Pandolfini, also lived in the newly converted house but, as a widow, was required to file separately. The number of residents would change over the years, especially as the younger generation grew up. Typically, when a daughter married, she moved out, whereas when a son took a wife, he stayed home, starting his own family right there under his father's roof. Such was the case at Palazzo Rucellai. By the mid-1470s, the septuagenarian patriarch had nearly two dozen mouths to feed: residing in the palace with Giovanni and Iacopa were their eldest son, Pandolfo, with his six children; their second son, Bernardo, with his wife and their first four children; and up to eight servants and slaves, as well as a tutor. One assumes Giovanni Rucellai ran a tight ship, that *his* was the mouth that laid down the law, but the steady ebb and flow of occupants, each with different needs at different life stages, must surely have called for some degree of flexibility—on the part of the owner as well as the palace.

In fact, the efficacy of the house depended as much upon a membrane that was mutable and buoyant as upon a skeleton that was constant and unyielding. To this end, wherever possible, the original house walls were left untouched and used throughout the new interior as bearing walls—what Alberti referred

to as the "bones" of the building: "It is not proper," he noted in his architectural treatise, "to show disrespect to the work of our ancestors or to fail to consider the comfort that citizens draw from their settled ancestral hearths." Alberti's recommendation, therefore, was to "leave all old buildings intact, until such time as it becomes impossible to construct anything without demolishing them." Such were the challenges, limitations, and curiosities facing any builder keen to cling to his ancestral site.

How, then, must the assemblage on Via della Vigna Nuova have looked, let alone functioned, when Giovanni Rucellai and his family occupied the mash-up of old and new? In his will of 1465, Rucellai described the patchwork structure only in simple terms, as "a great house with a loggia, courtyard, garden, cellar, stables, kitchen, rooms and bedrooms, passageways, and many other built parts." But other written accounts, such as inventories and records of the family's consumption habits, together with Alberti's guidelines on the use and decoration of domestic space, enable us to imagine how this "small city" with its "miniature buildings" was forged, furnished, and lived in.

We must first make it past the threshold, a gargantuan pair of walnut doors reinforced with eight shield-like roundels and more than 500 studs. The stone doorframe surrounding these knobby panels mimics a picture frame, its ornamental lines continuing ever so slightly along the bottom edge, pinching and holding in place two blistered planks. A cruel irony this portal, at once enticing us to pass through its frame, the way illusionistic painting encourages us to enter the space beyond the picture plane, yet also reminding us, with a thud, that the world beyond is flatly off-limits—to all but a few, that is.

From this facade portal, passage having been granted, a dark vaulted hallway, or *androne*, runs the entire length of the original town house, emptying into a bright, open-air courtyard so large that it consumes the entirety of three medieval houses. This generous and prominent space functioned, in many ways, as the heart of the home, as a sort of piazza within the palazzo, where children played games and adults played politics, where innocence and intrigue ran together, the roofless atrium never fully immune to the forces—both natural and manmade—of the outside world. Much of what passed through this relatively public space pertained to daily life inside the palace: deliveries of fresh food and dry goods, for example. But some ground-floor activity was business-related; and though rarely admitted to an upper floor, a fair number of clients were nonetheless received within palace walls and thereby granted a glimpse into the private world of the Rucellai. Given, then, that the cortile, or "bosom," as Alberti called

it, was "the most important part" of the house, the owner was especially attentive to its ornament, for here was another chance to trumpet the family's identity, this time from *behind* the facade.

In 1452, Rucellai paid Marco del Buono Giamberti and Apollonio di Giovanni di Tomaso for "a tondo in the ceiling of the loggia," the widest of two arcades that open onto the courtyard. Measuring nearly five feet in diameter, this stone roundel, once painted, is decorated with family emblems similar to those found on the facade. In the center are three interlocking point-cut diamond rings; surrounding this motif, the *mazzocchio*, the ceremonial chaplet decorated with three ostrich plumes, alternates with an unfurled banderole pierced by a single feather. The full iconographic program, encircled by a laurel wreath, might be read as a glorification of Giovanni and his family; even the position of this tondo, hovering high overhead, proclaims the symbolic apotheosis of the Rucellai.

Three years later, in 1455, the painter Neri di Bicci recorded in his diary work to be done "for Giovanni Rucellai […] five arches of imitation stone, a coat of arms in relief with a helmet, and two half-figures [of] a woman and a boy"—and, the artist was quick to add, "it was not done cheaply." Though the *trompe l'oeil* arches and frescoed half-figures have since vanished, washed away by centuries of rainwater, the coat of arms, carved upon a second stone tondo, remains in place, embedded in the courtyard wall that rises above the loggia. The family shield, identified by zigzag lines and a lion rampant, carries a helmet from a suit of armor that has been embellished with wavelike flourishes; and teetering at the top of this totemic column is Giovanni Rucellai's personal device—Fortune in the guise of Opportunity as the mast of a merchant ship in full sail. At last, the orphan, buoyed by his kin, rides the crest.

Closing off the courtyard and forming the rear block of the palace was a stable, converted from a single town house, one of two Rucellai had acquired from a cousin, Leonardo di Benedetto di Como, in 1445. With that purchase, Rucellai had pushed his property line as far back as he could, to the ecclesiastical compound of San Pancrazio. Conveniently, the side street, Via dei Palchetti, now served unofficially as his own private driveway. Horses and carts came and went through a colossal wooden door, the opening for which had been carved out of the western sidewall of the cortile. Workers, servants, and those visitors who had been deemed unworthy of entry through the main portal on Via della Vigna Nuova could quickly and quietly slip in and out of the palace through a wicket door that had been cut into one of the enormous wooden panels.

At the front of the palace, on either side of the entrance hall, were two main ground-floor rooms. A small *camera* with a mezzanine-level *studiolo*, or small study, was carved from the original house—the emotional cornerstone of the palace. This multipurpose room most likely changed function with each season, serving as a sleeping chamber, for example, during the hot summer months or, given its roots, as a private retreat. Across the entrance hall, a *camera terrena grande*, occupying an entire town house, probably served as a meeting space, filled as it was with chests and a round table. The last feature of the *piano terra* was the stairway, found off the entrance hall, just before the cortile, in the rear portion of the original house—now literally Giovanni's stepping stone. Narrow and steep, one ramp of stairs led down to the basement. With its thick masonry walls, this sizeable subterranean level provided cool storage space, where Rucellai stockpiled olive oil and Trebbiano, a local white table wine, among other provisions. Returning to the *piano terra*, two equal ramps per story, one doubling back to the other, climbed from the ground floor up. This original stairway was "lost" within the walls when a much grander staircase was installed in the eighteenth century, during which time an intentional "hidden" staircase was built to service the upper floors.

"In the house of a rich man," wrote Giovanni Rucellai, "numerous guests should be received and they should be treated in a sumptuous manner; if one did otherwise," he warned, "the great house would be a dishonor to the owner." And since honor was highly desired at Palazzo Rucellai, those guests who had been invited up were welcomed and entertained on the aptly named *piano nobile*, also referred to as the *primo piano*, or first floor, in the largest and most elaborate room in the house, the *sala principale*. This "spacious, cheery and splendid" chamber, as Alberti characterized it, was decorated with an *acquaio*, or wall fountain, used for ceremonial handwashing before and after meals, a *caminetto*, or fireplace, and built-in wooden benches with high backrests; it also held 13 chairs, a table approximately 14 feet long, and three birdcages, according to one inventory. Typically, the *sala principale* was decorated with sumptuous textiles draped over walls or at doorways. A credenza, or sideboard, might also be found here, used to display tiers of silver, glass vessels, or maiolica, brightly painted tin-glazed earthenware. In this room, the ceiling was not vaulted as below, but flat, adorned with five massive wooden beams running parallel to the facade and supported by wooden consoles, each intricately carved and selectively highlighted with gold leaf. Facing Via della Vigna Nuova, this imposing yet convivial room reserved for dining and dancing had

three windows on the facade; surely, the sounds, smells, and shadows of merrymaking emanating from the *sala principale* would have piqued the joy—or jealousy—of passersby.

It is worth noting the placement of windows at Palazzo Rucellai. Alberti's facade is divided vertically into bays, each containing a window; but because he designed the facade regardless of the interior arrangement of rooms, the windows are not always centered on the interior walls. Further, the decorative friezes, which divide the facade horizontally into three stories, do not correspond to the interior floor levels, which are four to six feet lower. Thus, the windows in the *sala principale* can only be reached by climbing a set of cascading stone steps—so that looking out, if desired, becomes a bit of a chore.

Giovanni may have done his share of entertaining, showing off the house to shore up his image, but guests only got so far. For the *piano nobile* also accommodated the family's main living quarters. Standard practice dictated that rooms, typically with high beamed ceilings and polished terracotta floors, be arranged in suites laid out in a strict sequence, with *ricetti*, or short hallways, serving as waiting areas outside the main rooms. "The husband and wife must have separate bedrooms," Alberti advised. "Each room should have its own door and, in addition, a common side door, to enable them to seek each other's company unnoticed." Further to this layout, Alberti called for a dressing annex off the wife's bedroom and a library or similar study room off the husband's. Young girls and maidens should sleep together, adjoined by a nurse; whereas boys and young men, he opined, should be stationed closer to houseguests, "to encourage them to form an acquaintance." The grandmother, on the other hand, "being weary with old age," must be sheltered from household noise, cold drafts, and other bodily discomforts. Alberti's guidelines for family living are not atypical but for the fact that he had no such experience—neither as an orphan nor as a lifelong bachelor without issue. Still, his was the authoritative voice on domestic living patterns, and Giovanni Rucellai obeyed to a tee.

In the sunny front corner of the palace, a small suite of rooms was perhaps allocated to Caterina Pandolfini, Giovanni's widowed mother, who presumably would have appreciated being reinstated in what must have been her original marriage chamber. Distributed among the *camera*, *cameretta*, and *studiolo* of this suite were many elegant pieces of furniture and works of art: a wardrobe, at least four large chests, a walnut *lettuccio*, or daybed, and a *lettiere*, an oversized platform bed with a high paneled headboard and a base of locking chests. (So exaggerated were these installations that "sinners," Saint Bernardino of Siena

exclaimed, "could hide their sins under them.") What, pray tell, must Caterina have kept hidden under her wool- and flax-stuffed mattress?

Behind this suite, we encounter the *camera principale*; given its prime location away from the main street and overlooking the cortile, this chamber most likely belonged to the head of household, Giovanni. The *camera* contained few but fine pieces of furniture, including a walnut marquetry *lettuccio* surrounded by benches and a pair of exquisite sarcophagus-like chests, each with a fabric backboard and gilded base. The adjacent *camerette* contained several pieces of sculpture and many paintings; "only hang portraits of men of dignity and handsome appearance," Alberti advised, "for they say that this may have a great influence on the fertility of the mother and the appearance of future offspring."

The third suite in this block may have served as Iacopa's bedchamber, attached as it was to the *camera principale*. But the wife had still other marital duties for which she needed to be strategically stationed: "The matron," Alberti wrote, "should be accommodated most effectively where she could monitor what everyone in the house was doing." This chamber would have been furnished on a par with the others but, as a designated female space, decorated with devotional images, wedding chests, and painted birth salvers. "Any place reserved for women," Alberti insisted, "ought to be treated as though dedicated to religion and

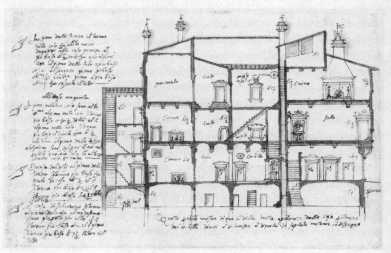

Figure 13. This cross-section of a Florentine family compound, c.1560, gives a sense of the mishmash of rooms and navigation routes that made up the Renaissance *casa*.

chastity." He did, however, make some allowances for "young girls and maidens," granting them "comfortable apartments, to relieve their delicate minds from the tedium of confinement."

Not surprisingly, given the segregated layout of the family's own living spaces, there was a strict hierarchy in place throughout the house, with the domestic staff kept as far away from the family and guests as physically possible. Backstairs, spiral stairs, narrow passages, and concealed doors were the standard building blocks of the parallel universe of the Renaissance palace. At Palazzo Rucellai, to facilitate service with separation, two galleries, flanking the courtyard, linked the front of the house with a service wing at the back. Placed directly above the stable was the *guardaroba*, or general storage room, which could have been used for anything from nonperishable foodstuffs to chicken coops, and the cucina. "The kitchen," Alberti recommended, "should be neither right in the lap of the guests, nor so far off that dishes intended to be served hot become cold in transit; those dining need only be out of earshot of the irksome din of scullery maids, plates, and pans. Take care," he continued, "that the dishes are carried along a route that is protected from the rain, has no tortuous corners, and does not pass through any dingy place, all of which may compromise the standard of the cuisine." These covered corridors, then, were a crucial artery for those servicing the front of the house—or for those up front in need of a discreet rear exit.

The upper floors of Palazzo Rucellai show a marked contrast to the lower floors, as well as to each other, in terms of layout, function, and furnishings. On the *secondo piano*, there are four *camere*, as below; however, there are no rooms north of the cortile and, consequently, no connecting galleries. Thus, the second floor is limited to the area covered by the front half of the palace. Designed for additional living space, these pragmatic rooms had less surface ornament (beamed ceilings, but with simpler consoles, for example) and were more sparsely furnished, perhaps with the exception of the *sala grande*, which contained a walnut trestle table and several benches, four embossed leather chairs, and at least two pairs of large locking chests.

The small *camera* in the front corner of the house enveloped a mezzanine room, or *camera a meza schala*, just as one finds in this same position on the *piano terra* and *primo piano*. These discreet slivers of space, sometimes referred to as "hidden floors," could be used to accommodate servants or, for absolute privacy, oneself. It may very well have been in one of these little rooms, tucked away from the rest of the house, that Caterina, the slave girl of Giovanni Rucellai, was impregnated in 1459. The father of the child, Paolo

di Giovanni Ottavanti, was forced to pay for a cradle, a complete layette, and a generous supply of food for the mother: several pairs of capons, four fresh eggs daily for two weeks, biscuits, and jam. (Any freeman who impregnated another's slave was obliged to pay for the birth cost, including alimentation for mother and child. Following parturition, he had to pay the owner one-third of the slave's value (full value if she died). He also was responsible for the upbringing and expenses of the child, who was to have the same legal status as the father.) Just how many illegitimate children were born under Giovanni's roof is anybody's guess.

In sharp contrast to these small, dark hollows was the open-air roof terrace, the *altana*. With its Ionic colonnade fronting Via della Vigna Nuova, the terrace (now enclosed) ran the full width of the palace. Added at the time of the 1450s remodeling, it was already in place when Alberti received the commission for the facade. Wishing to avoid any visual interference with his design, he increased the size of his cornice, in part to "hide" the *altana*, which does appear to sink behind the imposing crown. Despite its "disappearance," the terrace was an important part of the palace, attested by the presence here of a complex fresco cycle commissioned by Rucellai in the 1450s. *The Dream of Joseph*, a depiction of the prophetic reverie of the favorite (and envied) son of Israel, must surely have resonated with Giovanni, the eldest of six orphans, who had inherited by his own cunning his father's house.

From top to bottom and back to front, Palazzo Rucellai, as this "walk-through" demonstrates, was well stocked. Almost two decades into his residency in the renovated palace, the original owner proudly boasted, "we have in our house many items of sculpture, painting, intarsia and inlays from the hands of the best masters over a long period, not only in Florence, but also in Italy." By all accounts, although not formally trained in the humanities Rucellai had amassed an impressive collection of objects from some of the most prominent artists of his day, including Domenico Veneziano, Filippo Lippi, Giuliano da Maiano, Antonio Pollaiuolo, Andrea del Verrocchio, Andrea del Castagno, Paolo Uccello, and Desiderio da Settignano. The successful merchant banker surely had the means, but where had this layman acquired his appreciation?

Much of the credit must go to Rucellai's humanist uncle and guardian, Agnolo Pandolfini, and to his discerning father-in-law, Palla Strozzi, whereas his mature interests in art and architecture were profoundly shaped by Alberti, who may even have played an on-site tutorial role during a reported joint trip to Rome in 1450. Despite these formative, erudite influences, when it came to decorating his

personal space Giovanni Rucellai emerges, perhaps, less as a connoisseur than as a consummate consumer—and a covetous one at that.

"We decorate our property," Alberti explained, "as much to distinguish family and country as for any personal display (and who would deny this to be the responsibility of a good citizen?)." Certainly no one could argue that Rucellai shied away from this civic duty, eager as he was to concretize the family name through architecture. And to be sure, if his color-minded forefathers had dressed to impress, the material-minded Giovanni *decorated* to impress. Of course, Rucellai was not alone in his consumption habits; the sheer proliferation of objects at this time points to what is new and unique about Italian Renaissance culture.

But for some consumers, as Alberti understood, demand was driven as much by competitive spending as by private enjoyment:

> It is easier to keep safely things known only to a few, and even if they are lost it is easier to regain them from the few than from many. For this and many other reasons I always thought it less dangerous to keep my valuables as secret as possible, locked away from people's hands and eyes. I always kept them in my room, where they would be safe from fire and any other danger. There I could often look at them for my pleasure or check them, locking myself in alone or with anyone I pleased, without giving those who remained outside any reason to try and find out anything about my affairs that I did not want them to know.

In keeping with this fetishistic mind-set, Rucellai, too, as indicated by his methodical recording of nearly every artifact in his home, exhibited a marked pride and possessiveness regarding his "many items," or, to borrow a phrase from Henry James, his "empire of things." He also, unwittingly, exposed his agenda. For an early modern inventory must be understood not as an objective presentation of household objects, but as a strategic, biased, and intentional text, a subjective representation of an owner—in this case, one with aristocratic aspirations.

EXPANSIONIST POLITICS

Tax records tell us that by 1458, Giovanni Rucellai had become the third-richest man in Florence. The same year, the 55-year-old acquired a seventh house—his

first mistake. For ten years, he had remained at the mercy of a stubborn cousin, Jacopoantonio, who held what Rucellai saw as the potential jewel in his crown: a substantial and contiguous property on Via della Vigna Nuova that would extend his frontal exposure by nearly 30 percent, while bringing his total footprint to ten times its original size. But when the owner died intestate and in arrears, his widow, Piccina, was forced to forfeit the house to the Magistrato dei pupilli, or Office of Civic Guardians. Working on behalf of the children, the magistrates put the house up for auction. Town criers hawked the property with a starting bid well above its value, for it was widely known that there was "someone who would gain great convenience from it." Sure enough, determined to have this missing piece, Rucellai outbid his rival by more than 40 percent, buying the house for 1,000 florins, an amount greater than he had paid for all of his other houses combined. He paid dearly, indeed—in more ways than one.

An extension of Alberti's facade went forward without the architect's supervision, seriously compromising his philosophy of *pulchritudo*. As though Alberti had anticipated this unauthorized manipulation of his design, he warned the reader in *On the Art of Building* of the consequences of breaking the rules:

> When even the smallest parts of a building are set in their proper place, they add charm; but when positioned somewhere strange, ignoble, or inappropriate, they will be devalued if elegant, ruined if they are anything else. Look at Nature's own works: for if a puppy had an ass's ear on its forehead, or if someone had one huge foot, or one hand vast and the other tiny, he would look deformed. Even cattle are not liked, if they have one eye blue and the other black: so natural is it that right should match left exactly.

Nonetheless, two more bays were added, one of which included a second entrance, resulting in a squat, asymmetrical design with a jagged eastern edge. Not that this bothered the patron unduly, confident as he was that he would be able to remedy the snafu with his *next* acquisition. Rucellai, you see, already had his sights set on the house next door—his second mistake. For not only did the owner of that house hold out from selling during his lifetime; he even stipulated in his will that his descendants must never relinquish the house to Giovanni's heirs. That spiteful testament would be upheld for 173 years.

The facade covering Jacopoantonio's house was not the only thing out of sync. The interior of this most recent acquisition was hastily and only partially

remodeled, a quick fix meant to provide additional yet temporary living space until the adjacent—and, presumably, final—property could be bought, at which point, as a contemporary document relates, both houses would be thoroughly rebuilt and incorporated into the original palace: "From his old house Giovanni […] is building […] a large and agreeable edifice which is understood not yet to be completed, at least in breadth." Though relatively modest, the changes carried out during this initial phase made for a rather murky assemblage. The floors, for example, were re-leveled to correspond with those in the original palace, enabling a seamless extension of the *altana*. But on the ground floor, the newly added second entrance, although a visual echo of the first, led nowhere; that is, it provided no direct access to the rest of the palace complex. Not merely disorienting, the 1458 addition was also differently organized. In the front half of the house, for instance, the courtyard and most interior walls were removed to create two large rooms, one behind the other, on each of the three floors, while the back half remained a medieval jumble of tiny rooms. Despite the creation of these upper spaces, Giovanni chose not to add a stone stairway to this portion of the palace but left in place simple wooden stairs that reached only as high as the first floor. Suffice it to say, the total effect was awkward. Even a contemporary account acknowledged the split personality of the palace: "[It] was made and constructed in two stages, namely the large house and the small house, which at present are […] one house, [and] are being used as one house."

Giovanni Rucellai may have become quite the real estate mogul, as his ever-sprawling palazzo attests, but once he had reached the upper echelon, he was no longer an anomaly—at least not in terms of ownership. Between 1450 and 1478, some 30 palaces were built in Florence, never mind the thirty-odd that had been built in the first half of the century. And his wasn't even the largest; his in-laws held that record with the mammoth Palazzo Strozzi located a block away. But what *did* set Rucellai apart from his peers was his grandiose sense of self. Yes, his had been a precocious journey up until now, but his ego trip was just getting underway.

"With wealth," Alberti advised, "if it is used to do great and noble things and to show a fine magnificence and greatness, fame and dignity can be achieved." Rucellai would take this to heart. With a substantially expanded budget at his disposal, he could now embark upon a full-blown building campaign in his persistent quest for "fame and dignity." And, indeed, his projects from this point forward would be among the most elaborate and expensive in the city. Rucellai himself later wrote in his *zibaldone* that these architectural endeavors had given

him "the greatest contentment and the greatest pleasure because they serve the honor of God, the honor of the city, and the memory of me."

With the secular front more or less under control, Rucellai embarked upon his first religious commission, a marble facade for Santa Maria Novella. Situated just a thousand feet behind Palazzo Rucellai, in the heart of Lion Rosso, this late-thirteenth-century Dominican church had long been the focus of the family's patronage, albeit on a much smaller scale. As early as 1355, Cenni di Nardo commissioned a chapel dedicated to Saint Catherine of Alexandria in the right transept, and ensuing decades saw a number of men from the lineage serving as friars and participating in lay confraternities. The next major donation took place in the 1440s, when several of Giovanni's cousins paid for a white marble pulpit, designed by Brunelleschi, to be installed against a pillar facing the nave. But with his financing of the facade (of all the great churches constructed in Florence during the late medieval and early Renaissance period, this was the only one to receive a completed facade), Giovanni established himself indisputably as patriarch of his *consorteria*—not to mention as one of the preeminent art patrons of the city.

But Rucellai's pious gesture was not without its problems. Such ecclesiastical donations were commonplace for Christian merchant bankers eager to atone for their sins of usury—the church may have turned a blind eye to the rampant practice of charging interest, but God-fearing businessmen saw matters differently. What distinguished Rucellai's gift, however, was how he actually went about paying for it. On 15 November 1448, Rucellai had a certain Matteo di Stefano di Lullo buy, on his behalf, a farm of approximately 33 acres at Poggio a Caiano. In fact, the true value of the property was much higher than what was paid. Soon after the suspiciously low sale, this same Matteo turned around and, again acting in the interests of Rucellai, transferred the estate to the Arte del Cambio. But the transfer was fictitious; Rucellai had simply pretended to give away the property to the bankers' guild in order to avoid paying taxes on it. Ten years later, he reversed the "transfer" and declared that all of the income from the farm, which had been accruing interest in a bank account managed by Rucellai himself, was to be used for the "door and face" of Santa Maria Novella. The irony here is obvious: an extremely wealthy merchant banker, keen to make amends for questionable business practices, funded his "pious" offering precisely with the source of his original sin. But as far as the unknowing congregation was concerned, Giovanni Rucellai had admirably embellished both the church and his own image.

For the preexisting medieval structure, Alberti designed a colorful ornamental screen that combined a temple-like upper story with Tuscan Gothic elements below. The arrangement was innovative yet respectful of local tradition, a sharp contrast to its adornment, which bordered on the indecorous. In an unprecedented gesture, the decorative program of the facade included the full Rucellai escutcheon—twice; and, filling the main frieze, Giovanni's stylized windblown sail—repeated 35 times. The most audacious design choice, however, had to be the addition of a self-referential proclamation running beneath the pediment: GIOVANNI RUCELLAI, SON OF PAOLO, MADE THIS IN THE YEAR OF SALVATION 1470. The Latin inscription, in gilded classical capital lettering, the first of its kind since antiquity, is enormous, running 56 feet across, with each letter measuring nearly 20 inches in height. (To better contextualize scale and sense of self, think of the inscription commemorating Agrippa on the Pantheon in Rome.)

Giovanni's favorite son would go one step further, literally: the inscription BERNARDO ORICELLARIO can be found upon a rectangular tablet that was added to the rise of the doorstep to the church's main entrance nearly half a century later. What might appear a humble gesture today—the placement of one's memorial squarely in a path of heavy foot traffic—was anything but in the early sixteenth century. For the material Bernardo chose for the tablet, as well as the roundel beneath which his body is buried, was none other than recycled porphyry, the illustrious hard purple rock originally mined from the Porphyry Mountain at the edge of the Red Sea. Few Florentines walking through the central portal of the Dominican church would have failed to recognize the multivalence of porphyry, with its centuries-old connotations of congealed fire, of imperial glory, of spilt Christian blood turned to stone—and now, at least for the Rucellai, of *oricella* congealed, ossified, sanctified.

But Alberti's graffiti, though less blatantly self-referential, managed to outshine both. Conflating Christian, Egyptian, zodiacal, and personal iconography, Alberti invented yet another emblem—a large sun with human facial features surrounded by straight and wavy rays—and boldly emblazoned it on the pediment of the facade. The autobiographical significance for Leon Battista is clear, Leo being the astrological symbol of the sun. But beyond this onomastic link, there may also be a connection between the sun and Alberti's personal emblem, the winged eye. The association of the eye with the sun occurs in the hieroglyphic and classical traditions known during the Renaissance, and the sun, in turn, was equated metaphorically with kings and gods and, within

Christianity, Almighty God. Thus, this über-Father identification might be interpreted as much a symbol of the church as a compensatory device for an orphaned son.

Still not content with his now-sweeping infiltration of Lion Rosso, Giovanni would extend his grip even further with an aesthetic as well as topographical reshaping of the neighborhood. As interior remodeling of the palace extension continued apace, Rucellai began planning what would become the final component of his urban spread: the loggia. As before, site restrictions mandated a resourceful solution. Typically, these open galleries were constructed at the rear of a property—in the backyard, if you will—as part of the garden and, usually, as the outermost boundary of the property. If land were not available, the loggia could be built on top of the house. But neither was an option for Rucellai. Having already bought all available property to the westernmost and northernmost edges of the city block, and having already allocated the entirety of that footprint for living space, there simply was no land left for a loggia. And as for the rooftop, the eastern edge of his palazzo had no terminus (he was still waiting—and becoming increasingly impatient—for his neighbor next door to sell); thus, building on the terrace was also out of the question. Moreover, Rucellai may have been willing to stretch Alberti's design horizontally, but he knew better than to touch the elevation.

He would not hesitate, however, to cross the street, to bully a distant cousin into sacrificing his house for the good of the clan, or so Rucellai claimed. Ugolino agreed, but only on the condition that his wife, Nanna, could remain in the house until her death. Against all odds, the dowager would live another seven years! No sooner had they buried the body than Rucellai, according to a disgruntled cousin, pounced on the property. In his tax report of 1469, Niccolò di Vanni Rucellai lashed out, reporting:

> I used to have the sixth part of Ugolino di Francesco Rucellai's Florentine house, which house Giovanni di Paolo di Messer Paolo Rucellai had knocked to the ground without my permission, and he has made of it a piazza and a common loggia: I don't know how I will ever be able to get any return from it.

This acerbic attack ended with what must have been for Giovanni a gut-wrenching insult: "I should remain satisfied," he cursed, "if the same were to happen to his house."

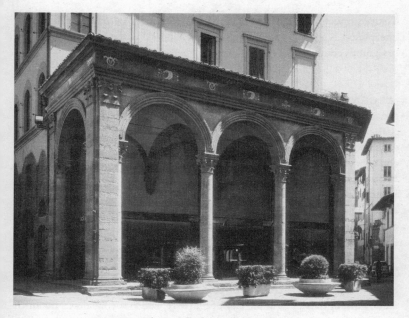

Figure 14. The Rucellai loggia, built in the 1460s.

The immediate and total destruction of Ugolino's house, as impolitic as this move was, had a significant impact on the parameters of Rucellai's palace. Not only did the razing of the town house open up a space for the loggia, to be built perpendicular to the as-yet-undefined easternmost edge of the palace, but it also provided enough space for the creation of a triangular piazza spilling out westward from the loggia and fixed to the south by the narrow Via del Purgatorio. A piazza affords a view, of course, and this is precisely what Palazzo Rucellai needed most. And so, a full decade after Alberti's innovative adjustments to the facade, the *site* was now adapted to fit the palace.

Modeled after a Roman triumphal arch, the imperialist symbolism of Rucellai's loggia is obvious; the architrave of the one-bay-deep by three-bay-wide arcade, not surprisingly, is filled with personal and family emblems: the stylized windblown sail and the double-feathered diamond ring. But the position of the loggia *across the street* from the family palace provides even more fodder for a consideration of Rucellai's expansionist politics, raising awareness of the ambiguous boundaries between public and private in the Renaissance city; for

running right through the center of this Rucellai enclave was a major street, Via della Vigna Nuova, a most appropriate name (street of the New Vineyard) for a vigorous climber such as Giovanni.

ASCENSION

If the common objective of Alberti and Rucellai had all along been a celebrated homecoming, there was still one more house to occupy. As early as 1448, 33 years before his death, Rucellai had begun planning his final resting place, "a chapel with a sepulchre similar to the one in Jerusalem of our Lord [...] in the church of Santa Maria Novella or in San Pancrazio." That Rucellai chose to be buried in the *gonfalone* of Lion Rosso, in his beloved city of Florence, is hardly surprising, for this native son's *campanilismo*, or local chauvinism, had never wavered. Writing at the start of his sixth decade, for example, he thanked God "first for having given me life and for making me a rational creature, for he as easily could have made me [...] a Turk, a Moor or a barbarian, in which case I would have been irreparably lost." He goes on to "thank him for having been born in Italy [...] in the city of Florence, which is considered the most worthy and the most beautiful birthplace there is, not only in Christendom but in the whole world." And within that microcosm, as far as Rucellai was concerned, there was no block more "worthy" or conducive to eternal rest than his own. And so it was that Giovanni elected to have his tomb installed in a chapel at San Pancrazio, the Carolingian church adjacent to the back edge of his "great house."

But why this curious choice of monument? The cult of personality in fifteenth-century Florence had certainly fostered an increase in monumental funerary sculpture, but no one—not even Cosimo de' Medici—had dared deem himself worthy of the tomb of Christ. But then again, who more than Rucellai self-identified as the chosen son, the family redeemer?

An as-yet-undisclosed detail from the family myth of origin might also have had something to do with Giovanni's decision. In his *zibaldone*, he twice claimed that the Rucellai clan, shortly before they acquired the appellative "Oricellariis," had been known as the "Tempiali," in honor of their earliest known ancestor, Messer Ferro, who, Giovanni reported, had been "a knight of the Order of Knights Templar." If Giovanni sought the succor of his ancestor, a defender of holy places, then clearly only one tomb would do.

In a letter to his mother dated 25 April 1457, Giovanni described an expedition he had sent to Jerusalem to obtain "the exact form and measurements of the Holy Sepulchre." This exceptional epistle seems too good to be true, if nothing else because sending a team of surveyors from Florence to the Holy Land would have been a considerable danger—not to mention expense—so soon after the fall of Constantinople, an event that, just four years earlier, had unsettled the whole of Christendom. In fact, there is some doubt about the authenticity of this letter, which has recently been imputed to an overzealous family archivist, possibly Giovanni's great-great-grandson, also named Giovanni, or to an eighteenth-century forger. More likely than not, Alberti stayed home and culled local European sources, models as well as verbal and written accounts, in order to construct an inspired, if not identical, marble *tempietto*: the diminutive temple, rectangular in plan, with a semicircular apse, measures approximately half the size of the original. It sits in the middle of the cavernous chapel like an oversized dollhouse—or, rather, jewelry chest—its entire surface richly articulated. Dotting its walls, and set between nine fluted Corinthian pilasters, are 30 ornamental discs of white marble and serpentine inlay, including a depiction of the windblown sail. Above, a ciborium with spiral dome, surmounted by an orb and cross, rises from a crown of Florentine lilies, beneath which a wraparound classical entablature boasts an inscribed frieze: YOU SEEK JESUS OF NAZARETH, WHO WAS CRUCIFIED: HE IS RISEN; HE IS NOT HERE: BEHOLD THE PLACE WHERE THEY LAID HIM.

Figure 15. Giovanni Rucellai's tomb, designed by Alberti in 1467.

It almost goes without saying that Rucellai's concerns with resurrection and personal salvation border on megalomania. His godlike sense of self is, literally, written all over the surface of his sepulchre. A plaque above the tiny entrance door, which leads to an interior chamber containing a sarcophagus, reads as follows: GIOVANNI RUCELLAI, SON OF PAOLO, CAUSED THIS CHAPEL, SIMILAR TO THE SEPULCHRE IN JERUSALEM, TO BE MADE IN 1467, IN ORDER THAT HE MIGHT PRAY FOR HIS OWN SALVATION FROM THAT PLACE WHENCE THE RESURRECTION OF ALL WITH CHRIST WAS ACCOMPLISHED. Rucellai wasn't the only one to pray for his salvation. In 1471, Pope Paul II issued a bull of indulgence to those who visited the tomb on Good Fridays and Holy Sundays, thereby granting it sacramental status. Having risen—in the eyes of the church—well above his station, Rucellai would spend the next decade elevating, still further, his secular reputation.

Both he and Alberti, in fact, had worked hard to rewrite their own narratives while still players on the stage, successfully concealing their efforts at memorial self-fashioning in the pages of a private notebook, for instance, or a veiled autobiography—deliberately composed texts that would one day serve as primary source material for art and architectural historians. Indeed, they themselves are largely responsible for the textbook celebrity status each holds today: "Merchant-Prince" and "Renaissance Man," respectively. Take, for instance, Alberti on Alberti:

> His mind was versatile, so much so that it seemed there was no worthy skill he had not mastered. Idleness and laziness had no hold on him, and he never tired of being productive [...] For letters sometimes delighted him so much that they seemed like flowering and fragrant blossoms from which hunger or weariness could hardly distract him; yet at other times they would seem to be piling up under his eyes, looking like scorpions [...] When books thus temporarily lost their appeal, he would shift his attention to music and painting and physical exercise [...] with his feet together, he could jump over the shoulders of a standing man [...] with his left foot pressed against the very wall of the highest temple, he would throw an apple straight up far above the highest roof of the building.

To be sure, words seldom failed these egotists, as Alberti's inflated sense of self, which has been effective—and infectious—for well over 500 years, attests. But to the Renaissance ego, there was no better way to perpetuate one's image than

through the image itself. What was immortalized, of course, was less a likeness than a head game.

In a posthumous portrait of uncertain authorship, Giovanni Rucellai, looking rather like a romanticized version of Leonardo da Vinci, sits before his trophies: Palazzo Rucellai and its loggia, the facade of Santa Maria Novella, and his very own Holy Sepulchre; the pages of his leather-bound memoir, positioned between the man and his monuments, are densely filled in. One sees Rucellai just as he saw himself—through rose-tinted lenses, the crimson coloring of the canvas as much a nod to his ancestors' fame as orchil dyers as to his own idealized gloss on things. And in a similarly enhanced portrait, one sees Alberti through a bronze fog, the golden boy having chosen to represent himself in the copper alloy that carries with it an unmistakable ancient pedigree. Yet if Alberti, assuming the profile pose—not to mention the costume and hairstyle—of a Roman ruler, gives the impression, in this plaque of 1435, that Leon Battista has been around for millennia, the addition of his omniscient winged eye to an otherwise-classical design suggests that "L. Bap.," as he signs it, is here to stay.

If painting, or sculpture, "contains a divine force which not only makes absent men present but moreover makes the dead seem almost alive," as Alberti famously opined, just imagine—as both men must have—the recuperative possibilities of architecture.

Figure 16. In this bronze self-portrait plaque of *c.*1435, Alberti inserts himself into the tradition of ancient commemorative portrait medals.

Secondo Piano

*When the starry sky, a vista of open seas or a stained
glass window shedding purple beams fascinate me, there
is a cluster of meaning, of colors, of words, of caresses,
there are light touches, scents, sighs, cadences that arise,
shroud me, carry me away, and sweep me beyond the
things that I see, hear, or think. The "sublime" object
dissolves in the raptures of a bottomless memory.*

Julia Kristeva, *Powers of Horror*

Despite several weeks of almost daily library visits, I still couldn't identify what arcana Francesco might possibly possess, or what it was about the house that vexed him so. By now I'd digested a century's worth of scholarship on Palazzo Rucellai. A great deal of ink had been spilled on the construction sequence of the piecemeal palace, to little avail; nor could anyone agree upon when exactly Giovanni had called in Alberti—or as some rogue scholars believed, the sculptor Bernardo Rossellino—to mask the strange labyrinth that was slowly metastasizing along Via della Vigna Nuova. Yet for all this heated discussion, Palazzo Rucellai was dead on the page: floor plans and elevations, so stiff and authoritative with their bold outlines and foldout format, failed to convey the true nature of the palace I'd come to know—arthritic, cranky, gassy.

Take Archivio, for example. I now understood that my apartment hovered above—and replicated, at least in terms of surface area—the original footprint of the modest medieval town house that had once belonged to Giovanni Rucellai's father and, thus, formed the emotional cornerstone of his urban sprawl. This discovery alone fascinated me. But as I stood in my little room, floating between stories, my thoughts turned away from the structure itself and toward the people who'd called it home centuries before I did. Who besides Giovanni and his immediate family had lived here? Just how many lives had played out within these walls? As I pondered my own place within Palazzo Rucellai, considering my yearlong residency as yet another layer in its dense history, I began to see myself as a legitimate, if temporary, member of this storied household. As I gloated over my borrowing privileges, I couldn't help but think about Lorenzo's loss and his own "palace complex." Maybe, just maybe, I told myself, the aristocrat with the cannibalism gene and I *did* have something in common. I pulled the archived napkin from the *Wunderkabinett*, took a deep breath, and dialed his number …

I'd scarcely known Lorenzo when he invited me to his winery. I didn't think twice about accepting, confounded by the speed with which he moved but also starving for an adventure. I sat in Archivio, listening to the buzz of the Vespas speeding down the small streets that circumscribe Palazzo Rucellai, my head vibrating. A mere six weeks ago, I was a cog in the academic machinery: reading uncreative papers by grade-hungry students, following the orders of a tuition-hungry administration, trudging through banks of dirty snow to reach my drafty office on campus. Twenty-four hours from now, I'd be drinking wine and swimming in the Tyrrhenian Sea with an Italian nobleman whose widowed ancestor's image just happened to grace the cover of my last book. Had *Fortuna*, I mused, brought us together?

Nothing in my Southern upbringing, let alone my life in academe, had prepared me for this. I'd yet to figure out men in general, to say nothing of the Italian variety—never mind the nobility. What was the code of conduct? What, for me, was within the realm of possibility? What were the rules of the game?

I had one source to whom I could turn.

Luca was an old flame, one of those summer things. He was the chief barman at the Hotel Excelsior, had started off there as a busboy in the late 1980s, and thus was privy to more society secrets than *Chi* magazine. What he didn't witness with his own eyes, there in the leather-lined Club Donatello, he heard directly from the source, for Luca was a trusted sounding board—his livelihood depended upon it.

Our own affair had been easy. An occasional summer resident, an obvious outsider content to stay that way, I'd never posed a threat to the five-star hotel lounge ecosystem. And by the time I did have reason to ask questions, Luca and I had developed a genuine friendship, an unexpected connection that proved much more rewarding than our admittedly enjoyable romp of some years ago, the night I walked into the bar with my friend Giulia looking for nothing more than a comfortable chair and a few hours of air-conditioning. But with every new drink order, another folded note arrived, tucked discreetly between a pressed linen napkin and an heirloom silver tray. By my third Aperol spritz, Luca had orchestrated our first *appuntamento*. When the bar closed at one in the morning, Giulia went home in a taxi, and I slipped into an oblong service closet that contained a still-steaming Cimbali and an irresistible Sardinian. I found myself brushing espresso grinds off my pants for days.

On the eve of my trip to see Lorenzo, Luca and I met for a drink in Piazza Santo Spirito. The fact that Lorenzo's ancestral burial chapel sat silently in the background, nestled among dozens of other fifteenth-century semicircular niches lining the perimeter of the Brunelleschian church, did not escape me. Rather, like a wraith, the depths of Lorenzo's history possessed me. Until now, I hadn't revealed my chance encounter with the 25th-generation Florentine to anyone in Italy—and I knew enough about the workings of the Old World to keep it that way. Luca, however, tickled by my bombshell, promised to safeguard my secret and prepare me for my journey to Elysium. One Negroni and two dishes of San Carlo potato chips later, I dashed home to finish packing, feeling sufficiently satiated. I had an early morning train to catch.

No sooner had I dumped my luggage in the beyond-my-means suite than my phone rang. It was an unidentifiable female voice: *"Buongiorno, Professoressa. Aspetti in linea per Marchese—"*

I stared down at my Motorola, trying to make sense of the instructions, not to mention the messenger.

"Professor!" trumpeted that inimitable voice a moment later. "Quickly—I'm on another call—Come for lunch! I'm sending the boy to pick you up. Be ready, please."

I was more than ready.

I threw my bathing suit and a change of clothes into my canvas tote and bounced down to the lobby. Within minutes, a Land Rover Defender pulled up in front of the hotel. I sat in the front seat (this was wrong, I would later

learn—"too democratic") and introduced myself. Apparently, my gesture came as a surprise to the Moroccan man, but he offered his name all the same: "I am Kamal." He smiled cautiously and then added, "Marchese calls me Khalid." We rode on in silence.

From the Via Aurelia, the 2,250-year-old "highway" that still runs from Pisa to Rome, we turned left at a little hexagonal chapel and onto a fairy-tale lane that leads to an idyllic hamlet set at the top of the hill. We drove inward about three miles toward the *castello*, all the way guarded by two densely planted rows of mammoth *cipressi*, this verdant screen of centuries-old Mediterranean cypresses effectively cutting off my peripheral vision and channeling me even deeper into the heart of what was once Etruria. Several winding roads later, we pulled up short in front of an uninviting metal gate. I had no idea what lay beyond; I knew only that I wanted in.

It took some time to reach the house, the Defender now moving at a snail's pace as we drove over gravel through acres of meticulously groomed olive groves and grapevines. My heart skipped a beat as I realized we were driving through Lorenzo's world-renowned vineyards. Then, as soon as we arrived at the side of the *casa colonica*, I was greeted by a grandmotherly type with a familiar voice: "*Benvenuta a Ariabella!*" Aha, here was the messenger—and, wiping her hands on her apron, apparently the cook. Elisabetta, as she was called, whisked me to the pool, past fruit orchards and lavender fields, under pergolas covered in wisteria and clematis, across peach-colored stone terraces, and through the greenest grass I'd ever seen.

Lorenzo was waiting for me. "*Eccola!* Come, let's eat." He took my hand and led me over to a stone table, formally set, under a Bedouin tent. "I hope you like langoustines," he said, and then quickly changed the topic. "So, what's your sign?"

"Sagittarius," I replied, one eye on him, the other on the plump crustaceans being served to me by a white-gloved hand. "I'm a Sagittarius, too!" he crowed, and then added, with some urgency, "But what is your *rising* sign?" Sensing, correctly, that I wasn't following, he proceeded to explain, "You know, the ascendant—the sign that rises in the east at the time of your birth. It signifies your awakening consciousness, the image you project to the world, how other people perceive you. The outer versus the inner self."

"Oh. I'm not sure. I'll have to look into it."

"Professor, either you *know* who you are or you don't."

Before I knew it, lunch was over, and Lorenzo was escorting me back to his driver. I was worried I'd blown it, but then he said in a hushed voice, his

hand pressing against the small of my back, "Listen, I have to fly to Amsterdam tomorrow, but I'll be back in time for dinner. The boy will pick you up at seven thirty."

The next evening unfolded according to schedule. I sat in the front seat again and proceeded to tell Kamal about my day. From his warm but quizzical expressions, I sensed that he regarded me as a curiosity. I couldn't imagine why.

Within half an hour, we'd reached our destination, Falcone. "This is the estate of Marchese's mother," Kamal announced, before interjecting, "*Guarda!*" We stopped to watch half a dozen doe leap across the private dirt road. Kamal beamed. "These are Marchese's animals." It occurred to me at that moment that it didn't much matter to Kamal what Lorenzo called him, for he understood fully that the marchese moved in another orbit. I, on the other hand, hadn't yet grasped that fact. "Do you know what tonight is?" he asked as we approached the house. "It's the night of San Lorenzo. That's why Marchese prefers to have dinner on the beach. If you see a shooting star, you must hurry and make a wish!"

The Defender came to a slow stop in front of what appeared to be a service entrance to the house. But I wasn't invited in. Nor was I asked to enter elsewhere. "Marchese already knows you are here. Please," Kamal said with a delicate ta-dah gesture, "feel free to walk around." Having been left to my own devices, I strolled the presumably under-surveillance grounds until I came upon a nineteenth-century cast-iron gazebo, under which I waited for what seemed like a century. Standing there, in *paradiso*, I began to wonder if this, dare I say, blossoming romance wasn't some sort of sick joke the bored aristocracy play on naive Americans. Just then, my prince appeared.

As Lorenzo bobbed ceremoniously from one of my flushed cheeks to the other, I closed my eyes and breathed in his cedar scent, which now mingled with the local flavors of sweet pine and saltwater.

My salutation was less coy. "So, I found out my rising sign." Unlettered in astrology, I had no idea, of course, of the significance of my findings; still, I reported them all the same.

"You're a *double* Sagittarius? *Mon Dieu!*" he said, his eyes dilating. "I've met a lot of people in my life—a *lot* of people, Professor—and, I swear on my mother's grave, I've never met another double Sagittarius before now."

"Is this a *good* thing?"

"We can talk about that later. Now, come with me, my sister." He smiled, flinging his tattooed arm around my shoulders.

The sky wasn't the only thing aflame that night. Far gone, I'd made sure to see two shooting stars before I left that private moonlit beach. This double Sagittarius had wishes, after all, for both of us—my inner *and* outer selves.

Back in Archivio, my head still spinning, I collapsed onto the couch. The euphoria of the last three days had left me exhausted. But what had worn me out most, I reflected, was the literal incomprehensibility of Lorenzo, my inability to process most of what he said—despite the fact that we spoke to each other primarily in English. Not only did we come from completely different worlds, making it nearly impossible for me to connect with the topic at hand or anticipate the direction of the conversation, but I also failed, consistently, to recognize whole strings of words. I was over-listening, of course, clinging to his every utterance. And though I'd always been prone to mishearing, Lorenzo's speech, characterized by staccato rhythms and misplaced accents, left me befuddled. But rather than ask for clarification, I tended to let out a long *hmmm*, indicating deep interest or empathy. My disjointed responses surely did not go unnoticed, let alone my every non sequitur (I kept a mental list of talking points, which I inserted whenever he paused to take a breath). What, then, must *I* have sounded like to *him*? Were we both lost in translation? Apparently, he didn't see any such obstacles, remarking on the night of his patron saint, "Well, I've finally met my match!"

In the days that followed, to keep myself grounded, I resumed my house research. My new approach, however, was more haphazard than my initial efforts had been. Having combed through the standard bibliography on Palazzo Rucellai—and having barely escaped being buried alive by boring brick-and-mortar shoptalk—I decided to open another window. I wanted to know what had gone on inside Palazzo Rucellai beyond the Renaissance. Spending time in a storied home with a contemporary mentality seemed the right course of action, so I hopped the No. 10 bus to Ponte a Mensola and hiked up the long and narrow road to Villa I Tatti, the art historian and connoisseur Bernard Berenson's former home, now the Harvard University Center for Italian Renaissance Studies.

I ran into a friend from graduate school in the reading room, and we shared research topics. Hers was on the fourteenth-century painter Bernardo Daddi, also her dissertation topic, and thus she knew the master's oeuvre inside out. Upon learning of mine, she recalled having come across a reference, just a few days earlier, to an altarpiece by a follower of Daddi that had once hung in Palazzo Rucellai, but she couldn't remember where the painting had ended up. Nor could she name her source. This was certainly worth investigating, I decided,

and prepared myself for a bicep-breaking slog through the stacks. It wasn't until well after lunch (just before closing, in fact) that I finally struck gold. (I'd been fortunate to score a seat at the fellows' lunch table, and the obligatory wine service, admittedly, had slowed me down a notch.) The reference I'd been searching for consisted of a single line—*Madonna and Child with Saints*, c.1340, follower of Bernardo Daddi—and an image, but this was just enough information to advance my research the next morning.

I collected my belongings from reception and hurried down the hill, a half-mile walk along Via Vincigliata, hoping to catch the 18:21 back into the *centro*. Alas, just as I turned onto the main road, the bright orange ATAF bus was already disappearing into the sunset. I now had 20 minutes to kill. Mentally depleted from my academic sleuthing, in need of something lowbrow to read on the eventual ride home, I decided to browse the book exchange located a few paces from the bus stop. Carved out of a stone wall, this shallow alcove is plastered with notices from the commune and, against its back wall, a plea: PRENDIMI O LASCIAMI MA NON GETTARMI! (*Take me or leave me but don't trash me!*) On offer that evening were a Danielle Steele paperback, an array of Christian newspapers, and a Mondadori *giallo*. I reached for the vintage pulp. The 1955 detective novel was tattered, quite *un*like the martini-drinking femme fatale who graced its soiled yellow cover. The redhead wore a determined expression and a low strapless gown of lime-green satin, the display of flesh offset by a pair of matching opera gloves that rose well above her elbows. Her only other accessories were a short strand of pearls and a lit cigarette. The mood for the rest of my evening was set.

Next morning, groggy in Piazza San Marco at 8:30 a.m., ten minutes ahead of schedule, I popped into the little bar located a few doors down from the big bar on the corner, eschewing pizza baked in gigantic square trays for a *spremuta d'arancia* and a strong cappuccino. Forty-five minutes later, more or less fortified, I was back in the Berenson Library, tracing the provenance of the fourteenth-century altarpiece. That this was a Rucellai commission had gone uncontested, but details on where the painting originally hung were understandably sketchy: either in the family chapel in the church of San Pancrazio, adjacent to the back of the palace, or in Palazzo Rucellai itself. Wherever it had rested, it had done so in peace—for at least 560 years.

At some point, the altarpiece ended up in the collection of Achille Chiesa (a man, not a church—a Milanese coffee importer who'd started collecting art around 1900). Then, in early 1926, the painting crossed the Atlantic and was put on public display, for five days, at the American Art Association Galleries

in New York City, before being purchased on the evening of Friday, 16 April by a Mrs. L. W. Hitchcock. Fitting name, I thought, as I continued to trace the footsteps of the Florentine painting whose meanderings were starting to look murky; the next player I encountered was Count Alessandro Contini-Bonacossi, a Florentine art dealer whose clients ranged from Bernard Berenson himself to Hermann Göring. With Contini-Bonacossi involved, I couldn't help but wonder if the Rucellai altarpiece had been transported back to Italy, and if Berenson had tried to acquire it for I Tatti. If so, his bid was unsuccessful, for I soon learned that the altarpiece was sold to the great American collector Samuel H. Kress, founder of the S. H. Kress & Co. "five and dime" stores, on 4 March 1932. Seven years later, Kress gifted the "Italian primitive," as early Renaissance painting was then called, to the National Gallery of Art in Washington. Inexplicably, to my mind, the National Gallery deaccessioned the painting 20 years later and returned it to the Kress Foundation. Nearly a decade later, in 1961, the foundation gifted the painting a second time—this time, my mouth fell open—to the New Orleans Museum of Art.

I leaned back in my Savonarola chair, my body all but paralyzed, my eyes darting with abandon, my breathing uneven, and tried to fathom this stunning

Figure 17. Bernard Berenson probes an old master.

chain of events. So the Rucellai altarpiece had ended up in New Orleans, of all places, and I had landed in the palazzo. What were the odds? Talk about a reversal of fortune! I spent the rest of the day reflecting upon my journey, the serendipitous turns I'd taken, my current coordinates. Was I headed in the right direction, or had I long ago lost my way? That I hadn't bothered to leave a trail of crumbs, I told myself, could only mean I had no intention of turning back.

Though I hadn't thought about the altarpiece for some 30 years, I could remember with precision having seen it for the first time in the museum. An undergraduate writing assignment, a standard museum response paper, had brought me face-to-face with the highly gilded panel. I could have chosen any painting in the Early Renaissance galleries, but this one caught my eye. I think it was the attribution more than anything else; I'd recently heard the name Bernardo Daddi in class, only to find myself standing in front of a real live specimen. I couldn't remember what I had written about the painting, or what my professor had thought of my response. I only knew that that museum experience had cemented my relationship with the Renaissance. Now here I was, in Florence, studying a reproduction of the altarpiece in a library book. Looking down at the richness of the altarpiece—the solid gold background, the bright red crimson cloak of Saint Pancras, the jewel-toned shot silk cape of Saint Michael—I was smitten all over again, swept up as I was in my new gilded lifestyle.

— CHAPTER THREE —

The Heir Aberrant

*There is a middle state between perfect grace on
the one hand, and senseless folly on the other.*

Baldassare Castiglione, *The Book of the Courtier*

W hat is the measure of a man? Stock and square footage, it would seem to Giovanni Rucellai. But once he had built the bulk of his palace, the patriarch issued a different—though no less daunting—mandate for the first generation to grow up under his magnificent roof: continuation of the *casa*. A heavy plumb line, indeed, had been dropped.

TOUGH LOVE

With the survival of the house at stake, extreme measures were often employed to drive home the primacy of matrimony and procreation. Consider, for example, this most peculiar wedding gift: to commemorate the marriage of his son Giannozzo to Lucrezia Bini in 1483, Antonio Pucci commissioned Sandro Botticelli to paint a series of four panels depicting *The Story of Nastagio degli*

Onesti, a novella from Boccaccio's *Decameron*, a dark and bloody drama as raw as the story that inspired it—Dante's *Inferno*.

The morose tale, "no less pitiful," its narrator cautions, "than delectable," unfolds as follows: when Nastagio, a young bachelor of recent fortune from Ravenna, falls in love with a beautiful lady from the Traversari family, "a girl of far more noble lineage than his own," the enamored fellow begins "spending money like water." His spendthrift efforts to get the girl, however, yield nothing, for the fair maiden of "exalted rank" is "persistently cruel, harsh and unfriendly towards him." His friends, worried that the jilted Nastagio might be "in danger of exhausting both himself and his inheritance," urge him to flee the city for the country; a self-imposed exile, they hope, might curtail "both his wooing and his spending." The hopeless romantic finally agrees but retreats only as far as the nearest hamlet, located a mere three miles from Ravenna. There, he continues to squander his inheritance, setting up a mini-court, of sorts, with "a number of tents and pavilions," under which he proceeds to drown his sorrows in lavish spreads of food and drink. Still, the change of scenery eventually proves beneficial to the lovesick profligate.

One Friday morning in May, some weeks into his stay, a melancholic Nastagio wanders into a neighboring pine forest. "Lost in thought," his "pleasant reverie" is suddenly broken by the sounds of "dreadful wailing and ear-splitting screams." He looks up to find "a naked woman, young and very beautiful," running toward him with "a pair of big, fierce mastiffs" nipping at her heels and "a swarthy-looking knight" on horseback bringing up the rear. Horrified, Nastagio quickly grabs the closest tree branch and steadies himself to defend the vulnerable girl against her angry attackers. But as the knight approaches, he calls out to Nastagio and warns him not to interfere:

> I was a fellow citizen of yours, Nastagio, my name was Guido degli Anastagi, and you were still a little child when I fell in love with this woman. I loved her far more deeply than you love that Traversari girl of yours, but her pride and cruelty led me to such a pass that, one day, I killed myself in sheer despair [...] and thus I am condemned to eternal punishment. My death pleased her beyond measure, but shortly thereafter she too died [...] No sooner was she cast into Hell than we were both given a special punishment, which consisted in her case of fleeing before me, and in my own of pursuing her as though she were my mortal enemy rather than the woman with whom I was once so deeply in love. Every

time I catch up with her, I kill her with this same rapier by which I took my own life; then I slit her back open, and (as you will now observe for yourself) I tear from her body that hard, cold heart to which neither love nor pity could ever gain access, and together with the rest of her entrails I cast it to these dogs to feed upon [...] Every Friday at this hour I overtake her in this part of the woods, and I slaughter her.

Upon learning that the macabre chase between the scorned knight and the cruel lady is eternal punishment for her lack of compassion, Nastagio decides to use their condemnation to his advantage. He arranges for an elaborate banquet to be held in the exact spot in the woods where he witnessed the grisly massacre and invites his own "cruel" lady to attend. Having strategically seated the Traversari girl and her family directly opposite the action, Nastagio steps aside and watches as the hideous events play out. Just as before, shrill cries precede the appearance of the fugitive girl, whose naked body is then viciously disemboweled by the knight, her torture no less horrific than the rapacious ripping apart of her viscera by wild dogs. The terrified guests watch squeamishly as the posthumous punishment unfolds to the knight's narration. When the doomed pair finally vanish into the woods, Nastagio's once-reluctant beloved, realizing that "these matters had more to do with herself than with any of the other guests," announces to the gathered company that she "would be pleased to become Nastagio's wife." A magnificent wedding banquet is held the following Sunday, and the willing couple, we are told, live happily ever after.

As bewildering as Boccaccio's gruesome story may seem to modern readers, the message of the moralizing tale, popular during the fifteenth century, was not lost on its Renaissance audience. The bride's avoidance of her societal duty to marry, especially when presented with an eligible candidate, threatens the line of descent, as does the young man's fruitless prodigality (not to mention the knight's suicide); such selfishness is to be punished, while matrimony and reproduction will be rewarded.

Still, for the newlyweds who received Botticelli's vivid interpretation of Boccaccio's tale, the outcome of the admonitory cycle must have been, to at least some degree, counterproductive. For much like the protagonists who are forced to reenact the chase and butchering in the pinewood in perpetuity, the begifted couple was condemned to see the virulent scenes night after anxious night: Botticelli's four rectangular panels, each measuring roughly the size of

a twin headboard, were designed as *spalliere*, decorative insets lodged into the wainscoting, typically of a bedroom, at or above shoulder (or *spalla*) level. Thus, set within the physical matrix of the building, in the nuptial bedchamber no less, the immovable sequence—and its intimidating message—was, literally, hammered into the house: flesh and blood beget flesh and blood; progeny is bound to palace, and vice versa.

The paintings hit home in other ways, too. In the first three panels, Botticelli's visual text adheres closely to Boccaccio's written account: horror, savagery, and chaos play out in the middle of a lush sylvan paradise. But in the final banquet scene, where civility reigns, the action shifts from Ravenna to Florence; an open loggia and triumphal arch take the place of dense umbrella pines, and members of the Pucci–Bini wedding party, outfitted to the nines, fill the stage. These adjustments, as well as the inclusion of family heraldry, make the cycle more relevant—and personal. If Nastagio "sees" himself, anagrammatically, in Anastagi, and the Traversari girl readily recognizes herself in the actions of the unaccommodating bride, the twinning of egos is made altogether transparent for Giannozzo and Lucrezia, who, literally, come face-to-face with their own portraits—and purpose—on their bedroom wall.

When it came to one's marital duty, however, there was a right way and a wrong way to do it. Sodomy, alluded to by the positioning of Anastagi kneeling astride his prone victim, was condemned by the church as unnatural and, more to the point, nonprofitable. To sire, with sanction, was to assume a different position—and a proper partner. Further, the violent manner in which the young girl is killed and then gorged upon by dogs conjures up a wild boar hunt, linking the scene to sexual excess and the sin of *luxuria*. Thus, the Pucci–Bini illustrations might also be read as a sort of sex manual, offering proscriptive lessons for the groom, at least as he performed under the roof of his ancestral palace.

"GOOD MEAT, WITH LOTS OF FLAVOR"

Matrimony might provide the promise of legitimate succession, yet it could also offer, if carefully orchestrated, a shot at socioeconomic mobility. In late medieval and early Renaissance Florence, endogamous marriage was the rule rather than the exception, particularly among elite families. But because of an increase in "new men," marriage within the ranks was often a tricky trade-off: a

girl from an established family brought history and honor to the union; a man without such a pedigree brought money—and not a small amount of chutzpah.

It almost goes without saying, then, that the marriage market in fifteenth-century Florence was big business. Just peer into this letter of 1465 between Alessandra Macinghi Strozzi and her son Filippo, in which she describes "the various girls" she has considered for him, "because if you want a meal you need to order it in advance":

> About that member of the della Luna family, I've heard that there's 3,000 florins in dowry and 1,500 in trousseau [...] And they are building a beautiful house, at least it looks that way from the outside [...] I must tell you how, during the Ave Maria at the first Mass at [the Duomo], having gone there several times on feast mornings to see the Adimari girl, as she usually goes to that Mass, I found the Tanagli girl there [instead]. Not knowing who she was, I sat on one side of her and had a good look at her. She seemed to me to have a beautiful figure and to be well put together; she's as tall as [your sister] Caterina or taller, with good skin, though it's not white, and she looks healthy. She has a long face and her features aren't very delicate, but they're not like a peasant's. It seemed to me, from looking at her face and how she walks, that she isn't lazy, and altogether I think that if the other considerations suit us she wouldn't be a bad deal and will do us credit.

An embarrassment of riches! It may have been a buyer's market in fifteenth-century Florence, but arranging a marriage was still an expensive and time-consuming endeavor, and this doting mother expected more than a little bang for her buck. Yet for all her heady matchmaking, when it came down to choosing a daughter-in-law, Alessandra went with her gut, crudely boasting of the successful candidate, the Adimari girl, "she's good meat, with lots of flavor."

Once the bride had been procured and her father persuaded, a drawn-out affair for both families, what unfolded next was not a single ceremony, but a complicated legal and ritual process, with venues all over town. There was first and foremost the ever-delicate matter of money. The bride's trousseau, or *donora*, in addition to practical household items and clothing, could consist of a significant combination of cash, land, and investments. The groom promised, as his counter-gift, jewelry and the nuptial wardrobe; he would also pay a cash tip, or *mancia*, upon consummation of the marriage. Carefully negotiated contracts

established the value and deadline for delivery of these gifts and held both parties to their end of the bargain. With the alliance, or *parentado*, now in place, the focus shifted from the negotiants to the betrothed couple.

The union was legitimized in two stages. First, a simple ring ceremony, or *anellamento*, took place at the bride's home. This was a private, secular affair that functioned more as a meet and greet than as any sort of romantic declaration. The couple, practically strangers at this point, had only to agree to the marriage, an act made official not with a kiss but with a handshake. Much more festive was the *nozze*, the extravagant banquet hosted by the groom's family—but only after a substantial portion of the dowry had been delivered.

This much-anticipated culminating event began with a provocative procession between the two households, a highly choreographed transfer of both material goods and matrimonial body. All eyes were on the so-called new woman, or *donna novella*, as she and her trousseau, contained in gilded wooden chests, or *cassoni*, were paraded through the dense city streets. By all accounts, the crowd, a rowdy mix of well-wishers and naysayers alike, got an eyeful. Consider a second letter penned by Alessandra to her son, this time describing the clothing ordered by her future son-in-law, the silk merchant Marco Parenti, for her daughter Caterina's *nozze*:

> When she was betrothed he ordered a crimson dress of voided satin velvet and an overgown of the same fabric, which is the most beautiful cloth in Florence [...] And he had a garland of feathers and pearls made, which cost 80 florins; and the headdress underneath has two strings of pearls, costing 60 florins or more. When she goes out she'll have more than 400 florins on her back. And he ordered some crimson velvet to be made up into long sleeves, lined with marten, for when she goes to [his] house.

It was not unusual for the groom, or his family, to outfit the bride to such a degree—and at such a cost; she was, after all, his prize, a commodity to be dangled in front of a sensation-hungry audience. Indeed, just as soon as Alessandra had sealed the deal with the Adimari family (as widow, she acted as head of the household), she thought immediately of the pageantry to follow, proclaiming, "Get the jewels ready, beautiful ones, for we have found a wife!"

The wedding party and all their booty, the groom with his spoil: this rhetoric of war may seem divorced from a discussion of Renaissance marriage, but plunder was part of the game—just think back to the Nastagio story. Yet even

beyond the page of the medieval novella, virility and pillage went hand in hand. Writing to fellow humanist Poggio Bracciolini in 1412, the Florentine chancellor Leonardo Bruni declared his wedding night "a bloody victory," crowing, "the forts I'd come to conquer were invested and captured the first night." This civic leader's bravado on the domestic front calls to mind the *bagordo* (from the verb *bagordare*, meaning "to carouse" or "to indulge"), a rite of passage for adolescent males, both an initiation into public life and an essential component of the larger courting ritual. In this ceremonial joust, a young man on horseback, accompanied by a group of friends, would charge toward the palazzo of a young lady, ramming the facade with his lance and breaking its tip against the stone before steering away at the last minute, demonstrating his prowess in battle—and, presumably, in bed.

But if, with this symbolic penetration of the palace and its daughter, he showed off his manhood, he was also stripped of it. For in this and similar equestrian tournaments, *his* was the objectified body, silver-plated and plumed, goosed to perform before matchmakers and other discerning onlookers. Not everyone, however, was aroused by such blatant displays of coquetry, especially when the flaunting of female sexuality was the main event: "Virgins are dressed up as much as possible, publicly displayed on horses, and painted with lascivious cosmetics," decried the humanist Matteo Palmieri in his treatise of the 1430s, *On Civic Life*: "Trumpets go before them calling the people to come and see the unbridled daring of meretricious passion. They take these brides-to-be to the jousting fields," he disparaged, "and circle them around the piazzas to show that they are going to lose their virginity."

The bride's loss of virginity, of course, was the whole point. Given that the lineage depended upon it, the consummation of the union was hardly a private matter between husband and wife, but, rather, a collective concern. The newlywed couple under surveillance, in fact, was a popular motif for satirists working in all media. A typical scene, as performed on the stage or printed on a broadsheet, might show an impatient groom hurrying matronly busybodies out of the room, while his timid young bride, already disrobed, waits for him in bed—and in tears.

Cold feet didn't have to be a deterrent. Lest she forget her duty, or he his, one had only to lift the lid of any of the *cassoni* scattered around the room. Used initially to commemorate the marriage, these wedding chests then provided practical storage space in the bedroom. They also served to spice things up, for hidden inside the richly decorated chests were often images of stripped-down

bodies, either male or female, cast in seductive poses. These passive pinups might have appealed to both partners—depending upon their preference—and thus prompted the newlyweds to complete the task at hand while offering, from a safe distance, something otherwise off-limits. However successful these provocative boxes might have been, the discrepancy between outer casing and inner lid mirrors the double nature of the palace itself—namely, the disconnect between exterior and interior: what you see isn't always what you get.

THE GUSHING BRIDE

Alessandra Macinghi Strozzi may come across as quite the procuress, but the matchmaker of the century has to be Giovanni Rucellai, who successfully arranged the marriage of his youngest son, Bernardo, to the granddaughter of Cosimo de' Medici, Lucrezia ("Nannina"). The betrothal of the two 13-year-olds, in 1461, and then the wedding five years later, on 8 June 1466, joined the two families legally, socially, and politically, bolstering the Medici power base and according a gloating Giovanni unequivocal prestige.

Spread over three days, the opulent festivities took place "outside of the house," in the piazza in front of the newly completed Palazzo Rucellai. To accommodate the more than 500 guests in attendance—and to pander to what was no doubt an even larger crowd of gawkers—an enormous triangular stage was constructed. Stretching approximately 3,000 square feet from the palace facade across Via della Vigna Nuova to the far edge of the loggia, the platform was raised some three feet off the ground and crowned with an awning of bright blue cloth. Decorated with rose garlands, tapestries, and the entwined Rucellai and Medici coats of arms, the pavilion, "the most beautiful and finest ever made for a wedding banquet," was filled with "very beautiful furnishings," the host tells us, "above all a credenza furnished with works of silver, very rich."

Rich, indeed. By Rucellai's own calculations, he spent 6,638 florins on the whole affair (as mentioned in Chapter 2, the median cost of a palace in the mid-fifteenth century was between 5,000 and 10,000 florins). From Sunday morning until Tuesday evening, 50 cooks prepared lunch and dinner in a makeshift kitchen set up behind the palace, in the piazza of the church of San Pancrazio, and in the connecting side street, Via dei Palchetti. No expense was spared on provisions, which included 2,800 loaves of bread and 4,000 wafers; 1,500 eggs; 2,496 chickens and small birds, and about 700 ducks; saltwater seafood and silver-scaled fish

from the Arno; lard, sausage, and tongue; *mozzarella di bufala*; baskets full of sweetmeats, tarts, and pomegranates; and 120 barrels of wine, local and Greek. Piled high on gold and silver platters, meals were marched out by servants dressed in matching livery; for tights in the family colors, Rucellai allocated 290 florins, serving up gastronomical and sartorial excess in healthy portions.

The dramatic setting and sheer opulence of the Rucellai–Medici *nozze* are suggested by a fifteenth-century *cassone* panel depicting the marriage of Esther, a biblical story transposed to contemporary Florence. Against a monumental backdrop of family palace and parish church, the king and his retinue process across the piazza toward an Albertian loggia, lushly outfitted for a wedding banquet. Guests draped in gold brocade blend seamlessly into the gilded tapestry hanging at their backs, while bride and groom, equally encrusted, are wed in the foreground.

If the Rucellai–Medici wedding party oozed such opulence, consider the gushing bride. Every gown, every handkerchief, every needle of Nannina's top-drawer *donora* Rucellai covetously recorded in his ledger, laying claim to Medici patrimony—and a magnificent one at that:

1 pair of large wedding chests with painted backrests, very rich
1 full-length overgown of bright purple cloth, embroidered with pearls
1 long sleeveless overgown, open at the sides, of rich blue silk, laced with pearls
1 long sleeveless overgown, open at the sides, of white and crimson damask with fringe and pearls
1 full-length overgown of gray cloth, the sleeves embroidered with gold thread
1 dress of bright purple cloth with gold, silver, and pearls
1 basic gown of rich blue satin with brocade sleeves
1 dress of white cloth with striped damask sleeves
1 gown of diagonal weave silk with white and red damask sleeves
1 dress of purplish-blue cloth with sleeves of silver silk
1 gown of double-faced eyelet, green and black
A length of scarlet English wool, 13 yards long
Enough cloth for 13 towels, to be cut as needed; one piece of fine linen cloth and one yard of scarlet English wool, enough for one short dress
12 undershirts of delicate white linen from Reims, handwoven
1 small cap of fine woolen fabric embellished with pearls

1 cap embroidered with silver thread and pearls
1 cap of rich blue satin embroidered with diamonds
1 little book of Offices of Our Lady, illustrated, with silver clasps
1 doll dressed in pearl-embroidered damask
A length of purple voided satin velvet, 16 yards long
A length of green damascene brocade, 14 yards long
A length of rich blue damascene brocade, 9½ yards long
A length of smooth crimson velvet, 16 yards long
A length of crimson satin, 10 yards long
A length of golden crimson brocade, just under a yard long
Enough fine cloth for 32 handkerchiefs, to be cut as needed
Enough cloth for 30 handkerchiefs, to be cut as needed
Enough cloth for 50 small head veils, to be cut as needed
16 linen undershirts, handwoven
28 linen snoods, handwoven
6 small caps of fine linen from Reims
4 pouches with tassels
7 pieces of multipurpose ribbon
7½ yards of fine cloth reserved for veils
2 pocket pouches of fine linen from Reims, handwoven
Enough floral-patterned cloth for two towels, to be cut as needed
4 towels for stored goods
1 pair of Venetian gloves
1 cap embroidered with gold thread
1 small cap embroidered with gold thread
1 cap embroidered in a fleur-de-lis pattern
1 snood embroidered with silver and pearls
1 nightcap with a figural pattern
1 nightcap of floral damask
3 small close-fitting caps of velvet and satin with pearls
1 Virgin Mary [pendant] of gold-plated silver
1 little book of Offices of Our Lady, with a brocade cover
1 string of coral with silver and pearls
1 belt of crimson brocade
1 silver purse with pearls and buttons
1 brocade purse in the Venetian style
1 embroidered damask purse

5 multipurpose bags decorated with pearls
4 needle cases embroidered with pearls
8 quill cases, one with pearls
2 thimbles, one gold and one silver
1 set of two small knives and one spike, in silver
1 small knife and one fork, in silver
1 pair of small silver shears
1 pair of small iron shears
3 pairs of gilded scissors
2 small silk Catalan-style collars
5 ivory combs
1 multipurpose quill case
4 pairs of multipurpose gloves
2 nice bristle brushes
1 Milanese hat with fringe
3 multipurpose mirrors
8 pairs of stockings emblazoned with her device
2 pairs of velvet slippers emblazoned with her device
2 small boxes of inlaid ivory
1 basin and one pitcher, for hand washing, of silver enamel
1 small shawl of fine linen from Reims with pearls and silver
3 short multipurpose veils
1 small shawl with gold ends
1 necklace with 6 pearls

plus yarn in every color
1 long sleeveless overgown, open at the sides, of white wool with a diagonal weave, very fine
4 paper strips of pins
1 embroidered fan
1 Venetian hand mirror
1 small Venetian vase

plus a bundle of linens
12 pairs of stockings, emblazoned with the family devices
1 ring with one balas ruby to give to [her mother-in-law] Iacopa
1 cross with four rubies and one diamond

12 pearls for [her nephew] Paolo di Pandolfo

5 belts of purplish-blue brocade, two belts of bright blue brocade, and four belts of silver damascene brocade to give to the daughters of [her husband's cousins] Filippo and Donato Rucellai

Enough cloth for 12 towels, to be cut as needed, for the maidservants

5 small multipurpose brocade purses

Enough cloth for four veils, to be cut as needed

For years leading up to the wedding, seamstresses and embroiderers toiled over Nannina's wardrobe. Silk and velvet and damascene were dyed to order, measurements were made and fabric cut, fittings and refittings took up entire days. As the trousseau began to materialize, carpenters were hired to build large storage chests out of lumber from the Casentino forest, the same source Brunelleschi had used for the scaffolding of the cathedral dome project. Weeks before the wedding, the massive undertaking of transferring the goods from one household to the other got underway. Wooden crates and leather cases were carried by hand and by horse, from Palazzo Medici on Via Larga, past the Duomo and Baptistery, down Via Tornabuoni, to Palazzo Rucellai on Via della Vigna Nuova. And then there was the business of *un*packing. Dozens of servants worked around the clock, making space, preparing drawers, hanging and refolding Nannina's clothing. In addition to their manufacture, transfer, and storage, let us also imagine the circulation of these items within Palazzo Rucellai, either on the back of Nannina or in her hands, on her head or on her feet, past the colorful tapestries and paintings on the *piano nobile* or through the severe stone and plaster cortile on the ground floor.

How and what do things communicate? And how might meanings change when people and things move through streets, through doors, through rooms? A Medici dowry, of course, carried with it significant economic value, but Nannina's possessions—and these *were* her only possessions coming into the marriage—also held high symbolic value. Take, for example, her overgown of bright purple cloth, embroidered with pearls. This dress conveyed her gender, her class, her age; it also said a lot about her father, the person who had paid for it. What happened, then, when Nannina wore that same bright purple pearl-embroidered gown in someone else's house, no longer as Medici bride but as Rucellai wife—or, more to the point, daughter-in-law? What do objects convey about the bearer as well as the beholder? In other words, whose baggage are we really talking about here?

Not to be outdone by the Medici, Giovanni welcomed Nannina into Palazzo Rucellai with a substantial counter-dowry: One gown of white velvet embroidered with pearls, silk, and gold, with open fur-lined sleeves; another of high-low figured velvet with ermine sleeves. One basic gown of white and gold floral damascene brocade with pearl-embroidered sleeves; the other, of silk, with sleeves of golden crimson brocade. And other full-length overgowns, with and without sleeves, of silk and wool. And then there was the jewelry provided by Rucellai, proudly self-appraised:

> One rich necklace with diamonds, rubies, and pearls valued at 1,200 florins; one shoulder brooch with one big balas and pearls that cost 1,000 florins; and another for the head valued at 300 florins. One necklace of large pearls with a large pointed diamond pendant […] of which the diamond alone cost 200 ducats. One hood embroidered with pearls […] one 'hornet's nest' [a head ornament of intertwined hair and pearls worn around the top of the forehead] of large pearls valued at 500 florins; and two pairs of 'horns' [a style of headdress with horn shapes on both sides of the head draped with a thin gauze veil] at a cost of 200 florins.

Marrying up, as Giovanni's accounting indicates, was not cheap; nor was it inconspicuous (exemptions from sumptuary legislation could be had for a fee). "It is unbelievable how much is spent on these new weddings," complained the Florentine chancellor Leonardo Bruni. "Habits have become so disgusting."

Some may have recoiled at the prospect of a big wedding, but Giovanni relished the opportunity to flaunt his new wealth, surely justifying the inordinate cost of the wedding as a shrewd investment in his and his sons' future. For with this Medici marriage came an abrupt end to the 30-year "period of adversity" during which Rucellai, because of his Strozzi *parenti*, had been socially and politically isolated. Now, under the aegis of Bernardo's in-laws, Giovanni, at the ripe age of 60, began to rack up prestigious political appointments, serving first as prior of the Signoria, then as gonfalonier of justice, and later as a member of the Council of Seventy. Finally feeling "honored, revered and respected," Giovanni continued to ride on Medici coattails, confessing eight years after the advantageous marriage, "their happiness and prosperity I have enjoyed and still enjoy along with them, and this has been a source of great contentment to me." In fact, long before Bernardo and Nannina ever exchanged vows, Giovanni had begun to capitalize on their prospective nuptials, boldly incorporating into the

design of his palace facade Medici family emblems: interlocking diamond rings in the spandrels and double-feathered diamond rings in the lower frieze—rocks set in stone. It was precisely the idea of permanence, of eternity, that must have attracted Giovanni to the Medici ring; conjoined with his own emblem, the windblown sail, the nuptial band, without beginning or end, heralded a felicitous union: two families, one familial house.

But this was a love story tarnished from the start. Her father-in-law may have been filled with joy, boasting as the man who had himself wed a Strozzi only to win a Medici for his son, "Our house has been able to make the principal marriage alliances of this city," but the young Nannina had a different view of things: "O do not be born a woman if you want your own way."

A ROSE IS A ROSE IS A ROSE?

Bernardo may have taken a bride, but this youngest son was a far cry from matriculating to manhood. He still, after all, had a lot to learn—less about the birds and the bees, perhaps, than about something much more elemental: how to *be*.

For fathers of the mercantile elite especially, the upbringing and education of sons were of the utmost importance. Well-groomed heirs would keep up the family image and, eventually, the family enterprise. To this end, male progeny was molded to mirror the paterfamilias, whose own carefully constructed persona matched that of the collective patriarchy. Independence and individuality were stunted, effeminacy nipped in the bud. "From the very beginning," Alberti enjoined, "boys must be accustomed to being among men [...] they must be made manly from an early age." This instruction on gender roles and the division of domestic space appears in *On the Family*, Alberti's mid-Quattrocento treatise on household management, or the *social* structuring of the house.

At the start of the next century, prescriptive literature, increasingly concerned with conduct and manners, would hone in on the issue at hand: how to be a man—an *aristocratic* man, that is; for this "civilizing process" was self-consciously class-specific. But whereas Baldassare Castiglione's deeply influential *Book of the Courtier*, published in 1528, catered to the gentleman already at court, Giovanni Della Casa's *Galateo* of 1558 addressed the rising scion—namely Annibale Rucellai, a member of the clan who came of age in the mid-sixteenth century: "In as much as you are now just starting that journey that is this earthly life," the author wrote to his nephew, "I have taken it upon myself to show you (as someone

who has had experience) those places in which I fear you may easily fail or fall [...] If you follow my advice," the dedication continues, "you may stay on the right path towards the salvation of your soul as well as for the praise and honor of your distinguished and noble family." Judging by the rudimentary nature of Della Casa's counsel, this concerned uncle surely had his work cut out for him:

> A well-mannered man ought to abstain from yawning too much [...] And when you have blown your nose you should not open your handkerchief and look inside, as if pearls or rubies might have descended from your brain [...] A man must stand erect and not lean [...] One should not, for the sake of making someone else laugh, say obscene words, or indulge in such ignoble or unsuitable acts as distorting one's face [...] Nor should you chew your words, or swallow them all joined and pasted together [...] It is impolite to scratch oneself while at table [...] We must also be careful not to gobble up our food and develop hiccups or some other unpleasant result [...] Similarly, it is not proper to rub one's teeth with one's napkin, and even less with one's finger [...] Nor is it proper to rinse one's mouth with wine and then spit it out [...] It is also unsuitable to sprawl over the table, or to fill both sides of your mouth with food until your cheeks puff out [...] One should not take off his clothes, and especially not his lower garments, in public [...] It is not proper either to show one's tongue [...] or sigh, or lament, or tremble, or shake, or stretch [...] All these are unpleasant and unsuitable mannerisms.

Comportment, however, was only half of the story; being a man also meant dressing the part: "Two ells of rose-colored cloth," Cosimo de' Medici famously decreed, "make a fine man." But does a rose by any other name still smell as sweet? Renaissance portraits of adolescent understudies abound, yet often the psychophysical weight of the crimson cloak—oversized and overwrought—on the back of a boy makes all too clear the fact that his "manhood" doesn't yet fit. Clothes might have the power to produce gender identity and genealogy, but a misfit must be cut down to size, just as a weak limb will have to be pruned.

Both authoritative fathers and subordinate sons felt the pressure to perform. "Children whose character is excellent," Alberti wrote, "are proof of the diligence of their father, and an honor to him," whereas "children whose character is poor must be a terrible sorrow [...] as everyone knows, every errant child in many

ways brings shame on his father." Though sons were expected to "behave with honesty, restraint, and nobility," many went astray. In such cases, the onus for raising an irresponsible and reckless heir lay, ultimately, on the disciplinarian:

> A father can do with his sons as much as he wills to do. A good and careful trainer can make a colt gentle and obedient, while another, less alert and more neglectful, will not be able to break him [...] The father of sons who do not behave well but go wild and vicious, therefore, is not without great guilt for his negligence.

As the younger generation became increasingly resentful of their oppression, elders feared betrayal. Filial abandonment, in fact, had long been cause for anxiety: "A man wants to have sons," the fourteenth-century poet Franco Sacchetti disclosed, "but five times out of six they become his enemies, desiring their father's death so that they can be free [...] abandoning those for whom they should [be willing to] die a thousand deaths."

To avert such a scenario, fathers, Alberti advised, should be as attentive as possible to the needs of their sons, acting like "architects, [who] look for signs [...] through which they may be able to tell what is hidden beneath the surface." Never having produced an heir himself, Alberti's fatherly advice is, effectively, the wishful rhetoric of an adult son still sensitive to the genealogical and geographical interruptions caused by his illegitimate birth and exile. Not surprisingly, then, this middle-aged orphan promotes cohabitation: "I never liked dividing families, living in separate homes [...] let families dwell under one roof."

Giovanni Rucellai, acutely aware of the consequences of growing up fatherless, had been similarly preoccupied with the threat of separation and the need for cohesion. An advocate of hands-on parenting, Rucellai reveled in his paternal role—"the greatest love," he wrote glowingly, "is that of a father for his son"—and considered his own relationship with his boys, Pandolfo and Bernardo, exemplary. Until the age of 18, he wrote in his *zibaldone*, a son should be "obedient and reverent"; between 18 and 30, father and son should behave "like brothers"; and from 30 on, the father "should want to become the son, and the son should take his father's place and should run everything while the father relaxes.'" Of course, the success of this ideal father–son relationship would depend upon having "good sons," Rucellai was quick to caution, "with administrative ability and sound judgment." Thus, his was a conditional love, contingent upon filial obedience and ingenuity. In this light, Rucellai's "greatest

love" might be reread not as "that of a father for his son," but, rather, as that of a son for his father. Charged with continuing the lineage and the patrimony, Pandolfo and Bernardo were valued, in essence, as custodians of what Rucellai cherished most—his *casa*.

The fifteenth-century philosopher Marsilio Ficino would take these basic tenets one step further, proposing a Neoplatonic model whereby "the son is a mirror and image" of his father, that "second God," whose commands sons should fearfully and reverently obey; and "the house," he concluded, "is nothing other than the union of the father with his sons in one residence." By this configuration, the father is granted quasi-divine status, the son ordained his acolyte, and the house remodeled as Heaven on Earth. For Rucellai, Ficino's Father–Son–Holy House trinity was gospel truth, any disputation of this ideal union a sacrilege. Alas, as Rucellai bowed to Ficino's perfect universe, his own hallowed structure on Via della Vigna Nuova stood on the brink of schism.

EXTRA MUROS

"I have two sons, who are," Rucellai ultimately conceded, "what they are." This aging patriarch's straightforward assessment of his male heirs intimates that his parenting methods may have failed miserably. Granted, both boys had married well, Pandolfo to a Pitti daughter in 1456, and Bernardo to a Medici ten years later, and between them they would sire enough (legitimate) sons—five between the two of them—to keep the Rucellai name in circulation for at least one more generation. But the saplings, it would seem, had grown up to be thorns in Giovanni's side.

The two brothers, though cut from the same cloth, could not have been more different. A document in the Rucellai archive, offering an account of Pandolfo's marriage to Caterina Pitti, portrays the eldest son as reverent and meek: "The submissive son did not refuse but willingly obeyed his good and determined father and accepted wholeheartedly the burden placed upon him, sacrificing his own volition for that of his father." Indeed, the 20-year-old, still subject to Giovanni's steerage, tirelessly devoted himself to the arranged marriage as well as to the mercantile activities of his family, fathering six children and facilitating the economic growth of the Rucellai patrimony. But when his unsought yet honored wife of eight years died in 1464, the heir apparent, ever servile, turned his attention away from his holier-than-thou father to follow a higher calling.

Pandolfo had long struggled to reconcile his family's wealth and commerce, much of which he himself now managed, with his proclivity for restraint and sobriety, an inner conflict only heightened by his deepening spirituality. Even out from under his father's opulent roof, the understated and humble Pandolfo must have felt tested at every turn, at odds with the principles of his very own profession. He had to contend with some weighty theological scruples about the business of banking, for example, even as he served, with prudence and diligence, as consul of the Mint. And he must have been equally frustrated, if not racked with guilt, when he obligingly accepted absorbing political appointments—such as gonfalonier of justice or ambassador to Charles VIII of France—that tethered him to the secular world, when he longed to be shackled, instead, to the church.

A sonnet of 1473, written by the poet Luigi Pulci, takes an irreverent jab at the idea of the immortality of the soul and illuminates Pandolfo's public reputation as a "lost soul":

> Those who create such great debate
> about the soul, where it goes and from where it comes,
> or how the pit stays in the peach,
> have studied on top of a great big melon.
>
> They cite Aristotle and Plato
> and claim the argument is at rest;
> between sounds and songs, they make a big to-do
> and fill your head with confusion.
>
> The soul is nothing more than
> a pine nut pastry,
> or an open-faced pulled pork.
>
> And whoever thinks otherwise has holes in his knife pouch:
> those who were promised a hundredfold for one
> will pay us in chestnuts at the market.
>
> I am told by one who has been
> to the other side—and won't go back again—
> that it's just a ladder climb away.

> But there are those guys who believe they'll find there
> songbirds and garden vegetables ready to eat
> and good sweet wines and plumped-up beds;
>
> so they go following after friars.
> We'd rather go far away, Pandolfo, into a dark valley
> where no one sings Hallelujah!

Pandolfo languished in this limbo for decades, until, swept up in the fanatical fervor of the Dominican friar Girolamo Savonarola, the privileged son—staging his own bonfire of vanities, if you will—walked right out of the magnificent Palazzo Rucellai and straight into the modest convent of San Marco, deserting family and fortune over the short course of one mile. Renouncing everything from his father's world, including his name, the purple-born Pandolfo, now refashioned as Fra Santi, shed his crimson silks for austere black-and-white sackcloth and wrote impassioned tracts on the evils of exchange dealings, usury, and other questionable banking practices. Brother Santi died, happily sequestered, in 1497, two years into his unworldly residence and just one year before his surrogate father, Savonarola, was charged with heresy and burned at the stake; the public execution took place in front of Palazzo della Signoria, the central government seat, where Pandolfo during his earlier, earthly life had served as gonfalonier of justice.

If the eldest heir can be characterized as a soul-searching ascetic, the youngest emerges as a splendor-loving aesthete. Bernardo, the baby of the family and his father's favorite, was not groomed for a banking career—Pandolfo, his elder by 12 years, had graciously assumed that responsibility—but, instead, was generously granted a formal humanist education. Under the tutelage of Marsilio Ficino, Bernardo developed a passion for literature and philosophy; he traveled to Rome with Alberti to study, firsthand, ancient sculpture and architecture; and back in Florence, he planted himself in the gilded garden of his brother-in-law Lorenzo de' Medici, in whose philosophical circle he would take root and thrive. A true man of letters, Bernardo fulfilled his father's own ambitions and paved the way for the next generation of Rucellai intellectuals, of which there would be many. But if the erudite Bernardo thus brought honor to the family, he also brought hubris. "Immodest and arrogant," the Florentine historian Francesco Guicciardini wrote of his contemporary, further describing Bernardo as "anxious" and "impatient," a young man of "unlimited ambition" with "an extraordinary desire for power

and authority." No wonder, then, that the second son, neither heir apparent nor heir presumptive, regarded his position at Palazzo Rucellai as a dead end.

With his big wedding behind him, the fiercely independent and obstinate Bernardo packed up his all-too-willing bride and left home. A commemorative marriage print shows the 18-year-old newlyweds embarking upon their own Ship of Fortune, pirating—even capsizing—Giovanni's personal emblem: In place of a classicizing female nude, a buff Bernardo stands as the mast of a merchant ship in full sail, while an ornately outfitted Nannina sits in the stern. This topsy-turvy image and its accompanying inscription—"I let Fortune take me where she will, hoping in the end to have good luck"—allude to the freewheeling spirit of the honeymooners.

For the first eight years of their marriage, the couple made the Rucellai ancestral villa at Quaracchi their retreat of choice. Nannina was even called "la Quaracchina," enamored as she was of the estate. Located about five miles northwest of Florence along the Arno, the suburban property provided shelter from the rigid social codes of the city. Indeed, the name of the retreat, Lo Specchio, or The Looking Glass, makes clear that the house outside the walls was a world apart, a carefree court where rules were relaxed, if not altogether reversed. Even the architecture *extra muros* took on a different appearance: "The ornament of a town house," Alberti explained, "ought to be far more sober in character, whereas in a villa," he posited, "the allures of license and delight are allowed." Complying with his architect's guidelines, Giovanni, who had reconfigured the family estate

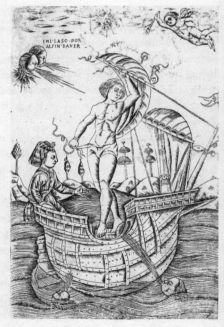

Figure 18. An impresa *amorosa* celebrates the 1466 union of Bernardo Rucellai and Nannina de' Medici.

around mid-century, barred the staid lines of his urban palazzo and set up a lush and whimsical playground, of sorts. Guests were treated to shaded lawn games, pond fishing, and carriage rides around the property, which he had decorated with box hedge in the shape of "monkeys, dragons, centaurs, camels, diamonds, goblins with bows, chalices, horses, donkeys, oxen, dogs, deer and birds, bears and wild boar and dolphins, jousters, bowsmen [and] harpies," he itemized, as well as "philosophers, popes, cardinals, Cicero, and many other similar things."

Interpreting Alberti's allowance for "license and delight" far more liberally than his father had, Bernardo indulged freely in the countryside. In late March 1466, three months before his marriage to Nannina, the fun-loving bachelor wrote to his future brother-in-law, Lorenzo de' Medici, that he planned to pass "quite a few fun days" at Quaracchi and the neighboring town of Peretola. The result, if not of that *brigata* than certainly of a contemporaneous one, was his natural son, Tommaso. Though given the name Tommaso Masini da Peretola and cast as the son of a gardener, the boy knew perfectly well who his father was, or so he claimed—and so his every proclamation was countered with charges of madness. As a short aside, "Zoroastro," as he was later called, was, by all accounts, an eccentric—a sculptor, painter, and engineer, as well as an astrologer, necromancer, and alchemist. He was also the interpreter and executor of Leonardo da Vinci's drawings; in this capacity, he may well have worked on one of the hydraulic machines commissioned by Bernardo around 1510. In any event, Tommaso's unorthodoxy clearly reflected his biological father's independent ways.

A looking glass, of course, is a mirror. And from this perspective, one cannot help wondering how Bernardo saw himself in his father's *specchio* as he spread his seed—licitly and illicitly—over the glorified grounds that had once belonged to his father's father, and to his father before him. We might better understand Bernardo's sense of self—and of self within space—by considering Jacques Lacan's theory of identity formation, specifically what he calls, coincidentally, "the mirror stage." Between the ages of six and 18 months, Lacan argues, the child recognizes himself in a mirror; yet this "jubilant assumption" of his reflection is soon dulled by the act of "misrecognition." In other words, the external image seems unified and whole and, thus, at odds with the fragmented, uncoordinated movements of the as-yet-underdeveloped, dependent infant. This conflict, or "discordance" between bodies, results in a formidable feeling of self-alienation and so begins a lifetime of anxiety, fantasy, and aggression as the subject struggles,

unsuccessfully, to live up to his specular image. It would follow, then, that our early modern subject, cast in this irresolvable drama, enacted on the stage of Lo Specchio precisely what he perceived himself to be: an assemblage of shards, his performance—the symbolic shattering of his father's looking glass—a mimicry of that splintered self.

Like Bernardo, who "found" himself by breaking the rules, Nannina enjoyed her own share of freedom at Lo Specchio, her excessive lifestyle there immortalized in a riotous satire penned by the Medici-sponsored poet Luigi Pulci in 1471. His frottola, or popular secular song, enumerates all the costumes, cosmetics, and cures required by the Florentine elite for a fete in the country:

> The galleys bound for Quaracchi
> set sail to the winds
> and reached safe harbor—
> despite the cargo within—
> thanks to some Jack,
> from Contraband City,
> and two local bosses,
> who gave the order
> to ferry the booty
> straight to the border.
> The clerk from Capalle
> made a very long list
> of all of the lading,
> which went something like this:
> For the head and the hair,
> first a vat full of bleach,
> so filled to the brim
> I sunk an arm in;
> enough aquavit to flood a canal
> and for facials, a mortar slosh;
> but I can't understand the rationale
> behind the banana squash!
> Nor that unsavory solution
> of brown water and broom—
> it could only have come
> from a sewage room.

Who knows how many lupins,
seemed an entire collection,
said to soften wrinkles
and cure bad complexions;
plus two casks of astringents,
both filled to the top,
for tightening pores
and for lightening one's mop;
huge barrels of sulfur,
both yellow and black,
to mix up solutions
for unsightly attacks;
for still other ablutions,
so much purified soap
that counting it all
was a forlorn hope.
With horsehair by the handful
and gum to make things grow,
thicker manes
they said would show.
Oh, come on now!
Must I write this stuff down?
For itchy scalps and dandruff,
they had whole jars of snake oil—
and lizard lard, too.
Plus heaps of ground goose fat,
powder puffs, and poufs.
So blanched in a talc
of lily and squid,
these dainties must have emptied the kegs
then—heaven forbid!—
scavenged the dregs.
To rinse the paste,
which slims the face,
were a good six casks
of lemon, melon,
and cantaloupe water;

plus pumpkin and white figs,
wild bush and vines;
add to that fava,
flowers, and pine;
twigs thick as branches,
and sprigs and shoots;
extract of pimpernel
and other juice:
tonics of mallow and burning bush,
of elder flower and elm;
one could do a field report on each cask—
I was thoroughly overwhelmed!
They brought dishrags and greases
to fill in the creases
caused by Old Man Winter,
who'd left their little faces
all dried up and splintered.
They packed boiled must and fresh cheese,
iris, peach pit, and broad beans;
gypsum by the jug
to whiten the mug;
twelve gallons of lotions
and various potions
to cure the pox
and other eruptions;
to skip the infirmary,
they brought their own gurney
and loaded it down
with sea salts and mercury.
Six boxes overflowing
with camphor and borax
kept skin calm and brightly glowing.
Rosacea they quelled
with a balm of lily and
powdered eggshells.
You wouldn't believe it—
the concoctions they shipped;

it's truly a wonder
the boats didn't flip!
To redden the cheeks
of those of green or yellow cast,
there was a huge ball of rouge
and two or more of witch grass.
These ladies weren't kidding!
There were stone flowers galore
and ten barrels of red dye, horseradish and borage,
and pumpkin leaves, more
than any herd could ever gobble.
To depilate their brows,
they brought a wondrous assortment:
razors and shards,
pumice and orpiment.
Mixing pots
held preparations
for poultices
and other applications;
I saw a serum of egg whites
and dried snail shells
to polish and buff
all that was rough;
but did they really need
a hundred vials of the stuff?
And there for the taking
was a forbidden fat—
suet concealed in ampoules,
said to impart a pearly luster
and to banish ugly pustules.
Acacia gum by the keg gave me pause—
there was enough to feed an army—
used, I was told, for applying gauze
to turkey necks and
similar wrecks.
For smallpox scars
and other defects,

donkey milk by the drum;
and to clean one's teeth—
as a rule of thumb—
if ground coral and brick
didn't do the trick,
they brought piles of pesto
made from a mash
of carnations and sage,
sour grapes and antler ash.
There were baskets full
of secret agents:
rosemary, honey, and garden patience.
Sponges by the dozen
and cotton pads—
but surgical dressings?
These women were mad!
Little pieces of felt
and stacks of cork
went under the heel,
to rise like a stork.
Still other strange tools
were shipped by these fools:
pharmaceutical wrappers
and medicine jars,
flasks, vials, and mirrors—
truly bizarre!—
plus boxes and bowls,
and glasses and basins.
There were brooches and combs
and I hasten
to add: hairpins and earrings,
some shaped like half-moons,
plus wigs of every color
to be worn by these loons.
To decorate the head
there were plenty of inventions,
like paper ribbons

and goat hair extensions;
garlands and hats
and other toppers,
so large and so many
they were held in huge hoppers;
hair ties and rubber bands
to control loose strands;
plus add-ons like braids
and other pieces they'd made.
Not to mention the pile
of hemp and textiles,
which rose—God help me—
as high as the sky!
I thought we would drown
from the weight of the crowns,
the tails and the bonnets,
the trinkets and bling,
and the thousand other
frivolous things.
O poor husbands,
you blind buffoons!
Give these girls a kick—
send 'em straight to the moon!
For I know well from where I speak;
it's three days in and all they've done
is dress up and giggle and gossip and squeak.
One day they sailed along the shore,
a scene that was hardly serene;
for with all of their humming,
the whole world heard them coming.
But then,
at the end—
it felt like a dream—
all of a sudden
they ran out of steam.
They no longer cared
about the flies in the air,

> nor bee stings nor bites,
> nor disheveled hair.
> Why the dismay?
> Their cosmetics used up,
> they could no longer play
> Miss Priss or PinUp.
> So take my advice:
> Steer clear of a wife.
> But if you've already fallen
> into her trap,
> curse her often
> and give her a slap.
> The galleys bound for Quaracchi.

Pulci's burlesque on the primping and preening habits of Nannina and her circle is hardly as shallow as its subject. Indeed, his lengthy inventory of natural ingredients and surgical instruments, though satirical, is clearly based on contemporaneous books of "secrets," or recipes. Thus, not only is this frottola on female vanity an invaluable primary source for understanding the materials and techniques of early modern aestheticism, but it also, in its encyclopedic range, calls attention to the dangerous lengths to which some women went to achieve an ideal beauty. From the harmless (pumpkin, elderflower, lily) to the toxic (mercury, lead white, arsenic), nature could either produce desired effects or destroy the body.

Moreover, "The galleys bound for Quaracchi" pierces a consumer culture that valued the ephemeral as much as the concrete. Having listed all of the lading, which goes on for pages, Pulci then describes the feckless behavior of the hostess and her guests and, as soon as the cosmetics and remedies have all run dry, the abrupt dissolving of the house party. But what is the spillover of evanescence upon identity? Dresses may go out of style, but they don't evaporate; likewise, stockings may wear thin, but they don't melt, get rinsed off, or become absorbed. How long can the plastered faces of Pulci's frottola stay afloat?

Perhaps not surprisingly, Bernardo and Nannina's Ship of Fortune, loaded to the gunwales, would eventually sink. In 1474, on the verge of bankruptcy, Giovanni was forced to sell Lo Specchio, sending the 26-year-old exiles back to the city—and back behind the facade of Palazzo Rucellai. The long honeymoon was over.

SFORTUNA

> It is generally said, and I believe it to be true, that earning and spending are among the greatest pleasures in life [...] I myself, having done nothing for the last fifty years but earn and spend, have taken the greatest joy and satisfaction from both. In my opinion, though, it is even more pleasurable to spend than to earn.

And spend this patriarch did, on everything from buildings to big weddings. But creating and maintaining the life of a Renaissance prince took a bit more of an effort—and expense—than Giovanni had imagined.

By the mid-1470s, the 71-year-old was in dire straits. Having been "struck down by fortune" in the bank failures of 1474, his resources plummeted by 20,000 florins (recall that his cash inheritance at the age of 18 had amounted to a mere 400 florins—his share of a joint patrimony). "It was a great loss," he lamented, "that together with other financial hardships left me poor." Rucellai's golden years may have been rather seriously compromised by his debt to pleasure; still, he was determined to salvage the house on Via della Vigna Nuova. Facing near-total financial ruin, he was forced to liquidate his real estate assets, which, by 1469, had grown to include at least six farms, a mill, two vineyards, and expansive woods, among other impressive parcels. First to go, however, were two large country estates, the one at Poggio a Caiano, which Lorenzo de' Medici was able to pick up for a song, and, as mentioned, Lo Specchio, Rucellai's beloved villa at Quaracchi; letting go of the latter must surely have been hard for Giovanni, as this estate, inherited from his father and located not far from the Rucellai ancestral town of Campi, carried immense emotional value. But even with the sale of these two prized properties, not to mention a consequential property tax reassessment, Giovanni Rucellai found himself threatened with excommunication *and* exile as an infamous bankrupt.

To the Renaissance mind, fortunes came and went; reputations, however, remained. Rucellai's image may have been irreparably tarnished, but this "new man" would manage to stave off total catastrophe *and* reinvent himself yet again, turning the tide one last time—at least for the sake of his heirs. Heeding the advice of Alberti ("As the times dictate, we must change the setting of our sails and seek refuge with dignity or chart a safe course through the waves"), a humbled Rucellai advised his sons to put a new face forward: "The fact is that you are shopkeepers; which is to say that you must govern yourselves as wool

manufacturers and silk manufacturers and as that sort are accustomed to doing." Casting aside his aristocratic posture, the 73-year-old embraced his mercantile roots and counseled the next generation to do the same: "It is enough to hold on to what you have." Given this reversal of fortune, or *sfortuna*, Rucellai's impresa, the windblown sail, might now be interpreted as a symbol of a journey gone off course.

IN THE GARDEN OF GOOD AND EVIL

With the clan now forced to consolidate, the palace was packed to the eaves: Giovanni and Iacopa; Pandolfo and his six motherless children, Elisabetta, Dianora, Piera, Paolo, Alessandra, and Ginevra; Bernardo and Nannina and their eldest four, Lucrezia, Cosimo, Palla, and Piero (Giovanni was still in utero and Tommaso had been farmed out); as many as eight servants and slaves; and one tutor all called Palazzo Rucellai home during these trying times. Having the whole brood under one roof must have provided some comfort to the all-but-ruined patriarch, who had managed to salvage the house only by the skin of his teeth; but his adult sons, now fathers themselves, were still feeling the heat insofar as their presence further fueled Giovanni's belief that his "brothers" should "take [his] place and run everything while [he] relaxes." For the restless Bernardo, especially, this overdetermined residency in the emotionally cramped *casa* had to have been suffocating. An exit would come soon enough—with his "brother" Giovanni's death in 1481.

Within a year, Bernardo, courtesy of his Medici in-laws, came into possession of an abandoned property on the outskirts of town, a former leprosy hospital on the road to Prato. It was exactly what the architect had ordered:

> The physicians advise us to breathe air as clear and pure as possible; this, I do not deny, may be found on an isolated hilltop villa. On the other hand, urban, civic business requires the head of the family to make frequent visits to the forum, curia, and temples [...] of all buildings for practical use, I consider the *hortus* to be the foremost and healthiest: it does not detain you from business in the city, nor is it troubled by impurity of air.

Alberti, extolling both its curative properties and convenient position, regarded the suburban *hortus* "the best solution." So did Bernardo, whose political activities

in Florence—as gonfalonier of justice, to name just one—occupied him through the end of the fifteenth century. The estate, located between the second and third rings of the city walls, offered the perfect balance between proximity and distance, duty and desire. "It is useful," Alberti summarized, "to have the city close by and to have places to which you can withdraw easily and do what you will."

What Bernardo willed most, of course, was his own demesne, a place apart, a parallel humanist universe. To this end, he spent the better part of the 1480s and 1490s painstakingly developing the property, which he named the Orti Oricellari, an honorific nod to his dye-manufacturing roots. Artfully combining "the dignity of a city house," as Alberti recommended, "with the delight of a villa," Bernardo built a commodious *casa* with two loggias, "one facing south and the other west, both very beautiful, and made without arches on the columns," the biographer Giorgio Vasari noted, "which is the true and proper method that the ancients used." Above the entrance, Bernardo installed a simple welcome—*AVE HOSPES*—inscribed, appropriately enough, in porphyry. The zealous antiquarian planted the garden with species mentioned in classical literature, such as almond, bay laurel, and jujube, and filled the grounds with busts of famous rulers, philosophers, and poets, to which he added a curated menagerie of rabbits, deer, goats, and porcupines.

Bernardo's erudite *hortus* was soon peopled with some of the greatest thinkers of the period. "This spot," wrote the historian Jacopo Nardi, "was a general meeting place and refuge for people with intellectual interests, whether foreigners or Florentines, because of the magnanimity, liberality, and hospitality of Bernardo Rucellai." More than a convivial gathering spot, however, the Orti Oricellari had become home, by the turn of the century, to the newly resurrected Platonic Academy. The original philosophical camp at Careggi, where Bernardo received his humanist education, had come to a close with the death of its sponsor, Lorenzo de' Medici, in 1492, leaving the grown-up Ficinisti, followers of Marsilio Ficino, in search of a new habitat. The Orti was the perfect venue, Bernardo the proudest host.

Early meetings, loosely organized, tended to focus on ancient history, literature, and linguistics, but those discussions quickly gave way, amid a changing political landscape, to more contemporary concerns, such as the ideal form of government. This shift in attention is reflected in Bernardo's own writings: *De urbe Roma*, published in 1496, is a topographical study of ancient Rome with an emphasis on epigraphy, whereas *De bello italico commentarius*, begun in 1495, is a critique of the French invasion of Italy by Charles VIII, which had taken place

just one year earlier. The former is a romantic study of old-world inscriptions; the latter, praised by Erasmus as the work of a new Sallust, proved to be a game changer, introducing the term *balance of power* into political discourse.

Disillusioned by what he considered the calamitous state of Florentine politics (inadequate Medici leadership in the wake of Lorenzo's death had ushered in Savonarola's short-lived popular regime, followed in 1502 by a prolonged republican period led by Bernardo's archenemy, Piero Soderini), the uncompromising elitist quarantined himself in his lazaretto and waited for the populist air to clear: "It is a miserable time," wrote Rucellai's compatriot Francesco da Diacceto. "Florence, once flourishing, is sick; the most valuable citizens, and particularly the aristocracy, are persecuted by envy and exposed to insults and injury."

Unable to justify aristocratic control beyond the walls of his *hortus conclusus*, the impatient Medici loyalist left town: "Recently," Giovanni Corsi recorded in 1506, "Bernardo Rucellai has made the decision to become an exile rather than stay any longer in the city of Florence, which he detests as though she were the most savage of stepmothers." He stayed away for five years, visiting Avignon, Marseilles, Bologna, and Milan before settling down in Venice, and returned only in 1511, three years before his death, on the eve of a Medici restoration.

Following the return of the Medici, meetings in the Orti Oricellari reconvened—but with new members and a different mission. This next fellowship sang the praises of the vernacular as opposed to Latin, for example, and discussed, in an anti-Medicean vein, the merits of broad democratic government. These gatherings of the second decade of the Cinquecento, which would have a profound impact on the development of Italian language and political thought, were presided over by Bernardo's grandson, Cosimo di Cosimo. Disfigured by syphilis, the diminutive "Cosimino," as he was called, welcomed—always from a portable "cradle" or litter—such prominent guests as the Emperor Charles V and Niccolò Machiavelli, who devised *The Art of War* as a series of dialogues not only set within Cosimino's gardens but also starring him. Additionally, the earliest extant Italian tragedy, written by his uncle Giovanni di Bernardo Rucellai, was first performed in the Orti in 1516 for Pope Leo X; *Rosmunda* tells the story of the Lombard king, Alboin, who forced his wife to drink wine from the skull of her father, which he wore around his belt as a spoil. The madrigal, a short secular vocal piece of music, was also developed within the gardens around 1520. This lyrical, effusive atmosphere ended abruptly, however, with the events of 1522, when a failed plot to assassinate Cardinal Giulio de' Medici resulted in the beheading of the leading member, Jacopo da Diacceto, and thus the dissolution of the garden fraternity.

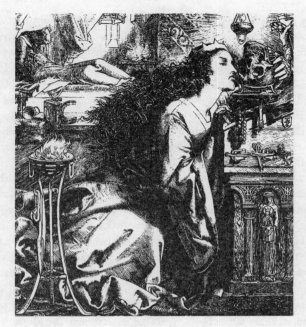

Figure 19. In this 1861 engraving, the Pre-Raphaelite artist Frederick Sandys shows the sixth-century Lombard queen, Rosamund, embracing her father's skull and wine cup.

The Orti Oricellari itself remained intact, but the focus of subsequent on-site gatherings shifted from politics and the performing arts to mad science and hedonism. For the remainder of the Cinquecento, the *hortus* became a theater for the illicit and the irrational, a private laboratory for the lurid. One such occurrence deserves special attention, a necropsy—of a "monster"—performed in the service of scientific knowledge.

The dissection, of 1536, was attended by Palla Rucellai, another of Bernardo's sons, "& a few other excellent Physicians, & Painters." A description of the event and the monster in question followed 12 years later, in a disquisition of some 50 printed pages presented by Benedetto Varchi to the Florentine Academy and entitled, "On the Generation of Monsters & Whether They Are Intended by Nature or Not":

> Many monsters [have] been seen, both long ago & in our own times, not only in Italy (like the one in Ravenna) but even in the Florentine Realm, & in Florence itself [...] There are so many people in this place who remember having seen that Monster that was born at the Prato gate, some twelve years ago [...] They were two females [he explains] joined & stuck together, one toward the other in such a way that half the chest of one along with that of the other made up a single chest, & thus they formed two chests, one joining up with the other; their backs were not shared, but each had its own: it had its head turned directly toward one of the two chests, & on the other side, in the place of the face it had two ears that were joined one to the other, & they touched: the face was very beautiful: blue eyes: it had upper teeth, & the lowers of one girl were extremely white, softer than bone, & harder than gristle, as big as a man's; she was very well proportioned; the other girl, from mid-back down, was twisted, & especially her legs, which were very short in comparison with the other girl's; she had a certain purplish skin that covered her back, & it came forward all the way to her private parts, adhering to the pubic region; both of their arms, & hands were very beautiful & well proportioned & appeared to be, like all the other members, about ten or twelve years old, even though the Monster was young. The girls were separated at the navel, which was the sole source of nourishment for both.

Varchi paints quite a portrait: of "blue eyes," "purplish skin," and "extremely white" lower teeth. But there were visual artists present at the dissection, as well, including the Mannerist painter Bronzino. One wonders how his *Monster* (now lost) might have looked—as "beautiful" as Varchi describes her?—and where such a picture might have been displayed.

This was certainly an unusual commission, yet there were precedents; one of those was still on display at the time of Varchi's address. Inserted into the facade of the Ospedale di San Martino alla Scala was a carved slab of *pietra forte* showing, according to the fourteenth-century chronicler Giovanni Villani, "a boy with two bodies": two heads, two sets of arms, and three legs. This "monstrous birth" had occurred in the Valdarno, or Arno valley, in January 1317. The portent was taken to the hospital in Florence, where it lived for more than 20 days. The bas-relief posthumous portrait, carved by Francesco di Neri, was installed a few decades later and remained in place at least until the mid-eighteenth century.

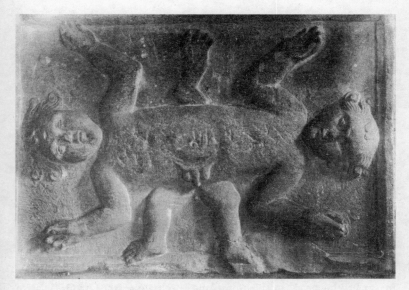

Figure 20. Conjoined twins, identified as monsters, from the facade of the Ospedale di San Martino in Florence (now lost), c.1317.

Petrarch, as a child, had seen another (now lost) image of the same boy. "Some friends in Florence sent a picture [of the child] to us in France, where we were staying," the poet vividly recalled,

> and a huge crowd of people came just to see it. I was seven years old when I saw the image in the hands of my father. When I asked what it was, he told me, showing it to me, and ordered me to remember it.

Equally peculiar was the location of the 1536 dissection—"in the garden of Palla Rucellai," as opposed to in a hospital (San Martino alla Scala was just across the street), suggesting that there was something covert about this operation from the start. Indeed, Varchi does not disclose the source of the specimen, offering up only that it was "born at the Prato gate," the Porta al Prato, practically in the backyard of the Orti Oricellari. Might its "certain purplish skin" allude to Rucellai blood, to Palla's seed mis-sown? Was this, then, an illicit birth—damned and, thus, to be destroyed? The scavenger-anatomists put the monstrous infant on private display in the garden, visually devoured it, and then mutilated it:

[Inside] they found two hearts, two livers, & two lungs, & finally everything was doubled, just as for two bodies, but the windpipes, which began at the hearts, joined up near the entrance to the throat & became one: inside the body there were no divisions, but the ribs of one stuck to the ribs of the other all the way to the pit of the stomach, & from there down it served both of their lower backs.

In this description of the body's interior, Varchi uses slightly more specialized, dispassionate language. Still, if this is his clinical impression, what boggles the modern mind most is the sixteenth-century classification and characterization of what we would objectively identify as conjoined female twins. "Monsters," Varchi concluded before the Florentine Academy, are "filthy and wicked things," "errors and sins" that are "produced by Fortune & by chance." Finally, it is not known what became of the anatomized malignancy, whether its parts were tossed in the Arno, shelved under bell jars, or buried in the garden.

Before too long, however, misfortune would once again rear its ugly head. In 1573, new financial hardships forced the Rucellai to sell the Orti Oricellari to Bianca Cappello, the Venetian noblewoman who was for 14 years mistress to Francesco I de' Medici and later his second wife. In the year of their marriage, 1578, the grand duke and his consort threw a party in the garden; guests of the alternative court had no idea what they were in for. The first act featured a bizarre necromancer, who wore on his head a miter decorated with five-pointed stars. Walking in slow, solemn steps, this knife-wielding sorcerer inscribed a large circle onto the lawn and carved within it all sorts of magic symbols. Accompanying this mysterious master of ceremonies was a group of assistants, dressed as devils, to whom he had assigned nonsensical names. An eerie glow of charcoal bonfires illuminated the early-morning antics, which crescendoed around 1:30 a.m. as the wizard threw a fetid concoction of tar and sulfur onto the flailing flames. The resultant stench, unbearable to the point that guests had to stuff their nostrils, diffused throughout the garden. One by one, the senses of the distressed celebrants were attacked. As putrid air continued to circulate, the garden was suddenly filled with the sounds of infinite voices and laments, strange howls and frightful rumblings, as though the whole world were caving in; teeth-gnashing, hand-clapping, and chain-rattling rounded out the cacophony. With his audience now perfectly discombobulated, the unrelenting necromancer next set off a mine, the explosion causing the earth to open up,

to swallow whole the colluding duke and his writhing victims. Bodies, one on top of another, plunged into what appeared to be the bowels of Hell, its prisoners unsure if they were dead or alive. At this point, seemingly of no return, the second act ensued. From within the torture pit there appeared a group of graceful young women, perfumed from head to toe and entirely nude under golden mantles which were studded with pearls, diamonds, rubies, sapphires, and emeralds. These preciously encrusted escorts quickly led the party out of the diabolical labyrinth and up to a freshly scented terrace that had been prepared for a sumptuous feast. A final thunderous roar expelled the devils from the garden, to everyone's relief, before a melodious concert of madrigals commenced and continued into the wee hours, turning this nightmare into a dream.

Following the sadistic hosts' unexpected deaths, less than a day apart, in 1587, caused by either malaria or poison—the jury remains out—the property

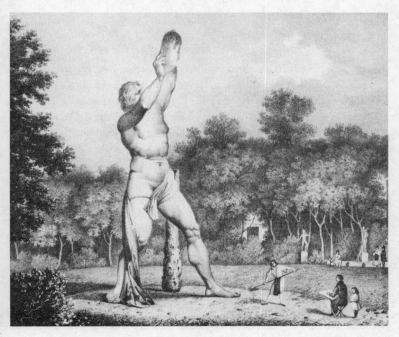

Figure 21. In this lithograph of 1832, the seventeenth-century colossus of Polyphemus looms over nineteenth-century garden idlers in the Orti Oricellari.

changed hands several times before passing once again, in 1640, to the Medici family. Under the ownership of Gian Carlo, the epicurean second son of Grand Duke Cosimo II, who much preferred gambling, hunting, and female companionship to the asceticism required of a cardinal, an unsolicited office to which he would ascend in 1644, the Orti Oricellari became the setting for bacchanalian orgies and general debauchery. The centerpiece for the cardinal's sexcapades was an enormous statue of Polyphemus guzzling from a wineskin; everything about this drunken Cyclops, carved by Antonio Novelli and measuring more than 27 feet high, speaks of excess, abandon, alterity—everything the Orti had enabled from its inception.

In sum, over the course of 150 years, the suburban plot on the road to Prato, always a liminal space, had been repurposed from a leprosy hospital to a retreat for intellectual convalescence to a breeding ground for moral ill and mischief. Meanwhile, Palazzo Rucellai was undergoing a transmutation of its own.

A ROOM OF ONE'S OWN

If open space can be said to foster idleness, is architecture, by contrast, conducive to discipline? How might an edifice, closed and vertical, direct its occupants? Can a floor plan be read as a manual for human behavior? Might a building's coordinates serve as a moral compass? Palazzo Rucellai is an urban residence, centered and, to some degree, centering. Standing in the middle of a congested city block on the corner of Via della Vigna Nuova and Via dei Palchetti, the palace is at once a neighborhood landmark and an aloof neighbor rising head and shoulders above the crowd. But are its inhabitants, too, merely by association, elevated? Precisely what does this structure provide to those ensconced within its partitioned shell? Do its collective cavities and parietes regulate the body, or safeguard it? What happens, then, when architecture's manufactured interior is further subdivided, reconfigured, parceled out?

Bernardo had long known, at least from the age of 17, that he would one day inherit a share of his father's house. Giovanni's will of 1465 had made this much perfectly clear: Palazzo Rucellai was never to leave his paternal lineage (typical practice was to bequeath a palace to one's direct descendants and, thereafter, to those branches closest to the deceased's own line), and it was never to be abandoned or even rented. Should the clan become extinct, the palace was to pass to the commune—to be used solely as the residence of an ambassador or

a foreign prince. (Alberti, too, would bequeath his share of the family palace to his male relatives—after a long legal battle, he finally acquired, four years before his death at the age of 68, half of his grandfather's palazzo on Via de' Benci—but in the event of the extinction of the line, the palace was to pass to Ospedale di Santa Maria Nuova, Alberti clearly envisioning a less pompous future for his home than Rucellai had anticipated for his.) Under no circumstances, Giovanni insisted, was the house ever to be inhabited by anyone of Florentine birth. In sum, Palazzo Rucellai, by Giovanni's own ordinance, was inalienable, but it was *not* indivisible.

Still, the palace complex was not legally and physically divided until 1492, a full decade after Giovanni's death. Given that the division of an estate inevitably resulted in the disintegration, gradual or otherwise, of the patrimony, the decision to delay was not unusual. Moreover, from a legal standpoint, property could not be split until the youngest son had come of age. But in the case of the Rucellai brothers, aged 45 and 33 at the time of their father's death, the reasons for postponing the process probably had more to do with matters of lifestyle than of litigation: Pandolfo, widowed, was busy raising six minors and counting the days until he could join Savonarola at San Marco; Bernardo, withdrawn, was preoccupied with cultivating the Orti Oricellari. Neither party, it seemed, was in a hurry to assume ownership of his share of Palazzo Rucellai.

Eventually, however, the palace that Giovanni built, town house by humble town house, was, much like Palla Rucellai's "monster" or the medieval knight's reluctant bride, ripped apart and reapportioned. Pandolfo, the elder male heir, received "the large house, that is, court with loggia, stables, and cellar and whatsoever is built over it along its breadth and height." Bernardo, the spare, was assigned "the small house," according to the notarial record, "which was bought by the said late Giovanni their father from [the heirs of] Iacopo Antonio Rucellai [in 1458]"; he was also compensated 750 florins for having received the short end of the stick. To elaborate, Pandolfo was handed the original palace—everything that lay behind Alberti's five-bay, triple-elevation, single-entrance facade; Bernardo, instead, was allotted the adjacent town house—complete with disjointed interior and unauthorized facade extension. Who, then, could blame him for walking away, for giving up his portion to his widowed sister Marietta in the early 1490s? Bernardo's abdication was only temporary, however; records indicate that upon his return from exile in 1511, having been ousted—politically and philosophically—from the Orti, he finally made the house his home. But

Pandolfo, who had received the lion's share of the palace, permanently bestowed property rights to his only son, Paolo, in 1494, forfeiting "the large house" for a monastic cell.

If the first division seemed more or less cut-and-dry, based as it was on the party wall between the original structure and the later acquisition, a second division, in 1531, was akin to avulsion. For the majority of the sixteenth century, the smaller portion passed in an orderly fashion from one eldest son to the next. But the rules of primogeniture were not upheld upon Paolo's death, prompting Pandolfo's four grandsons to divvy up the larger portion rapaciously, butchering it to suit their own wants and needs. One pair of brothers, Giovanni and Pandolfo, received half of the *volta*, or basement; a ground-floor storage room at the rear of the property and the western half of the stable; the small *camera* with a mezzanine-level *studiolo* located in the front corner of the house; the entire *piano nobile*; and the western side of the *altana*, the open-air roof terrace. The second pair of brothers, Filippo and Lionardo, were given the remainder of the larger portion of the palace, which included half of the *volta*; half of the stable; the *camera terrena grande* to the right of the *androne*, or entrance hallway; all of the rooms above the *piano nobile*; and the eastern half of the terrace. The cortile, with its well and decorative emblems, the loggia, the facade portal and side entrance, and the main stairway were deemed common property. One can only imagine the transmutations that took place when the paired brothers subdivided their shared spaces—building up partitions, sealing openings, cordoning off turf. In light of the fact that everyone was fighting for a piece of the palace, the term *housekeeping* takes on a whole new meaning.

But back to Bernardo. When the headstrong 63-year-old finally laid claim to his share of his father's house, he did so on his own terms. Fresh from his self-imposed exile, fueled by the Medici restoration, the heir aberrant resettled in the center of Florence, making Palazzo Rucellai his new political platform. In 1512, for example, when news of Giovanni de' Medici's election to the papacy reached Florence, some of the most spectacular celebrations were held on Via della Vigna Nuova, "at the house of Bernardo Rucellai." Against a backdrop of fireworks, a contemporary diarist records, "pouches full of money" were thrown from the windows to the crowd below, along with "caps and hats, cloaks, gowns, and other garments." In the middle of the street, in front of Palazzo Rucellai, morning and night, there was "bread for the taking" and "casks full of wine, white and red." Citizens "went there with flasks or pitchers or jugs and dove in

[...] it was such a magnificent party that all of Florence was drunk with joy." The celebration marked an aristocratic homecoming on two fronts: the Medici were back in power, and Bernardo was back in the palazzo—neither as son nor as "brother," but as patriarch in his own right. Alas, his rule would be short-lived: Bernardo died just two years later, in 1514.

Terzo Piano

*Everyone sees what you appear to be, but
few really know what you are.*

Niccolò Machiavelli, *The Prince*

I continued to see my own Lorenzo "il Magnifico," though we rarely met in Florence. Instead, I'd take the second-class regional train over to Pisa, then down the coast to his winery, from where, usually after a bubbly lunch alfresco, we'd depart, flying as far from Italy as his turboprop could take us: Dubrovnik, Paris, Vienna, and innumerable points in between. For the Grand Renaissance Commander—yes, that was its actual model name—required no more than a 3,000-foot landing strip, or, as Lorenzo called it, a "runaway."

Indeed, I'd spent the majority of the fall semester running away with him on short notice—and my passport had the hastily made impressions to prove it. Mauve and gray smudges from over-inked stamps, haphazardly hammered down, quickly accumulated on the once-spare light blue government pages, paying no mind to delineated boundaries, blotting out any trace of my former life as a commercial flier. I had other travel trophies, too, these of shiny brass and nickel: kuna, forints, and lei. I kept the foreign coins in little felt pouches from Prada and Gucci that had once held extra buttons and care instruction

cards—I'd been spending what was left of my stipend on clothes and accessories more suitable for palace life.

For Palazzo Rucellai had finally acknowledged my presence, albeit in fickle ways. The house was often indulgent, coaxing me into the courtyard on silent nights, enticing me to run my hands over its girdled columns; other times, it was decidedly uncharitable. One Sunday afternoon, returning home after a lazy lunch at Trattoria Cammillo, my key broke as I was extracting it from the lock of the second set of entry doors. Knowing I'd be going out that evening, I propped open the uncooperative threshold with a brick. When Niko got home, and read the explanation I'd left for him, his reprimand made even the house shake. He threatened to report my breaking of House Rule No. 1 to the contessa but, upon realizing that he, too, would have hell to pay, settled on a firm finger wag and a gruff retreat into his alcove.

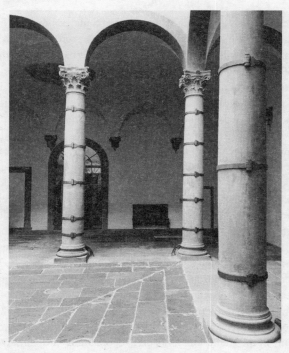

Figure 22. In a restoration campaign of the twentieth century, metal girdles were wrapped around the monoliths of the courtyard. The effect is both penitentiary and sensual.

Figuring I ought to lie low for a while, I tried to refocus on my research. It was bad enough that I'd deserted my tomb project altogether; but the fact that I'd taken a hiatus from my house homework was starting to gnaw at me. My cherished library visits had grown few and far between, and I wasn't the only one to notice. At the bar in Piazza San Marco, where I'd regularly down a cappuccino before heading up to I Tatti, the barista asked if I'd been in the US; and in the reading room, I noticed on my first day back, my Wi-Fi password had expired a month earlier. At the Kunsthistorisches Institut, my unofficial locker had been taken over by an eager graduate student, and my *tessera* glared with more blank squares than stamped ones. I'd missed several lectures at Villa La Pietra, and half a dozen email requests for letters of recommendation from my students had gone unanswered. I was determined to get back on track.

Soon enough, however, I found myself newly distracted.

On the occasion of my upcoming birthday and to commemorate my "Florentine period," the marchese commissioned a portrait of his professor. Having spent the first half of November plotting, I was finally ready to sit for my portrait. On the face of it, donning "royal purple," given my address, seemed apropos; but where, at the dawn of the twenty-first century, could I possibly find a garment dyed with *oricella*? Instead, I decided, as a specialist of widow portraiture, I should wear black, a subtle nod to the academic life I'd somehow ended up putting on hold and was slowly letting bleed out.

The painter was an American expat, approximately my age, who'd established himself in Florence 15 years earlier. His passion was *plein-air* landscape, but he earned a living by making his noble patrons appear "noble." His studio was located in Piazzale Donatello, just north of the old English Cemetery, about a 30-minute walk across the *centro* from Palazzo Rucellai. Developed following the Risorgimento, when Florence briefly became capital of the new Kingdom of Italy, the streets in this Romantic neighborhood are named for either freedom fighters or Renaissance artists popular in the nineteenth century: Via Sandro Botticelli, Via Leonardo da Vinci, Via Masaccio, Via dei della Robbia, Via Giambologna, Via Andrea del Castagno, and so on.

Initially, I enjoyed my mornings there immensely. But the excitement of posing soon waned as the process dragged on, and genuine melancholia set in. Sitting stiffly in the studio for weeks on end, breathing in the heady fumes of linseed oil and turpentine, I thought at length about the art of painting, about subjects, about surfaces: which self was I projecting? And which was I concealing?

As I sat in my Prada weeds, I couldn't help but think of Virginie Gautreau, the eccentric widow from my native city who, through John Singer Sargent's "scandalous" gaze of 1884, had become *Madame X*. What, midway through this sabbatical, had *I* become? A blank slate, a black hole, *Professoressa X*?

And what did Lorenzo want with a portrait of a professor anyway? Though my surname outdated his by millennia, I couldn't see him hanging my image on one of his walls—an academic among the aristocrats? But then again, as much as Lorenzo prided himself on his portrait collection, it probably could use an original. Historically, non-partible inheritance law, still the norm among the Florentine nobility, kept the contents of a palace in place. By this practice, Lorenzo's picture gallery likely consisted of copies of paintings inherited by his brother. Perhaps, then, the presence of an art historian would help to authenticate Lorenzo's art collection. Yet aside from that, what would this patrician gain by grafting an American professor onto his rootstock? I began to wonder if Lorenzo's generous commission was less a validation of me than of himself.

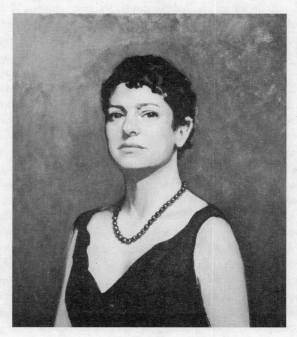

Figure 23. Portrait of the author, 2007.

The painter usually put down his brushes around 12:30 p.m., signaling the end of the session, at which point I'd change out of one costume and back into the one I'd arrived in, before walking around the easel to face the picture I was becoming, a fraught encounter that inevitably ended with me standing down. Whatever the real source of my discomfort, I was quick to blame my hasty retreat on a need to stretch my legs. And, truth be told, I always took the long way home.

Of course, doing so in Florence demands a concerted effort, for the *centro* measures no more than two miles from top to bottom, or from side to side. Upon leaving the studio in the northern quadrant, I was fond of swinging east, hitting as many *piazze* as I could—d'Azeglio, Sant'Ambrogio, Ciompi—before heading west toward the swarming Piazza della Signoria or the equally chaotic Piazzale degli Uffizi. The smaller squares hosted markets once or twice a week and attracted locals looking for fresh flowers, produce, or cotton underwear. By contrast, the landmark piazzas offered, at any given time, imitation Gucci, Fendi, and Louis Vuitton handbags.

One afternoon, having reached Piazza della Signoria famished, I picked up a panino from Rivoire and headed to the Loggia dei Lanzi, to share a space with Cellini's *Perseus*. I struck a *contrapposto* pose and, lunch in hand, began to survey the street theater unfolding below: African hustlers hawking fake merchandise manufactured in Prato by Chinese immigrants, their counterfeit goods, laid out on white sheets, bundled up and scurried away at the first whiff of approaching carabinieri. What fascinated me most about this circular act of unfurling and absconding was not the frequency or spontaneity with which it occurred, but *where* it occurred—the mise en scène: the city as showroom, its streets as runway, its buildings as backdrop. For it was clear to me that the architecture of Florence validated the knockoffs, endowing the inauthentic with history, with gravitas, with bona fide Italian style. Until the whistle-blowing began, that is, warning signals between sellers which triggered stampedes out of open spaces and into dark alleys, behind and between the very buildings that served to legitimize the fraudulent. In this regard, I myself understood well the efficacy of architecture.

In need of an afternoon pick-me-up, I stopped at the *enoteca* on my way home. Francesco, as I'd come to expect, was all business, preparing place settings and pouring spumante for the *uomini d'affari*, lawyers and bankers for the most part, who'd colonized my bar. I took a seat at the far end and, fueled by Francesco's healthy pour, turned my gaze toward the *belli ragazzi* clamoring and gesticulating frenetically at my side—spitting images of their Renaissance ancestors. My anachronistic eye focused on the strawberry-blond sideburn of Raphael's *Bindo*

Altoviti, the edgy five o'clock shadow of Antonello da Messina's *Man in a Red Cap*, and the bee-stung pucker of Pontormo's *Halberdier*. The only thing missing on these descendants, I decided, were two-toned tights and padded codpieces. Still, they sported their own inflated accessories: bloated wristwatches worn over shirt cuffs, big-knot ties throbbing at the neck, gilt-framed sunglasses unfolding from a foulard-stuffed chest pocket—fetishes all! Perhaps not surprisingly, the effervescence of my spumante-induced voyeurism fizzled prematurely, drowned out by the din of these contemporary Florentines, not to mention Francesco's midday indifference.

For months now, I'd kept my affair with Lorenzo under wraps, above all from Francesco; it was crystal clear, if unspoken, that discretion reigned supreme in this house. I'd spotted Lorenzo's brother once or twice, entertaining clients on the mezzanine, but I hadn't seen the black sheep since November. The patron of my portrait had been on the slopes in Gstaad for most of its creation; but we'd see each other soon, he promised.

A week later, as per Lorenzo's instructions, I took a taxi to Florence airport and asked to be dropped off at General Aviation. Once inside the hangar, I picked up a phone mounted to the wall and spoke the tail number. Within a few minutes, a minivan arrived and zipped me across the tarmac to Lorenzo's chariot. He was already on board, as was his seven-year-old daughter, Fiammetta. The surprise was mutual: she didn't know that her *Papà* had a new friend; I hadn't realized that his hunting trip would be a family affair. A niece arrived shortly thereafter, along with a cousin from Milan. And then we were off.

The plane landed in Oradea, in present-day western Romania. I wasn't expecting to see a familiar face in that part of the world, but there was Kamal, waiting for us on the other side of the customs counter. He and another man loaded our cargo—a veritable mound of duffel bags, ice chests, and weaponry—into a pickup truck and then handed the Land Rover keys to Lorenzo. We drove in convoy across the border, heading toward the Puszta, the Great Hungarian Plain. The journey, over a bleak expanse dotted with defunct military bunkers, took just under an hour; though, to me, time stood still in what seemed the last surviving parcel of a lost empire.

"I named the compound Mon Rêve," Lorenzo told me as we approached the gate.

I wondered just how many dreams he had. This property was unlike anything I'd ever seen; but then again, I'd had the same reaction to Ariabella, his

estate in Tuscany. The rules of primogeniture may not have worked in his favor, I thought, but the youngest son clearly had the means to piece together his idea of a respectable patrimony. Hence Lorenzo's vast real estate holdings all over the world—his way, I gathered, of making up for the loss of the Florentine properties.

Mon Rêve was a new acquisition, and Lorenzo delighted in telling its history. Until 1989, the 100-acre estate had belonged to a leader of the Hungarian Socialist Workers' Party; his shooting range was still intact. We passed a thatched-roof guesthouse and numerous barns, separated by wide tracts of barren land. And then emerged, against a palette of hard mud and dry wheat, the main house, its exterior walls painted a warm and welcoming shade of scrambled-egg yellow. The contrast didn't stop there. Inside, the rooms had been outfitted with English furniture and fabrics from Nina Campbell, Colefax and Fowler, and George Smith; the walls were hung with nineteenth-century Russian landscapes. The house was also teeming with people: a staff of four, including Kamal and Elisabetta, had come from Italy to supplement the local husband-and-wife team. There was also a twentysomething nanny from California; her charge, however, had other ideas. And then there were more guests, cousins who'd arrived beforehand and were by now thoroughly soaked with Zwack liqueur.

Kamal showed me to my room and offered to unpack my bags, but I politely declined. I needed some time to myself to process my whereabouts. Just as I'd started to run a hot bath, Lorenzo burst in. "*PRO·FES·SOR,*" he said suggestively, "I'm having a fantasy: would you do a little homework with Fiammetta before dinner? She likes you very much—she told me so on the plane—she thinks you're 'cozy'!"

This wasn't the fantasy I'd been expecting. Nonetheless, I said yes, of course.

"And would you come to my room later tonight? I could use some help with my email."

Again, I agreed, swallowing my weariness.

Fifteen minutes later, I found Fiammetta in the kitchen with Elisabetta; the stand-in *nonna* was loading down *la piccola* with giant carrots. Fiammetta, cute as a button in her full English riding attire, insisted we first visit her horses. As soon as we entered the 12-stall horse barn, I realized there would be no handwriting lesson before dinner.

When we returned to the house, Lorenzo introduced me to the clan, adding, "She comes from a line of *professori*—Russian descent." I was intrigued by this profile. While not incorrect, did my lineage warrant mention at that moment?

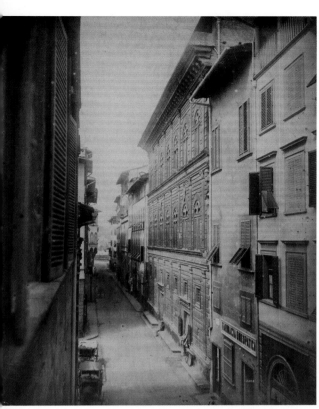

Plate 1. Palazzo Rucellai, *c.*1865, nestled in the middle of the long and narrow Via della Vigna Nuova.

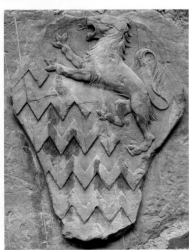

Plate 2. The Rucellai coat of arms: a lion rampant against a horizontal zigzag pattern.

Plate 3. Giovanni Rucellai seated against a backdrop of his most celebrated architectural commissions, all by Leon Battista Alberti.

Plate 4. Giovanni Rucellai's personal emblem: a windblown sail, this stylized example designed by Alberti for his patron's tomb.

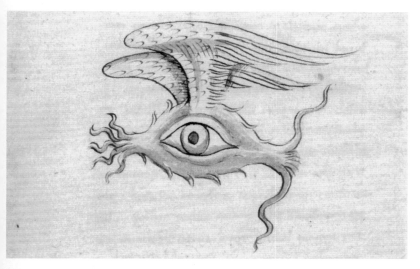

Plate 5. Alberti's personal emblem: an open eye surmounted by a pair of eagle's wings, this autograph drawing dated *c*.1437.

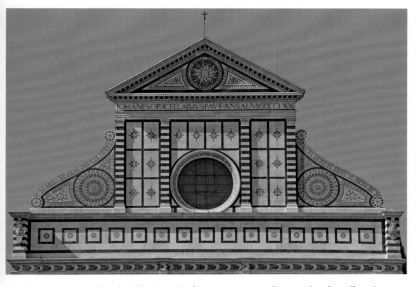

Plate 6. Upper facade of the church of Santa Maria Novella, completed to Alberti's design in 1470, featuring Giovanni Rucellai's name and personal emblem.

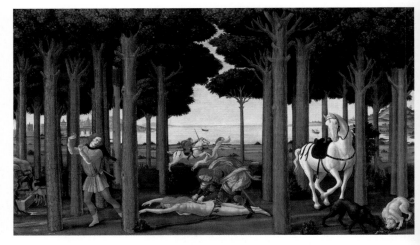

Plate 7. A peculiar wedding gift: Botticelli's 1483 depiction of *The Story of Nastagio degli Onesti*, a gruesome novella from Boccaccio's *Decameron*.

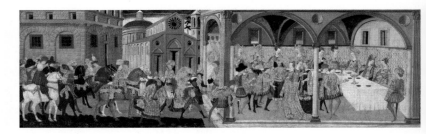

Plate 8. *The Story of Esther*, c.1460–70, ornately painted on a wooden wedding chest, conjures the sumptuous 1466 nuptials of Bernardo Rucellai and Nannina de' Medici in Piazza Rucellai.

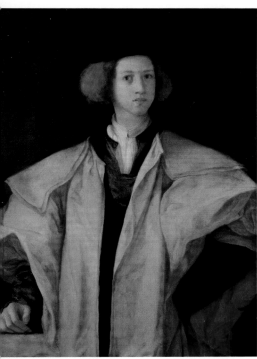

Plate 9.
In Pontormo's *c.*1525 *Portrait of a Youth in a Pink Cloak*, a frizzy-haired fop is all but smothered by his overlarge rose-colored coat.

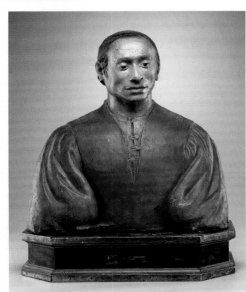

Plate 10.
Portrait bust of a bloodred-clad Palla Rucellai, *c.*1506, 30 years before he played host to the dissection of a "monster" in the family garden

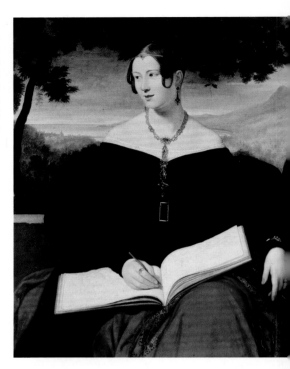

Plate 11. Marianna Rucellai on the eve of her marriage in 1836: the 20-year-old heavily jeweled bride wears an off-the-shoulder black velvet gown overlaid with a red Persian shawl.

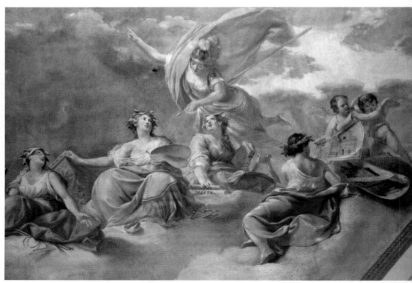

Plate 12. Mnemosyne, mother of the muses, floats with four of her daughters high above the *piano nobile*, painted on the occasion of an eighteenth-century wedding in the house.

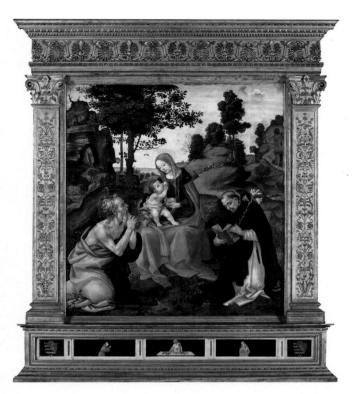

Plate 13. Filippino Lippi's *Virgin and Child with Saints Jerome and Dominic*, c.1485, sold by the Rucellai family to the National Gallery, London in 1857.

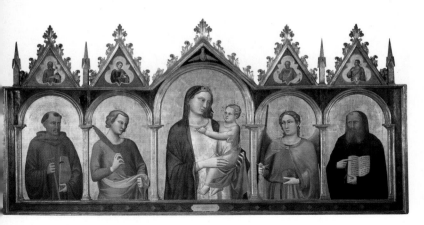

Plate 14. *Madonna and Child with Saints*, c.1340, remained in the Rucellai enclave for nearly 560 years; it was eventually acquired, in 1932, by the American collector Samuel H. Kress.

Plate 15.
Delaney, abbi pazienza (*Delaney, Be Patient!*), a *giallo* from the Mondadori crime fiction series, published January 1955, 42 years before Alvise di Robilant was murdered in Palazzo Rucellai.

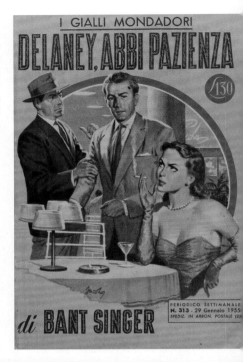

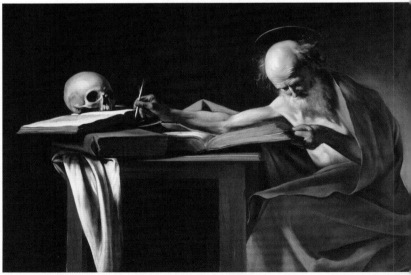

Plate 16. In Caravaggio's dramatic rendering of a crimson-cloaked Jerome, the Rucellai patron saint's outstretched arm directs our gaze toward a glowing skull, a vivid reminder of death ever-looming.

Long after everyone else had gone to bed, I tapped on Lorenzo's door. He was waiting for me, laptop in hand. I walked in and looked around. His room was Habsburgian in nearly every way: gilded wisps of stucco waltzed over ivory-colored walls; a collection of tiny silver snuffboxes sat upon a bedside table, assembled like an audience; and in the center of the room, muted gold satin cascaded from an oversized mahogany canopy. The fox-fur blanket spread across the bed—and a grab bag of massage oils from Thailand—betrayed just enough 1970s kink to confirm that I'd entered Lorenzo's bedroom and not an imperial throne room.

"We're going to start locking this door during the off-season. Khalid thinks the gardeners take turns sleeping in my bed."

I bit my tongue and sat down with Lorenzo's laptop. Looking over his earlier exchanges, I noticed that he used no punctuation whatsoever. When I suggested inserting a few periods, he was taken aback. "Don't you think that's a bit extreme?"

"No," I assured him. "It's the rule."

"Do you always follow the rules, Professor?"

"Not lately," I answered.

Lorenzo laughed approvingly and invited me to join him atop the fox. He handed me a shallow box, about two inches square, covered in gray pinstripe paper. The inside of the lid was stamped HALDER—REITSCHULGASSE 4, 1010 WIEN. I removed a fluffy cotton square to reveal an exquisite silver and gold circle brooch. A five-point crown was mounted on the upper curve and the lower was engraved MON RÊVE. A pheasant in flight, Lorenzo's coat of arms, and a leaping roebuck filled the round field.

"It's to welcome you to Hungary."

"I don't know what to say."

"Don't say anything, darling; just relax." He dimmed the light. "Oh, if Fiammetta walks in, say you were sick—tell her I cured you."

Immediately after breakfast on the second day, Lorenzo and his entourage left for a midmorning hunt, while Fiammetta and I, wrapped in wool blankets, were taken on a horse and carriage ride to the neighboring village. Her favorite color was green, I learned; she loved licorice and marzipan; and she missed her mother and half-sisters—but I wasn't to tell her father.

The party reconvened for a hearty lunch of wild boar and, courtesy of the local caretaker, a traditional goulash. Just enough of Lorenzo's fleshy Bordeaux-style blend had been poured to set the mood for a lazy afternoon. There were bicycle

rides up and down the drive, long walks with Rhodesian ridgebacks named after Eastern European rivers—Danubio, Tisza, Rába—and a planning session for the dacha that would eventually be built behind the main house.

A late-afternoon hunt had left the estate pretty much empty. I watched Fiammetta trot in circles for about an hour and then, when the flurries began to stick, lured her back to the house with the promise of hot chocolate. Once inside, I suggested we read a book together, but she preferred to use the quiet time to call home. Just as I, too, was beginning to miss Florence, the Italian staff cut through the living room, carrying champagne bottles and silver trays crowded with crystal flutes. "*Marchese è ritornato!*"

Fiammetta ran ahead; I followed her out the door and onto the front lawn. The sight was astounding. Against a black sky, flashlights shone down upon a smorgasbord of fresh kill. Hungarian men, having tossed aside a fox or two, scrambled to assemble three fallow deer into a neat line, straightening trophies and stuffing oak leaves into gaping mouths. Lorenzo and his cousins walked back and forth, ranking the bounty. In the mix was a perruque deer head, the grotesque antler formation, I was told, an auspicious sign. Indeed, the hunt had been a success: one gold medal and possibly a bronze. Just as the entire group was ready to toast, Lorenzo leaped toward me, ripping the glass from my right hand and shoving it into my left. The learning curve, I now realized, would be steeper than I had supposed.

That night at dinner, I sat quietly, fingering the brooch on my lapel between courses.

"You look spaced-out, Professor."

"Sorry. I was just admiring that landscape."

"It's a Ruisdael. You should know that."

That's when I focused my gaze. Though not a specialist of seventeenth-century Dutch art, my otherwise trained eye told me there was something wrong with Lorenzo's attribution; the painting in front of me simply didn't look old enough to be an old master. But I kept my opinions to myself.

— CHAPTER FOUR —

The Suicide Bride

*Because we are linked by blood
and blood is memory without language.*

Joyce Carol Oates, *I Lock My Door Upon Myself*

GIVE UP THE GHOST

Palazzo Rucellai, some believe, is haunted. And the chief of its ghosts is Bianca, an eighteenth-century Rucellai daughter, who, unwilling to go through with an arranged marriage, took a plunge of a different sort, hurling herself into Alberti's pristine courtyard on the eve of her wedding. But if there are skeletons in the closet of this great house, they are almost certainly also our own. For this popular story of the suicide bride offers up an opportunity to reflect upon the place of Palazzo Rucellai, oscillating somewhere between myth and history, during the so-called Age of Reason as well as the present day.

Western attitudes toward suicide have changed dramatically since Socrates ingested hemlock, or Lucretia thrust a dagger into her breast, two self-inflicted deaths deemed patriotic and virtuous by the ancient Greeks and Romans. This tolerance of suicide, even admiration, eventually gave way to condemnation by

the early Christians. Saint Augustine, for example, considered the act of taking one's life a cardinal sin, an ecclesiastical crime to be punished. Offenders were denied a Christian burial, their property confiscated, their corpses desecrated. During the medieval and early modern periods, suicide came to be associated with diabolical temptation and possession. But by the late eighteenth century, voluntary death was decriminalized and increasingly approached from a secular, medical perspective, aligned with social or mental ills—cultural pressure or psychomachia. Where, then, does Bianca fall within this trajectory?

If only she had left a note, or there was an *X* marking the spot. But the spirit of Palazzo Rucellai left no such trail. The plaster has been repeatedly whitewashed; any nicks or chips to the sandstone incurred by bodily collision are by now indistinguishable from other surface scars.

There may be no discernable trace of Bianca, yet she is hardly a lost soul. Having assumed a popular presence within the household, this specter of the *longue durée* has come to serve as a convenient excuse whenever things go wrong

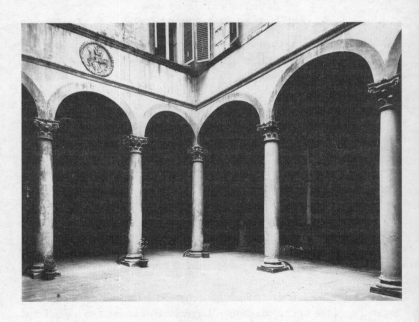

Figure 24. In this vintage photograph of the courtyard, *c*.1920–30, diminutive flowering plants placed at the bases of the columns set an elegiac tone.

or objects go missing. But I prefer to see her as a metaphor for the void—or, rather, lull—of that endless eighteenth century on Via della Vigna Nuova, a prolonged period of settling in.

GUT

Whether or not we choose to see through Bianca, the house is most certainly haunted, at least in the oldest sense of the word. *Haunt* was not used in relation to ghosts until the end of the sixteenth century, as in Shakespeare's *A Midsummer Night's Dream*: "O monstrous! O strange! We are haunted. Pray, masters! Fly, masters! Help!" Prior to this usage, the word *haunt* simply meant to use something or visit someone frequently, to occupy a place habitually. Thus, a haunted house was not necessarily a frightening place. As Freud observed in his essay "The Uncanny," the antithetical word *heimlich* meant, on the one hand, "homely" or "familiar" and, on the other hand, "unhomely" or "unfamiliar" —"haunted." Yet this split meaning could also fold into itself, collapse, rattle one's very comfort zone.

Which brings us back to Palazzo Rucellai, site of said fall. What course, exactly, did Bianca's downward spiral take? In other words, what structured her decision to succumb, to throw herself out of a window and into a courtyard? We cannot pretend to know her inner demons, but we *can* peer inside her haunt, to experience for ourselves the order and chaos that shaped the waking nightmare of this felo-de-se.

Before exploring the eighteenth-century viscera of the building, let us look, once again, at its veil, which, a century earlier, had finally slipped. In 1654, the descendants of Giovanni Rucellai at long last acquired, after 173 years, the adjacent town house on Via della Vigna Nuova that their cousins had held out from selling. But once the long-coveted property was purchased, the new owners made no attempt to extend Alberti's facade over the plain plaster front of the medieval town house next door, despite its comparatively uneven roofline and off-kilter windows. Instead, the family marked their territory by adding a discreet coat of arms to a raw wall that, like a flayed Marsyas, brings us one plane closer to the conceit of our subject.

The placement of this heraldic symbol, which resembles a full stop, may have finally established a *terminus ad quem* for Giovanni's palace complex, but it also punctuated the jagged edge of the unfinished facade. That serrated line

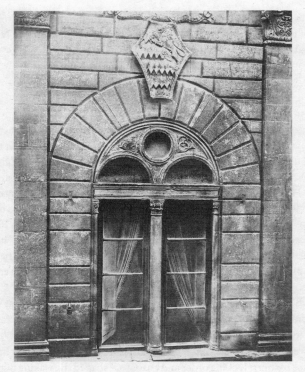

Figure 25. An upper-floor window and the Rucellai coat of arms, c.1890.

surely must have been an embarrassment in the late fifteenth century, a glaring reminder of the family's dramatic financial decline. But centuries later, this tear on the surface would still taunt—or, rather, barb—as Giovanni's descendants, for the most part, left the 1654 portion of the palace alone.

Feeling too vulnerable, perhaps, without a veneer, the next generation turned their attention back to the original compound, literally boxing themselves in and holing up behind the portions of the palace that *did* boast a facade (the loggia across the street they had walled up as early as 1677; it would not be reopened until the 1960s). Yet if their "improvements" were designed to quell any anxiety of overexposure, an archivist's description of Palazzo Rucellai, drafted sometime between 1722 and 1734, suggests a dark and tortured interior more than a center of enlightenment:

Giovanni di Paolo di Messer Paolo Rucellai constructed a palace by combining his existing house with some others. Some say that the original design, drawn up by the most famous Leon Battista Alberti, called for eleven windows and three doors, or fourteen windows and four doors. Only seven windows and two doors were completed, and an eighth window was begun; however, the design of the built structure is uniform from foundation to cornice.

This palace description will begin with the portion presently owned by Signore Paolo Benedetto Rucellai. Beyond having a nice internal loggia and courtyard, this portion has a good stone stairway, which leads from the ground floor to the first floor and from there to the second via a similar pair of ramps. On the first floor, there is a bright reception room with five windows facing the street, two good-sized bedrooms, and a dressing room. From the reception room, one passes to the kitchen by way of a gallery. On this floor, there is nothing more. Signore Paolo Benedetto walled in this gallery [...] and enlarged the aforementioned dressing room.

The other portion of the palace built by Giovanni, which has only two windows and one door, contains the second stairway, which, uncovered, is old-fashioned; it climbs only as far as the first floor, where, to the right of a short hallway stemming from the stairhead, one finds a living room. From there, one passes into a very large and beautiful bedroom, which has two windows facing onto the piazza below. Returning to the stairway, there is to the left of the stairhead another room, which has a ceiling of thin beams rather than of rush matting. This room, as far as one can tell, seems to have served as a dining room, as it has a fireplace and certain exit doors that lead to the kitchen on the other side of the palace. Given that this portion had a shortage of rooms, no kitchen of its own, and inadequate stairs, its two owners [Abbate Filippo and his brother, Signore Francesco Maria] decided to add those comforts that were lacking. And so they built a mezzanine on the first floor. In the lower half, they added a kitchen; and the upper half they divided into two rooms. In one of those rooms, Abbate Filippo built a little alcove, which is as yet unfinished. The brothers also divided the large and beautiful bedroom at the front of the house with windows onto the piazza into two parts [...] and on the half that faces the street, [there, too,] they built a mezzanine, which receives some light from the oculi at the top of the windows. A little wooden ladder, about an arm's length wide, is used to reach this mezzanine; and from

there, in order to access the second floor, another wooden ladder leads to a trap door, which they created by breaking through the floor above. As of today, this is the layout. The floors, from the ground floor up to the second, are all level.

All of the rooms on the second floor, on both sides of the palace, are uninhabitable and without wall plaster. The second-floor rooms of the original portion are poorly framed up, but the situation is even worse in the smaller portion, where the hard-to-access top floor was simply neglected.

By this account, walls went up, walls came down. Entire floors were added; others were perforated; some rooms were deemed "uninhabitable." The *piano nobile*, it appears, bore the brunt of the damage—twice over. For the mezzanine floor added by brothers Abbate Filippo and Francesco Maria was eventually taken away, likely as early as 1743, when their nephew, Paolo Benedetto's son Giulio, bought the smaller portion and reunited the palace. It was probably during Giulio's tenure that another, similar mezzanine—facing Via della Vigna Nuova and receiving light from the oculi at the top of the biforate windows—was added to the structure; this one, however, bisecting the second floor, hence the third floor of Palazzo Rucellai, inserted just below the existing cornice and still intact today. The palace may have been gutted more than once, but its glory was far from gone. Indeed, the archivist, writing nearly 300 years after its construction, gives Giovanni Rucellai and "the most famous Leon Battista Alberti" top billing, a gesture which no doubt would have pleased both men.

But what became of the material that once filled Giovanni's mnemonic shell? Frescoes and stone carvings, wall fountains and fireplaces tend to remain in place. But not so panel paintings, which can easily be sold or painted over. Still, whoever inherited the Veneziano, the Verrocchio, or the Uccello, to name just a few of Rucellai's choice commissions, must have known better than to part with any one of those Quattrocento gems, regardless of personal taste. But the three birdcages that decorated the *sala principale*? Or the gigantic daybeds and hard walnut benches? Not everyone likes to live with old things, which is exactly what these Renaissance furnishings were in the eighteenth century. And let's face it: would Bianca, if as stylish as her ancestor, have been caught dead in one of Nannina's dated damask gowns adorned with fringe? On second thought, perhaps a hand-me-down trousseau is precisely what drove this suicide bride over the edge—the burden of history; the charge of remembrance; the decision, instead, to forget.

THE SUICIDE BRIDE

Figure 26. A housewares store occupies the loggia, c.1920–30. Showcased in the window of the emporium are silver tureens, tea sets, porcelain figurines, and bomboniere.

LOCI

Forgetting, it must be remembered, is only half of the story. In his treatise *On Memory and Recollection* (*De memoria et reminiscentia*), Aristotle outlines the Greek method for organizing and improving memory, or mnemotechnics: "One should get a starting-point [*arche*]," he says, adding,

> And this is why people are thought sometimes to recollect starting from places [*topoi*]. The reason is that people go quickly from one thing to another, e.g. from milk to white, from white to air, and from this to fluid, from which one remembers autumn, the season one is seeking.

Yet Aristotle's *topoi* were merely "commonplaces," sites without physicality. It was the Romans who would develop a memory system around concrete, rather

than conceptual, places: *loci* were architectural models, mental images of cities, neighborhoods, or buildings, within which information could be distributed, stored, and later recalled. Among the architectural mnemonics, the memory palace was the most common:

> Some place is chosen of the largest possible extent and characterized by the utmost possible variety, such as a spacious house divided into a number of rooms [...] The first thought is placed, as it were, in the forecourt; the second, let us say, in the living-room; the remainder are placed in due order all round the impluvium and entrusted not merely to bedrooms and parlours, but even to the care of statues and the like. This done, as soon as the memory of the facts requires to be revived, all these places are visited in turn and the various deposits are demanded from their custodians, as the sight of each recalls the respective details.

According to Quintilian's instructions, published in his first-century *Institute of Oratory* (*Institutio oratoria*), one must first call to mind a domestic interior. The larger the house, the better—an epic poem, for example, takes up a lot of space. "Facts," in the abbreviated form of letters or words or images, are then "placed" in different rooms, or affixed to decorative objects within those rooms, "statues and the like." Lastly, in order to recollect and recite the housed information, one walks through the rooms in the same sequence as before, picking up the "details," stringing them together, and fleshing out a narrative. In this way, the pieces of the epic poem are, literally, re-membered. But "symbols are highly efficacious," Quintilian cautions, "and one idea suggests another."

During the early modern period, specifically with the invention of movable type, a subtle yet crucial shift occurred: The text was no longer merely stored in the palace; it also structured the palace—and vice versa. In other words, stories were now understood as nothing more or less than stories. And because the advent of the printing press altered the ratio between storytellers and story readers, a new set of instructions was warranted. To this end, a seventeenth-century Venetian text urged readers not to settle for first impressions, or illusions, but to forge ahead, forgetting everything they thought they knew about a work from its preface:

> But those who believe, from the little they have learned there, that they have perfect knowledge of [the story], are like those who arrive before

a royal palace and stop at the door to gaze at its frontispiece; and, after having considered with not a little amazement the height of the roof, the breadth of the site, the refinement of the marble, the detail of the work, the proportion of its parts, and all of that which is seen to be beautiful and elegant in the first encounter, they believe that there is nothing else to see, nor do they attempt to penetrate further inside to see the rooms, the apartments, the porticos, the gardens, and other beautiful things that are enclosed in the bosom of the palace; and if they were to see these things in their beauty and wonder, they would erase from their minds that which they had first admired as beautiful in the frontispiece [...]

But we will introduce the reader to much more in its most secret rooms and we will show him not only all of the rooms and the chambers, one by one, but also the riches they contain and the purpose of each thing that he will see, and, moreover, we will make a gift to him of everything for which he shows a liking.

Thus, only by penetrating *all* of the spaces, including the "most secret rooms," can one fully understand the work and be rewarded—or, possibly, vexed.

"INK-STAINED HANDS"

The Rucellai family archive is locked away, appropriately enough, in the front corner of the original town house, in a small windowless room on the second floor, a room that appeared only in the eighteenth century with the addition of the second mezzanine. Behind an unassuming door, a hulking wooden truss bears down upon long trestle tables scattered with leather-bound tomes and parchment scrolls tied with string; other sheets, untethered, curl on their own. An uninterrupted row of short bookcases, inadequately closed off with wire-mesh doors, lines the walls. Inside those cabinets, dust and pulp: sleeves, folders, and envelopes of yellowed cotton, once ivory, now flocked gray. Birth, marriage, and death certificates cling to shorthand biographical notes; last wills and testaments brood beside inheritance disputes; personal letters and diaries lean tight-lipped against tax ledgers and receipts. On top of the *librerie*, a series of small family portraits runs, like an iconostasis, around the perimeter of the square room—dozens of eyes guarding the patrimony from every direction, from every generation. Yet this romantic repository is precisely that: a work

of historical fiction, a twentieth-century reconstruction of a fractured family archive, an assemblage floating between stories.

The core text in the collection is Giovanni Rucellai's *zibaldone*, his oft-quoted commonplace book, a miscellany begun for his sons in 1457 to which he continued adding over the rest of his life. Most of what we know today about the family—let alone the social world of Renaissance Florence—hinges upon the contents of Giovanni's notebook, a thick, timeworn volume encased in wood and leather, sealed with two gilt trefoil clasps: the ark of Giovanni's covenant.

This illuminating text, in fact, belies a dark history, the impetus for the merchant banker's foray into memoir-writing being the most horrid death imaginable in the fifteenth century: "This book was organized and written by me, Giovanni di Paolo di Messer Paolo Rucellai, Florentine merchant and citizen, [begun] this year, 1457, in San Gimignano, where I have come with my family to flee the plague." Rucellai was not alone in his exodus: "As long as there is plague," wrote Alessandra Strozzi in one of her frank assessments of her own social set, "the well-off people have all left Florence." Rucellai may have separated himself from the pestilence that was ravaging the Arno valley, but, having relocated a mere 30 miles outside of town, he was still living in the shadow of death. Perhaps, though, there was a way to circumvent this threat of erasure.

"It befits a merchant," Alberti imparted, "always to have ink-stained hands." Heeding his architect's cunning advice, Rucellai channeled his talent for meticulous bookkeeping into record keeping of a different sort: He filled his days writing the story of his life. But rather than a classic autobiography, his was a scattering of notes and impressions—from the practical, such as estate inventories and business advice for Pandolfo and Bernardo, to the picayune, such as what he ate for breakfast (figs on 17 July). Still, for someone so keen to leave a road map to his life, he left out a lot.

The menace of the 1457 plague notwithstanding, Rucellai's future looked bright. He was well on his way to becoming the third-richest man in Florence, a gilded crown he would don just a year later; and soon thereafter, his youngest son would wed the granddaughter of Cosimo de' Medici. Thus it was with a celebratory, survivalist tone that he began his *zibaldone*, setting down the history and boosting the future of what he saw as the illustrious house of Rucellai:

> First, it seems to me that I should give you notice of our family, the Rucellai's descent, and of other matters attached to the honor of our house, and worthy of recollection. I find that the first who began and gave

reputation to our family—of riches, state, and marriage alliance—was named Nardo di Giunta d'Alamanno di messere Ferro, around the year of our Lord 1250.

Giovanni's genealogical reconstruction spanned two centuries, from his most remote ancestors to his grandsons—13 generations, to be exact, and a total of 197 names.

Yet his was a carefully pruned family tree. Aside from the names of Nardo's first two wives, no women appear prior to the four wives of Giovanni's grandfather. This systematic omission of women was remedied nearly 20 years later, when, perhaps not surprisingly, the 73-year-old widower (Iacopa had died in 1468) found himself, at the end of his life, in financial ruin, in need of socioeconomic support, in search of memory keepers. And so, in 1476, Rucellai inserted two densely written sheets into his *zibaldone*. In sharp contrast to the first, his second genealogy included the names of 117 women. Impressive, but only to a certain extent, for Rucellai's addendum was limited to those women—his grandmother, mother, wife, and daughters-in-law—who had married *into* the family; it failed to consider sisters and female cousins, women whose marriages literally removed them from the house of Rucellai. Marianna Rucellai de' Bianchi, who married Giuseppe de' Bianchi of Bologna in 1836, was one such sister; in a telling portrait by Giuseppe Bezzuoli, she looks away from the open book on her lap, its pages blank, perhaps a nod to her ancestor Giovanni's erasure of Rucellai brides—or her erasure of him.

Thus, from one family chronicler, two very different histories, bound together in a single book: the first a vertical line of men, a classical model that highlights the Rucellai name, one bloodline flowing without interruption from father to son; the second a horizontal web of marriage alliances, a Germanic model that brings into focus the families of the women who transmitted *their* blood to the sons who would carry on the Rucellai name. Histories of convenience.

Rucellai's eclecticism, in fact, minces most of his *zibaldone*. A diligent collector and copyist, he, like other fifteenth-century compilers of chapbooks, borrowed liberally from authors old and new: Aristotle, Cicero, and Seneca; Dante, Petrarch, and Ficino, all forced into a one-sided conversation with Rucellai. While his heavy reliance upon other voices does not constitute plagiarism per se, his manipulation of those texts—not just paraphrasing but wholesale rewriting—to bolster his own narrative would have raised even Renaissance eyebrows.

Add to this blurring of voices Rucellai's use of professional scribes over the course of twenty-odd years; and to those different hands his own, which occasionally appears in the margins, Rucellai having taken an active role in the transcription of his "original" notes, revising or correcting as needed. Suffice it to say, the *zibaldone* was much tampered with during Rucellai's lifetime. But when the patriarch died, his memory book was soon forgotten.

In fact, the whole archive, it seems, was ignored. Just a dozen years after Rucellai's death, some documents pertaining to his Strozzi in-laws were reported lost. And two years after that incident, his grandson Paolo di Pandolfo could not find a certain red notebook. "I've turned the house upside down," he told his father on 26 September 1495. When he finally found it, a month later, "on top of the big armoire," Paolo declared the discovery "nothing short of a miracle."

The next spark of interest occurred in the 1590s, when an anonymous member of the family, possibly Rucellai's great-great-grandson, Giovanni di Pandolfo, added to the *zibaldone*, appending a brief history of the family through the sixteenth century. But did Rucellai's namesake, as alleged, also copy 13 of his letters, including the epistle describing an expedition to Jerusalem? The appearance of these "genuine" copies in an eighteenth-century manuscript otherwise unrelated to the family, combined with a slew of anachronisms and flamboyant rhetoric, suggests, instead, the work of a later forger.

Giovanni likely would have been flattered by the eighteenth-century fiction. For interest in the family history—under his own roof, no less—was on the wane. In 1767, with the death of Maria Luisa Rucellai, the entire archive, including the *zibaldone*, was moved from Florence to Prato—an inexplicable transfer to her husband's house, given that Maria Luisa was hardly the last of the line. In any event, the archive remained in Prato until the middle of the nineteenth century, when the disinterested heirs of Alessandro Goggi sold it to the English collector John Temple Leader, Lord Westbury. He kept some of the documents in Tuscany, in a villa attic, but the crown jewel he sent on to London, where it was studied and copied and, some 75 years later, put up for auction. In 1923, Bernardo Rucellai and his American-born mother, Edith Bronson, were able to outbid their rivals and bring Giovanni's memory book back home. The *zibaldone*, then, took its place, along with fragments from the original archive that had been graciously returned to the family, in the newly reconstructed repository on the second floor of the palace.

The front corner of Palazzo Rucellai was once again *arche*, starting point. For the archive, that seemingly authoritative place in which information is housed

and guarded, inevitably signifies forgetting as much as it does remembering: "Places of memory," French historian Pierre Nora posits, "only exist because of their capacity for metamorphosis, an endless recycling of their meaning and an unpredictable proliferation of their ramifications." The inhabitants of Palazzo Rucellai, for example, had all along insisted the house be at once impenetrable bastion and porous sac—an accommodating cavity, ever ready to absorb and provide for whatever need or desire. The palace was also expected to perpetuate an image, an ideal, upon which every subsequent generation of residents would piggyback, borrowing a history to buttress their standing in their own age—never mind that the actual details of that history might have all but gone up in smoke.

SMOKE AND MIRRORS

Having purchased the smaller portion of the palace in 1743, Giulio Rucellai, an esteemed minister of state under the Habsburg-Lorraine dynasty, was determined to unite—for the first time—the many disparate pieces of Palazzo Rucellai. To this end, he initiated an extensive renovation campaign, which included "a remake of the main staircase, with secret stairs and with others leading up to the terrace," the invoice states, plus "the installation of a bathroom and modernization of the other rooms on the noble floor; in addition," the builders, Gaspero Billi and Giuseppe Baccani, "added a service stair for the kitchen, increased the size of the oven, and built a pantry." On the second floor, they "refinished the rooms, subdividing one into a bathroom and a closet, plastered the walls, and added fireplaces," so states the bill, "all in order to connect one palace with the other." But it was the application of a fresh coat of paint that truly restructured the house of Rucellai.

Continuing the tradition begun by Giovanni Rucellai, who, to commemorate his son's marriage to Nannina de' Medici, had added family emblems to the facade, Giulio, to celebrate his marriage to Teresa de' Pazzi, decorated the ceiling of the *piano nobile*. Yet if the Medici diamond ring, carved in *pietra forte*, conveys a message of permanence, the puffs of cloud, dabbed in pastel-hued tempera, suggest a lot of hot air on Via della Vigna Nuova. Indeed, the eighteenth-century embellishment undercuts the earlier ornamentation insofar as the illusionistic ceiling paintings seem to dissolve the very building they adorn.

In 1752, the Florentine painter Gian Domenico Ferretti was paid 90 ducats for work, he recorded, "done by me [...] in the palace of that Most Illustrious

family on Via della Vigna Nuova; in oil and fresco; and commissioned by the Most Illustrious and Enlightened Signor Senatore Giulio Rucellai." The same year, Pietro Anderlini received "ten scudi as payment for all of the fictive architecture painted by me in his palace," a pictorial program, it was noted, "full of little clouds."

Monochromatic representations of fluted columns and statue-filled niches rise from the floor, covering the walls in a fantastical outside-in manner, before giving way to a nebulous empyrean tinted lilac, lime, rose, and butterscotch. On the ceiling of the *sala principale*, gauze-draped maidens, feet and shoulders bare, sprawl upon bouffant perches, their fair ringlets held in place with crowns of laurel. One holds a hammer; a T square and metal spikes suggestively peak from under her bottom. Her neighbor, balancing a palette in one hand, caresses a gilded altarpiece with the other. Two tragedies and a book of poetry occupy the third heavily rouged goddess; and the fourth, so enraptured by a set of blueprints (or by the naked putti who present them to her), gives us her chemise-less back. Mnemosyne, the mother of these muses, floats overhead, guiding her daughters—and the Rucellai objects they inspired—to still another dimension.

This choice of pagan subject matter was, in fact, fitting for the home of a famously anticlerical minister for ecclesiastical affairs. Yet there is much more to this saccharine picture of *belle donne* than frivolity and relaxed sensuality. Random bursts of light breaking through the clouds, for instance, align these Rococo frescoes with Enlightenment philosophy, a seemingly antithetical aesthetic. Both, however, share an enthusiasm for freedom, the natural world, and historical self-awareness. Nonetheless, this pictorial and intellectual puffing-up of the house of Rucellai clouds a darker truth.

TURNING TRICKS

The Rucellai may have been highly skilled in the arts of selective remembering and purposeful forgetting, or self-glorification through word and image, but they were not immune to outside forces—diarists and other notetakers who observed and recorded what the family chose not to see. Yet even these accounts, not altogether objective, sometimes get lost and buried in an archival abyss, until the story, twice purged from history, resurfaces.

Such is the case of the love triangle of 1668. The incident, involving a certain Giulio Rucellai, is one the family would have rather forgotten. In fact, they did.

But not so an eighteenth-century antiquarian, who recorded the historical event in his diary:

Having come to Florence "to cash in on her beauty," Pisanella, as she was called, was famous all over town—"much sought-after and highly praised." This poor girl from Pisa, who sought "only pleasure in life," managed to obtain the finest things and, having "few scruples," offered no apologies for her methods. "As shrewd as she was beautiful," Pisanella, to satiate her material cravings, "fell into sin only with men with heaps of money." Among her best clients, "two stood out—one secretly from the other, however"—Cavaliere Giulio Rucellai and Conte Giovan Francesco del Benino.

And since this libertine opportunist never missed a trick, "the sly girl satisfied them both [...] staying a little with this one and a little with that one." Neither the knight nor the count was of the sort "to swallow Pisanella's poppycock; for as much as she tried to keep her nonsense neat, those two, experienced in such matters, suspected each other as rivals" from the very start. Nevertheless, each continued to profess his undying love by showering her "with money and gifts." Meanwhile, everyone in Florence "whispered about the conduct of these two descendants from venerable houses" and about the comportment of Pisanella, who strutted through the city streets "flaunting the riches and splendor" they had bestowed upon her.

The two noble rivals did not much care if she took in "common lovers" or even "the raffish youth of Florence"; no, they were only jealous of each other. Whenever Rucellai and del Benino crossed paths near Pisanella's home, for example, "their faces became enflamed, their cheeks turned bright red." But to keep the peace—and the presents coming—she "sweet-talked them both," claiming to one that she could never accept the other's love. "With the patience of a saint, and with a naivety and a candor that seemed real," Pisanella was thus able to keep both men happy—and herself bedecked. But if this "patchwork resolution" worked for a little while, it was only because "the patches weren't of real fabric"; otherwise, the cunning clotheshorse would have worn those, too.

She had still other tricks up her sleeve. Pisanella convinced her green-eyed lovers—"secretly from each other, of course"—that she had yet another client who was not only jealous but violent to boot. And so, when one was with her, knowing the other was knocking, "she feigned the greatest fright, and hid under the bed, swearing, 'God help us! That's him!'" Other times, "the audacious Pisanella would go all the way down to the door and open it by a hair, saying to the one outside, 'Go away, for goodness sake! [...] *He's* up there,'" and she would slam

the door on the tip of the duped lover's, ahem, nose. "But this constant seesaw of doubt and suspicion, of deception," couldn't last forever; and even Pisanella herself was "amazed that the game had lasted as long as it had, worried, from one moment to the next, that the whole thing might blow."

And it nearly did one day when Rucellai, prone to "jealous fits," went on a rampage. But the guileful Pisanella threw her *own* fit, telling Rucellai that if he continued "harassing her with his ridiculous and foolish envy, she would dump him and take del Benino openly as her lover, without even fearing that infamous *him*." Pisanella's performance seemed to have done the trick. For the knight now found the courtesan, "in all her fury," more beautiful than ever. And though he wasn't certain that hers had not been empty threats, "Rucellai was so afraid of losing Pisanella that he gave her all the money he had on him—about 40 gold ducats—and the girl quickly came around, with the most affectionate and least disinterested kisses imaginable!"

Then, on 17 July 1668, "that whole edifice of foolishness, jealousy, and deception fell down, and dragged into ruin two of the city's most ancient families." Within minutes of meeting on Corso dei Tintori, an impromptu duel broke out between the knight and the count, attracting a crowd that dared not interfere with their battle over Pisanella. A show of lunges and parries entertained the onlookers until, with a single thrust to the heart, "Rucellai turned as white as a freshly laundered sheet." Mortally wounded by del Benino, he dropped his sword and fell backward. There, on Dyers Avenue, Rucellai "raised himself up a little, opened his eyes, coughed up a mouthful of blackish blood, and died."

Upon the sad realization of Rucellai's indecorous death, "everyone's thoughts instantly flew to the two illustrious families, which were thrown so suddenly and atrociously into grief and, in a certain way, into dishonor." The next day, Cavaliere Giulio Rucellai was buried, with decorous pomp, in the church of Santa Maria Novella. Del Benino, who had fled the scene, leaving his sword in Rucellai's wound, stayed in hiding until his family could sort out the affair. Grand Duke Ferdinand II de' Medici, wishing to sweep this embarrassing incident under the rug, intervened on behalf of both families. Conte del Benino, praised for his gallantry, received a reduced jail sentence of one month; "but the one who really paid the price was Pisanella, who was publicly shamed—likened to a discarded rag—and expelled from Florence for life. *Sono sempre gli stracci che vanno all'aria!*"

It is, perhaps, easy to see why the Rucellai kept silent about this particular Giulio, the dark knight who has been effectively erased from the family history, absent even from modern genealogies. But there still lurks the unpublished

diary account, the eighteenth-century antiquarian's leak, which, with every transcription, becomes more and more corrupted. But such is the work of time, the murkiness of memory, the "fact" of history.

NOBLE ROT

The family's habit of reneging was not limited to biographies. Buildings, too, suffered great loss.

In 1767, Fra Vincenzio Fineschi, one of the friars of Santa Maria Novella, sent an embittered plea to the overseers of the church, asking that action be taken against the Rucellai, who had neglected their responsibility as custodians of the facade, which had come under attack from pigeons and ingrown plant life:

> Since February of last year, 1766, it has been observed that some pieces of marble have fallen from the top of the facade of the church down into the cemetery. Verbal notice of this was given to the aforementioned commissioner, who ordered that a detailed petition should be made to the men of the Rucellai family, the designated owners of the facade, so that the appropriate repairs could be made in order to prevent further incidents or injuries to church visitors. I immediately carried out the order, and the Signori Rucellai sent a master marble cutter to assess the site.
>
> But because it was agreed that Senator Giulio, Giuseppe Rucellai [...] and Conte Paolo Rucellai [...] would themselves figure something out, the work was never begun. By the feast day of Corpus Domini, given that more pieces of marble had fallen, a second petition was made to Senator Giulio and Giuseppe Rucellai, and the surveyor was again sent to examine the facade. In order to protect the crowds from accident, it was decided that all precarious pieces of marble should be removed; and so this much was done. It was then hoped that the repair work would finally begin; but since Conte Paolo Rucellai opposed this, it was never carried out.
>
> Given that, from time to time, additional pieces of marble have fallen onto the pavement of the cemetery, and given that Conte Paolo Rucellai has since died, we beseech you to renew the petition to the aforementioned

Rucellai for the restoration of the facade, which is gradually falling apart, and is on the brink of endangering worshipers and the structure as a whole.

Santa Maria Novella, in the heart of Lion Rosso, had long been the focus of the family's patronage. The chapel dedicated to Saint Catherine of Alexandria that had been built in 1355 by Cenni di Nardo had, rather unfortunately, been neglected: in the early 1760s, before the facade had started to crumble, the friars had had to put pressure on the Rucellai to repair their family chapel. But it was Giovanni's spectacular donation to the exterior of the building—Alberti's colorful marble screen emblazoned with the Rucellai name and emblems—that forever linked the family to this church. That promise of eternal salvation, however, was now broken.

Aside from sending a surveyor to the site and approving the removal of "all precarious pieces of marble," the Rucellai did nothing. And so, within a year, the facade, once "gradually falling apart," was now "in danger of collapse." On 5 March 1768, the *operai* of Santa Maria Novella had no choice but to threaten legal action against Paolo's heir and other members of the family:

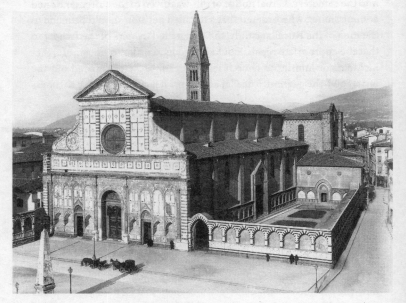

Figure 27. Church of Santa Maria Novella with view of the east cloister, *c.*1890.

Cavaliere Goppi di Prato, heir of the Most Illustrious Conte Paolo Rucellai, should contribute to the cost necessary to repair the facade of the church of Santa Maria Novella, which is in danger of collapse; otherwise, he, and other members of the Rucellai family, will be ordered to do so by the court.

Surely these actions, or lack thereof, would have caused the patron and his architect to turn over in their graves—Alberti, especially, who had devoted the tenth and final book of his architectural treatise, *On the Art of Building*, to the restoration of buildings. In those pages, he analogized sick buildings to bodies. Some ills, he accepted, cannot be remedied, such as those generated by nature. But Alberti simply couldn't cope with ruin caused by man:

> If we are to discuss the faults of buildings and their correction, we ought first to consider the nature and type of the faults that may be corrected by the hand of man; as the physicians maintain that once a disease has been diagnosed it is largely cured.
>
> Of the faults in both public and private buildings, some are integral and inherent, as it were, and the responsibility of the architect, while others result from some outside influence; they may be further divided into those which can be corrected by some form of art or ingenuity and those for which there is no remedy [...]
>
> I think that those which result from some outside influence are almost too numerous and varied to list. The saying "Time conquers all things" refers to some of them; the batteries of old age are dangerous and very powerful; the body has no defense against the laws of Nature and must succumb to old age [...] We feel the sun burn or the shadows freeze; we feel the power of ice and wind. The working of this engine can crack and crumble even the hardest flint [...] Then there is damage caused by man. God help me, I sometimes cannot stomach it when I see with what negligence, or to put it more crudely, by what avarice they allow the ruin of things.

Alas, the diagnosis, to which Alberti referred, would come too late.

Quarto Piano

*I feel the past and the future pressing so hard on either
side that there's no room for the present at all.*

Evelyn Waugh, *Brideshead Revisited*

Throughout the damp Tuscan winter, Palazzo Rucellai, stubborn as ever, had maintained a stone-cold silence. Despite my amped-up lifestyle, nothing new had been revealed to me—nothing, that is, that might explain Francesco's incertitude upon learning of my sabbatical address. Though I'd readily embodied everything that the palazzo stood for, at the risk of professional and financial ruin, my object of desire had yet to embrace *me*.

One brisk morning, sipping a cappuccino at the bar across the street, I stood, as I did every morning, facing the facade. A strong tramontana blew over the peninsula, signaling the advent of spring; though the air was still cold, the light was clear and bright. The late-winter sun shone differently upon my empire, I reflected, as I walked back toward the palazzo. And as I approached the portal, though revved up on Lavazza, I paused to bask in its crisp golden glow.

For years, I'd stared at the facade from the far edge of the piazza, on the corner of Via del Purgatorio, from where I could take in, as best one can, the entirety of Alberti's design. Then, once I'd made it past the threshold, I focused all of my attention on the building's interior. But on this day, standing still,

within arm's reach of my subject, I became fixated on a passage about two feet square. My peripheral vision obliterated by my proximity to the surface, the facade, with its perpendicular lines and large rectangular forms, now looked not unlike a composition by Mondrian. My initial amusement with Alberti's "modernism" quickly turned to amazement. For upon this grid, I also saw a glyph: Δ. And then another: ß. As my field of vision slowly expanded with every measured step backward, I perceived, for the first time, a series of stylized letters and numerals and symbols crudely etched on the facade of Palazzo Rucellai: A, X, P, K, S, U, 8, 6, 4, ∂, †, and so on. Was it a text of some sort? How could I have missed this?

Figure 28. Glyphs on the facade of Palazzo Rucellai.

By noon I was back on the second floor of the Kunsthistorisches Institut, scaling a ladder to the perilously high shelf that houses the monographs on Alberti. I fingered the spines, pulling to the edge any titles I'd passed over during my previous visits. To my chagrin, I'd left unread virtually a small library. I began to carry the dusty tomes, one aching armful at a time, down to my table. With the lot spread out before me, I pulled up a chair and got to work.

Sure enough, my eyes had not deceived me: on almost every stone, on all three levels of the elevation and running the full length of the facade, are more than 50 different glyphs; most occur at least twice, and many several times. Barely perceptible to the naked eye, these incisions, measuring less than four inches in height, have gone largely unnoticed. And those in the know remain puzzled. Do the markings refer to an assemblage code? There seems to be no rhyme or reason to the order or orientation of the symbols. Were they scratched before or after the panels of blocks were set in place? The stylized letters and numerals suggest mason's marks, but the inclusion of stars and crosses hints at something much more mysterious.

I began to wonder if, hiding in plain sight, these weren't stonecutter's marks, but a secret message embedded by the architect himself, the quintessential man of letters who'd invented the first polyalphabetic cipher, a device he described, in his treatise *On Cryptography,* as an "extremely secret and convenient method of writing." (So secure was Alberti's encryption tool that it was still employed by the US Navy at the time of the American Civil War.) If Alberti did embed a message into the sandstone membrane of Palazzo Rucellai, what did it say? And, more to the point, for whom was it meant? For me?

Fed up with the sporadic internet connection in Archivio—not to mention the contessa's refusal to pay €30 for a technician to come into the apartment to fix the problem—I walked over to Vodafone, rental contract in hand, prepared to change the service into my name, at my expense. But when I presented the lease, the transfer came to a standstill.

"*Mi dispiace,*" the man said, handing the paperwork back to me. "I'll need a valid contract in order to proceed."

I looked at the lease. The address was correct. The contessa's *codice fiscale* was there; so, too, was my passport number. Every page had been signed and dated by both parties.

"What's wrong with this one?" I asked.

"There's no *marca da bollo,*" he answered, and called the next customer.

"What? *Momento!*" I begged him to stay with me, having waited more than an hour for my turn. "How can you tell?"

"*Signorina*, the stamp!—it's missing."

Somehow, the contract never made it to the local Ufficio del registro. If not paid, the lease, under Italian law, is considered invalid. Had my entire palace idyll been a fraud? I rushed back to Palazzo Rucellai, multiplying and dividing in my head every panicked step of the way. By the time I reached the building, I'd come up with a ballpark figure of €370. (The standard registration fee for long-term rentals is 2 percent of the annual rent plus the cost of government stamps, and this amount is typically divided between the landlord and the tenant.) For the cost of a pair of shoes, my residency in Palazzo Rucellai had been jeopardized? Furious, I climbed into the birdcage elevator and hit the button for Archivio. I was going straight upstairs to call the contessa from the landline.

A few moments later, I felt a sudden jerk upward, then a quick drop down. The floor, for the second time that morning, had fallen out from under me.

To say that the birdcage elevator in Palazzo Rucellai was a precarious hoist would be putting it mildly. The 1928 lift, the first of its kind in Florence, should have been retired to the Triennale Design Museum in Milan decades ago. More than once, this charming relic had failed me, stopping dead in its tracks, leaving me hanging, literally, within the makeshift shaft that had been carved out of the front right-hand corner of the palazzo to accommodate it. On such occasions, I would push "EMURGENCIA [sic]." And though the word itself sounded promising, the handmade label, scribbled in a palsied hand by Niko, was beyond discouraging. Still, I'd never stayed stuck for too long. On this day, however, it would take Niko nearly 90 minutes to release me. I emerged on the ground floor, somewhat shaken, my bladder achingly full, only to find myself face-to-face with the contessa. She'd come to collect the rent.

"That Bianca," she tsked. "Up to her old tricks, I see!"

I was beginning to understand why Niko feigned deafness in Contessa Rucellai's presence, and I let my sigh be heard.

"No one's told you yet? She's our ghost! But don't worry—she's perfectly harmless—"

I handed her the unregistered lease.

"An oversight, obviously," she explained. "I'll call the agency tomorrow."

*

My research, reconceived, plodded along. I still hadn't been able to crack the code on the facade, but I'd finally figured out the building sequence. Privy to its mazelike interior, I certainly could confirm Palazzo Rucellai's labyrinthine structure, but I didn't interpret this disjointedness as problematic. Rather, once you passed through the door, there was the gratifying feeling of having been cut off from the world outside—a lovely loneliness, everything still, despite the haunting sensation that something was always seeping through the plaster. Problem was, nothing did, at least not on my watch.

So one balmy evening, around 9:00 p.m., I headed over to the *enoteca* for a late dinner. The days were getting longer, and the city was starting to heat up; indeed, with the change of seasons, I no longer felt the Florentine chill—not even from Francesco.

"*Dimmi, cara*, what have you learned about your beloved Palazzo Rucellai?"

"All there is to know, I think. I've read practically everything in print."

"*Brava*. So who do you think did it?"

"The facade? Alberti. Sure, Rossellino would have overseen the implementation of the design, but—"

Francesco shot me a pitying look.

"Oh—do you mean who carved those emblems on the facade?"

He shook his head. "No, *cara*. I mean the murder."

My jaw dropped to the bar.

"*Un nobile*," Francesco whispered as he placed an empty Spiegelau balloon between us, tacking on "ten years ago January."

What his tantalizing pronouncement lacked in substance, his pour—high above the fill line—more than made up for. I grabbed the glass by its impeccably polished bowl and took in a mouthful, uncomfortably still on the wooden barstool, trying to digest the juice that had just been spilled before me. *I have to get home*, I thought. Ghosts, I'd been warned about. But a *murder?!*

As I raced to the door, Francesco called out after me, "*Stai attento! È insoluto.*" His words rang in my head ominously as I made my way through the vestibule and out onto the street. *Pay attention. No one knows who did it.*

I walked straight home, through the *portone*, through the second set of double doors, and up the hundred-plus stairs to Archivio, quickening my pace to beat the timers on the three sets of lights that, from day one, had inadequately illuminated my ascent. Once inside, I double-checked the lock and caught my breath.

*

It was shortly after 2:00 a.m., from what I can recall, when I bolted out of bed. With no idea where to run, I hurled myself onto the floor. The pain was excruciating. I flung my left arm around to my back, desperate to liberate myself from the twisting knife. But the only thing I could feel was another tornado ripping across my flank. I ground my face deeper and deeper into the sisal mat that now seemed destined to become my winding-sheet, until the recurrent image of a devastated mother—her daughter found dead, days later, in a palace attic—prompted me to collect my spasmodic body and leave Palazzo Rucellai. *Must. Get. Out.*

But how? There was no point in calling down to Niko, who'd only blame the specter for not having heard the phone ring. Barely able to walk, I had no choice but to close myself in behind the steel cage and leather accordion doors of the finicky birdcage elevator. As I contemplated the probability of yet another mechanical breakdown—and a too-long wait at the most inopportune moment imaginable—the herky-jerky ride continued apace until, to my relief, the journey down came off without a hitch.

Still, I was far from free. The contessa, after all, pretty much had me in lockdown. On a good day, with just the right amount of penetration and wrenching, I could navigate the ground-floor barrage of locked doors in four minutes flat. But the herculean task ahead of my pain-riddled body would require nothing short of a miracle and, above all, exceptional dexterity. Keys in hand, I repeated my mantra and continued my flight out of hell.

Upon escaping the palace, five and a half minutes later, my chances of survival increased tenfold. The taxi I'd somehow managed to call from upstairs was already curbside. I crawled into the backseat and closed my eyes as we made the short trek to the emergency room, along the way hitting every single pothole to the beat of Euro calypso-punk.

Ospedale di Santa Maria Nuova, I'd always thought, was a cruel misnomer for a healthcare facility. Founded in 1288 by Folco Portinari, the father of Dante's Beatrice, it was hardly what I'd call "*nuova.*" Nor did my familiarity with the place, having studied it in the context of the tomb project (bubonic plague, bloodletting, mass burial, etc.), do much to quell my anxiety. But I also knew that Santa Maria Nuova was the first Western European hospital, and thus the oldest direct ancestor of the medical institutions we know today. So I held out hope as I propelled my debilitated body from the nightclub on wheels to the stoic arched entryway. I pushed open a colossal wooden door (how I longed for

something automatic at that moment) and, with all the strength I could muster, blurted out in desperation, "*Sono americana!*" And with that uncharacteristic declaration of patriotism (the body, I figured, would have to be returned), I collapsed into a Naugahyde wheelchair that a half-awake nurse had scurried to slip under me.

Floating in and out of consciousness, I was rolled down a long fluorescent-lit corridor. I could just make out from various architectural clues that I was moving though what had once been the hospital's first cemetery, the so-called Cloister of Bones. I was happy to make it through that stretch alive. But when she deposited me at the other end, I was disappointed to see that more than just the inner structure had been altered. Where was the "little bed covered with a cloth on which the sick are laid when they first arrive?" Where was the infirmarer who "sends one of the head nurses to wash the sick person's feet and another [...] to get slippers, a leather robe, a shift, a cap and two pillows?" Where were the "perpetual servants [who] go around the infirmary three times a day [... asking] each person in turn what dried fruit, or sweets [she] would like—pine-nuts, walnuts, or almonds coated with sugar?" Where was "the excellent wine—white, red, smooth, sweet, or dry?" Where was the famous "soup made from puréed chicken?" Or the "shoemaker, [who] cuts out and sews shoes for everyone in the hospital, sick and well?" And where, pray tell, was my "one grain of opium, [which] eases pains, matures, helps sleep?"

As I hazily pondered the absence of everything I'd ever read about Santa Maria Nuova, a handsome young doctor walked into my curtained-off chamber and punched me in the back. For the second time in my life, I saw shooting stars. My cries for mercy must have confirmed what he'd already suspected: "*calcoli renali*." And with that dismissive diagnosis, Patient X was labeled "non-urgent" and abandoned on a self-soiled gurney.

As I awaited my lithotripsy, a procedure that pulverizes kidney stones, I considered the quintessence of stone—its persistence and yet its susceptibility, its *seeming* permanence, its *reputed* resistance. I recalled how Giovanni Rucellai's descendants were responsible for the upkeep of Alberti's facade for the church of Santa Maria Novella. But in 1766, when it began to crumble, the family did nothing, and large chunks of marble fell to the ground. If stones (of all sorts) can indeed be broken, I reasoned, might I finally, by solving the mystery it had for ten years kept secret, be able to penetrate the stronghold that possessed me?

An unsolved murder—of a nobleman—in *my* palazzo? Mere hours after Francesco's staggering revelation at the *enoteca*, I felt all the more frustrated with

Palazzo Rucellai, betrayed even. That I'd had to learn its dirty little secret from another house left me nonplussed—and determined to get even.

But first, back in Archivio, high on Lixidol and supersaturated with Acqua Panna, I read up on my diagnosis. An "honourable" malady, wrote fellow sufferer Michel de Montaigne, "it preferably attacks the great; it is essentially noble and dignified." The affluent, I also learned, were believed more prone to developing kidney stones due to their lifestyle: protein-rich diets, excessive amounts of wine, and "immoderate sexual intercourse"—on feather beds, no less. Sounded like a fair trade-off to me.

Until I came across some of the treatments from the *Ricettario* of Santa Maria Nuova, which, in 1515, contained as many as 12 recipes for kidney stones, ranging from the comforting—cucumber and melon seed mixed with pumpkin—to the unsavory: "Boil in sweet Malvasia wine the dung of a hen that has not yet mated with a cock. Reduce. Add powder of dried betony, horseradish, white ginger and honey. Take with a good Trebbiano wine." There was also an extra-strength formula, recommended "to break the stone":

> Combine scorpions, heads of cabbages, hares, and eggshells collected after the birth of chicks. Add sodium nitrate and burn. Mix ashes of aforementioned ingredients with equal parts dried blood of an old goat, fossilized spines of sea urchins, sponge mollusks, walnut gum and sweet sedge.

Much more palatable seemed the time-honored tradition of taking the waters at one of the thermal baths, perhaps at Montecatini or Bagno Vignoni or Saturnia. I downed another dose of painkillers and packed my bag.

—CHAPTER FIVE—

The Salonnière

The past is a foreign country: they do things differently there.

L. P. Hartley, *The Go-Between*

"PARADISE OF CHEAPNESS"

Ever since Giovanni Rucellai's Ship of Misfortune steered him to bankruptcy in 1474, the family had struggled financially. Yet they had always managed to stay afloat—and to keep to themselves. Their centuries-old sequestration, however, came to an abrupt end when, in 1826, the reigning patriarch, Giuseppe, was forced to share Palazzo Rucellai with strangers: Henry Layard; his wife, Marianne; and their four children, Austen, Frederick, Arthur, and Edgar.

The eldest son would grow up to become Sir Austen Henry Layard, the archaeologist and politician well known for his excavations of Nimrud and Nineveh, the ancient Assyrian cities recently destroyed by ISIL. His popular account of those discoveries, published in the mid-nineteenth century, became an instant bestseller—not surprising, for Layard was, indeed, a talented storyteller. In his memoirs, drafted at the end of a long and adventurous career, he wrote with remarkable precision about his childhood home. Though he

lived only three years in Palazzo Rucellai, from 1826 to 1829, the residence left an indelible mark on the precocious boy, who, upon his first visit at the age of nine, was "captivated":

> My father, having determined to establish himself permanently at Florence, endeavoured to find a convenient house suitable to his income, which was not large. He was fortunate enough to light upon the first floor of the Rucellai Palace in the Vigna Nuova, built in the fifteenth century by Alberti, the greatest architect of his time, and considered one of his greatest works. I was taken to see it, and my advice as to engaging it was asked. I was captivated by the appearance of the principal rooms, the walls of which were covered with damasked silk, and hung with old pictures in carved Florentine frames. I gave a decided opinion in favour of securing at once so desirable a residence. At that time many of the old families of Florence—and the Rucellai were amongst the most ancient and illustrious, having been celebrated even before the Medici were known—were almost reduced to poverty, and were glad to let the principal part, if not the whole, of their magnificent palaces. They retired to the upper floor, where they lived economically, if not meanly, on their slender incomes.
>
> My father agreed to pay one hundred louis d'or a year for this fine suite of furnished apartments—a sum which in these days will appear absurdly small. He and my mother established a friendship with the owners of the palace, who lived above us, and their children became the playmates of my brother and myself […]
>
> Although the Rucellai family agreed to give the whole of the first floor over to us, there was one room, opening into my mother's bedroom, of which the key was not delivered to my father, and which I was told it was forbidden to enter. My curiosity was naturally greatly excited as to the contents of this mysterious chamber. I had read the story of "Blue Beard," and fancied that there must probably be some such ghastly remains as those contained in the cupboard in which that worthy concealed the bodies of his slaughtered wives. One day, when my father and mother were away on a visit to some friends in the country, I coaxed our old French servant, Pachot, into making the attempt to unlock the prohibited door. He produced a large bunch of keys, and, after many trials, one was at last found, to my great delight, to fit the lock.

> I entered, trembling, into a dark room fitted up as a chapel. Above the altar in a glass case lay the dead body of a lady richly dressed, her brown and shriveled features crowned with a wreath of artificial flowers. Pachot and I were equally terrified at the sight, and, beating a hasty retreat, closed the door again. What I had seen made so strong an impression upon my imagination that it haunted my dreams for long after. It was some time before I could muster courage to inform my mother of this act of disobedience. We afterwards learnt that the body was that of a *beata* of the Rucellai family, who had been embalmed and preserved as an object of veneration on account of her reputed sanctity.

That "brown and shriveled" body crowned with artificial flowers was, in all probability, the embalmed corpse of Camilla Rucellai, one of Savonarola's most ardent followers. In 1495, she and her husband, Rodolfo, decided to dissolve their marriage and enter the fervor-filled convent of San Marco. But unlike his deeply spiritual first cousin Pandolfo, Rodolfo soon had misgivings, and he begged Camilla to live together again as husband and wife. She adamantly refused, choosing instead to take the veil of the Dominican tertiary order and change her name to Lucia. Perfect name for a seer, which she claimed to be: Lucia was revered in her lifetime for prophesizing the death of famed Neoplatonic philosopher Giovanni Pico della Mirandola. Victorian writers George Eliot and Walter Pater recycled the story, as did Tennessee Williams in "The Resemblance between a Violin Case and a Coffin":

> And looking back upon him now, and upon the devout little mystic of carnality that I was as I crouched on a chill bedroom floor, I think of Camilla Rucellai, that highstrung mystic of Florence who is supposed to have seen Pico della Mirandola entering the streets of that city on a milkwhite horse in a storm of sunlight and flowers and to have fainted at the spectacle of him and murmured as she revived, "*He will pass in the time of lilies!*" meaning that he would die early.

She herself died relatively late, at the age of 64, in 1529. The Rucellai preserved her body in a glass case in the family chapel, where she rested in peace, largely undisturbed, for some 300 years—until, that is, a curious little boy and his trusty old servant barged in, gas lantern in hand, and got the fright of their lives.

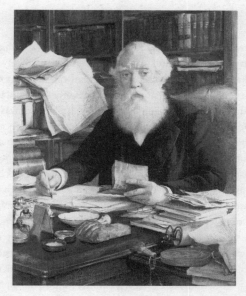

Figure 29. Sir Austen Henry Layard, at the age of 74, surrounded by books and papers, perhaps recording his childhood memories of Palazzo Rucellai.

In addition to the gruesome surprise behind the chapel door, we also discover from Layard's vivid recollections that, despite the sumptuousness of the *piano nobile*, the Rucellai "were almost reduced to poverty." Yet they were hardly the only family "to let the principal part, if not the whole" of their palace for an "absurdly small" amount. By the 1820s, following the fall of Napoleon, Italy was inundated with visitors. But these travelers, the cultural offspring of the Grand Tourists who had swept through Italy in the eighteenth century, chose, instead, to stay awhile. This fast-growing Anglo-American community needed housing, and the Florentine aristocracy needed cash. Practically overnight, then, the birthplace of the Renaissance had become a renter's market. Or, as Nathaniel Hawthorne called the city, writing in 1858 from the *piano nobile* of Casa del Bello, a 13-room apartment for which he paid a mere $50 a month, the "paradise of cheapness."

A decade later, Henry James arrived. He would come and go over the next 40 years, changing his residence often according to the season as well as his constitution. Such was the abundance and variety of housing on offer: "This one has a story; that one has another; they all look as if they had stories."

HEMORRHAGE

In addition to renters, there was also an influx of buyers—of art. Taking advantage of an uncertain political situation on the eve of and immediately following the unification of Italy, art collectors descended upon the Arno valley en masse. Due to a major restructuring of its historic center (the city was capital of the newly founded Kingdom of Italy between 1865 and 1871), Florence was flooded with late medieval and early Renaissance spoils. To this state of affairs add a destitute aristocracy, whose newly opened-up palaces were ripe for the picking.

Case in point: the house on Via della Vigna Nuova. Giuseppe Rucellai may have ceded the *piano nobile* to the Layard family as early as 1826, but he had left its contents in place. Indeed, the "damasked silk [walls] hung with old pictures in carved Florentine frames [...] some of them of merit"—are precisely what sold the young Austen Henry on the place. Yet by the time the former resident sat down to pen his memoirs, some of the pictures he had grown up with had been removed ("Over the bed in which I slept was the fine altar-piece by Filippino Lippi, now in the National Gallery"). Moreover, we read, "the picture still bears the traces of a wound inflicted by the heel of [my] shoes, flung at [my] brother in a childish quarrel." Priceless; but perhaps the most important thing to take from this charming anecdote is the fact that the Lippi left the house.

The large, almost square altarpiece, depicting a nursing Virgin and Child seated in a landscape between Saints Jerome and Dominic, with the Rucellai coat of arms at either end of the predella, was painted c.1485 for the family's burial chapel in the church of San Pancrazio, where it remained for more than 300 years. And when the church was deconsecrated in 1808, the altarpiece was simply walked to the front of the block and installed on the *piano nobile*. But in 1857, the choice painting with the hitherto pristine provenance traveled well outside of the Rucellai enclave, as far away as London. That year, Giuseppe Rucellai, the same man who had rented out the first floor of the palace 30 years earlier, sold the Lippi altarpiece for £627 to the National Gallery, then under the directorship of Sir Charles Eastlake, the avid Victorian collector who, over the course of his ten-year tenure, amassed for the museum an astonishing 139 paintings. (Also in 1857, Eastlake purchased, from Roberto Pucci, Antonio del Pollaiuolo's monumental *Martyrdom of Saint Sebastian* for a staggering £3,155.)

The sale of the Lippi may have been a tough pill for the family to swallow, but not so the tapestries, wedding chests and other pieces of furniture, bronzes, ceramics, stucco, and the odd *objet d'art*, all of which the Rucellai sold thirstily

to dealers like Stefano Bardini. And they were hardly alone in their wholesale dumping of "inherited effects." In fact, the supersaturated market of "family relics" led the antiquarian James Jackson Jarves, writing in the 1880s, to christen Florence "the capital of Bric-à-bracdom":

> Properly speaking, bric-à-brac is the result of the lively ransacking and disinterring of everything, from earliest paganism down to our childhood's days, in which there exists any artistic or aesthetic features whatever, from the fragments of ruined temples, contents of long-buried tombs, or the pins and buckles, ruffs, snuff-boxes, and old china of our grandmothers [...]
>
> [Florence] has always been a favorite mart of old art; but the business in past times was confined to a few well-known dealers and agents. There are now more than one hundred regular shopmen, and a much larger number of persons of all ranks who make the traffic a special pursuit. Noble families, openly or covertly, are largely represented, and family relics, which in Italy appear to have powers of procreation, still abound [...] in one palace of hereditary fame, with an uncommonly imposing coat of arms over the huge portal, there is a commendable frankness of exhibition and terms: "One price" and "cash on delivery" are the system. Wandering through its suites of beautiful rooms filled with objects that attest both the taste and wealth of the noble collector, the visitor is particularly impressed by the harmonious combination of mercantile shrewdness and aesthetic culture [...] Such a palace is the very paradise of bric-à-brac, open only to the elect, and capable of inoculating with taste even the soul of the grimmest Puritan. Nevertheless, neither blue nor red blood must forget the cash rule [...]
>
> [Not everything] that is temptingly offered in mansions of old families can be authenticated. Sometimes the heraldry of a family is grievously mixed with baser elements, and even in best of faith a member of one may hazard a statement from mere hearsay, which being in his own interest, in his ignorance he devoutly believes [...] [Another] descendant knows nothing about the object you covet, cares not a pin for it, and has not the faintest idea who made it, or why you should want it. He sees money in you, if not in it, and can soon discern how far he can draw bills at sight on your taste. It occasionally happens that, after disposing of his inherited effects to chance buyers, the aristocratic seller grows so fond of the

occupation as to turn his home into a scantily disguised shop, and keep on buying and selling with all the zest of a regular trader [...]

Thence it is that Florence has become both the cheapest and dearest emporium of antiquarianism.

The English may have gotten a head start on "the lively ransacking and disinterring of everything" in Florence—as early as 1847 the influential art critic John Ruskin urged, "Let agents be sent to all the cities of Italy." But the Americans would soon reign supreme.

"WE MUST BREED MERCHANT PRINCES"

On 30 October 1881, Jarves, the same critic who would later in the decade lampoon the nineteenth-century Italian aristocracy for their binge selling of the cultural patrimony, hailed the fifteenth-century Giovanni Rucellai a model collector, "The Ideal Florentine," in the pages of the *New York Times*. Addressing the new American millionaires back home, the Connecticut-born expat, an early promoter of Renaissance art in the United States, was, with the publication of this article, essentially shopping for customers. He himself had made massive purchases of Tuscan and Umbrian painting, which he kept on display in his Florentine home, the sprawling Palazzo Guadagni in Piazza Santo Spirito. Jarves now wanted American industrialists—Andrew Carnegie, J. P. Morgan, John D. Rockefeller, Henry Clay Frick—to establish themselves as patrons of the arts (read as "hire him to furnish their private mansions"). The best way to reach the nouveaux riches, Jarves believed, was to introduce them to one of their own—"enterprising," "successful," "calculated," the self-made man:

> In Florence the root of roots was trade. Its real builders were not its great architects, artists, and Barons, but its traders. Like Venice, its nobility sprang from commerce. Its *Libro d'oro* is literally a record of successful merchants, whose highest maxim was to buy where they could buy cheapest and sell where they could sell dearest. The titles that now sound so melodiously aristocratic as affixed to the names of their degenerate descendants all sprang from the yardstick and the steelyard, and many of the noblest names, traced to their origin, are simply fanciful derivations from the humblest occupations. There has recently been printed

in Florence, but only for private circulation, a remarkable book, which gives a graphic picture of the type of men that made medieval Florence and were her true founders [...] there is in [this *zibaldone*] that which is particularly interesting to Americans [...] We are traveling the same road socially, mercantilely, and artistically, if not politically [...]

As a citizen [Giovanni Rucellai] was munificent in public works, conservative and sagacious. His palace became a veritable museum of art, containing pictures and sculpture by Domenico Veneziano, Fra Filippo Lippi, Verrocchio, Giuliano da Maiano, Castagno, Paolo Uccello, Desiderio da Settignano, Pollaiuolo, Finiguerra, and their contemporaries. Unfortunately, his descendants have sold nearly all his collection [...]

Here we see the ideal Florentine, the complete type of the enterprising, sagacious, level-headed citizen, respectable, successful, and esteemed in every relation to life, pious without bigotry, acquisitive without stinginess, thrifty and yet very munificent, every action closely calculated in its consequences, scholarly, moral, hospitable, and self-controlled; one of the veritable makers of Florence; not so absorbed in the narrow horizon of self or "set" as not to take a broad view of the interests of his city and to give and labor zealously to promote them. This is the real secret of its greatness [...] If we are to build up on American soil cities like Florence,

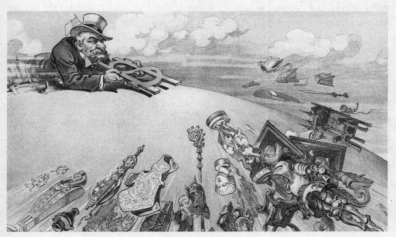

Figure 30. "The Magnet," of 1911, caricatures J. P. Morgan, whose agents mined European palaces and churches, buying up artworks on an unprecedented scale.

world-renowned for art and science even more than for commerce and luxury, we must breed merchant princes cultured like Rucellai, and deeply imbued with his maxim, that it is pleasanter and more honorable to spend money for wise purposes than to make it; men whose souls are not shriveled by delusive notions of "set" and "social position," mistaking the farthing light of self-importance for the electrical blaze of public munificence and duty. Rucellai is not the highest type of man and citizen by any means, but there is in him a public spirit which may be studied to advantage by many of our merchant princes whose fortunes are as far superior to his self-made one as America is a land of greater diversity of gifts and promise than ever was Italy at any epoch.

By forging this link between the Renaissance patron and the American collector, Jarves hoped to capitalize on the late-nineteenth-century New World desire to build something—make that *everything*—just as Giovanni Rucellai had had to do nearly 500 years earlier. If this Quattrocento "new man" now served as a model collector (and his *zibaldone* as a conduct book), Palazzo Rucellai, once "a veritable museum of art", became a model house. And for all of those prospective American collectors "acquisitive without stinginess," those nouveaux merchant princes feverish with "the electrical blaze of public munificence and duty," Jarves just happened to have for sale "pictures and sculpture" fit for an American prince—and his palazzo.

Far from holding a monopoly on the enterprise of buying and selling Renaissance objects to clients abroad, Jarves had to compete with other advisor-dealers, such as Bernard Berenson, whose activities on behalf of American clients have been well reported. And yet, despite this thriving, competitive market, not everyone shared Jarves' enthusiasm for the period—neither its sociopolitical values nor the value assigned to its material culture. In *The Innocents Abroad*, Mark Twain's tongue-in-cheek travelogue of 1869, he ribs, "Who is this Renaissance? Where did he come from? Who gave him permission to cram the Republic with his execrable daubs?"

"EVERY CHIP OF STONE AND STAIN IS THERE"

One need not have been a millionaire to take home a piece of the Renaissance. Access to private homes and showrooms may have been limited, but the

streets of Florence were open for business. Indeed, responding to a spike in middle-class tourism, an entire industry had sprung up during the second half of the nineteenth century. Kiosks mushroomed in every major piazza, hucksters colonized street corners, and, in between, obedient sightseers, guidebooks and cheap souvenirs in hand, followed well-trodden itineraries. By the time Sigmund Freud visited, for one week in 1896, the city was an established tourist trap: "The people of Florence kick up the most infernal racket, shouting, cracking their whips and playing trombones in the street," he wrote to his wife, Martha, on 7 September. "In a word, it's unbearable. Our feet were shot to pieces."

What—or, rather, *how*—did the short-term tourist see at the turn of the century? In E. M. Forster's *A Room with a View* (1908), Lucy Honeychurch, the

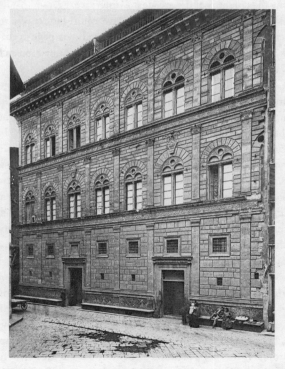

Figure 31. Palazzo Rucellai, *c.*1890: at left, in the doorway, the porter speaks with a passerby; at right, a young family shares the bench with street vendors and their wares.

naive tourist brainwashed by her Baedeker's *Handbook for Travellers*, eventually ventures across town, beyond the church of Santa Croce, to the Alinari shop on Via degli Strozzi, where she spends almost seven lire on photographs: black-and-white reproductions of Botticelli's *Birth of Venus* and Fra Angelico's *Coronation*, both in the Uffizi; Giotto's *Ascension of Saint John*, from the Peruzzi Chapel; and some della Robbia glazed terracotta babies, ornament from the facade of Brunelleschi's Ospedale degli Innocenti; as well as other, non-Florentine works of art. Yet apart from the della Robbia roundels, Lucy seems wholly uninterested in architecture, for she certainly could have added to her purchase several different views of Palazzo Rucellai, made *c.*1890 by the Alinari firm: an oblique view of the facade, the jagged edge cropped out; a close-up of one of the biforate windows on the *piano nobile* with the coat of arms above; or a courtyard shot emphasizing the columns of the arcade and interior loggia.

And if she had just continued westward two short blocks, she would have seen the actual site, recommended—in fact, starred—on page 533 of her trusty guidebook, assuming, of course, that the predictable Lucy Honeychurch had purchased the latest (1906) edition of Baedeker:

> Two streets lead to the W. opposite the Pal. Strozzi: the Via della Vigna Nuova, to the left, and the Via della Spada, to the right. In the former (No. 20; right) is the *Palazzo Rucellai (Pl. D, 4), erected in 1446–51 by *Bern. Rossellino* from a design by *Leon Battista Alberti*, who for the first time here employed a combination of rustica and pilasters. Opposite is a loggia of 1468, now built up. —In the Via della Spada are the former church of *San Pancrazio* (now a cigar-factory), in the Piazza S. Pancrazio, and the little *Cappella de' Rucellai* (key kept by the porter of the Pal. Rucellai; fee 30–50 c.). The chapel contains an ideal imitation in marble of the Holy Sepulchre at Jerusalem, a charming early-Renaissance structure, also by *Alberti* (1467).

Alas, Lucy had gone out that afternoon *without* her Baedeker, her bright red security blanket having been swiped from her by the sage, adventuresome Miss Lavish. ("'The true Italy,'" she insists, "'is only to be found by patient observation.'")

Worse, Lucy would also go home without her Alinari photographs. While passing through Piazza della Signoria on her way back to the Pension Bertolini, she laments the fact that nothing exciting ever happens to her. A few moments later, standing in the shadow of Palazzo Vecchio, something does:

Two Italians by the Loggia had been bickering about a debt [...] They sparred at each other, and one of them was hit lightly upon the chest. He frowned; he bent towards Lucy with a look of interest, as if he had an important message for her. He opened his lips to deliver it, and a stream of red came out between them and trickled down his unshaven chin.

Amid the ensuing chaos, Lucy glimpses one of her fellow *pensione* boarders, Mr. George Emerson. "Even as she caught sight of him he grew dim; the palace itself grew dim, swayed above her, fell on to her softly, slowly, noiselessly, and the sky fell with it." In the course of fainting, Lucy drops her photographs. When she comes to, having been carried to the steps of the Uffizi by George, she asks him to go back out into the piazza to fetch her souvenirs. He obliges, and the pair eventually head home along the Arno, at which point George throws Lucy's mementos into the river. "'I didn't know what to do with them,' he cried, and his voice was that of an anxious boy [...] 'They were covered with blood. There! I'm glad I've told you.'"

But most people who bought photographs in Italy also left with them. As did John Ruskin, for whom the photographic reproduction wasn't merely a souvenir but a surrogate: "I have been lucky enough to get from a poor Frenchman here," he wrote to his father from Venice at mid-century,

> some most beautiful, though small, Daguerreotypes of the palaces I have been trying to draw—and certainly Daguerreotypes taken by this vivid sunlight are glorious things. It is very nearly the same thing as carrying off the palace itself—every chip of stone and stain is there.

The acquisition of photographs, then, enabled the visitor, for just a few lire, to take home a piece of the Renaissance, to possess—on some level—a palace.

ALL THE WORLD'S A STAGE

The once-homogenous Florentine skyline, punctuated by medieval bell towers and Renaissance domes, had become, by 1900, richly cosmopolitan. Brunelleschi's terracotta-tiled, marble-ribbed cupola now had to share the airspace over the Arno valley with the Tempio Maggiore Israelitico, the Moorish-style synagogue with its huge copper dome, and the Russian Orthodox church, its five onion

domes gleaming in iridescent shades of peacock blue, emerald, and goldenrod. Colorful, indeed, was the Russian community in Florence.

"To me," wrote the British historian and connoisseur Harold Acton, "the most strikingly Russian of the Russians was Contessa Lysina Rucellai." By all accounts, the twice-widowed wife of Giulio di Giovanni was one of the most eccentric and uncontainable characters ever to occupy the *piano nobile* of Palazzo Rucellai. Ginger-haired, with impeccable posture, she dominated any room she entered, her arrival heralded by yipping Pomeranians, Fifi and Felix among them, and a pungent breath of garlic—the elixir, she believed, capable of sustaining eternal youth ("she did not pronounce a word one could not smell"). Acton, a generation younger, was drawn to the flamboyant redhead "like a magnet": "Though she was at least seventy, she set Florentine matrons a good example by whirling into every waltz within earshot. Seeing her marmalade coiffure in the centre of a laughing circle," he recalled, "you could be sure that some fun was brewing."

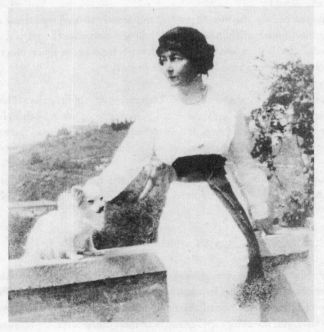

Figure 32. Lysina Rucellai.

Lysina, in fact, was famous all over Tuscany for her "tango teas," glamorous parties held in the *sala principale* during the prewar years. Local and visiting society alike coveted her summons:

Cher Marquis,
 J'espère que vous avez reçu mon invitation, et que vous viendrez tous a mon petit bal de Dimanche 30 Avril?

<div style="text-align: right;">*C.tesse Rucellai*</div>

Loosely handwritten on a folded sheet of light-blue English stationery printed with a tiny red stemma charged with a nine-point crown, this most unassuming invitation, or rather reminder, from 1911, gives little indication of the notorious decadence that awaited the unnamed marchese and his entourage on Via della Vigna Nuova. The neighborhood oglers were fascinated, the hostess later boasted, "to see the beautiful women, dressed to the nines, getting out of their cars in front of our door." Once inside the torchlit, polka-spewing palace, guests were treated to gluttonous spreads of food and an endless flow of champagne—with as many bottles consumed as smashed on the terracotta floor.

Lysina's contemporary, Beatrice Niccolini di Camugliano, a Florentine of the same social set whose sister had married into the family, later waxed lyrical about the aristocratic party scene in the first decades of the twentieth century:

There were plenty of balls [...] all of them with an orchestra, a buffet [...] We danced the waltz, the fox-trot, the tango, not to mention new dances like the "Lambeth Walk," the "Bumpsy Daisy," and the rhumba; it was the era of Fred Astaire and Ginger Rogers, of De Sica, Jean Sablon, and Tino Rossi.

You never made it home before dawn. And I can still remember the excruciating pain I felt upon leaving, going down the stairs of one palace, then back up the stairs of my very own—my feet were on fire from too much dancing! At the important balls, there was always a midnight dinner. Upon arriving at the house, you were handed a flower, which also appeared, in a great bouquet, on one of the tables—that's how you found your seat for dinner. Champagne flowed like a river—so, too, the whiskey—and it wasn't unusual to see some young man smashed or passed out; the women, by contrast, were much more careful.

The houses themselves set the mood, because at that time all the palaces were still private. Of the most famous parties were those held in the house of Contessa Lysina Rucellai. She was born in Russia, the child of Cossacks. She always recounted having been born in the middle of breakfast, brought to the table, and baptized with champagne. She was the crazy type, and she bickered with all of Florence.

"She was fantastic all of a piece," Acton fondly recalled, "and what she left unsaid her malicious eyes declared." Lysina recorded many of her legendary anecdotes, originally relayed in French "with a sonorous Russian accent, enormities that from other lips would send shivers of shock down your spine," in her memoir, *Souvenirs d'une cosaque*. "Instead of talking about myself—of my incomparable beauty, of my worldwide reputation, of my eternal youth—I write only of others I've known; I recall funny anecdotes and interesting meetings once forgotten." Despite her selfless disclaimer, the vanity press-publication was anything but:

> I was born a Cossack in the vast grasslands of the Ukraine, the land of my father.
>
> I came into this world by surprise, under an enormous chandelier in the middle of a ballroom and surrounded by an army of Cossack officers, of whom thirty became my godfathers. As nothing had been prepared for my arrival, they bathed me in a huge silver bowl filled with champagne.
>
> The very same night, my nurse died of cholera. A fierce epidemic was sweeping through Russia then. And though five more countrywomen were found to nurse me, they all died by the end of the week. With each catastrophe, my old Swiss maid nursed me with the corner of a milk-soaked handkerchief. No one knew what to do—another wet nurse, another case of cholera! Fortunately, a group of peasants, led by our village priest, set off on a pilgrimage to the shrine of Saint Elizabeth. Along the way, they met a group of Gypsies and saw that one was suckling a newborn. The good priest immediately ordered his muzhiks to take the mother and infant as a gift to my mother, Princess Kudashev. Mamma was delighted—like all Cossacks, she adored originality! That Gypsy, not dying like all the others, gave me plenty of milk and called me Lysina, for I was baptized Elizabeth in honor of the saint, thanks to whose feast day I had been saved. She remained in our house, and eventually we married her off; she

had six strapping sons, and they all called me "sister." So you must make allowances for my being a bit unusual.

So begins Lysina's memoir, a chatty text, by turns benign and noxious, which nonetheless takes us deep inside Palazzo Rucellai during the prewar years, allowing us to mingle with a society high on themselves.

What's in a name? Everything—for some:

> Once, on a train bound for Florence, three lovely French ladies entered my compartment. One of them said hello and asked where I was going. I said to Florence. The other asked if I go there often. I told her "very rarely," and then I asked, "Do you know Florence well?"
>
> "Oh, yes!" they exclaimed in unison, "not to mention *all* of society! We know the whole world." They began to name a number of my friends and assorted personalities, among others the Countess Rucellai.
>
> At the mention of that name, which is mine, I stopped them and asked if they knew much about her.
>
> "Her?" asked one. "She's an ass—the absolute worst!"
>
> I held my tongue in front of my new "rail friends" until we reached Florence. Then, as I was getting off, and they were continuing on to Rome, I handed them my card—
>
> <div align="center">
> CONTESSA RUCELLAI

> PALAZZO RUCELLAI

> PIAZZA RUCELLAI
> </div>
>
> —and added that I would be only too delighted to receive them on their next visit to Florence. Funny, they never told me their names.

Had Lysina's "rail friends" shown up at the eponymous palace in the eponymous piazza, there would have been some confusion, for Lysina wasn't the only Contessa Rucellai living at that address. By the start of the twentieth century, the family had managed to reclaim the *piano nobile* from renters. Long gone were the Layards; so, too, was most of the art that had once decorated Palazzo Rucellai. Still, two advantageous marriages would infuse the palace with new blood, returning a degree of luster to the dried-up edifice and filling it, again, with little Rucellai. Notably, the grandsons of Giuseppe, the man who first opened

up the house to non-Italians, each took a foreign wife: Giulio married Elizabeth Pilar von Pilchau in a Russian Orthodox ceremony in Paris in 1890 and moved his family into the first-floor rooms in 1906. Cosimo married the American Edith Bronson in Venice in 1895 and installed his family on the second floor in 1909. Despite—or, perhaps, due to—Edith's presence in the house, Lysina made a point of omitting her Christian name from calling cards and letterheads, befuddling hostesses and mail carriers alike, and chafing Edith in the process. Indeed, though each had a floor of her own, the tension between the sisters-in-law was thick enough for Lysina to hiss "family is a disease that never heals." The panacea of choice, for both contessas Rucellai, was to mingle among *amici*, for friendship, according to Lysina, was "like an operable case of appendicitis"—rarely fatal.

These rival courts of Palazzo Rucellai could not have been more different. Having grown up in Venice, the only daughter of Katharine De Kay Bronson of Newport, who famously entertained Robert Browning, John Ruskin, Henry James, Anthony Trollope, John Singer Sargent, and James McNeill Whistler in Ca' Alvisi on the Grand Canal, Edith followed in her mother's footsteps and organized on the second floor of Palazzo Rucellai parties of an intellectual bent. The quiet sophistication of the upper-floor gatherings, which attracted local and visiting literary and artistic personalities, contrasted starkly with the raucous circus-like atmosphere just one floor below, where Lysina held court over an international crowd of aristo-celebrities, wannabes, and cads:

> One day, while walking along the Arno in front of the Grand Hotel, I saw a pretty young lady come out. She followed me for a bit and then finally stopped me: "Excuse me, Madame, but Her Royal Highness Princess Adolf of Schaumburg-Lippe, upon seeing you pass and learning that you are Contessa Rucellai, has sent me to announce that she would be delighted to make your acquaintance today at her home."
>
> I accepted the kind invitation and found a lovely Princess and her lady-in-waiting, the Princess ———. Upon leaving the home of HRH, I invited her for dinner and dancing at our house, as I was throwing a grand ball that very same evening. The Princess arrived accompanied by her lady-in-waiting and the lovely person I'd met earlier in the day outside the Grand Hotel. Only then did I learn that that messenger was the daughter of Selim Pacha, the Baroness von Schlotheim.
>
> All of Florence was at the ball, including a very chic young man, the son of an important diplomat. HRH greatly admired his dancing skills and

asked me to bring him to her. Smitten, she asked me later in the evening to fetch him once more. I finally found the young man, sprawled out on a couch, his feet propped up on a cushion of yellow satin. Shocked by his lack of manners, I moved closer, but he still didn't sit up. Only when I began to shake him did he stir, audaciously asking me what it was I wanted. I told him sternly that the Princess had requested another dance.

"I don't give a damn," he sneered. And with that nicety, I promptly told him to get the hell out of my house. Such are the charming manners of today's youth.

"Florentine society," Harold Acton cleverly observed, "was expansive without being expensive." Guest lists tended to be composed of displaced nobility—vestiges of dissolving empires, pretenders in search of a still-active court; along with aspirants—mostly distant cousins who had married other distant cousins and, thus, had blown all chances of adding yet another, preferably exotic appellation to their already sesquipedalian monikers. Basically, Florentine society was made up of the used-to-haves and the have-nots.

And then there were the queer fish. Although Acton was a generation younger than Lysina, these two born entertainers formed a friendship early on, and in later years, when not presiding over his own salon at Villa La Pietra, Acton spent a considerable number of evenings at Palazzo Rucellai, still under the tutelage of Lysina, whose mastery of the arts of conversation and amusement had clearly rubbed off on this quintessential aesthete (the model, many hold, for the character Anthony Blanche in Evelyn Waugh's *Brideshead Revisited*). Acton, then, could play both parts—perfect guest and perfect host—with finesse. Perhaps for this reason, he saw right through his very own set.

"Every other member of the foreign colony had had a purple past," he remarked matter-of-factly:

> Though the purple had faded, there was a piquancy in knowing that the suave Lord X had had to flee from the London police because he was "a Greek born out of due time," and that the motherly Mrs. Y had been the power behind a throne.

As titillating as their histories may have been, the demands of these larger-than-life personalities, Acton explained, burdened many a hostess: "Ex-ambassadors and their wives continued to claim the privileges they had enjoyed in their heyday,

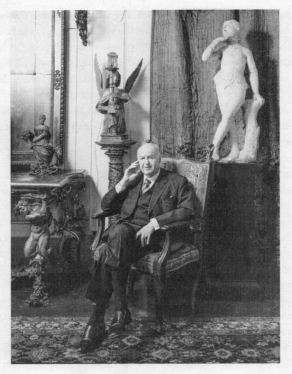

Figure 33. Sir Harold Acton, photographed in 1989 by George Wright, surrounded by Renaissance and Baroque trappings.

and since they invariably took the seat of honor, this complicated the problems of hostesses, especially when an acting ambassador was present." And if they were not seated to the right of the hostess, "their resentment was heard from the housetops!" These purple-stained outcasts "must have been drawn to Florence by the knowledge that their pretensions would be respected," Acton reasoned, for "titles roll naturally on the Italian tongue, and almost every foreigner was addressed as Excellency as a matter of course."

Not surprisingly, rampant ennobling—cavaliere, conte, marchese—came into vogue just as the boundaries between classes were beginning to blur. But already in the mid-sixteenth century, Giovanni Della Casa, addressing Annibale Rucellai in the conduct book *Galateo*, had ridiculed the then-burgeoning practice:

When men first began to pay respect to each other in artificial, inappropriate ways, and to call each other Lord and Sir, bowing and bending and writhing as a sign of respect, and uncovering their heads, and giving themselves exquisite titles, and kissing each others' hands as if they were sacred like a priest's, someone who did not have a name for this new, silly habit called it a ceremony.

Della Casa warned that this "ceremony", "so beautiful and becoming on the outside, is inside totally empty, and consists in appearances without substance and in words without meaning [...] as oversized and superfluous as the clothes of a large man placed on a midget."

But of course, artifice and folly made for perfect dance partners:

In need of some distraction, I decided to play a little game on my friends. And so, because we Florentines love a visiting star, I announced that I would be having a party to welcome to town a certain Princess Schleswig-Holstein.

Someone asked me, was she pretty? I responded that I'd heard it said that she was, indeed, a great beauty, but that I'd personally never seen her. The evening of my party, the *sala principale* was packed to the eaves, but the Princess kept everyone waiting. When her arrival was eventually announced, the guests saw a hideous old hag staring insolently at them through her lorgnettes. She greeted no one, but for me. She wore a Second Empire-style dress with a long train and a lace headdress over her bunched white hair. I immediately presented her to the notables, among them Conte Piero Cioja, Prefect of Florence, and Principe Scilla Torrigiani. All the men kissed her hand—but the noble German maintained a frigid silence. I also presented her to several of the ladies, but she turned her back on them and walked through the rooms to examine the pictures.

All of a sudden, we heard a loud cry [...] Everyone rushed to the Princess, who was having violent convulsions on the floor, kicking up her legs and displaying long white knickers and dirty stockings. She kept shouting, to everyone's dismay, "A bed! A bed!" Several young people, in spite of her kicking like a mule, managed to carry her to my *salotto* and to lay her on my couch. There, after a final kick and several somersaults, the "dame" dropped her disguise. It was Marchese Carlino Torrigiani, the handsome son of Principe Scilla, who, in ignorance, had previously kissed

his hand! The entire party laughed uproariously at the hoax—except for the Prefect, who found it offensive to have kissed the hand of such a pretty young boy.

Bored and desperate for "some distraction," Lysina found a willing cohort in the "pretty young boy" Carlino. So caught up in appearances, the starstruck guests had fallen for the ruse. That night, the palace rang with laughter, but Lysina's stage would soon go dark.

LA BRUTTA FIGURA

I'll give you some idea of the changes we're going through in Italy. In our good city of Florence there is a famous street, known for its noble beauty as much as for the chic crowd it draws daily. This street, practically the world's salon, is the beautiful Via Tornabuoni.

Nowadays, society ladies completely avoid it, making numerous detours down the poetic but dark little alleys in order to steer clear of what we call "the two sidewalks." One of these dreaded places is the very popular tearoom Doney, where the aesthetes and big spenders congregate. The stylish clientele spills out onto the sidewalk, always blocking the way and, several times a year, breaking into a fight. Directly opposite Doney is the Circolo dell'Unione, a venerable and illustrious club, whose members, aristocratic and impeccable, gather genteelly on the sidewalk in front of their clubhouse, the former Palazzo Corsi; and if it rains, they take shelter under the carriage door, never losing sight of a single passerby. They hold court like magi, these men, deciding and dishing out the fate of humankind. For instance, if a woman passes in front of them, on *their* sidewalk, they scrutinize her and whisper among themselves, just loud enough to be heard: "That one there—*che disastro!*" The poor ladies, shocked and offended, cross the street, only to land upon the playboys at Doney, whose whispers are even louder, their "admiration" a bit too blunt, their curiosity too uncontained [...]

Several foreign women not familiar with the idiosyncrasies of "the two sidewalks" were quite put off by this behavior and came to talk to me about it. I explained to the ladies that these days catcalling should be taken as a compliment, that the men obviously find them, let's say, desirable;

I did, however, concede that the word *disastro* is questionable, as it could mean "wreck," "catastrophe," or just plain "ugly." They left without saying a word. But ever since our little conversation, they no longer walk down Via Tornabuoni in front of the Circolo dell'Unione, which stands so proud and aristocratic, choosing instead to cross the street, to pass in front of Doney, which is a far less contemptible place.

Lysina's account of "the two sidewalks" is spot-on. Though the haughty members of the Circolo dell'Unione, who stood "like magi" on one side of Via Tornabuoni, could not have been more different in appearance from "the stylish clientele" of Caffè Doney, who posed on the other side like shop window mannequins, both sets of bullies had made the *passeggiata* through "the world's salon" decidedly unpleasant.

There were plenty of other important tearooms around Florence—the *caffè letterario* Paszkowski, for instance, or Le Giubbe Rosse, frequented by the Futurists Filippo Tommaso Marinetti, Umberto Boccioni, and Carlo Carrà. But the most popular place to see and be seen remained Caffè Doney, a Vanity Fair both inside and out. In the early teens, "you saw Rudolf Valentinos by the dozen," Acton recalled, "their impassive virility contrasting piquantly with a

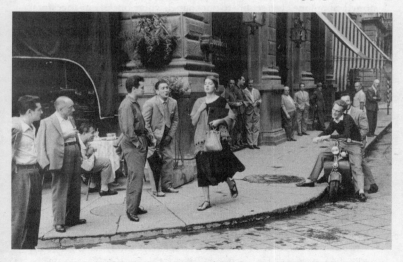

Figure 34. Ruth Orkin's *American Girl in Italy, 1951* captures the blatant voyeurism of Florentine *caffè* society in the early twentieth century.

flashing wristwatch, a sparkle of rings and a silk handkerchief reeking of Coty." Caffè Doney was, "by midday, compact with young men oozing infinite leisure: super lounge-lizards, buttonholed, brilliantined and bespatted." These peacocks "acted as decoys, enticing wealthier fowl they could pluck and keep on plucking." According to Acton, "it was from the ranks of these unemployed Narcissi that Mussolini was to draw his most rabid supporters. From Narcissus to general nuisance," he interposed, "was an easy step." Indeed, on the eve of the Great War, fashion, Futurism, and Fascism would collide at full speed, the impact catastrophic.

Here Lysina recounts, with her typical solipsism, the events of June 1914, "on the advent of Fascism. 'Red Week,' as it is called, wasn't simply a continuation of the hardships we'd long endured in Florence but," she bemoaned, "would prove to be the peak of our suffering":

> No one could drive around in cars anymore without the occupying forces confiscating them; one day, however, I had the courage to go out in my Mercedes, and some ghastly women threw bottles of ink all over my windshield! Not only that but at home we could no longer light up any of the rooms facing Via della Vigna Nuova for fear of having our facade stoned. Someone even set fire to our chapel, where one of our ancestors, Nannina de' Medici, daughter [sic] of Lorenzo the Magnificent, is buried. A mere stable separates our palace from that chapel. The firemen were called, but to no avail—they arrived forty minutes *after* we'd been rescued by a group of young Fascists who, though only children, were our real heroes. They climbed up onto the roof at the back of the palace and fought the fire with axes while the flames leapt at their feet. As for the firemen, well, there was little left for *them* to do by the time they finally arrived on the scene.
>
> That night, I spoke with my majordomo about the incident, and when I mentioned my admiration for those heroic children, he replied: "*Saved* you? Everyone knows perfectly well that those are the little Fascists who *set* the fire." Not only he, who has worked in our house for the last twenty years, but everyone—out in Piazza Rucellai and in all of the streets that surround the palace—said the same thing.
>
> Around that time, an old woman who sells cigarettes, and is very tight with our staff, stopped me in the street one day to ask why we no longer throw big parties. She added that everyone in the neighborhood regretted

it, because it had always been so fascinating for them to see the beautiful women, dressed to the nines, getting out of their cars in front of our door. I told her that, having been ruined by the Bolsheviks, we could no longer entertain on such a grand scale.

"But how is that possible?" she cried. "We are told that in your country it is the nobility who have destroyed and massacred the rest of the people!"

To think how history gets told! That woman is neither stupid nor spiteful, but her having fallen for that fiction really hurt.

Another time, while leaving the palace at dusk, I was accosted by a fairly well-dressed man, who, shaking his fist in my face, screamed at me: "If you think that you will live in this house a long time, you are mistaken. We will chase you out of it, and *we* will be the masters!"

Some of my servants were seated on the stone bench, which, as was the style in the Quattrocento, decorates the facade of the palace. Not one of them got up to defend me. And there were six men, all of whom had been in our service for many years. But as I knew from experience, one gets further with laughter than with force or rage. So I sneered in the face of this thug, gave him ten lire, and told him to drink to my health. He accepted the money, without concealing his delight, and, in return, offered to accompany me on my walk!!!!

I certainly did not want to seem afraid of him, and so, even though it was getting dark, I accepted his invitation. Luckily, an old doorman who works in a neighboring house followed me step by step and told me, "I will not abandon you, and I've warned the secret police—there, across the street, I know them well."

That charming promenade lasted just a few moments before four officers in civilian dress seized my cavalier, handcuffed him, and began to frisk him. They pulled out of his pocket a very long and frightfully sharp knife, which, he later confessed, had been destined for me. Nonetheless, throughout the search, he kept calling out to me, "Oh, dear Contessa, save me!!!"

So I'd been rescued by a poor little porter, whom I barely knew, while my minions, chauffeurs and carriage drivers, who'd always appeared so devoted, didn't so much as budge from the *banco* in front of our palace.

Upon reading of the author's "courage to go out in [her] Mercedes," one can understand why Contessa Rucellai's "rail friends" described her as they did. But

this vexing text also provides a much-appreciated account of Palazzo Rucellai—and *its* "suffering"—during Red Week.

What would Alberti have thought of the fact that the family "could no longer light up any of the rooms facing Via della Vigna Nuova for fear of having [his] facade stoned"? One now wonders if the chips and pockmarks of the *pietra forte* veneer, once attributed to time and neglect, were also caused by violence, by anarchy, by revolution. And, aside from the attacks, what would Giovanni Rucellai have thought about the invention of electricity? What better way to show off his palace, to highlight the family jewel? Alas, his ancestors, despite having managed—with great difficulty—to keep the house going for nearly 500 years, were now forced to turn off the lights, to shutter the *sala principale*.

Lysina's sense of Renaissance history, no matter how limited, is somewhat endearing. Nannina was, in fact, the sister of Lorenzo; still, Lysina is correct to name her a notable ancestor—surely the "Cossack countess" identified with "la Quaracchina," *the* hostess of the sixteenth century. She also offers an elucidative remark about the *banco*. But perhaps most striking is Lysina's description of a fire at the rear of Palazzo Rucellai. The chapel to which Lysina refers was not Giovanni's private burial chapel, which contains Alberti's replica of the Holy Sepulchre, but rather the family's communal burial chapel on the southern side of the former church of San Pancrazio, which held the Lippi altarpiece until 1808. Since its deconsecration, the building had served as the seat of the city's lottery and as a tribunal before being used as a tobacco factory as early as 1906; hence the presence of the cigarette seller who yearns for the glory days when "big parties" were held at the house. Hence, too, Lysina's very real fear that the whole block might go up in flames—as she rightly pointed out, "a mere stable separates our palace from that chapel." But because the properties are adjacent, the "children" who "climbed up onto the roof at the back of the palace" were able to put out the fire before it spread over the stable and into the courtyard.

Lysina was clearly confused about who had started the fire and who had extinguished it. Never mind that the whole neighborhood concurred on the source of the fire, Lysina spelled out in no uncertain terms exactly where her loyalties lay: not with her "minions, chauffeurs and carriage drivers," but, as the passage continues, with her "savior Mussolini, who delivered us all from mortal danger."

Lysina provides no details on how Palazzo Rucellai fared during the war,

but the family seat was still standing on Armistice Day. The shutters of the *sala principale* were reopened, the electricity turned back on, but the light within was dim.

DRESSING DOWN

In the years immediately following the war, an atmosphere of political, economic, and social instability prevailed. Italy, the Fascist regime argued, needed a strong national identity, a single social body, a population refashioned. To this end, the *tuta*, "the most innovative and futuristic garment ever produced in the history of Italian fashion," its maker proclaimed, "was born in Florence."

The inventor of the *tuta*, Ernesto Michahelles, better known by his palindromic pseudonym, Thayaht, was a second-wave Futurist artist who had also worked in the fashion industry as a designer and illustrator for Madeleine Vionnet in Paris. Back home in Florence, during the sweltering summer of 1919, Thayaht, suffocating in his heavy, stiff prewar clothes, longed for "something new and fresh." But this was a luxury few could afford. Then one day he saw in a downtown shop window several pieces of cotton and hemp. He bought the inexpensive remnants and, with the help of his brother, the artist RAM (Ruggero Alfredo Michahelles), created, after a series of "diagrams, tests, drawings and finally prototypes," a simple uniform, in white cotton, "for the masses." The unisex jumpsuit was designed to erase differences of class and culture and, to some degree, gender.

It was only logical, then, that Thayaht should market his egalitarian *tuta* through the local media. On 17 June 1920, the newspaper *La Nazione* ran an article on the novel creation and offered, for an additional 50 *centesimi*, a supplement printed with the pattern and instructions for making the *tuta* at home. A follow-up flyer, written by the artist himself, explained the origin of the name, a riff on the Italian noun *tutto*, meaning "whole": the *tuta* is "a whole piece of fabric"; it "dresses the whole person." Within weeks, Thayaht predicted, "the whole population" would be wearing the *tuta*. And as for the spelling, "the lost consonant is found in the form of the *tuta* itself, which is T-shaped." Finally, pitched the designer, the universal one-piece "is suitable for every occasion and every season. For sport, for work, as evening wear, for sleeping, for the city, for the country, for the mountains, for the beach, for the automobile, for traveling, for hunting, etc." Thayaht's "*tutti con la tuta*," or "everyone in *tuta*,"

campaign was only beginning. He himself had been photographed wearing the androgynous uniform, but the *tuta* needed a proper coming-out party, an exclusive stage to truly popularize it—never mind the inherent contradictions of his marketing scheme.

In July 1920, a "*serata futurista*," or "Futurist soirée," was held in, of all places, Palazzo Rucellai, that fifteenth-century aristocratic stronghold on Via della Vigna Nuova. The evening was hosted by Nannina, the daughter of Edith and Cosimo. A friend and contemporary of Thayaht, the 24-year-old Rucellai represented, to some degree, the new guard. As per the hostess's instructions, all of the guests showed up wearing the *tuta*, which they had personalized by dressing it "up": They interpreted "do-it-yourself" to mean not simply a choice of fabric and color

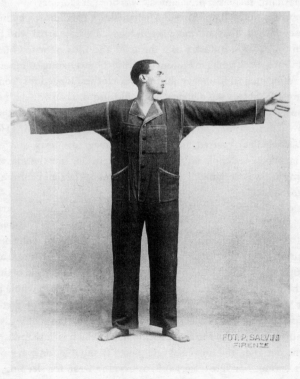

Figure 35. Thayaht's egalitarian *tuta*, modeled by the artist himself in this photograph of 1920, proved to be anything but following a presentation party in Palazzo Rucellai.

but also a choice of accessories: some wore the jumpsuit belted, others loose; many added a Robespierre collar and matching pocket square; some topped off the look with a wide-brimmed hat, others with a beret; flat perforated sandals, without stockings, were de rigueur.

Following the much-talked-about party at Palazzo Rucellai, the *tuta* did, indeed, become a sensation—but with the wrong crowd. Thayaht's standardized dress, conceived as a reaction *against* luxury, became the uniform of the very group that defined luxury—or had, at least, before the war. Now, in the summer of 1920, the upper class was dressing down. Or were they just slumming? (Nannina's ancestors, if you recall, had made their name with the discovery of *oricella*, the lichen dye—nicknamed "poor man's purple"—that enabled the lower classes to "pass," differently blurring the boundaries between high and low.)

Alas, the aristocrat's adoption of the classless garment was short-lived. Nannina herself considered the fad just that—"an isolated episode." Italy was merely going through a phase; soon, she forecast, "everyone would be back to thinking about exotic fashion." Sure enough, just as the hostess had predicted, the novelty of the *tuta* quickly wore off, leaving Florentine society as starched as before.

BOUDOIR RUSSE

After the war, and the Russian Revolution, Lysina—"having become," in her own words, "nothing more than a poor Cossack"—no longer had the means to entertain as she once had:

> One day in 1927, my cousin Prince Felix Yusupov, the famous assassin of Rasputin, came to lunch at our house in Florence with his wife, the beautiful Grand Duchess Irina of Russia […] Just as everyone was being called to table, he pulled me aside and asked if he could leave something in my *salotto*. He reached into his pocket and took out a small jewelry box. I asked him what was inside. "Oh," he answered nonchalantly, "it's only a pair of earrings. The last gift from Louis XVI to Marie Antoinette. Open it."
>
> They were a marvel: two pear-shaped drops encrusted with diamonds. Very fashionable, my cousin told me, at the end of the eighteenth century.
>
> "I don't know what to do with them," he said. "They cost a million."

I told him *exactly* what to do with them: "Put those back in your pocket at once! Ever since the Bolsheviks ruined me," I explained, "we have too few servants to leave jewelry like *that* unattended, especially in a room so far away."

The "two pear-shaped drops encrusted with diamonds" had, in fact, belonged to the guillotined Queen of France. Though the circumstances of when and how they left her possession are unclear (at one point during the French Revolution, she is said to have sewn them into her bosom), the earrings remained in the French royal family for nearly a century. In 1853, Napoleon III presented the marvels as a wedding gift to Eugénie de Montijo, but 20 years later, following France's defeat in the Franco-Prussian War and the couple's subsequent exile to England, the last empress consort of the French was forced to sell them. The diamonds, weighing 14.25 and 20.34 carats, respectively, were then acquired by the Grand Duchess Tatiana Yusupov of Russia. It was her grandson, Felix, who would reveal them to Lysina on the *piano nobile* of Palazzo Rucellai.

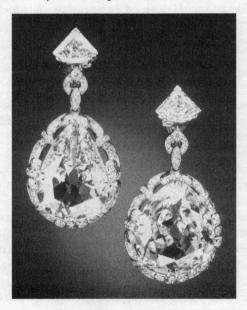

Figure 36. The nearly 35-carat diamond earrings that had once sparkled on the lobes of Marie Antoinette never suffered a dull owner post-1793.

That he was not sporting the earrings himself is somewhat surprising, given Felix's longtime penchant for cross-dressing. At the age of 12, he recollected, "I began to lead a double life: by day I was a schoolboy and by night an elegant woman," wearing on one occasion

> a dress of blue tulle embroidered with silver, and a headdress of ostrich feathers in several shades of blue. To complete the effect, I wore my mother's well-known jewels [...] On an icy winter night, a diamond-bedecked young woman in a ball dress passed rapidly through the streets of St. Petersburg in an open sleigh [...]

Felix's "complicated" lifestyle would only gain traction:

> Later on, when I was old enough to take an interest in women, life became even more complicated. Although I felt much attracted to them my numerous love affairs never lasted long because, being accustomed to adulation, I quickly tired of doing the courting and cared for no one but myself. The truth is I was a horrible little beast. I liked to be a star surrounded by admirers [...] doing whatever I liked. I thought it quite natural to take my pleasure wherever I found it, without worrying about what others might think.

Felix's self-centered approach to romance equally colored his outlook on politics and palace intrigue, as indicated by his 1953 retelling of his role in the 1916 assassination of Grigori Rasputin, the controversial spiritual healer and member of Czar Nicholas II's court. The two men had met nearly a decade earlier, when Felix, then a student at Oxford, was visiting his parents in Saint Petersburg for Christmas:

> He walked up to me, said "Good evening, my dear boy," and attempted to kiss me. I drew back instinctively. He smiled maliciously [...] From the very first his self-assurance irritated me [...] he looked like a lascivious, malicious satyr.

Over the years, Felix's disdain for Rasputin's growing influence over Czarina Alexandra only intensified, until, on 16 December 1916, the 29-year-old heir to pre-Revolutionary Russia's greatest fortune invited Rasputin to the Yusupov

family seat, the massive neoclassical Moika Palace, and there, in an elegantly outfitted basement room, plied his satyr with poisoned wine, then shot him:

> A shudder swept over me; my arm grew rigid, I aimed at his heart and pulled the trigger. Rasputin gave a wild scream and crumpled up on the bearskin. For a moment I was appalled to discover how easy it was to kill a man. A flick of the finger and what had been a living, breathing man only a second before, now lay on the floor like a broken doll [...] On hearing the shot my friends rushed in [...] Our hearts were full of hope, for we were convinced that what had just taken place would save Russia and the dynasty from ruin and dishonor.

On the contrary, Felix was immediately placed under house arrest and soon thereafter banished from Saint Petersburg. Three months later, the czar and his family were brutally murdered. Felix and his young family managed to flee Russia, but not without first retrieving from Moika Palace two Rembrandts ("Unframed and rolled up," he explained, "the paintings were easy to carry"), and—far more valuable—his mother's jewels.

In order to finance his Parisian exile, he was forced to sell the paintings early on (the American collector Joseph E. Widener, future benefactor of the National Gallery in Washington, purchased *Portrait of a Lady with an Ostrich-Feather Fan* and *Portrait of a Gentleman with a Tall Hat and Gloves* in 1921), but the diamonds and other jewels he clung to as long as he possibly could. Indeed, he still had the earrings when he visited his cousin Lysina in 1927. By the following year, however, the prodigal prince, if he was to keep caviar on the table, had no choice but to part with his family's most precious heirloom. Pierre Cartier bought Marie Antoinette's pear-shaped earrings in 1928, and in October of that same year sold them to Marjorie Merriweather Post, owner of General Foods Corporation and the wealthiest woman in the United States. In November 1964, Mrs. Post's daughter donated the earrings to the Smithsonian Institution.

Catching a glimpse of the sparkling diamonds in Palazzo Rucellai, Lysina surely pined for her lost imperial lifestyle. The salonnière may have been forced to scale back her court, but she refused to abdicate her throne. "We are pompous and grandiose in Italy," she declared. "The breath of our palace seduces us, and there is a certain harmony between us and these old walls." Thus, the frayed yet unflinching contessa, buttressed by the fortitude of the "antique Rucellai citadel,"

simply decamped from the *sala principale* to her private *salotto*—"a room," in every sense, "so far away."

There, this "remarkable survival of an extinct régime" hosted intimate gatherings for "the prewar faithful." Members of that inner circle included Gabriele D'Annunzio, Ida Sitwell, and Harold Acton, whom she affectionately called "*ce cher chinois*." The room, "one of the smallest in the Palazzo Rucellai," Acton recalled, was "crammed with preposterous stuffed pets and gew-gaws." She was "spacious even in her tiny boudoir […] straight as a column and as vivacious as her marmalade coiffure […] Unfortunately," he divulged, "the Bolsheviks had given her such a scare that she imagined they were ready to pop out on every side of her." And yet, from behind the door of her garlic-infused boudoir, "under the glass eyes of her stuffed Pomeranians," Lysina, "now nearer eighty than seventy," upheld her "salacious" reputation:

> "No Europeans have the virility of our Cossacks," she would add, scrutinizing a tired young man through her lorgnette, "we can do without sleep. We carouse and make love as long as there is any breath in us. What we call parties you call orgies. You simply can't live up to them."

Lysina's inexhaustible libido intimidated all but one, the equally insatiable Gabriele D'Annunzio, the poet-prophet of the Decadent movement in Italian literature. These fellow nonconformists forged a friendship in Paris, well before Lysina settled in Florence, and their bond continued to sustain her through the Tuscan years. D'Annunzio rebaptized Lysina "Monna Lisa degli Oricellari," a reverential nod to the Rucellai Gardens, one of the most important literary, philosophical, and political stages of the early sixteenth century. His disciple obeyed, signing her letters to him "*La sorcière des Orti*." Though the property had passed to the Venturi Ginori Lisci family, Lysina still considered it her own, courtesy of her sister-in-law Tecla Rucellai's willingness to indulge this eccentric's appetite for amusement of all sorts.

"The sorceress of the Gardens" wasted no time in forming a society of likeminded friends, who gathered, perhaps with some trepidation, whenever the enchantress summoned:

> For different reasons, frivolous and fleeting, the presence of the illustrious members of the glorious garden is kindly requested […] in the intimacy of elite spirits [… for] a night of orgies. Mona Lisa degli Oricellari plants

a spiritual kiss on those foreheads pulsating with ideas on the eve of the mystical night, while Lysine Woronzow-Schouvaloff, wife of Giulio Rucellai, awaits you with her madness this Thursday evening. *Ave Hospes!*

Lysina's double sense of self—a sort of now-and-later persona—is noteworthy, as is her self-diagnosis of "madness." The invitation is dated 29 January 1407. Was the recording of a fifteenth-century date merely a slip of the pen, or was she channeling an adopted ancestor?

Lysina, herself "frivolous and fleeting," finally ran out of breath in 1936. She was buried on the outskirts of town, in the Cimitero degli Allori, the nineteenth-century cemetery for foreigners.

Figure 37. Gabriele D'Annunzio on the beach at Francavilla al Mare in the 1880s.

Quinto Piano

*He who has not first laid his foundations may be able with
great ability to lay them afterwards, but they will be laid
with trouble to the architect and danger to the building.*

Niccolò Machiavelli, *The Prince*

Fresh from my Grand Tour of the *terme*, I returned home to find that Palazzo Rucellai had gone from quiet, esoteric edifice to three-ring circus. For in my absence a new tenant had arrived—a princess from an undisclosed Middle Eastern country, complete with full domestic staff.

Amirah, as the cute coed was called, had come to Florence as a sort of postmodern finishing school: Petrarch OUT. Pucci IN. Penthouse OCCUPIED. I hadn't been expecting a housemate—let alone one with a retinue. (Palazzo Rucellai hadn't seen liveried footmen in well over a century.) I vowed to simply ignore the interloper, just as, for the previous nine months, I'd successfully overlooked the contessa and her weekly audience with no one.

While the girls were fighting over the crown, I went about my usual business. My palace prowls, however, though they'd taken on a new deliberateness, turned up nothing in the way of a murder weapon or bloodstains or sinister shadows cast from dark doorways. I tried my hand, yet again, at unlocking the few doors that had continually resisted my advances, but the house remained obdurate.

Even the neighborhood was mum. At the *frutta e verdura* around back, at the *farmacia* next door, where every purchase is discreetly wrapped in green and white tissue paper, no one, it seemed, could—or *would*—say anything about the unsolved murder in their midst. If there were a buzz, I figured, I'd find it in the Italian press.

It was a lovely spring day, and Niko had unfolded his nylon and aluminum chair in a sunny corner of the cortile. I waved on my way toward the *portone*. Upon reaching the front of the palace, I pulled back one of the colossal doors and stood for a moment, flush with the facade of Palazzo Rucellai, on the threshold between my inner sanctum and the rest of the world. Standing there, looking out into the piazza, I saw myself as occupying the privileged, omniscient position *behind* the facade, when, in fact, I'd become a fundamental part *of* it. I grabbed the door by its thick side edge and haughtily slammed it shut behind me.

I was headed to the Biblioteca Nazionale Centrale di Firenze to see what I could dig up. Practically a mausoleum, this venerable institution, founded in 1714 by grand ducal librarian and bibliomaniac Antonio Magliabechi, serves as a library of deposit, meaning that, since 1870, every work published in Italy must be given to the library (as early as 1743, a copy of every work published in Tuscany was deposited in its collection), making the BNCF the largest national library in Italy and one of the most important libraries in Europe. Since 1935, the collection has been housed in a decidedly austere, almost clinical, building along the Arno, a far cry from the mausoleum proper located a mere stone's throw away—the church of Santa Croce, its thirteenth-century interior filled with the bones of Florence's greats, its richly colored beams of light selectively brightening Giotto's frescoes, its air heavy with the smell of hot wax.

Would Palazzo Rucellai be named, I wondered, as I loaded the first roll of microfilm onto the machine and fast-forwarded to January 1997. Sure enough, there was the house, above the fold, over and over again. Seeing the palazzo's face, in less-than-flattering photos, splashed across the front pages of the local and national newspapers, labeled a "crime scene," accused and scorned, I couldn't help but feel violated—as though something sacred had been taken from both of us. Nonetheless, I read on. With every new report, another kicker. That the crime had been committed on the third floor, on *my* floor, left me numb.

Six hours later, my eyes crossed from a full day of scanning reels of microfilm, I staggered home, to case the joint for myself. For some time now, I'd avoided the more direct, grandiose route home, along the boutique-lined Via della Vigna Nuova, in favor of the smaller, umber streets, which offered their own rewards.

At the corner of Via della Spada and Via dei Federighi, for example, an unassuming wooden door opens every Saturday at 5:00 p.m. onto Giovanni Rucellai's tomb, Alberti's replica of the Holy Sepulchre in Jerusalem. Most visitors come to admire the architecture of the miniature building; others come in search of salvation. (In 1471, Pope Paul II, if you recall, issued a bull of indulgence to those who visited the tomb, thereby granting it sacramental status.) And just around the corner, in a bleak piazza, sits the former Carolingian church of San Pancrazio. Deconsecrated in 1808, the space served as home to the city's lottery and then to a tobacco factory, before being resurrected in the 1980s as the Museo Marino Marini, a showcase for the modern sculptor's signature work—the deliberately unheroic *Horse and Rider*. Few can appreciate the graffiti-riddled walls that rise up along the southern edge of this piazza, but that expanse of Basquiat beige, admittedly an eyesore, is none other than the meager backside of the majestic Palazzo Rucellai.

Sneaking up on Palazzo Rucellai in this way had become my preferred approach to the property, my own little gotcha in the ongoing game between us: Building vs. Boarder. I'd then walk all the way around to the front of the palace and enter through the massive *portone*, which I'd push wide open, flashing the recessed courtyard to the ever-present spectators along Via della Vigna Nuova. Despite these minor victories, I was struggling to score; once inside, I was clearly at a disadvantage, still searching for answers, still stumbling in the dark.

Just as I was passing the side entrance, I heard a roar, and then a plea, "Stop! Stop!" I unlocked the wicket and slid into the cortile, where I found an agitated Niko looking up to the sky and an insouciant Amirah maneuvering her Fiat 500 reissue between columns (no, the car's model name, Cinquecento, was not lost on me). My *bicicletta*, once again, had been knocked to the ground. The princess offered her usual apology, but I only wanted her out of the house.

So did Niko. It was obvious that Amirah's constant demands had put a serious dent in his decades-old routine. But something else, I sensed, was gnawing at Niko. The next day, over a mid-morning espresso across the street, he confided in me: Amirah was hoping to transport the entire top floor of Palazzo Rucellai back to the Arabian Peninsula. If, that was, the contessa were willing to sell it.

The *altana* had been an add-on all along, but surely the converted roof terrace couldn't be amputated—or could it? And what about the Paolo Uccello fresco cycle? Though the fifteenth-century scenes had been detached from the walls and mounted onto Masonite in a rescue bid of the 1960s, the

dozen-odd panels were arguably still *in situ*. And anyway, weren't they too fragile to travel?

Suppressing my shock, I assured Niko that the Ministero per i beni e le attività culturali would never permit such a rapacious act, that Palazzo Rucellai was too significant a monument, that American and English academics, crying foul, would sign petitions! Despite my emphatic finger-wagging, I wasn't entirely convinced of my across-the-board dismissal of any such deal going down at Via della Vigna Nuova, 18. Of course, what this desert princess wanted with a single layer of a Florentine palace I could only guess at. The greater perversion, it seemed to me, was the mere idea that Giovanni Rucellai's daughter-in-law to the nth degree might be the one to dismantle his 550-year-old house of cards.

Left with little appetite, I considered skipping lunch. The prospect of losing part of Palazzo Rucellai, however, prompted me to walk halfway around the block, to the trattoria located in the ground-floor cellar at the rear of the building. I tended to avoid the tourist-friendly spot, unwilling to wait in line to enter Palazzo Rucellai. Yet there I was, sharing a bench with a family from Toledo, drinking flat prosecco beneath a dangling ham. Still trying to wrap my head around the potential purchase of the penthouse that hovered above me, I began to think about the boundaries—no matter how fluid these might be—between public and private, present and past, history and heritage. Was this about the cultural patrimony, or was it a private concern? When should ownership be considered guardianship? Could a case be made for the "public demesne"? Whose house was this, after all?

After lunch, meandering through Lion Rosso, ruminating on loss and liability, I popped into the little *libreria antiquaria* on the corner of Via Tornabuoni and Via della Vigna Nuova. Flipping through the print rack, stuffed with oversized images of the Duomo, I came across a delicate engraving of a man. He seemed out of place—and out of time: his dress was modern, relatively speaking, as was his face; that is, he wore a white neckcloth, loosely wrapped, under a dark double-collared coat, and his features were refined, nothing like the cartoonish heads of the fifteenth century I'd spent decades studying. He was unfamiliar and yet accessible. I picked up the folio and read the tiny caption printed below the bust-length portrait: LEON BATTISTA ALBERTI.

This was hardly the Alberti I'd grown up with. Gone was his Caesar cut and cassock. Eradicated, too, was his omnipotent winged eye: this man looked away. A description affixed to the back of the sheet confirmed my hunch that here, in my hands, was "Renaissance Man" remade—and removed: the engraving, by

Figure 38. Leon Battista Alberti.

a certain Giuseppe Guzzi, had been excised from an 1837 publication, an illustrated volume on famous men and women. I promptly purchased the *spolia* for €80 and took it home.

Having been returned to the building site, the architect, I hoped, might shed some light on its many secrets. I removed the picture from my bag and placed it squarely in the middle of the mantelshelf. Like Michelangelo to his *Moses*, I commanded Alberti to speak. But like that masterpiece in marble, my paper giant only looked away. His diverted gaze prompted me to refocus my attention on the mysterious glyphs of his palace facade, those carved letters and numerals and other symbols I'd taken to be a coded message meant exclusively for me. I now wondered, in the midst of this impossible banter with an appropriated Alberti, if the said message was nothing more than a figment of my imagination, an ideal narrative that I myself had projected onto this most perfect of facades, just as I'd scripted my life *inside* the palace.

*

"We'll pick you up as soon as my lunch meeting is over. Be ready to jump in," Lorenzo had instructed me a day earlier. "Khalid can't stop in your piazza."

Given the short distance between his brother's palace and mine, I went down early. It had rained quite a bit that morning, and the slightly sloped pavement of the cortile, I could see from the stairs, was still wet. I left my bags in the vestibule and hopscotched across the courtyard, trying not to soak my driving mocs in the process. I found Niko, as expected, tinkering in his workshop, a low-ceilinged labyrinth that, in its compoundedness, mimicked the layout of the palazzo itself. This suite of tiny, irregular-shaped rooms connected the original palace with the annex. I knew this because the previous summer, almost as soon as I'd arrived, my a/c had gone out; Niko and I had spent a good 45 minutes moving through his quarters searching high and low for a box fan. Ever since then, I'd always spoken to Niko from the courtyard, afraid to enter what, to my mind, was a rat-infested dungeon.

"Any word?" I asked.

"Nothing yet."

I raised my eyebrows, still optimistic that the deal between the principessa and the contessa wouldn't go through. "I'll be away for a few days, Niko. See you Monday."

I walked back to collect my bags and then exited the palazzo. Feeling somewhat nostalgic, I sat on the built-in facade bench and waited for my ride.

Before long, there was Kamal.

"*Eccola! Brava!*" Lorenzo exclaimed, as I joined him and Fiammetta in the backseat.

"Why were you sitting outside?" Fiammetta asked, as though I'd done something verboten.

"Why not?"

"Because … it's dirty."

"Yes—but it's also Palazzo Rucellai!" I replied, squeezing the tip of her nose and giving her a serious case of the giggles.

Lorenzo rolled his eyes. "Tell Elisabetta to wash your clothes as soon as we arrive, Professor."

We were headed to Falcone, formerly his mother's estate, now his own. The house had recently undergone an extensive—and expensive—restoration; just as the first wall was being torn down to make room for a subterranean gym and massage room, the architect had realized that Falcone had no foundations. A typical Tuscan farmhouse conversion soon became new-villa construction.

Robert Kime, the London decorator, was then called in to "lord" it. The full heraldic achievement mounted on the facade—a crowned black shield depicting a white wolf rampant with red tongue and claws—made me flinch.

Despite the fascist flavor of the marquis's marquee, the property was magnificent. Of course, it had already been something special when I first saw it back in August, but now, reassigned and reconfigured, the estate had taken on a decidedly regal gloss. A canopy of umbrella pines stretched from the front gate along the gravel drive to the guest entrance of the main house, in front of which dozens of American quarter horses grazed in pristine pastures of clover and alfalfa, post-and-rail fences methodically dividing the land into perfectly sectioned rectangles. Ariabella, too, had been neatly groomed—but to a different end. Set as it was deep within lush, high-yielding vineyards, the primary purpose of that estate, fashioned by designers David Mlinaric and Arabella Lennox-Boyd, had been to court critics and entertain collectors.

Falcone, instead, was more melancholic. Indeed, Lorenzo's death drive was on full display. That he had chosen his mother's house, the symbolic womb, as his final residence—where he "should die," as he solemnly put it—should have come as no surprise. As the youngest child and second son, there was simply no place for him in Florence, and he knew it; hence his lifelong self-imposed exile. He claimed to have never returned to live in his ancestral city because the pollution and mass tourism aggravated his nerves. But the truth was, it seemed to me, he just couldn't face his father's ghost. And thus the resurrection of this majestic maternal villa, Falcone, a substitute for the paternal palace he would never, not even fractionally, come to own, and a patrimony, perhaps one day, for Fiammetta. Falcone, newly fortified, might have displaced some of the disinherited son's disenfranchised grief, but Lorenzo was haunted by more than just the loss of his father's house in Florence, I now realized. He was also facing the end of the line, the extinction of the house. Since neither brother had produced a male heir, the family's venerable name would succumb with their passing; and this was a hole that could not be built up with brick and mortar.

Later that afternoon, before the housewarming weekend officially got underway, Lorenzo took me for a drive up the coast to Massa Marittima, a medieval hill town facing the island of Elba.

"I'm bringing you to the Man in the Forest," he announced. "A magician," he said matter-of-factly. "The best in Tuscany."

"Does he pull rabbits out of his hat?"

Lorenzo jerked his head around to me, his brown eyes aflame. "If you don't appreciate what I'm doing for you," he snapped, "I'll turn the car back right now!"

"Of course, I do," I said, ascribing my skepticism to nervousness. "But do you really think Fiammetta's mother put a curse on me?"

"Professor," he huffed, "you might know everything about the Renaissance, but you know very little about the real world." Without further exchange, we continued on our drive to see the Man in the Forest.

Petite and shriveled, this local psychic looked older than the metal-bearing mountains from which he apparently drew his extrasensory strength. (He used to work from a shed in the forest at the base of the Colline Metallifere, but his emphysema had forced him back into the village. The Man's powers, Lorenzo assured me, were still peaking.) Despite his hardened visage, the soothsayer had a soft side, too, revealed to me by a wide, toothless grin and the gentle hand with which he grabbed mine as he led me back to his den.

"Are you okay with the Italian?" Lorenzo asked. "Do you need me to translate for you?"

"I'll be fine," I said, politely refusing his request to serve as my confessor.

The Man shut the door on Lorenzo and took his seat behind a bureaucratic metal desk that had been covered with a thick piece of filmy glass, under which were pressed Padre Pio prayer cards, a few dry palm fronds, and a US dollar. I sat opposite him and watched, anxiously, as he prepared.

First, he emptied a one-liter bottle of non-sparkling water into a shallow, hammered bronze basin, approximately 18 inches in diameter. Next, he picked up an Aladdin-style lamp and, raising it level with his beady eyes, randomly let extra virgin olive oil drip into the bowl below. We sat quietly and watched as the beads clumped and cleaved, eventually morphing into a single prophetic blob. "Now," he said, "what can I tell you?"

I was at a loss for words, never having been to a psychic before now. I wanted to believe. I wanted to know all the answers. I just didn't have any questions—none that I could articulate, that is. The Man in the Forest must have read my mind, for he divined the following message: "Love is still a ways off" ... *plop* ... "but the book, eh, the *book* will be good."

The book?

The main event, organized for Saturday morning, was to be a wild boar hunt. Though the hunting season had long ended, *cinghiali* had become a big enough nuisance that authorities turned a blind eye to what was, in reality—at least in

Tuscany—a year-round practice. But this was a moot point, considering the expansiveness of the family's collective property: gunshots were seldom heard by anyone other than the hunting party.

I was hoping to witness this Tuscan ritual, but Lorenzo decided that I would go out riding with Fiammetta—never mind that I'd never been in the saddle. He handed me one of her helmets. It fit like a glove. How appropriate, I bemused, given his increasing infantilizing of me.

My analysis of the situation was confirmed a second later.

"Have fun, girls!" he shouted, as he walked back to the house.

Beginner that I was, I'd been paired with Milkshake. Just my speed, I thought. But before we'd even hit the main trail, the very naughty pony threw me straight into a massive mound of Mediterranean *macchia*. It was all a blur of sand and shrubbery, and as I lay supine, in a state of psychosomatic paralysis, I entertained myself with fantasies of being medevaced to the nearest hospital in the family chopper. Clearly, that much wasn't to be. Before long, the trainer had somehow managed to get me on my feet, calling ahead to alert the staff there'd been an accident. Back at the house, my requests for medical care appeared DOA. Lorenzo was furious that news of my fall had delayed the start of his hunt. "Khalid will go to the *farmacia*. No farther."

I spent the rest of the day propped on a plump chaise in the marchese's private salon, satisfactorily sedated with a steady drip of *vino rosso* and *un*satisfactorily patched with analgesic bandages. Kamal and Elisabetta had positioned my bruised body against a glorious ground of Ottoman embroidery—"handwoven for Marchese," I was told, with silk thread, "by little old ladies" in Uzbekistan villages. Lorenzo's sense of colonialism at the dawn of the twenty-first century was by now thoroughly discombobulating. Though I had the luxury of contemplating this facet from a cushy perch, my uncertainty about where he saw *me* in the Great Conquest made me only more uncomfortable. Nor was the tapestry of grouse and boar trophies in the room exactly helping matters. Looking around at this display of corpses, and then down at my own, I could only wonder what sort of appetite was being satisfied here.

That evening, as the clan gathered for dinner, I took my assigned seat, my rigid posture determined as much by the kink in my back as by the red-clawed wolf embossed on every plate, glass, and napkin within sight. Most of Lorenzo's cousins I'd met in Hungary; thus, I was well aware of their penchant for *barzellette*. Listening to their jokes, spoken in an arcane dialect, exhausted me; I simply couldn't keep up. Imagine my delight, then, to find an unfamiliar, mature face

directly to my right. The interest was reciprocal: "So, Lorenzo tells me you're a *professoressa*. How wonderful! And you're living in Palazzo Rucellai? He says you're writing a book?"

Before I could confirm all of the above, the doyenne turned to Lorenzo and asked, sotto voce, "Does she know about Alvise?"

He winced.

And I nearly choked. As I downed a healthy dose of *rosso*, she leaned in and whispered to me, "Don't be a *chiacchierona*, eh? There's nothing there."

Had Contessa Selvaggia just chided me? Fairly sure the mouthful meant "a gossip," I thought it best not to ask for a translation. And what, exactly, was meant by that grim addendum? I quickly turned to the junior equestrienne, hoping she might redirect the conversation. Alas, having parted ways with Milkshake, I was no longer idolized by Fiammetta and she, too, was ready to pounce: "What are the colors of the Levi?"

Months earlier, I would have told her simply that my family didn't *have* "colors." Now, up to my ears in the trappings—and toxicity—of the Old World, I replied, "Yellow." She held my gaze blankly. "Our emblem is the star."

"I *love* stars!" Fiammetta exclaimed. "Hearts and stars."

As the little girl cooed, the doyenne honed in on me and divulged, very pointedly, "Lorenzo has never loved anyone in his life. *Everything*'s a lie. It's called 'good manners.'"

—CHAPTER SIX—

The Tenant

*To really appreciate architecture, you might
even need to commit a murder.*

Bernard Tschumi, *Red Is Not a Color*

BLOOD IN THE ANTIQUE PALAZZO RUCELLAI; FLORENTINE COUNT MASSACRED AT HOME; MURDER PALACE. So screamed the headlines of the dailies as the story of Alvise di Robilant's murder began to emerge. There were some discrepancies between reports, but the consensus seemed to be this:

On the frigid evening of Wednesday, 15 January 1997, the 71-year-old victim had been expected for dinner at the Circolo dell'Unione, an exclusive men's club "rigorously off limits to anyone without a noble title." This was a special night at the club—the annual induction of new members—and Alvise had already paid for his seat at the celebratory dinner. His absence was confounding; he had sent no regrets. Perhaps, though, he had never planned on making the short walk from his rented flat on the third floor of Palazzo Rucellai to the private club around the corner on Via Tornabuoni, for the first part of his evening unfolded as follows: "It was around seven thirty and we heard the piano being played, as we did every evening, from Alvise's apartment," remarked Contessa

Barbara Rucellai, who lived with her husband, Conte Niccolò, on the top floor, one level above di Robilant's apartment. "I remember saying, 'how poorly he's playing tonight!' I'm certain of the time because that night we went to see a movie that started at eight-thirty and, therefore, we left the palazzo half an hour before." A little while later, at 9:30 p.m., di Robilant made a phone call to a cousin, Aleramo Scarampi. "'I'm at home,' he said, 'working on my book about the family history; if it's not too much trouble, tomorrow morning at nine I'd like to come by to photograph the portrait of our great-great-grandmother, Maria.'" The next day, the notoriously punctual di Robilant failed to keep his appointment.

On Thursday, 16 January, at 4:45 p.m., Rosa Ingrisei, the elderly wife of the porter, entered the apartment for routine cleaning. She found the door just barely shut. This didn't seem unusual to Rosa; every so often a distracted Count Alvise would leave his keys in the lock. But noticing all the lights on in the apartment gave her pause. As Rosa passed through the entrance hall, she spotted di Robilant's yellow scarf on the floor; unlike *il conte*, she thought, and picked it up. She proceeded towards the living room, passing the piano along the way. Nothing there appeared out of sorts; the usual sheet music, fugues by Bach, was spread neatly across the rack. But when Rosa reached the living room, she made a horrific discovery: Count Alvise's body, partially covered with a blue-and-white-striped bedspread, in front of the couch. His body lay prone; from his head, a pool of blood had spread across the carpet. Rosa screamed, and ran for her life.

Investigators concluded that di Robilant had been hit at least ten times on the forehead and back of the head by someone facing him in an elevated position. The bludgeoning had left the walls and ceiling of the fifteenth-century palace sprayed with fresh blood. The effect was macabre. Di Robilant's skull, it was said, resembled an aspergillum, the perforated instrument used for sprinkling holy water during a liturgical service. The murder weapon, never found, was thought to be a blunt object; perhaps a Lalique crystal duck, some surmised, the only thing said to be missing from the apartment.

Beneath the striped cloth, di Robilant was dressed only in a short robe. Perhaps he had prepared for bed; a carafe of water sat still on the nightstand. So orderly was the apartment for the most part that forensic experts were unable to retrieve any fingerprints from the piano keys, not even those of Alvise. What they did find, however, were four short streaks of blood upon a white curtain, traces of a hand evidently used to pull back a linen veil and open a window that

hovered high above the palace courtyard. A towel stained with blood was found in the bathroom. And in the bedroom, hanging above the bed, a modest canvas of Saint Jerome, one of di Robilant's most cherished possessions, had been slashed from left to right. Also vandalized in the bedroom was the screen of di Robilant's laptop computer, an old Toshiba model upon which he was writing his book. Two dresser drawers had been opened and rummaged through; credit cards had been strewn across the bed, but a check made out for 1.4 million lire had been left alone; nearby, a lampshade had been knocked severely out of whack. Despite the disarray of the bedroom, which seemed more a cover-up than a convincing scattering of clues, there were no signs of forced entry, no indications of struggle. Indeed, the door was unlocked, the lights were on, and an uncorked bottle of Asti Spumante, along with two glasses, had been set out on the kitchen table. The nobleman, it would seem, knew his attacker.

"We're looking very closely at his inner circle," the carabinieri revealed, "someone very close to him." Five hundred guests attended the funeral on Monday, 20 January, including "the crème de la crème of the grand Italian families." As friends and family filed in and out of the medieval church of Santa Trinità, located mere steps from Palazzo Rucellai, the police secretly filmed the procession in search of a suspect. Two days later, di Robilant was cremated in a private ceremony. The streets of old Florence were empty, the houses of noble families hush-hush. "More than an earthquake, di Robilant's death has shaken the very foundation of the Florentine nobility [...] wounded, they have taken refuge behind centuries-old stone, remaining silent, or they have fled from here."

The aristocracy was quick to support a theory that pinned di Robilant, a former managing director of the Florentine branch of Sotheby's auction house, to an underground art world. His murder, some speculated, was the result of a transaction gone awry. As was repeatedly mentioned, it was almost a year to the day that the English forger Eric Hebborn had been brutally assassinated in Rome; could di Robilant, a retired antiquarian short on cash, have fallen in with the wrong art crowd? The press, however, painted a different picture, calling di Robilant's murder "a crime of passion," the attack "a fit of madness" by "a spurned lover." Initial reports suggested "a feminine hand"—all eyes were on Livia Colonna, a 46-year-old Roman princess who fancied herself a psychic (the medium for a pharaoh of ancient Egypt) and with whom the victim had recently ended a long-term "sentimental" relationship. But by late January, there was a change of course: the investigation was now focused on Alvise di Robilant's "unsuspected double life."

NOBLESSE OBLIGE

"A true gentleman, his death is a deep loss for the nobility," so Marchese Niccolò Rosselli del Turco extolled the virtues of his compatriot:

> He was a lover of beauty, of history [...] hated gossip, never whispered a single word about romance, business, women [...] invited everywhere, he was gracious, attentive, gallant; a charmer in any tongue. He never spewed out nonsense, never lost control [...] he was a man of rare discretion.

Alvise di Robilant was born on 9 February 1925 in Bologna, the eldest son of Conte Andrea and Contessa Gabriella de Bosdari; grandson of Edmondo, Conte di Robilant e Cereaglio, and Contessa Valentina Mocenigo (the Mocenigo, one of the oldest ruling families of Venice, gave a total of seven doges to the Republic). He had one brother, Carlo Felice, born in 1927. Di Robilant, murdered just three weeks shy of his 72nd birthday, had been amicably divorced, for some time, from his American wife, Elizabeth ("Betty") Stokes of Lynchburg, Virginia. The couple had three grown sons.

"One of the most handsome men in Italy," the gray-blond, green-eyed, 6'2" di Robilant had been likened, since his twenties, to the English actor Leslie Howard, best remembered for playing the romantic Ashley Wilkes in *Gone with the Wind*. The

Figure 39. Alvise di Robilant, 1976, photographed by Milton Gendel in front of an art nouveau facade in Lucca.

elegant di Robilant—"*un uomo del* jet set," "*un irresistibile* playboy"—had been living alone in Palazzo Rucellai for at least a decade. His family had owned their share of palaces, including Palazzo Mocenigo on the Grand Canal, the Venetian house where Lord Byron wrote *Don Juan* and where di Robilant himself lived as a child. "In the twenties, all of the beau monde passed through Venice and, consequently, through Palazzo Mocenigo," his mother recorded in her memoir, *Una gran bella vita*. "The palace was our crown, and that crown was in large part responsible for our popularity." It was also the core of di Robilant's "palace complex," Palazzo Mocenigo having served as the first of many stages upon which the crown prince would perform:

> Alvise and Carlo, our two boys, were baptized in the *grande salone* in the arms of their English nannies [...] For the ceremony, we transformed the ballroom, designed by Sansovino, into a glorious chapel. A *Madonna* by Perugino towered above an altar we had built for the occasion, and one of four sketches of the *Paradiso* by Tintoretto—with the saved to one side, the damned to the other, and a self-portrait of the artist in a corner—was hung on the back wall. The joyous air was filled with the scent of tuberose.

Quite a debut. Before the scion could claim his birthright, however, the font dried up. "We had everything. Rather, we had too much," his mother, Gabriella, reflected. "And we wasted no time, as reckless and naive as we were, in destroying it all. We began to devour the patrimony, and little by little even our love was reduced to crumbs." Di Robilant's son Andrea describes, in a more searching vein, how his father's "enchanted childhood" in Palazzo Mocenigo quickly came to a close yet continued to haunt:

> By the early thirties, art dealers were dropping by more and more frequently. Large empty patches appeared on the walls. Pieces of antique furniture were carried out of the house. Eventually, my spendthrift grandfather sold off the palace floor by floor [...] leaving my father so bereft that he yearned for his Venetian heritage for the rest of his life. He never lived in Venice again, but even as an older man he continued to make nostalgic pilgrimages to the places of his childhood and especially to that grand old house, which had long ceased to belong to us, but where the family still kept a few old boxes and crates.

Figure 40. Alvise di Robilant's mother, Gabriella, photographed by Clifford Coffin for *Vogue* magazine in 1946.

Di Robilant's pining for the lost property finally yielded something more concrete: there, in the attic of Palazzo Mocenigo, the dispossessed aristocrat discovered a cache of some 100 coded letters written between two ill-fated lovers—Andrea Memmo, his dashing ancestor, and Giustiniana Wynne, an illegitimate English beauty, each a friend of Casanova's. The pages of their intimate missives, dating back to the 1750s, were covered with a combination of Italian script, mysterious hieroglyphs, wine stains, and more:

> When I left you, I came home and went straight to bed. As soon as I was under the covers my little nightingale felt an urge to fly back to you. I wanted to keep him here. I wanted him to stay quiet until the morning. But as much as I tried to distract him with fantasies about the nice legs of Cattina Barbarigo, the soft little tummy of Countess Romilii, and the pretty cheeks of Catina Loredan, he would have none of it. He wanted satisfaction. Would you believe he even convinced me you had ordered him not to let me sleep if I did not satisfy his every

desire? Thankful at last, and generous toward me, he wished to produce on this piece of paper the evidence of his satisfaction so that I in turn could prove to you, at the first opportunity, my blind obedience to all your wishes.

Andrea's "sticky little envelopes," smeared liberally with his semen, must have sustained Giustiniana during the dry spells between their furtive meetings, for the couple managed, cautiously, to carry on their liaison for nearly seven years. Di Robilant took the story of their clandestine, kinky love affair to heart, tirelessly devoting himself to what he called "*un amore impossibile*." Indeed, this was the book, this fetishistic piece of ancestor worship, that the homesick descendant was writing in the borrowed Palazzo Rucellai at the time of his death; alas, his transcripts of the cryptic love letters, saved to floppy disks, were confiscated by the crime-scene investigators, along with the smashed laptop.

An "*amore impossibile*." An "unsuspected double life." Was di Robilant merely decoding the illicit affair of his ancestor, or was he also donning one himself? Did the apartment on Via della Vigna Nuova provide at once a return to public grandeur and a refuge from it for more private gratifications? "Even though the count was noted for his female conquests," reported the *Corriere della Sera*, "investigators claim to have proof of a 'new vice' of Alvise's—homosexuality."

IN FLAGRANTE DELICTO

Three months after di Robilant's murder, the autopsy results were made known. The details of the report disputed his reputation as a ladies' man—self-fashioned and staunchly defended by his inner circle—and shored up earlier speculation that the victim consorted within an "*ambiente dei gay*":

> After another examination of the body [...] it has become clear that on the very night of his death the count had engaged in sexual activity: he was stretched out seminude in the living room [...] traces of blood and seminal fluid were found on the victim's body.

Semen was also found in the victim's mouth, it was reported. On 12 November 1997, the Florentine prosecutor's office officially announced that the murder investigation of Alvise di Robilant was proceeding along "the gay trail."

Both press and populace were quick to link di Robilant's homicide to a string of murders with a gay element. The first of these, and the crime with the most striking similarities (the temporal incongruity notwithstanding), had taken place in Venice on the night of 19 July 1970. The victim, Conte Filippo Giordano delle Lanze, a 46-year-old antiquarian, was bludgeoned to death in his apartment in Ca' Dario, a fifteenth-century palazzo on the Grand Canal; separated from his wife, he lived alone. Delle Lanze had been hit on the head several times with a blunt object, perhaps a silver vase. A favorite painting was found on the ground alongside the slain victim, whose body was discovered seminude in a bedroom bathed in blood. Raoul Blasich, a Croatian mariner and delle Lanze's lover, was charged with first-degree murder and sentenced to 18 years in prison, but he fled to London, where he was later assassinated.

The second murder of interest occurred two decades later, in Florence. On the afternoon of 14 June 1991, Rodolfo Lodovigi, a 59-year-old fashion merchant, was found dead in his apartment on the top floor of Palazzo Pocciani on Via Ricasoli, a block and a half north of the Duomo. The victim, married and the father of two children but long separated from his wife, lived alone. He had been savagely beaten on the head, presumably with a marble ornament; he was also stabbed in the neck and chest. His seminude body, stretched out on the bed, had been covered with a sheet. Lodovigi was known to frequent an adult-movie theater near the train station and to have engaged in group sex, on at least one occasion with two Albanian men who were arrested in connection with Lodovigi's death but later released.

The third murder in this series of "*omicidi gay*" took place in August 1997, seven months after di Robilant's murder and three months before investigators officially declared it a gay crime. Louis Blaise Inturrisi, a 56-year-old American professor of English at John Cabot University in Rome and a food and travel writer for the *New York Times*, was brutally attacked, reportedly with a wine bottle, at his home near Villa Doria Pamphili. Inturrisi was openly gay. No one was charged.

And then there were the two murders that occurred in short succession, in January and April 1998, while di Robilant's case was still open; the circumstances of these killings are remarkably similar to the first group, leading many in the media to blame the spree on a gay serial killer: almost a year to the day of the Palazzo Rucellai murder, Enrico Sini Luzi, a gentleman of His Holiness, or papal aide, under Pope John Paul II, was found dead in his apartment in Rome, just north of Vatican City, on Viale Angelico. The 67-year-old victim,

a descendant of minor nobility, was clad only in his underwear; a cashmere scarf was wrapped around his neck. His skull had been crushed with a brass candlestick. Two men were eventually arrested; one, a Romanian immigrant, admitted to killing Luzi.

Three months later, Piero Nottiani, a 50-year-old art conservator, was bludgeoned to death in his third-floor apartment in the center of Perugia, less than half a mile from the Galleria Nazionale dell'Umbria, where he specialized in the restoration of old master paintings. Nottiani's body, found on the living-room floor, had been rolled up in a Persian rug, his skull shattered with a marble statuette of an ancient goddess. The gruesome discovery was made by the victim's ex-wife; the couple, amicably separated, had one son. Nottiani, according to neighborhood lore, frequented male prostitutes. No one was charged.

Somewhat tangential in hindsight yet understandably linked at the time to these 1990s cases is the June 2000 murder of the 66-year-old Count Aldobrando Rossi Ciampolini, who lived between his vast Tuscan estate and his pied-à-terre in Florence, not far from Harold Acton's magnificent Villa La Pietra, on a street named for the first King of Italy. There, on Via Vittorio Emanuele II, the aristocrat's body was found, in an advanced state of putrefaction, nude and facedown on the bed. His neck was wound with the cord of a telephone answering machine; his mouth was stuffed with paper ripped from a phone book. A 22-year-old Albanian man admitted to having had a sexual encounter with Rossi Ciampolini the night he died, but denied killing him. He was arrested and tried, but later acquitted.

In all of these murders, the victims were found nude or seminude, at home, in grandiose surroundings; most were discovered in the bedroom; the men, excluding Rossi Ciampolini, had been bludgeoned to death with a blunt object—a silver vase, an *objet d'art*, a crystal duck, a wine bottle, a brass candlestick, a marble statuette. In a significant number of these cases, the bodies, or at least the crushed heads, had been covered. Not one of the crime scenes showed any sign of forced entry; all of the victims, it appears, knew their killers. Some, as indicated by the presence of wine bottles and pairs of wineglasses, were even expecting them.

The jury of public opinion, fueled by sensational reporting, passionately debated whether these crimes were linked, and whether di Robilant and the other victims were murdered by a gay serial killer or simply by several unconnected male prostitutes. On these questions, the jury is still out. What

was established, however, is the fact that some members of the beau monde mixed, openly or otherwise, with the demimonde, and that this historical habit had not waned. Buttressed by this cultural context of secrecy and slippage, as "outed" in the mainstream media, the Florentine authorities eventually dismissed—or, to translate the Italian term literally, "archived"—the murder investigation of Alvise di Robilant. Refusing to proceed further along "*la pista gay*," the prosecutor's office officially closed the two-year-old case. Dozens were interrogated, but no one was ever charged; nor was the murder weapon ever found.

Di Robilant's murder was likened to a *giallo*, the catchall term for crime fiction, after the yellow covers of the Italian publisher Mondadori's pulp crime series popular in the 1930s. The *Corriere della Sera*, for instance, called di Robilant's massacre "a *giallo* with all the right ingredients: the museum-city; the antique palace dripping in history; the solitary count, gentle, without enemies [...] *troppo moderno*." That the case was never solved only added to its allure. Di Robilant's murder, the *Corriere* could only conclude, was "a perfect crime, the solution of which, for now, remains within the walls of the antique Palazzo Rucellai."

WHAT THE HOUSE KNEW

There are historical precedents, of course, not only for murder, but also for its newsworthiness. Sensational crime stories, especially—those involving powerful or political figures, or those containing a particularly shocking or sexual element—have long captivated the public imagination. As far back as the Renaissance, and even beyond, murder was a normal part of daily life. Despite the church's moral imperative against it, not to mention horrific public punishments (searing the flesh of the perpetrator with hot pincers, burying the culprit headfirst in the ground, dragging the guilty behind a galloping horse), murder could be committed anytime, anywhere, and by anyone. And when it did, if known or suspected, word spread like wildfire among a public with an insatiable appetite for the unsavory.

Feeding this fascination with homicide, perhaps the most transgressive act against another human being, was the precursor to the true crime novel—the early modern murder narrative. This genre existed across media and material culture, from printed chronicles to handwritten letters, from recited verse

to illustrated broadsheets. Murder narratives—whether passed down orally and performed by *cantastorie*, or piazza singers, or preserved in print and sold as cheap pamphlets—were meant to inform as much as entertain. As such, the stories were often embellished with heartrending titles, dramatic enactments, and affecting musical accompaniment: anything to amplify the emotional impact of the crime and evoke strong audience reaction. Thus, in an attempt to "touch a nerve" or "hit home," the tales paid as much attention to the victims and culprits as to the communities and locations where the crimes occurred. Setting, thus, was a crucial element of any successful murder narrative.

That Giuliano de' Medici, the 25-year-old brother of Nannina, was killed while attending mass in the Florentine Duomo on Sunday, 26 April 1478, only augments the thrill of hearing that he had been felled by 19 stab wounds and a fatal sword blow to the head. And that Francesco Pazzi, one of the conspirators, was hanged from an upper window of Palazzo Vecchio, having been dragged stark naked from his bedroom in Palazzo Pazzi, uniquely galvanized public support for the Medici and incited Florentines to brutally attack Pazzi's corpse once the officials had released it. Or, in the sixteenth century, that Alessandro de' Medici, Duke of Florence, had been lured into a palace bedroom to be pleasured by his widowed cousin adds a titillating element to the fact that the perpetrator was also the widow's brother, Lorenzaccio ("bad Lorenzo"), and that the murder took place on the night of the Epiphany, 1537.

Even with ordinary or lesser-known homicides, details of place and space not only helped to paint a virtual picture of the crime scene, but they could also shed light on motive. This is certainly true with familial dramas such as "crimes of passion," which, more often than not, were enacted in a domestic setting, with the house itself serving as a stage or framing device for many a sexually charged crime. Indeed, in the narrative that follows, architecture clearly emerges as an accessory to murder.

One sultry Monday evening in July 1563, Vittoria, wife and distant cousin of Giovanni Battista Savelli, lay with her husband's half-brother, the bastard Troiano, in her husband's castle in the tiny medieval village of Cretone, in the Sabine foothills east of Rome. The castle was a modest one, as castles went, serviced only by two servants, a page, a widowed governess, and four lady's maids for Vittoria. Despite the close quarters and limited household staff, the couple had succeeded in carrying on their sordid affair at least since Christmas

the previous year. So how did Vittoria and Troiano manage to conceal their tryst from the lord of the manor, under whose roof they repeatedly pleasured one another? They were helped, in large part, by the castle itself.

The chunky three-story structure dates from the thirteenth century, its rustic plastered walls embedded with Etruscan pottery shards. A round, crenellated tower once fortified the northwest corner, but that defensive element lost most of its protective power when, in the sixteenth century, the ground floor and *piano nobile* were extended westward. As a result, the tower was largely engulfed by the two-story annex that now stemmed from it. On the *piano nobile*, a suite of three bedrooms was created: one at the rear, or southwest corner, for Giovanni Battista; one in the center, between master and mistress, for Vittoria's maidservants and the couple's two-year-old daughter; and one at the front of the castle for Vittoria. This, the smallest of the new rooms, was also the quirkiest, for the rounded wall of the tower, either by design or by will to survive, had shouldered its way into the already cozy room, affording the adulterous couple an array of accommodating crevices and niches.

Troiano, being the lord's half-brother, slept in the castle, but in the older part, just off the great hall. From there, he could reach Vittoria's bedroom in the annex by climbing one flight up the main stairway to a mezzanine that bisected the original structure. He would then cross over to the tower, creep up its half-forgotten stairs to the topmost window, and carefully wriggle out of it (this tower window measured a mere 14 inches wide). Next, using a cloth rope tethered to a bar, Troiano would rappel as far down as Vittoria's window, where his paramour stood, ready to scoop him inside.

For months, Vittoria's maids had turned a blind eye to the adroit couple's maneuvering, until a suspecting male servant witnessed Troiano's midnight window trick and tipped off Giovanni Battista. The next night, the lord and his servants stormed in, caught the couple in the act, and served them justice. As a servant butchered Troiano, the cuckolded husband addressed his wife, "Ah, traitress, this is the honor that you do the Savelli house. You have cut off the nose of the Savelli house!" In retaliation, he slit her throat so deeply that her head was cut half off. Still, the aggrieved husband stabbed Vittoria in the head, then plunged his dagger into her breast. Next, he ordered the room be sealed shut, and he summoned Vittoria's brother. When Ludovico arrived the next day, and Giovanni Battista recounted the events of the night before, his brother-in-law asked,

"Well, who killed her?" And Signor Giovanni Battista answered, "It was I who killed her, Signore, both of them." Then Signor Ludovico said, "You did the right thing, and you have honored the Casa Savelli, and if you had not done it, I would have done it."

In this sixteenth-century thriller, a nail-biting tale of trust, betrayal, dishonor, and revenge, architecture is offered up both as an accomplice and as an excuse. Vittoria and Troiano's deed in the accommodating annex bedroom had sullied and shamed the whole castle ("You have cut off the nose of the Savelli house!"). Giovanni Battista thus had no choice, as he saw it, but to commit a grisly double murder as an act of purification and healing—never mind that this cleansing ritual left the newly disfigured *casa* Savelli bathed in blood and permanently scarred.

FRONTAL EXPOSURE

Echoing the bent of early modern murder narratives, the crime scene at Palazzo Rucellai, from the moment the story broke, seemed to garner as much attention as the crime itself. Indeed, the first set of headlines named the palace before the victim; photographs above the fold showed Palazzo Rucellai sealed off with police tape and barricades. Full stories on the *locus delicti* soon followed, attempting to crack the case of the iconic yet enigmatic Renaissance palace—"*un palazzo nato strano,*" "a palace born strange."

The *Corriere della Sera* did an admirable job, all things considered, of conveying the lay of the (locked-up) land, in "Murder Palace: A Maze of Little Doors and Secret Passages":

> The cabalistic key to the Agatha Christie-style investigation of the murder of Count Alvise di Robilant is to be found inside the palace complex on Via della Vigna Nuova. Everyone wants to know how the assassin, or assassins, could come and go from such a famous and well-guarded palace as Palazzo Rucellai. The fact is, Alvise di Robilant didn't live in one of the noble apartments overlooking Via della Vigna Nuova, but in a little building adjacent to the palace, number 16, to be precise, which doesn't have a porter and is a modest extension, as opposed to the fortress of *pietra serena* [sic] at number 14 [sic],

> in which members of the Rucellai family still reside [...] The town house at number 16, narrow and tall, has a modern elevator and service stairs, found behind an iron gate on the ground floor, and only two rental apartments: one to a foreign lady and the other to Count Alvise. Moreover, the enormous Renaissance palace is half-empty [...] Between the crime scene and its noble neighbor, there are numerous passages; there is also the official entrance to the annex, a modest door [at Via della Vigna Nuova, 16]. On the top floor of this town house, there is a service entrance to the penthouse, located exactly above di Robilant's apartment. On the ground floor, a series of little doors and gates lead to the seemingly endless palace next door and, above all, to its courtyard, which, in turn, leads to the side street [Via de' Palchetti] [...] The incredible labyrinth of Palazzo Rucellai. An exception? No. Almost all of the historic Florentine palaces have been cut up into slivers, rented out, used as offices or retail spaces [...] All of them, now, labyrinths [...] The Rucellai annex is no exception, but for the horror that festered within.

This virtual "walk-through," pieced together in the aftermath of the crime, when any internal access was strictly forbidden, gets it almost right. Some details of the interior configuration, however, need to be corrected and others expanded, if we are to ever know "how the assassin, or assassins, could come and go from such a famous and well-guarded palace as Palazzo Rucellai."

Alvise di Robilant did, in fact, "live in one of the noble apartments overlooking Via della Vigna Nuova." The L-shaped, 1,800-square-foot apartment occupies the third-floor space that was created, in the eighteenth century, between the second floor and the roof terrace of the 1458 addition, that town house purchased by Giovanni Rucellai from his cousin Jacopoantonio and brought into the fold, visually, with an unsupervised extension of Alberti's facade. The three-bedroom, three-bath apartment also stretches west, into the original palace, and thus has a total of four windows facing Via della Vigna Nuova. But because the third floor was created when the second floor was bisected horizontally, the beamed ceiling in the front of the apartment is exceptionally low and the floor flush with the bases of the crowns of the biforate windows. Despite its westward flow, the apartment can only be accessed, as the article rightly points out, via "the Rucellai annex," the easternmost terminus of the palace complex; this bookend, of course, would be the town

house with the plain plaster front that was finally purchased in 1654, its link to the Renaissance structure signaled by the jagged edge of the unfinished fifteenth-century facade.

Further to the number—and numbering—of entrances at Palazzo Rucellai, there are three doors on Via della Vigna Nuova, each with its own address. The original door, 18, grants access to the oldest part of the palace, including the courtyard; the rooms located here (from bottom to top, those of the *piano nobile*, the Rucellai archive, the apartment Archivio, and the penthouse) are serviced by the grand eighteenth-century staircase—and its secret tributary—as well as the 1920s birdcage elevator. The 1458 door, essentially a dead end, leads solely to the ground-floor commercial space (in 1997, the Alinari photography museum) and, thus, is numbered 50r, according to the Florentine nonresidential numbering system. Lastly, the 1654 door, 16, opens into the seventeenth-century extension; the rooms found here (rental apartments plus a service entrance to the penthouse) are accessed via a modest service stair and a modern elevator, both of which are located behind a locked metal gate, as the article states. But there is also an apartment on the ground floor, a converted stable, which, at the time, was rented to a 37-year-old Scotsman "with artistic leanings"; as such, he was promptly fingerprinted (but never charged). The only other access to the palace complex is via the carriage entrance found on the side street, Via dei Palchetti, 2. Each and every door, located internally or along the palace's perimeter, must be unlocked with a different key.

Regardless of which entrance is used, however, anyone privy to the "maze of little doors and secret passages" can maneuver, albeit not without great effort, throughout the interior. On the ground floor, for instance, it is possible to go from the original structure to the annex without ever exiting door number 18 and reentering through door number 16, though doing so requires walking through the porter's personal quarters and a series of storage rooms, a labyrinth in and of itself, located smack-dab in the center of the palace complex.

But was di Robilant's assassin aware of these alternative navigation routes? Did he (assuming the killer was male) even need to be? For if the victim had been expecting a visitor, as the authorities believe he was, the culprit would have at least *entered* through the front door, which, though locked, was unmanned; passage into the palace from this point of entry required nothing more than a buzz from upstairs. Thus, the "intruder" would have appeared anything but, blending in with the regular foot traffic at Via della Vigna Nuova, 16, of which, apparently, there was a fair amount; the tenant who resided directly opposite

di Robilant, that "foreign lady," as the *Corriere* described her, was also, according to *La Nazione*, an "undesirable neighbor"—"an Albanian prostitute whom, more than once, the Rucellai family had tried, in vain, to evict."

Finally, anyone—cousin, client, or criminal—who entered the Rucellai annex in 1997 did so in plain view. For "the fortress" next door, at that time, was undergoing a major restoration. Draped scaffolding stretched across the fifteenth-century facade, as far as the jagged edge, concealing completely Alberti's noble facade and leaving the house next door fully exposed.

DEATH BY ARCHITECTURE

A built structure is always vulnerable. As we have seen, it can even be victimized—from the throwing of buckets of animal blood upon its threshold to the stoning of its facade to the cutting off of its nose. But architecture can also be an agent of violence.

In the ancient world, the Tower of Siloam in Jerusalem fell inexplicably, according to the Gospel of Luke, killing 18 people. In the year 27 CE, Fidenae Stadium, located five miles north of Rome, collapsed during a gladiator show, crushing an estimated 20,000 spectators, nearly half the audience. And in the year 140 CE, the wooden upper tier of the Circus Maximus collapsed as some 250,000 Romans watched a chariot race (the amphitheater had five times the seating capacity of the Colosseum); the cascading tier killed 1,112 spectators. In the modern era, on the morning of 18 March 1989, in the northern Italian town of Pavia, bricks started popping out the side of the massive, 255-foot-high Civic Tower, built in 1060 and embellished by Renaissance architects; the avalanche killed four people, including the 52-year-old woman who had spent half her life selling newspapers at the base of the 900-year-old bell tower. And on 19 October 2017, in Florence, a six-inch-square piece of stone ornament fell some 65 feet from the church of Santa Croce, begun in 1294, killing a 52-year-old tourist from Spain who was standing with his wife in the basilica's right transept.

How can we reconcile these catastrophes, the sudden disintegration of life and form, with the fundamental purpose of architecture to shelter, structure, and serve humankind? If architecture is the physical manifestation of how a society sees itself—and its future—how do we negotiate the fact that our buildings sometimes kill us?

By way of understanding, we might here consider Italian architect Aldo Rossi's reuse, in *A Scientific Autobiography*, of German theoretical physicist Max Planck's story

> about a mason who with great effort heaved a block of stone up on the roof of a house. The mason was struck by the fact that expended energy does not get lost; it remains stored for many years, never diminished, latent in the block of stone, until one day it happens that the block slides off the roof and falls on the head of a passerby, killing him.

"It is a death," Rossi explains, "that is in some sense a continuation of energy," a principle especially meaningful for architecture: "If one fails to take note of this, it is not possible to comprehend any building, either from a technical point of view or from a compositional one. In the use of every material," he continues, "there must be an anticipation of the construction of a place and its transformation."

For Bernard Tschumi, Rossi's contemporary, anticipation includes making allowances, for the unpredictable and the improvisational, for the unscripted and the impulsive. "There is no architecture without event [...] without violence," argues Tschumi, for whom architecture is defined as much by the enclosure of its walls as by the actions it witnesses. "Events have their own logic, their own momentum," he observes. "They include moments of passion, acts of love and the instant of death."

These musings on energy and event, on passion and death, by two key architects of the twentieth century bring us back to Alvise di Robilant and the question of his 1997 murder inside Palazzo Rucellai. To be sure, buildings do not always kill in the literal sense. And in this case, we know with certainty that Alberti's fifteenth-century Florentine palace did not stone di Robilant to death. But buildings can cause inadvertent harm by enabling certain behaviors or indulging certain lifestyles. In other words, death can also come to those who succumb to or are consumed by the affordances of an accommodating architecture.

If we can thus credit Palazzo Rucellai with having provided the stage for di Robilant's "double life," should we also blame it? What is the responsibility of architecture in managing expectations, in safeguarding against a perilous situation? Interactions, by their very nature, are never one-sided. So how do we negotiate di Robilant's actions with Palazzo Rucellai's accommodations? Is this

a matter of acquiescence or malfeasance, and, if so, on whose part? Moreover, what happens when there is a third player, an extra actor in the house, by invitation or by circumstance?

Let us return to di Robilant's biography. On 30 April 1956, the 31-year-old nobleman married the 25-year-old American model Betty Stokes, said to be one of Emilio Pucci's favorites. The newlyweds settled down in Grottaferrata on the outskirts of Rome, near Frascati, and on 3 February of the following year, Betty gave birth to the couple's first son. A few months later, Betty's friend from Lexington, the abstract expressionist Cy Twombly, traveled to Italy to be with her. Some 50 years later, Betty reflected on their friendship and Cy's summer sojourn in Grottaferrata:

> I met [Cy] through a mutual friend in Lexington, Virginia. I had just graduated and we got on like hot cakes because we were interested in the same things. We talked about art together and our aesthetic was the same [...] From then on we would go for picnics and go swimming together, and so on [...] In '55, I went [to Italy] working on a modeling job for a magazine and I thought—I wanted to stay on in Europe—that I could go on to Paris and London, as I'd never been to Europe, but instead I just got stuck in Rome [...] I had got married in Rome and I came back on a visit to New York and that's when Cy said that he always thought I was going to marry *him* [...]
>
> [In 1957] he stayed with us in Grottaferrata; there was an extra room and he lived with us for a short time. We had fun, he'd go up every afternoon and get ice creams, and so on. We were like brother and sister, really. He set up a studio and he did paintings in that place with us. I don't remember all of them [...] There was a lot going on then.

Cy took several photos of a postpartum Betty that summer. In one especially moving portrait, Betty stares out of a window, her left hand flat against her heart. Her neck protrudes, as though longing to connect with something beyond the room, yet her eyes appear glazed over. Her face betrays not a hint of a smile. Betty at the window, cornered, "stuck."

Ten years later, Twombly, now fully settled in Rome, would paint Betty's husband and now father to three sons. *Portrait of Alvise di Robilant*, of 1967, is one of a series of seven nearly life-sized portraits Twombly made of a group of friends from his earliest years in Italy, which included the scions Paul Getty

and Giorgio Franchetti, the latter an early champion of Twombly's work and eventually his brother-in-law:

> Alvise invited my sister [Tatiana] and me to a luncheon at a country house that he had rented near Grottaferrata. That was how we met this young artist, who was very elegant, very handsome, very aloof, but actually highly emotional. After lunch, he showed me the drawings he was doing, and I was dumbstruck, what an intensity! Like an electric current. They were obviously charged with such power and mental vibrations that I received the message.

Twombly's early "intensity" had only amplified by the time he portrayed his now 41-year-old friend, di Robilant. Using oil-based house paint, graphite, and wax crayon, Twombly created a multilayered, monochromatic abstract rendering of di Robilant. The only indication of the sitter's identity is his name scratched in large, loose letters across the top of the canvas. The "figure" is composed of nervous

Figure 41. Cy Twombly, at right, reveals his drawings to Giorgio Franchetti.

lines, frenetic attempts at obliteration, erasure by marking. Swift, spontaneous gray hatching against an off-white impastoed ground yields visible pentimenti, a compromised *tabula rasa*. Di Robilant's is a painful portrait—unrecognizable, violated, raw. Pulsating "like an electric current," Twombly's painting of 1967 eerily foreshadows his friend's vicious murder; for exactly 30 years later, this vision of a destroyed di Robilant would be fully realized.

Twombly's pictorial prophesy aside, what happened to Alvise di Robilant on the night of 15 January 1997 "remains within the walls of the antique Palazzo Rucellai." Indeed, this house, both witness and accomplice, will never tell.

Figure 42. Cy Twombly, seated before his work, strikes a melancholic pose.

Sesto Piano

I woke with this marble head in my hands;
it exhausts my elbows and I don't know where to put it down.
It was falling into the dream as I was coming out of the dream
so our life became one and it will be very difficult for it to separate again.

George Seferis, Mythistorema

Forty-eight hours after my fall from Milkshake, I was back in Florence—and finally in an emergency room. This time, however, the diagnosis came as no surprise: in the course of my spill, I'd broken a rib. This crack in my own little structure was an eye-opener: I'd become infatuated with the *idea* of the marchese, it finally dawned on me, just as he might have fallen for his quaint fantasy of the professor. Both of us, it seemed, seduced by the palimpsest rather than the person, had fallen for our very own fictions.

I tried my hand at writing a Dear John, a farewell epistle, an elegant invitation to call it quits, but I couldn't move beyond the salutation "*Caro Marchese*." I struggled to complete the letter—not because I had second thoughts, but because I'd slipped yet again, inadvertently addressing Lorenzo as the object of his very own desire, that precious persona under whose spell I, too, had fallen, nearly 12 months earlier. Now, however, doubting the existence of even an *inner* self behind his golden facade, I was no longer willing to play the game. So I simply

signed, at the bottom of the empty page, my name, to which I added my other suffix: "*S.nob.*" I chose not to mail the letter, autographed *sine nobilitate*, but, instead, to archive it, this manuscript testament to our year of dancing around one another—not to mention ourselves.

A couple of weeks later, Lorenzo called. He was in Florence, had just come out of a "very heavy" meeting with his brother. "Khalid is stuck in traffic. It could be 45 minutes. Are you close by?"

I agreed to meet him, only to then be told to hurry: "I'm sitting on the front bench," he whined. "Just like a tourist."

What was I running back to, I asked myself, even as I quickened what was already a brisk pace. But then, as soon as I turned the corner and saw his brother's palazzo looming in the near distance, my movements all but came to a grinding halt. My limbs were no longer my own. A nervous thumping deep in my chest inexplicably propelled me forward. Over the course of that short walk, the entire relationship played out in my head, an emotional arc that stretched from exhilaration to exhaustion.

Sure enough, there was Lorenzo—the last heir, the younger brother, the pretender to the throne—sitting on the built-in bench "just like a tourist." He wasn't leaning against the building at his back, the way I was fond of doing at Palazzo Rucellai, but had perched himself uneasily on its edge, his shoulders directed toward the street.

We walked in and sat at the bar, exactly where we'd met almost a year earlier. Francesco poured two glasses of spumante, then, obedient as ever, walked away. We each stared straight ahead. Facing us was a wall of antique wine bottles, family trophies, thick black glass covered in ash, excavated relics not unlike Pompeian body parts, remainders that heralded another end.

"In Italy," he said with a soft but detached voice, "we have a saying: *Ognuno prende la propria strada.*" *Each one goes his own way.* Lorenzo finished off his glass with a succession of childlike swallows, and then, fixing his sparkling brown eyes upon me, offered, "I'm sorry for your disappointment."

I remained silent, complicit.

In the aftermath of my riding accident, I thought differently about di Robilant's murder. His body, abused and abandoned, once lay just on the other side of the plaster wall I now sat facing. Had he felt the first blow? What had gone through his mind? Had he felt the second or even the third? Had he seen it coming? Had there been time for regret?

If di Robilant's assassin had penetrated, furtively or otherwise, both palace and apartment, could I—already behind the facade, already on the third floor—cross over to the other side and slip into the count's secret world?

I waited until after the first of the month, after the contessa had come around to collect the rent, and timed my entrance to coincide with the start of Niko's morning break. "Niko," I hollered, as I cut diagonally across the courtyard to his workshop. "The a/c has been blowing out hot air since last night."

I found him hunched over, nursing a sorry assemblage of potted plants. "Hard to believe it's that time of year again," he said, wiping the summer dew from his leathern brow. "I'll come up this afternoon—after lunch—three-thirty?"

"Sure." I counted to two. "Niko, I've been meaning to ask you: is it true that someone was murdered here?"

Niko took a deep breath, blotted his forehead again, and then, seeing that I had not blinked once, proposed, "Shall we have an espresso?"

We entered his workshop, and for the first time I ascended the short spiral stairs to his apartment, a squalid room furnished with not much more than a mattress, a bulky television set, a poster of Padre Pio, and a Formica table with matching vinyl chairs.

As the coffee came to a boil, Niko opened a cabinet and pulled out a stack of newspapers: *Corriere della Sera*, *La Nazione*, *La Repubblica*. He'd arranged them by date—beginning with 17 January 1997, the day the story broke—and kept them, perfectly folded, in plastic sleeves. I'd already read all of these, of course, in the *sala periodici* at the Biblioteca Nazionale. But holding the hard copies in my hands, there in Niko's hovel, mere floors beneath the crime scene, I felt a shiver down my spine.

"The newspapers are full of lies. Those *bastards*, they put words into the mouth of my wife!"

Seeing a paparazzi-style photograph of a frazzled Rosa (recently deceased) walking out of the *questura* on the front page of *La Nazione* understandably touched a nerve with Niko. It had been ten years since that late-night interrogation, but he was newly riled up—and more than ready to talk. All I had to do was read the article aloud, pretending to stumble over the Italian, and wait for Niko to refute the claims.

"Count Alvise had *no* intention of going out that night. Rosa had already prepared his dinner."

I knew exactly what Niko meant by "going out." He was referring to the Circolo dell'Unione, the private men's club on the *piano nobile* of the former

Palazzo Corsi, where di Robilant had been expected for the new inductees' dinner. I guess you could say I was a member of the institution that occupied that building's ground floor. Every other week, throughout my sabbatical, I'd paid my dues at Miuccia Prada's flagship store, outfitting myself for the next adventure with Lorenzo.

"What time was that?" I asked, rejoining the conversation with Niko.

"Around eight. He usually ate early. Rosa cooked dinner for him almost every night, and then she'd go back in the morning to clean the apartment. He never had the money to pay her," Niko said, scowling parenthetically. "Anyhow, that's when she found him—the next morning."

"'The next *morning*'?" I asked. "But it says here four thirty in the afternoon."

"Absolutely not. It was around eleven in the morning. Rosa went up to clean the apartment. I was right here, making coffee. Then, about ten minutes later, I heard the bell."

"Here?" I asked, pointing toward the main *portone*.

Niko nodded. "I thought it was the post. But when I opened the door, it was Rosa!"

I was as surprised as Niko. "Why was she *outside*?"

"Well, that wasn't strange," he said. "She preferred to walk outside instead of through my workshop—she thought it was too dusty." He chuckled to himself, then continued his explication. "The strange thing was how *quickly* she came back. You see, it never took a *long* time to clean the flat—Count Alvise was a very neat man—but it usually took her *at least* thirty minutes."

I reached for a Mulino Bianco biscuit as I waited for Niko to get back on track.

"Rosa was white as a ghost. She took one step through the door and collapsed in my arms. And, you know," he added, "my wife was a portly woman—Calabrian."

"Yes," I said respectfully. "Then what happened, Niko?"

"I could barely support her, so I sat her down on the wooden bench—the one in the vestibule where I leave your mail. She couldn't stop crying." Niko took the moka pot off the stove and joined me at the table. "So I came back here to get a damp towel."

"And Rosa?"

"I left her there—she was too hysterical. I eventually went back and wiped her face. We sat on that bench a good ten minutes. And then I asked her, 'Rosa, are you sick?'" Niko lowered his voice. "*That's* when she told me, 'Count Alvise is dead.'"

"What did you do?" I asked sympathetically.

"I said, 'Come on, it's time for breakfast.'" Niko looked at me with a *wouldn't you have done the same?* expression.

"Didn't you call someone?"

"*After* breakfast. My wife and I had coffee and biscuits *every* morning at eleven thirty."

"Yes, of course," I feigned concurrence in response to his vaguely sinister admission.

"When we finished, *then* I called Count Niccolò. I said, '*Conte, buon giorno.* Can you please come down?' I added that it was urgent."

"Is the conte still alive?"

"Oh, no. He died a year later. That's when his daughter-in-law began to manage the palazzo." Niko wrinkled his nose. "That's when everything changed."

As tempted as I was to pursue this most interesting digression, I refocused the conversation. "So you called him and said it was urgent?"

"Yes. He came right down. He and Contessa Barbara. They were still in their pajamas. You must understand, Count Niccolò *never* emerged before 11:00 a.m."

"What did you tell him?"

"I told him Count Alvise was dead."

"Just like that? What did he say?"

"Nothing. But Contessa Barbara cried out, 'Oh, poor Alvise, he died just like Errol Flynn!'"

I didn't follow, exactly, but Errol Flynn could wait. Niko was suddenly talking a mile a minute.

"Count Niccolò went back to his apartment to change—he lived on the top floor, where Princess Amirah is now—and then, around noon, we walked through my shop and took the modern elevator up to the third floor. Contessa stayed downstairs, and Rosa, well, she never went back into that apartment." He downed his espresso in one sip. "Do you want to see it?"

My heart was racing as we entered the apartment. It had the same colossal wood-beam ceiling as Archivio, but here, in di Robilant's spread, nearly five times the size of mine, the effect was even more claustrophobic. As we passed through the kitchen and the living room came into sight, I paused to imagine a bottle of Asti Spumante on the table, a piano somewhere nearby, a couch, a body strewn across the floor, Rosa dropping her mop.

Niko, on the other hand, had marched directly into the bedroom. I slowly followed him in, scanning the walls of the apartment for the slaughtered canvas

of Saint Jerome, whose wasted penitential body would have prefigured the grotesquely beaten flesh of di Robilant. I was spared both sights, but upon joining Niko in the bedroom I did see very clearly what, up until then, I'd only read about: the floor level cutting into the tips of the arched windows of the facade, resulting in a series of hemispherical humpbacks rising just about two feet off the floor. From an architectural standpoint, this detail was fascinating. From a renter's perspective, it was dark and penitentiary. Even though I lived on the same sliver of a floor, also in the front of the palace, my apartment had no such skewed view; Archivio had been a servant's room, after all, the window tops peremptorily plastered over.

Figure 43. The jagged edge of the unfinished fifteenth-century facade casts bladelike shadows upon the Palazzo Rucellai annex.

"This is where we found him—Count Niccolò and I."

I spun around. "Here? I thought Rosa found him in the living room."

"No. The bedroom. He was right here—facedown. His head was near the window and his legs came out into the middle of the room like this." Niko began to gesture like an air traffic controller.

"Was he covered with a sheet?"

"I don't remember. There was so much blood." Niko clasped his hands together and slowly squeezed as he told me that "his head looked like a deflated football. Do you understand? His face was missing—his eyeball was stuck to the wall."

I recoiled at the grisly image. "Is that when you called the police?"

"*I* wasn't the one to call the carabinieri," Niko snapped defensively. "*Count Niccolò* dialed one one two."

"What time?"

"Around four thirty."

When I asked about the time lapse, Niko shrugged. "High society," he said. "Secret life. Top-class people." He delivered this string of "clues"—or, rather, self-styled headlines—in a slow monotone, eyes squinted, as though I were naturally complicit with his assessment of the caste in question.

Back down in the cortile, Niko ascribed a value to his version of events: "Now, I'd like to ask you for something in exchange."

This was awkward. As I silently calculated how much cash I had on hand, Niko grabbed from his workbench a marked-up copy of *La Pulce*, the weekly classifieds. "You know, my wife passed away six months ago. And I've been very lonely."

I froze. Standing there in the courtyard, stiff and speechless, I must have appeared as white as Rosa had ten years earlier.

"They advertise 'girlfriend experience,' but I'm looking for a *wife*—someone to clean the apartments, cook, keep me company ... Maybe you know someone? Preferably, pardon me, a Christian woman."

Relieved to learn that Niko considered me the potential matchmaker and not the match, I let out my breath. "Not offhand, Niko, but I'll certainly let you know if I think of someone."

"*Please*"—Niko pressed his palms together as if in prayer—"don't tell the contessa I unlocked the door for you. I'm an old man. I don't want to lose my job."

I put my finger to my lips and returned to Archivio.

*

As I stared at the stone and plaster membrane that separated the crime scene from my apartment, trying to disentangle truth from fiction, I realized that the more intriguing mystery was not so much who had *killed* di Robilant, but who had *died* there. For it is precisely such uncertainty that defines the man and his murder—the inability to ever know the tenant on the third floor. Indeed, though our residencies didn't overlap, I felt a certain consanguinity with the departed di Robilant: both of us subscribing to the belief, like so many before us, that the palace is a place of opportunity, a place where identity can be assumed as desired; two tenants with much to gain, and maybe a thing or two to hide.

EPILOGUE

Seemingly overnight, Princess Amirah, having finished out her summer term, had flown back to her own court. *Without* the top floor of Palazzo Rucellai, I might add. The contessa's steadfastness in the face of a blank check was admirable—even if she was, as I liked to believe, still kicking herself. I, for one, was thrilled to have the place intact and all to myself again, if only for a few more weeks. My sabbatical now over, I was facing, once again, life on the other side of the facade—that is to say, life back on campus.

I'd put off the real-world task of packing up my belongings as long as I possibly could, until an email from the provost's office, announcing the date of the first faculty meeting of the fall semester, shook me, ever so slightly, from my Renaissance stupor. I began with the disassembly of my *Wunderkabinett*, for over the course of my sabbatical I'd gradually filled its tiny drawers with curiosities of my own choosing—collected objects and tokens, accumulated memories, material traces of instances from my palace idyll:

2 porcupine quills, ferreted out on my walks up to I Tatti
1 silver and gold hatpin, engraved MON RÊVE
20-odd buttons from Prada, in varying shades of dark
1 antique coral necklace from Dubrovnik
Assorted kidney stone granules
1 gold signet ring, engraved with the Florentine lily
6 silk sachets, in jewel tones, filled with dried rose petals from the *farmacia antica* of Santa Maria Novella
A veritable drawer full of bloated cork
1 silver-plated spoon, from Rivoire, for eating chocolate
A chip of *pietra forte*, masquerading as a piece of Palazzo Rucellai

A folded paper napkin, scribbled with a faded phone number
About 200 *messaggi d'amore* from Perugina
1 silver pillbox, engraved "AL," purchased at the Piazza dei Ciompi flea market
1 palace key, in 2 pieces

With my spoils swaddled in bubble wrap, I turned to my books. The shameful fact that the tomb project had never really been unpacked made this truant's job somewhat easier. Those 15 boxes, eventually unsealed but immediately shelved, simply needed to be pulled out from the lower half of the *Wunderkabinett* and retaped. But I did have to pack up all the photocopies on the palazzo that I'd made over the previous 12 months. This would require several trips to the bar across the street, six-bottle boxes being the perfect size for stacks of A4 paper. I also had a couple of books to pick up, including one rare text I'd coveted all year from the bookstore up the street, whose window would soon be shuttered for the full month of August. I rushed out to collect my book—and to bid the proprietors a *"buona vacanza"*—and then I did a sweep for boxes.

Balancing a cardboard tower in my arms, I shunned the palace stairs and took the birdcage elevator. I sealed myself into the walnut-paneled capsule and pushed "ARCHIVIO." The ascent seemed slower than usual, but there was no turning back, no way to alight onto another level, the doors to the *piano nobile* and the Rucellai archive resolutely locked shut by the contessa. (This I knew from my very earliest palace prowls.) So I took a seat on the fold-down leather bench and stuck it out. A few seconds later, stuck I was, for my journey had come to a jarring halt.

By now accustomed to being shafted this way, I pushed *"EMURGENCIA"* and waited for Niko to set me free. Well aware that my release might take the better part of the afternoon, I pulled out my book, a rare nineteenth-century reprint of the rarer-still fifteenth-century *Hypnerotomachia Poliphili*. Published in 1499 by the Venetian printer Aldus Manutius, this exceptional book, with its unprecedented number of woodcut illustrations one of the most beautiful in the world, is as sumptuous, and as mysterious, as the story it tells. Part fictional narrative and part scholarly treatise, the *Hypnerotomachia Poliphili*, written—many believe by Alberti—in a deliberately obscure language, is a complex story of love and architecture, of desire and illusion—an erudite (con)fusion of body parts and building parts. Well schooled in such matters, at the close of my year-long residency in Palazzo Rucellai, I began to read.

*

EPILOGUE

Suffering from unrequited love, Poliphilo, "nourished by a false and feigned pleasure," had been up all night. Then, finally, just as "the bright and twinkling stars were already starting to pale," he fell asleep and began to dream:

"I seemed to be in a broad plain that was all green and adorned with a mass of various flowers," he later recalled. "Reassured by the quietness and pleasantness of the place and thus feeling safe, I proceeded." So seduced by the beauty of this foreign landscape, Poliphilo suddenly found himself in the middle of a thick wood. "Scarcely had I entered it than I realized that I had carelessly lost my way, I knew not how."

Shortly thereafter, he awoke in a second dreamscape, where he saw "pyramids, obelisks, huge ruins of buildings, varieties of columns […] capitals, bases, epistyles or straight beams, bent beams, zophori or friezes, and cornices with their ornaments […] a magnificent portal […] a remarkable bath, fountains," and many other "magnificent works":

> After looking at this so intently and concentratedly, my senses were captivated and stupefied by an excess of pleasure that excluded any other joy or comfort from the grasp of my memory. As I marveled at it and examined carefully every part of the beautiful complex, examining these excellent and noble statues made from virgin stone, my emotions were suddenly so warmly aroused that I gave forth a sobbing sigh. As my loud, amorous sighs resounded in the close air of this solitary and deserted place, I was reminded of my divine and immeasurably desired Polia.

Escorted by two nymphs, Poliphilo eventually reached "the three portals." Upon entering "the third and central door," he was told, "'this is the place, Poliphilo, where it will surely not be long before you find the thing you love most.'" Behind the portal, he found a bevy of splendid nymphs, so "seductive, enticing and tempting" that they could "crumble even the hard flint-stone." Feeling "invaded and infected by the fiery contagion," Poliphilo "did not notice when the amiable ladies" departed, leaving him "alone, all aroused, in this pleasant pain."

"I was beside myself and in a kind of rapture as I raised my eyes a little," he recounted, "and saw before me an artificial pergola of flowering jasmine." He entered and "came without noticing it to the other end," where he saw a crowd of people "making merry together with loud voices and the melody of various instruments, with charming and playful dances and clapping." He stopped and stared, bemused, "hesitating to go any further forward."

And then, "a noble and festive nymph" emerged from the crowd. As she drew nearer, Poliphilo, "seized and dumbstruck," realized that the nymph was none other than his "golden-haired Polia." With her right hand she took his left, and spoke: "'O Poliphilo, you can safely come along with me, and have no fear.'" Poliphilo, "overthrown and seized by a fervent amorous flame," quickly offered his hand. "As I placed it in hers," he recollected, "I became her pupil."

Polia led Poliphilo "through other beautiful places," including "a marvelous temple" before being met there by Cupid. "'Come then with your inseparable companion into the sure protection of my boat,'" he announced to Poliphilo, "'for none can make the crossing to my Mother's realm, to that destined isle, unless I transport him as his own captain and fare.'" The lovers, "without hesitation," boarded "the fateful boat." Polia, "settled comfortably in the bow, and I," Poliphilo explained, "at her side." Accompanied by sea gods, "seahorses and mermen," nymphs, "shorebirds and white swans," he remembered, "we sailed on joyously, totally plunged and sunk in this unbridled desire, until our prosperous voyage brought us to the delicious Cytherean Isle."

There, the couple was met by "a numberless host of demigoddesses bearing gifts" and "noble nymphs of especial beauty"; some "were dressed in the purple of the sea snail, some in twice-dyed Tyrian purple, and others in transparent garments [...] O infectious artifice! O alluring company!" exclaimed Poliphilo. Next, the happy entourage traveled by "triumphal chariot to a wonderful theater," in the middle of which was a fountain. "And behold!" Poliphilo declared, "I saw clearly the divine form of her venerable majesty as she issued from the springing fountain." Poliphilo and Polia knelt "in an ecstasy of divine awe" before Venus, who "stood naked in the middle of the transparent and limpid waters of the basin."

Following a "divine speech" by the goddess of love, Cupid "took aim at me," Poliphilo recounted, "with his flying golden arrow"; then "quickly he drew it out of my inflamed breast, stained and steaming with hot blood." He "transfixed my blazing-haired Polia in her breast" with the same "wounding and bloodstained arrow" before bringing it to Venus's fountain to wash it. "Heavens!" Poliphilo trumpeted,

> My mind was so shaken and weakened that it could not understand whether I was undergoing a change like that of Hermaphroditus and Salmacis, when they embraced in the cool and lively fountain and found themselves transformed into the single form of their promiscuous union.

EPILOGUE

So enraptured, Poliphilo was left by the nymphs to revel in his hermaphroditic bliss, and Polia was called upon to tell her side of the story.

When Polia finished her short narrative, the nymphs thanked her and took leave of the couple. "Then, winding her immaculate milk-white arms in an embrace around my neck," Poliphilo recalled, "she kissed me, gently nibbling me with her coral mouth. And I quickly responded to her swelling tongue, tasting a sugary moisture that brought me to death's door." Polia, "more aroused, encircled me like a garland, and as she squeezed me in her amorous embrace," he recalled,

> I saw a roseate blush strongly suffusing her naturally snowy cheeks [...]
> The extreme pleasure caused tears like transparent crystal to form in her bright eyes, or like pearls finer and rounder [...] than those that Aurora distils as morning dew upon the roses."

Just as Poliphilo began to lose himself in "this deified, celestial image," Polia "dissolved in the air, like the smoke, perfumed with musk and ambergris, that rises to the ether from a stick of incense." All too quickly, he sighed, "she vanished from my sight, together with my alluring dream, and in her rapid flight she said: 'Poliphilo, my dear lover, farewell!'"

At the song of the nightingale, Poliphilo left behind his dreamscape and rejoined the real world:

> This was the point, O gentle readers, at which, alas, I awoke [...] this mysterious apparition was shattered and carried off, by which I had been led and raised to such lofty, sublime and penetrating thoughts. Perhaps the sun had become envious of such a blissful dream, and came to plunder the glorious night [...] And as the day dawned and supplanted them, I was left filled to the brim with a sweet and loquacious illusion [...] I awoke and emerged with a start from my sweet dream, saying with a sigh: "Farewell, then, Polia."

Several hours later, freed from the trap, I stood on the ground floor of Palazzo Rucellai, burdened by its stories, leveled by its refusals, unyielding in my sudden belief that the object of one's desire can never be fully penetrated. For I, like Poliphilo, had fallen for a fantasy, a fiction, a facade. It was time for me to bid farewell to my palace—my icon, my idyll.

It seems that the man should be the master of it,
but the opposite is true—our palaces are the masters of us.
This palace will last almost forever; ask yourself then
if this palace has mastered him,
and how many others still to come it will master.

—Luca Landucci, 1491

Figure 44. Florence, Christmas Day, 2012.

ACKNOWLEDGMENTS

Just as countless residents have passed through Palazzo Rucellai, leaving traces visible and invisible, so, too, have myriad friends and colleagues touched this book in ways large and small. My deepest gratitude to all. A special debt is owed to those literary architects who helped shape this story and see it to completion. Gillian MacKenzie, my talented and determined agent, worked tirelessly to find the best home for this book. Tatiana Wilde embraced this project with infectious enthusiasm and a clear vision. Jayne Parsons took up the editorial baton with commitment and care. On the production side, I have been fortunate to work with an expert team: David Campbell, Alex Billington, and Sarah Terry. At an earlier stage, Rob McQuilkin and Erika Goldman contributed to this project in invaluable ways. Tripp Evans deserves special recognition for bookending this work, quite literally, as he first encouraged me to pursue this story and then kindly indexed it. Finally, immeasurable thanks to my parents, as always.

TEXT PERMISSIONS

Excerpt from an interview with Rem Koolhaas, 6 March 2012, in Rem Koolhaas, "The Invention and Reinvention of the City," *Journal of International Affairs* 65, no. 2 (2012): 113–19, 115. http://www.jstor.org/stable/24388222.

"Theory" from *The Collected Poems of Wallace Stevens* by Wallace Stevens, © 1954 Wallace Stevens, 1982 renewed by Holly Stevens. Used by permission of Alfred A. Knopf, an imprint of the Knopf Doubleday Publishing Group, a division of Penguin Random House LLC. All rights reserved. Used throughout UK and British Commonwealth by permission of Faber and Faber, Ltd.

Excerpt from *The Divine Comedy of Dante Alighieri: Volume 1: Inferno* by Dante Alighieri, translated by Ronald L. Martinez and Robert M. Durling. © 1996 Oxford University Press. Reproduced with permission of Oxford University Press in the format Book via Copyright Clearance Center.

Excerpt from *Powers of Horror: An Essay on Abjection* by Julia Kristeva, translated by Leon S. Roudiez. Copyright © 1984 Columbia University Press. Reprinted with permission of the publisher.

Excerpt from *Brideshead Revisited* by Evelyn Waugh, copyright © 1979, 1981, 2008, 2012. Reprinted by permission of Little, Brown, a subsidiary of Hachette Book Group, Inc.

Excerpts from *A Room with a View* by E.M. Forster courtesy of The Provost and Scholars of King's College, Cambridge and The Society of Authors as the E.M. Forster Estate.

Excerpt from "Mythistorema" by George Seferis, translated by Edmund Keeley, reproduced with permission of Princeton University Press, from *George Seferis: Collected Poems* © 1967 Princeton University Press, 1995 renewed; permission conveyed through Copyright Clearance Center, Inc.

NOTES

PREFACE

"It often happens": Alberti, *On the Art of Building*, 1988, 4.
"If there is someone": Bruni, "Panegyric to the city of Florence," 140–1.
On the performativity of architecture, I drew upon Cairns and Jacobs, *Buildings Must Die*, 13; and Read, "The play's the thing."

PROLOGUE

"one's gaze": Alberti, *On the Art of Building*, 1988, 314.

CHAPTER ONE: THE MERCHANT

"clotted blood": Pliny the Elder, *The Natural History*, vol. 2, 447.
"needless splendor": Plutarch, *Plutarch's Lives*, 48.
"when [Nero] saw a matron": Suetonius, *The Lives of the Twelve Caesars*, 262.
"Let us be prepared": Pliny the Elder, *The Natural History*, vol. 2, 443.
"All such vanity": This quote and subsequent ones are from Clement of Alexandria, *Christ the Educator*, 183, 184, 188–9.
On the purple dye industry, I drew upon Greenfield, *A Perfect Red*, esp. 23; Born, "Purple in classical antiquity," esp. 113; Kok, "A short history of the orchil dyes"; Perkins, "Ecology, beauty, profits"; and Casselman, *Lichen Dyes*.
"far more beautiful": Theophrastus, *Enquiry into Plants*, 1:333.
On the cloth industry in late medieval Italy, I consulted Villani, *Cronica di Giovanni Villani*, 212; Raymond de Roover, "A Florentine firm of cloth manufacturers," esp. 533–60; Florence de Roover, *L'arte della seta*; and Goldthwaite, *The Economy of Renaissance*

NOTES

Florence, esp. 322–40, 367–76. The "Trattato dell'arte della lana" is reproduced in Doren, *Studien aus der Florentiner Wirtschaftsgeschichte*, 1:484–93.

"Strip us totally nude": Niccolò Machiavelli, as cited in Frick, *Dressing Renaissance Florence*, 1. On the workforce, in particular, see Edler, *Glossary of Mediaeval Terms of Business*, 324–31; Leix, "Dyeing and dyers' guilds," 11; and Origo, *The Merchant of Prato*, 64.

"The finger of a dyer": As cited in Brunello, *The Art of Dyeing*, 41.

"Take one pound of *oricella*": This excerpt from the *Plictho de l'arte de tentori*, the first printed book on dyeing, is reproduced in Hellot, *The Art of Dying Wool, Silk, and Cotton*, 233.

On the use of children's urine, see Brunello, *The Art of Dyeing*, 96. On urine collection ("urinous volatile spirit") and processing, see Hellot, *The Art of Dying Wool, Silk, and Cotton*, 234; and Casselman, *Lichen Dyes*, 9.

"Any body may be made to appear": Newton, "A letter of Mr. Isaac Newton," 3084.

On sumptuary legislation, I drew upon Hughes, "Sumptuary law and social relations," esp. 73; Rainey, "Dressing down the dressed-up," esp. 230–1 for the Saint Bernardino of Siena quotation; and Frick, *Dressing Renaissance Florence*, esp. 179–200 and 180 for the Villani quotation.

On dressing the "new man", I drew upon Frick, *Dressing Renaissance Florence*, who cites the Vespasiano quotation on 85.

On the neighborhood of Lion Rosso, I drew upon Kent and Kent, *Neighbours and Neighbourhood*, esp. 8; and Terpstra, *Lost Girls*, 108.

"Our ancestors were orchil dyers": Marcotti, *Un mercante fiorentino*, 54 (author's translation); on merchant banking and usury, see Origo, *The Merchant of Prato*, 147–53. On Alamanno's descendants and the Rucellai family pre-1400, see Gamurrini, *Istoria genealogica*, 275–83; Passerini, *Genealogia e storia*; and Marcotti, *Un mercante fiorentino*. See also Ross, *Florentine Palaces*, 275–92.

PRIMO PIANO

"When a little ray": Alighieri, Durling, and Martinez, *The Divine Comedy*, 517–19.

CHAPTER TWO: THE OPPORTUNISTS

On Rucellai's early years, I drew on F. W. Kent, *Household and Lineage*, 232; and idem, "The making of a Renaissance patron," esp. 14–21.

The bibliography on Alberti is immense. Readers will not find in these pages an exhaustive compilation, but rather only those works cited or consulted for the particular narrative presented here. On Alberti's early years, I drew upon Baxendale, "Exile in practice"; and Tavernor, *On Alberti*, 3–12. See also Grafton.

NOTES

"As soon as they have seen the city": Bruni, "Panegyric to the city of Florence," 143. On the use of surnames, see Molho, "Names, memory, public identity," esp. 240. On Giovanni's personal device, see Warburg, "Francesco Sassetti's last injunctions."

"Like sailors": Alberti, *Dinner Pieces*, 215. On Alberti's emblem, I consulted Watkins, "L. B. Alberti's emblem"; Schneider, "Leon Battista Alberti"; and Tavernor, *On Alberti*, 31–6.

On the development of domestic architecture, I consulted Goldthwaite, "The Florentine palace"; and Musacchio, *Art, Marriage, and Family*, esp. 63–66. On tower height legislation, see Trachtenberg, *The Campanile of Florence Cathedral*, 177.

On palace-building, see Goldthwaite, "The building of the Strozzi Palace"; and idem, *The Building of Renaissance Florence*. On construction costs, see F. W. Kent, "Palaces, politics and society," esp. 56; and Goldthwaite, "The Economic Value of a Renaissance Palace," esp. 2.

The pseudo-Bernardine's quotation is cited in F. W. Kent, "Palaces, politics and society," esp. 43; Salutati's quotation is from Salutati, *Colucii Salutati, De seculo et religione*, 60 (author's translation); Bruni's quotation can be found in his "Panegyric to the city of Florence," 140 and as cited in D. V. Kent, *Cosimo de' Medici*, 218; Dati's quotation is from D. V. Kent, *Cosimo de' Medici*, 218; Landucci's quotation is cited in Goldthwaite, "The building of the Strozzi Palace," 114; Cavalcanti's quotation is cited in D. V. Kent, *Cosimo de' Medici*, 223. See also D. V. Kent, "The importance of being eccentric," esp. 130–1; and on house scorning, generally, see E. Cohen, "Honor and gender."

"there are two important things": As cited in F. W. Kent, "The making of a Renaissance patron," 13.

"compelled to rent": This quote and subsequent ones are cited in Kent and Kent, *Neighbours and Neighbourhood*, 3.

"not accepted but suspected": G. Rucellai, *Giovanni Rucellai ed il suo Zibaldone*, I, 122 (author's translation).

"From eight houses": As cited in Preyer, "The Rucellai Palace," 156.

Although not published until 1485, Alberti's *On the Art of Building* (*De re aedificatoria*) was probably begun around 1443 and completed by 1450; see Grayson, "The composition of L. B. Alberti's *Decem libri de re aedificatoria*."

"I am like a foreigner there": Alberti, *Opere volgari*, 2:204.

"great pleasure and joy": This quote and subsequent ones are from Alberti, *On the Art of Building*, 4, 315. On the magnificence debate, I consulted Fraser Jenkins, "Cosimo de' Medici's patronage"; and Lindow, *The Renaissance Palace*.

For Alberti's remarks on decorum in private building, see Alberti, *On the Art of Building*, 292–3.

"that reasoned harmony": This quote and subsequent ones are from Alberti, *On the Art of Building*, 156, 302, 303.

"a salad of mixed greens": This quote and subsequent ones are from G. Rucellai, *Giovanni Rucellai ed il suo Zibaldone*, I, 2, 9 (author's translation). For the full text of Rucellai's commonplace book, see the edition edited by Gabriella Battista (Florence: SISMEL–

NOTES

Edizioni del Galluzzo, 2013). A microfilm of the manuscript has been deposited in the Warburg Institute Library in London.

"own longing": This quote and subsequent ones are from Alberti, *The Family in Renaissance Florence*, 179.

"How many respected families": This quote and subsequent ones are from Alberti, *On the Art of Building*, 3.

On the death drive, I drew upon Leach, "*Vitruvius crucifixus*," esp. 215.

"great honor": As cited in F. W. Kent, "The making of a Renaissance patron," 55 n. 2.

For the discussions on the physical and visual constraints of the building site and Alberti's design adjustments, I drew upon Tavernor, *On Alberti*, esp. 89–91.

On the illusionism of the facade, I drew upon Preyer, "The Rucellai Palace," 180; and Burroughs, *The Italian Renaissance Palace Façade*, esp. 14–16, 102–4.

For Alberti's remarks on the *velum*, see Alberti, *On Painting and On Sculpture*, 68–9; and Alberti, *On Painting*, 64. Alberti's description of his "demonstrations" is cited in Pastore and Rosen, "Alberti and the Camera Obscura," 260.

"If the city is like some large house": Alberti, *On the Art of Building*, 23, 119. On the question of palace access, I consulted Goldthwaite, "The Florentine palace," 998; F. W. Kent, "Palaces, politics and society," 44–5; Preyer, "Planning for visitors," esp. 370; and D. V. Kent, *Cosimo de' Medici*, 230–1. Giovanni's remark on receiving guests is cited in F. W. Kent, "The making of a Renaissance patron," 84.

"It is not proper": Alberti, *On the Art of Building*, 69, 62. On the reuse of walls at Palazzo Rucellai, see Preyer, "The Rucellai Palace," 160–1. On the reuse of walls in general, see Preyer, "Florentine palaces."

"a great house": As cited in Preyer, "The Rucellai Palace," 162 (author's translation). The "walk-through" of Palazzo Rucellai I provide is based upon a floor plan, drafted c.1846, that corresponds to a 1548 inventory prepared when the palace was divided between Giovanni Rucellai's great-grandsons; excerpts from the inventory, cited throughout, are reproduced in Preyer, "The Rucellai Palace," 162–78. On the basic elements of Florentine domestic interiors, which remained relatively constant in the period between 1400 and 1600, I drew upon Preyer, "The Florentine *casa*"; Lindow, *The Renaissance Palace*, 119–84; and Musacchio, *Art, Marriage, and Family*, 86–8.

Alberti's quotation on the courtyard as "bosom" appears in Alberti, *On the Art of Building*, 146. Remarks about the tondo and other decorative work done for the courtyard are cited in Preyer, "The Rucellai Palace," 165 and 211. Alberti's guidelines on the *sala principale* and the layout of bedrooms can be found in Alberti, *On the Art of Building*, 147 and 149. Saint Bernardino of Siena's remark on beds appears in Bernardino da Siena, *Le Prediche Volgari*, 1:36; and Musacchio, *Art, Marriage, and Family*, 109. Alberti's remarks on bedroom decoration, particularly for women, appear in Alberti, *On the Art of Building*, 149 and 299. Alberti's comments on the kitchen can be found ibid., 148–9. On the division of domestic space generally, see Guerzoni, "Servicing the casa."

On the Ottavanti–Rucellai case, see Origo, "The domestic enemy," 346. On the legalities of illegitimacy, see Kuehn, *Illegitimacy in Renaissance Florence*, 79.

"we have in our house": G. Rucellai, *Giovanni Rucellai ed il suo Zibaldone*, I, 23–34 (author's translation). On Rucellai as an art collector, see Tarr, "Giovanni Rucellai's comments on art and architecture"; Gilbert, "What did the Renaissance patron buy?"; and D. V. Kent, *Cosimo de' Medici*, 357–63. For Rucellai's trip to Rome, see F. W. Kent, "The making of a Renaissance patron," 52. Alberti's comments on collecting and display can be found in Alberti, *On the Art of Building*, 292; and Alberti, *The Albertis of Florence*, 216–17. See also Goldthwaite, "The empire of things"; idem, *Wealth and the Demand for Art*; and Riello, "'Things seen and unseen.'"

"someone who would gain": As cited in Preyer, "The Rucellai Palace," 158. Most scholars ascribe the implementation of Alberti's original design and the extension to Bernardo Rossellino. Alberti's remarks on the dangers of expansion appear in Alberti, *On the Art of Building*, 156 and 310. The contemporary descriptions of the rebuilding are cited in Preyer, "The Rucellai Palace," 176 and 182.

Regarding spending, Alberti's comment on wealth can be found in Alberti, *Opere volgari*, 1:141. Rucellai's remark appears in *Giovanni Rucellai ed il suo Zibaldone*, I, 121 (author's translation).

On Santa Maria Novella, I drew upon Hatfield, "The funding of the façade of Santa Maria Novella," esp. 88; Butters, *The Triumph of Vulcan*, 1:123–4 and 1:133–45; and Schneider, "Leon Battista Alberti," esp. 264.

On the loggia, I drew upon F. W. Kent, "The Rucellai family and its loggia," 399; and Preyer, "The Rucellai loggia."

"a chapel with a sepulchre": As cited in F. W. Kent, "The making of a Renaissance patron," 57–8; see also 59. On Rucellai's tomb, I drew upon Tavernor, *On Alberti*, 106–19; D. V. Kent, *Cosimo de' Medici*, 360–2; G. Rucellai, *Giovanni Rucellai ed il suo Zibaldone*, I, 117 (author's translation); F. W. Kent, "The making of a Renaissance patron," 59; idem, "The letters genuine and spurious," esp. 348–49; and Preyer, "The Rucellai Palace," 163 n. 3.

"His mind was versatile": Watkins, "L. B. Alberti in the mirror," 7.

Alberti's often-quoted remark on the "divine" power of painting appears in Alberti, *On Painting*, 63.

CHAPTER THREE: THE HEIR ABERRANT

"no less pitiful": This quote and subsequent ones are from Boccaccio, *The Decameron*, 419–25.

On Botticelli's panels, I drew upon Olsen, "Gross expenditure"; and Rubin, *Images and Identity*, esp. 229–71 and 358–62.

"the various girls": This quote and subsequent ones are from Macinghi Strozzi, *Selected*

Letters of Alessandra Strozzi, 138–9, 152–5, 184–5. Alessandra's further remarks on her children's marriages appear on 30–1 and 150–1.

On the marriage ritual, I drew upon Krohn, "Marriage as a key"; and Musacchio, *Art, Marriage, and Family*, esp. 2–61.

Bruni's comment on his wedding night is cited in Hankins, "The Latin poetry of Leonardo Bruni," 14. On the *bagordo*, I drew upon Scalini, "The chivalric 'Ludus' in quattrocento Florence," esp. 62; and Dunlop, "Parading David," esp. 691.

Palmieri's comment is cited in D'Elia, "Marriage, sexual pleasure, and learned brides," 382.

"outside of the house": This quote and subsequent ones are from G. Rucellai, *Giovanni Rucellai ed il suo Zibaldone*, I, 28 (author's translation). Giovanni's inventories appear on 29 and 32–4 (author's translation). A note on length: Florentines used the *braccio*, or arm's length, roughly two-thirds of a yard, for the standard measurement in wool and silk; I have modernized all measurements in Nannina's dowry. Bruni's remark on wedding expenses is cited in D'Elia, "Marriage, sexual pleasure, and learned brides," 382.

"their happiness and prosperity": As cited in Warburg, "Francesco Sassetti's last injunctions," 259.

For a summary of the debate surrounding the use and meaning of the Medici ring on the Rucellai facade, see Saalman, "The Rucellai Palace," 87–8. On the multivalence of Medici imagery, see Randolph, *Engaging Symbols*, 117–19.

Giovanni's remark on marriage alliances is cited in Molho et al., "Genealogy and marriage alliance," 44.

Nannina's remark can be found in Pieraccini, *La stirpe de' Medici di Cafaggiolo*, 1:147 (author's translation).

"From the very beginning": Alberti, *The Albertis of Florence*, 68.

The phrase "civilizing process" is borrowed from Elias, *The Civilizing Process*.

"In as much as you are now": This quote and subsequent ones are from Della Casa, *Galateo*, 3–61.

"Two ells of rose-colored cloth": Machiavelli, *Le istorie fiorentine*, 401 (author's translation).

"Children whose character is excellent": This quote and subsequent ones are from Alberti, *The Family in Renaissance Florence*, 58.

Sacchetti's comment on fathers and sons is cited in Trexler, *Public Life in Renaissance Florence*, 389.

Alberti's remarks on parenting can be found in Alberti, *The Albertis of Florence*, 65, 194. On Alberti's illegitimacy in the context of his writing, see Kuehn, "Reading between the patrilines"; and Najemy, "Giannozzo and his elders."

F. W. Kent, *Household and Lineage*, 56–7 and 46–7, cites Rucellai's and Ficino's remarks, respectively, on the father–son relationship.

"I have two sons": As cited in Richardson et al., *Renaissance Art Reconsidered*, 307.

"The submissive son": As cited in Fumagalli, "I trattati di Fra Santi Rucellai," 291. Pulci's sonnet appears in Pulci, *Opere minori*, 197–98 (author's translation).

NOTES

"Immodest and arrogant": Guicciardini, *Storie fiorentine*, 186, 426–48 (author's translation).

On the marriage print, see Warburg, "Francesco Sassetti's last injunctions," 242.

"The ornament of a town house": Alberti, *On the Art of Building*, 294. Rucellai's description of Quaracchi appears in G. Rucellai, *Giovanni Rucellai ed il suo Zibaldone*, I, 22 (author's translation). See also Lazzaro, *The Italian Renaissance Garden*, 80.

"quite a few fun days": As cited in F. W. Kent, "The making of a Renaissance patron," 81. On Zoroastro, see Brescia and Tomìo, "Tommaso di Giovanni da Peretola detto Zoroastro"; and Pedretti, "La macchina idraulica," 212 n. 1.

On the mirror stage, see Lacan, *Écrits: A Selection*, 4.

Pulci's frottola appears in Pulci, *Opere minori*, 21–30 (author's translation). See Levy, "The plastered female face." For a partial translation, see Dempsey, *The Early Renaissance and Vernacular Culture*, 92–7.

"It is generally said": G. Rucellai, *Giovanni Rucellai ed il suo Zibaldone*, I, 121 (author's translation).

"struck down by fortune": As cited in F. W. Kent, "The making of a Renaissance patron," 87.

"It was a great loss": G. Rucellai, *Giovanni Rucellai ed il suo Zibaldone*, I, 122 (author's translation).

"As the times dictate": Alberti, *Dinner Pieces*, 215.

"The fact is that you are shopkeepers": As cited in Molho, et al., "Genealogy and marriage alliance," 58.

"It is enough": As cited in Kuehn, *Heirs, Kin, and Creditors*, 5.

"The physicians advise": This quote and subsequent ones are from Alberti, *On the Art of Building*, 294–5.

On the Orti Oricellari, see Vasari, *Lives*, 3:43–8, esp. 46, who incorrectly attributes the house and garden design to Alberti. See also Gilbert, "Bernardo Rucellai and the Orti Oricellari," Nardi quotation at 116, da Diacceto quotation at 120; De Gaetano, "The Florentine academy," esp. 20–6; Bartoli and Contorni, *Gli Orti Oricellari a Firenze*; Comanducci, "Gli Orti Oricellari"; and Cummings, "The *Orti Oricellari*."

Corsi's quotation on Bernardo's exile is cited in McCuaig, "Bernardo Rucellai and Sallust," 75.

On Cosimo di Cosimo, see Nardi, *Istorie della città di Firenze*, 2:72 (author's translation).

Varchi's "On the generation of monsters" is cited in Hanafi, *The Monster in the Machine*, 18–19, 21, 30. See also Daston and Park, *Wonders and the Order of Nature*, 201–2.

"a boy with two bodies": As cited in Sframeli, *Il centro di Firenze restituito*, 492 (author's translation).

"Some friends in Florence": As cited by Daston and Park, *Wonders and the Order of Nature*, 57.

On Celio Malespini's contemporary description of the 1578 party in the garden, I drew upon Bartoli and Contorni, *Gli Orti Oricellari a Firenze*, 22–4; Hanafi, *The Monster in the Machine*, 17–18; and Lepri, "La 'Festa Labirintica' degli Orti Oricellari."

NOTES

On the division of Palazzo Rucellai, I drew upon Preyer, "The Rucellai Palace," 155–225, esp. 160–2, 218–22; and F. W. Kent, *Household and Lineage*, 143. On the division of property, generally, see Goldthwaite, "The Florentine palace," 998–1004.

"at the house of Bernardo Rucellai": This quote and subsequent ones are from Masi, *Ricordanze di Bartolomeo Masi*, 121–3 (author's translation).

CHAPTER FOUR: THE SUICIDE BRIDE

On Western attitudes toward suicide, I consulted Watt, *From Sin to Insanity*, esp. 1–8.

On the word *haunt*, I drew upon Jones and Stallybrass, *Renaissance Clothing and the Materials of Memory*, 260–1. See also Freud, "The Uncanny," esp. 220–6.

The archivist's description of Palazzo Rucellai (1722–34) is cited in Preyer, "The Rucellai Palace," 223–4 (author's translation). The archivist designates the ground floor as the first floor, and so on; I have adjusted his designations for reasons of consistency. On the 1743 amendments, see Preyer, "The Rucellai Palace," 177–8.

"One should get a starting-point": Aristotle, *Aristotle on Memory*, 56.

"Some place is chosen": This quote and subsequent ones are from Quintilian, *The Institutio oratoria*, 4:221–3, 4:229. I also drew upon Small, *Wax Tablets of the Mind*, esp. 95–116.

"But those who believe": Arese, *Arte di predicar bene* (Venice, 1610), as cited in Bolzoni, *The Gallery of Memory*, 194–95.

"This book was organized": G. Rucellai, *Giovanni Rucellai ed il suo Zibaldone*, I, 2 (author's translation).

Alessandra Strozzi's quotation is cited in Lillie, *Florentine Villas in the Fifteenth Century*, 148.

"It befits a merchant": As cited in Origo, *The Merchant of Prato*, 105–6.

The reference to figs appears in F. W. Kent, "The making of a Renaissance patron," 10.

"First, it seems to me": As cited in Molho, "Names, memory, public identity," 237.

On Giovanni's genealogical reconstruction, I drew upon Molho, "Names, memory, public identity," in Molho et al., "Genealogy and marriage alliance," 39–70.

On Giovanni's borrowing practices, I drew upon Tóth, "'Using culture'—Giovanni Rucellai's knowledge constructing practice."

"I've turned the house upside down": As cited in F. W. Kent, "The making of a Renaissance patron," 10 (author's translation).

On later additions to the *zibaldone*, see F. W. Kent, "The letters genuine and spurious," 346, 343–5.

On the return of the *zibaldone*, see Bracciali, "Il cantiere di restauro," 830–1.

On the archive, I drew upon Derrida, "Archive fever"; and Nora, "Between memory and history," esp. 19.

"a remake": This quote and subsequent ones are cited in Bacci, "Palazzo Rucellai," 202–5, esp. 203 (author's translation).

NOTES

Ferretti's description of work is cited in Bacci, 202 (author's translation). That of Anderlini is cited in Bracciali, "Il cantiere di restauro," 834 (author's translation).

"to cash in on her beauty": This quote and subsequent ones are from Giuseppe Conti, "Una rissa tra due nobili per via della 'Pisanella' (1668)," 525–30 (author's translation). Conti based his narrative on the earliest known account of the incident, an unpublished diary entry written *c.*1720 by Francesco Settimanni; that manuscript, *Memorie fiorentine*, is housed in the State Archives in Florence.

"Since February of last year": This quote and subsequent ones are cited in Hatfield, "The funding of the façade," 126–7 (author's translation).

"Once a disease": This quote and subsequent ones are from Alberti, *On the Art of Building*, 320.

QUARTO PIANO

On Alberti's polyalphabetic cipher, see Gadol, *Leon Battista Alberti*, 207–8.

"little bed": This quote and subsequent ones are cited in Park and Henderson, "'The first hospital among Christians,'" 181–7.

"one grain of opium": As cited in Henderson, *The Renaissance Hospital*, 316.

"honourable": This quote and subsequent ones are cited in Healy, "'A most troublesome and dangerous ailment,'" 207 and 212.

The treatments from the *Ricettario* are cited in Henderson, *The Renaissance Hospital*, 332–3.

CHAPTER FIVE: THE SALONNIÈRE

"My father, having determined": Layard, *Autobiography*, 1:21–2. In addition to renting out the *piano nobile*, the *altana*, or rooftop terrace, of Palazzo Rucellai was enclosed in 1868 in an effort to create additional housing in the new capital city.

"And looking back": Williams, *Collected Stories*, 278. On Camilla Rucellai, see also Villa, "Victorian uses of the Italian past."

See also Hawthorne, *Passages*, 295; and James, *Italian Hours*, 175.

"Over the bed": Layard, *Autobiography*, 1:27. See also Cook and Ruskin, *A Popular Handbook to the National Gallery*, 726; and, more recently, Dunkerton et al., *Giotto to Dürer*, 338–9.

On art dealers in Florence, I drew upon Roeck, *Florence 1900*, esp. 149–66; and Levi, "'Let agents be sent to all the cities of Italy,'" esp. 34. The Jarves quotation appears in Jarves, "The pursuit of bric-à-brac," in his *Italian Rambles*, 285–318, esp. 291–316.

Jarves' "The ideal Florentine" appears in the *New York Times*, 30 October 1881. The spellings of names have been modernized. Jarves also published an abbreviated version, "A lesson for merchant princes," in his *Italian Rambles*, 361–80. See also Molho, "The Italian Renaissance, made in the USA"; Gennari Santori, "Renaissance *fin de siècle*"; and Reist, *A Market for Merchant Princes*.

NOTES

Twain's quotation is cited in Molho, "The Italian Renaissance, made in the USA," 268.

On tourism, I drew upon Smith, "Florence, photography and the Victorians"; and Lasansky, *The Renaissance Perfected*, esp. 48–55.

Freud's quotation is cited in Roeck, *Florence 1900*, 83.

"The true Italy": This quote and subsequent ones are from Forster, *A Room with a View*, 15, 39, 41. See also Baedeker, *Italy: Handbook for Travellers*, 533.

The Ruskin quotation appears in Ruskin, *Ruskin in Italy*, 220.

Acton's remarks on Lysina appear in Acton, *Memoirs of an Aesthete*, 40, 41, 381, 105. For Lysina's biography, I also drew upon Vannucci, *L'avventura degli stranieri*, 133–5; Nesti, *Vita di Palazzo*, esp. 155 and 158–60; Giannarelli, "Donne a Palazzo," esp. 211; and Panajia, *Lysine*.

"*Cher Marquis*": Lysina goes on to inquire about a property for sale near Viareggio, about 60 miles west of Florence, on the Tuscan coast. Private collection.

"to see the beautiful women": L. Rucellai, *Souvenirs d'une cosaque*, 120. Other excerpts, in order of appearance in the present text, can be found on 12–13, 51–2, 50, 89–90, 96–8, 99–100, 119–22, 118, 91, and 15–16 (all citations from this text are the author's translation).

"There were plenty of balls": Niccolini, *Olio di ricino*, 29 (author's translation).

"Instead of talking about myself": Lysina characterized her memoir in a letter to Gabriele D'Annunzio dated 16 November 1927, as cited in Panajia, *Lysine*, 115 (author's translation).

On Edith Bronson's biography, see Nesti, *Vita di Palazzo*, 155; Giannarelli, "Donne a Palazzo," 211; and Panajia, *Lysine*, 37–38.

Acton's remarks on Florentine society appear in Acton, *Memoirs of an Aesthete*, 102; those on Caffè Doney appear on 39. See also Della Casa, *Galateo*, 23, 24, 27.

"I began to lead a double life": This quote and subsequent ones are from Youssoupoff, *Lost Splendor*, 87, 88, 90, 148, 149, 248–9, 280.

On the *tuta*, I drew upon Fonti, *Thayaht*, 43; Pratesi, "Thayaht e Ram," esp. 26 (author's translation); Paulicelli, "Fashion and futurism," esp. 200; Chiarelli and Uzzani, *Per il sole e contro il sole*, 12 (author's translation); Garavaglia, *Il Futurismo e la moda*, 149 (author's translation); and Paulicelli, *Fashion under Fascism*, 45.

"We are pompous": Biblioteca Marucelliana, Florence, *Carteggio Carlo Placci*, C. Pl. 824.13 (author's translation).

"antique Rucellai citadel": Biblioteca Marucelliana, Florence, *Carteggio Carlo Placci*, C. Pl. 824.5 (author's translation).

"remarkable survival": This quote and subsequent ones are from Acton, *Memoirs of an Aesthete*, 41, 381, 104–5.

"For different reasons": Biblioteca Marucelliana, Florence, *Carteggio Carlo Placci*, C. Pl. 824.11 (author's translation).

NOTES

CHAPTER SIX: THE TENANT

"BLOOD IN THE ANTIQUE PALAZZO": These and all subsequent newspaper citations have been culled from *Corriere della Sera*, *La Nazione*, *La Repubblica*, and *L'Unità*, with coverage beginning 17 January 1997; I also consulted Spezi, "Il caso di Robilant," 181–90; and Lucarelli, "Alvise. Il 'caso Di Robilant,'" (all translations are the author's).

My approach, which I would characterize as cautious, to the media representation of di Robilant's murder—a culturally sanctioned mix of journalism, history, politics, and true crime writing, peppered, like so many accounts of unsolved violent crimes, with conspiracy theories and alternative hypotheses—has been influenced by Gundle and Rinaldi, *Assassinations and Murder in Modern Italy*, esp. Giuliana Pieri, "Between true crime and fiction"; and Nerenberg, *Murder Made in Italy*.

"In the twenties": This quote and subsequent ones are from di Giardinelli, *Una gran bella vita*, 24–5 (author's translation).

"enchanted childhood": di Robilant, *A Venetian Affair*, 3.

"When I left you": As cited in di Robilant, *A Venetian Affair*, 98. The letters and di Robilant's notes were eventually returned to the family; the manuscript was completed by Andrea di Robilant.

"sticky little envelopes": di Robilant, *A Venetian Affair*, 98.

"*un amore impossibile*": As cited in di Robilant, *A Venetian Affair*, 6.

"There are historical precedents": I relied heavily on Dean and Lowe, eds, *Murder in Renaissance Italy*, especially the following essays: Dean and Lowe, "Introducing Renaissance killers," T. Cohen, "A daughter-killing digested, and accepted, in a village of Rome, 1563–1566," Dall'Aglio, "Truths and lies of a Renaissance murder: Duke Alessandro de' Medici's death between history, narrative and memory," and Salzburg and Rospocher, "Murder ballads: singing, hearing, writing and reading about murder in Renaissance Italy"; and T. Cohen, "Double murder in Cretone Castle."

"If we are to ever know": My reading of the journalistic reports of the crime scene against my own lived experience inside Palazzo Rucellai was influenced by Manaugh, *A Burglar's Guide to the City*.

"It is a death": This and the previous quote are from Rossi, *A Scientific Autobiography*, 1.

"There is no architecture without event": Tschumi, *The Manhattan Transcripts*, xx–xxi.

"I met [Cy]": Excerpts (with some modifications to punctuation) from Stokes, "Betty Stokes and Robert Brown in conversation."

"Alvise invited my sister [Tatiana] and me": Franchetti, "Giorgio Franchetti in conversation with Germano Celant," 132.

"nourished by a false and feigned pleasure": This quote and subsequent ones are from Colonna, *Hypnerotomachia Poliphili*. The eroticization of architecture that characterizes the *Hypnerotomachia Poliphili*, written in 1467, might seem entirely at odds with the far less profane, almost sacrosanct *On the Art of Building*, the *other* most famous architectural book of the fifteenth century and the first to appear in print (1485;

completed by 1450). And yet, because the metaphor of the building as a body structures both texts, some have attributed the *Hypnerotomachia*, the first *illustrated* printed architectural book in history, to Leon Battista Alberti, as well (of the 172 woodcut illustrations, 88 represent buildings, all of them depicted according to the rules of one-point perspective). Other contenders for author have included Lorenzo de' Medici and, most popularly, Francesco Colonna, based on an acrostic formed by the capital letters at the beginning of each of the 38 chapters. See Lefaivre, *Leon Battista Alberti's Hypnerotomachia Poliphili*. See also Pérez-Gómez, "The *Hypnerotomachia Poliphili* by Francesco Colonna."

BIBLIOGRAPHY

ARCHIVAL SOURCES

Archivio di Stato, Florence. Manoscritti 129, *Memorie fiorentine di Francesco Settimanni*
Biblioteca Marucelliana, Florence. *Carteggio Carlo Placci*, C. Pl. 824.5
Biblioteca Marucelliana, Florence. *Carteggio Carlo Placci*, C. Pl. 824.11
Biblioteca Marucelliana, Florence. *Carteggio Carlo Placci*, C. Pl. 824.13

NEWSPAPERS

Corriere della Sera
La Nazione
La Repubblica
L'Unità
New York Times

PRINTED PRIMARY AND SECONDARY SOURCES

Acton, Harold, *Memoirs of an Aesthete* (London, 1948).
Alberti, Leon Battista, *Opere volgari*, ed. Cecil Grayson, 3 vols (Bari, 1960).
——— *On Painting*, trans. John R. Spencer (New Haven, CT, 1966).
——— *The Family in Renaissance Florence*, trans. Renée Neu Watkins (Columbia, SC, 1969).
——— *The Albertis of Florence: Leon Battista Alberti's* Della Famiglia, trans. Guido Guarino (Lewisburg, PA, 1971).
——— *On Painting and On Sculpture: The Latin Texts of* De Pictura *and* De Statua, ed. and trans. Cecil Grayson (London, 1972).

BIBLIOGRAPHY

———— *Dinner Pieces*, trans. David Marsh (Binghamton, NY, 1987).

———— *On the Art of Building in Ten Books*, trans Joseph Rykwert, Neil Leach, and Robert Tavernor (Cambridge, MA, 1988).

———— *A Treatise on Ciphers*, trans Alessandro Zaccagnini (Turin, 1997).

Alighieri, Dante, *The Divine Comedy of Dante Alighieri: Volume 1: Inferno*, trans. Ronald L. Martinez and Robert M. Durling (New York, 1996).

Aristotle, *Aristotle on Memory*, trans. Richard Sorabji (London, 1972).

Bacci, Serena, "Palazzo Rucellai dalla ricerca archivistica all'indagine diretta sul fabbricato," in Simonetta Bracciali, ed., *Restaurare Leon Battista Alberti: Il caso di Palazzo Rucellai* (Florence, 2006), 202–5.

Baedeker, Karl, *Italy: Handbook for Travellers. First Part: Northern Italy Including Leghorn, Florence, Ravenna, and Routes Through Switzerland and Austria*, 13th rev. ed. (Leipzig and New York, 1906).

Bartoli, Leondro Maria and Gabriella Contorni, *Gli Orti Oricellari a Firenze: un giardino, una cittá* (Florence, 1991).

Baxendale, Susannah Foster, "Exile in practice: the Alberti family in and out of Florence 1401–1428," *Renaissance Quarterly* 44 (1991): 720–56.

Bernardino da Siena, *Le Prediche Volgari: Predicazione del 1425 in Siena*, ed. Ciro Cannarozzi, 2 vols (Florence, 1958).

Boccaccio, Giovanni, *The Decameron*, trans. G. H. McWilliam, 2nd ed. (London, 1995).

Bolzoni, Lina, *The Gallery of Memory: Literary and Iconographic Models in the Age of the Printing Press*, trans. Jeremy Parzen (Toronto, 2001).

Born, Wolfgang, "Purple in classical antiquity," *Ciba Review* 4 (1937): 111–17.

Bracciali, Simonetta, "Il cantiere di restauro di Palazzo Rucellai tra problemi di conservazione, manutenzione e conoscenza," in Roberto Cardini and Mariangela Regoliosi, eds, *Alberti e la cultura del Quattrocento: Atti dei convegno internazionale del Comitato Nazionale VI centenario della nascita di Leon Battista Alberti*, 2 vols (Florence, 2007), 2: 827–67.

Brunello, Franco, *The Art of Dyeing in the History of Mankind*, trans. Bernard Hickey (Cleveland, OH, 1973).

Bruni, Leonardo, "Panegyric to the city of Florence," in Benjamin G. Kohl and Ronald G. Witt, with Elizabeth B. Welles, eds, *The Earthly Republic: Italian Humanists on Government and Society* (Philadelphia, PA, 1978), 135–75.

Burroughs, Charles, *The Italian Renaissance Palace Facade: Structures of Authority, Surfaces of Sense* (Cambridge, 2002).

Butters, Suzanne B., *The Triumph of Vulcan: Sculptors' Tools, Porphyry, and the Prince in Ducal Florence*, 2 vols (Florence, 1996).

Cairns, Stephen and Jane M. Jacobs, *Buildings Must Die: A Perverse View of Architecture* (Cambridge, MA, 2014).

Casselman, Karen Diadick, *Lichen Dyes: The New Source Book* (Mineola, NY, 2001).

Castiglione, Baldesar, *The Book of the Courtier*, trans. George Bull (Cambridge, 2012).

Chiarelli, Caterina and Giovanna Uzzani, *Per il sole e contro il sole: Thayaht & Ram. La tuta/modelli per tessuti* (Livorno, 2003).

Clement of Alexandria, *Christ the Educator*, trans. Simon P. Wood (New York, 1954).

Cohen, Elizabeth S., "Honor and gender in the streets of early modern Rome," *The Journal of Interdisciplinary History* 22 (1992): 597–625.

Cohen, Thomas V., "Double murder in Cretone Castle," in *Love and Death in Renaissance Italy* (Chicago, IL, 2015), 17–42.

Colonna, Francesco, *Hypnerotomachia Poliphili: The Strife of Love in a Dream*, trans. Joscelyn Godwin (New York, 1999).

Comanducci, Rita Maria, "Gli Orti Oricellari," *Interpres* 15 (1995–6): 302–58.

Cummings, Anthony M., "The *Orti Oricellari*", in *The Maecenas and the Madrigalist: Patrons, Patronage, and the Origins of the Italian Madrigal* (Philadelphia, PA, 2004), 15–78.

Conti, Giuseppe, "Una rissa tra due nobili per via della 'Pisanella' (1668)," in *Fatti e aneddoti di storia fiorentina (secoli XIII–XVIII)* (Florence, 1902), 525–30.

Cook, Edward T. and John Ruskin, *A Popular Handbook to the National Gallery: Including, by Special Permission, Notes Collected from the Works of Mr. Ruskin. vol. 1, Foreign Schools*, 6th ed. (London, 1901).

Daston, Lorraine and Katharine Park, *Wonders and the Order of Nature, 1150–1750* (New York, 1998).

Dean, Trevor and K. J. P. Lowe, eds, *Murder in Renaissance Italy* (Cambridge, 2017).

De Gaetano, Armand L., "The Florentine academy and the advancement of learning through the vernacular: the Orti Oricellari and the Sacra Accademia," *Bibliothèque d'Humanisme et Renaissance* 30 (1968): 19–52.

D'Elia, Anthony F., "Marriage, sexual pleasure, and learned brides in the wedding orations of fifteenth-century Italy," *Renaissance Quarterly* 55 (2002): 379–433.

Della Casa, Giovanni, *Galateo*, trans. Konrad Eisenbichler and Kenneth R. Bartlett (Toronto, 1986).

Dempsey, Charles, *The Early Renaissance and Vernacular Culture* (Cambridge, MA, 2012).

de Roover, Florence Edler, *L'arte della seta a Firenze nei secoli XIV e XV* (Florence, 1999).

de Roover, Raymond, "A Florentine firm of cloth manufacturers: management and organization of a sixteenth-century business," *Speculum* 16 (1941): 3–30.

Derrida, Jacques, "Archive fever: a Freudian impression," trans. Eric Prenowitz, *Diacritics* 25 (1995): 9–63.

di Giardinelli, Gabriella, *Una gran bella vita* (Milan, 1988).

di Robilant, Andrea, *A Venetian Affair* (New York, 2003).

Doren, Alfred, *Studien aus der Florentiner Wirtschaftsgeschichte*, 2 vols (Stuttgart, 1901).

Dunkerton, Jill et al., *Giotto to Dürer: Early Renaissance Painting in the National Gallery* (New Haven, CT, 1991).

Dunlop, Anne, "Parading David," *Art History* 35 (2012): 682–701.

Edler, Florence Marguerite, *Glossary of Mediaeval Terms of Business, Italian Series, 1200–1600* (Cambridge, MA, 1934).

Elias, Norbert, *The Civilizing Process: The History of Manners*, trans. Edmund Jephcott (New York, 1978).

Fonti, Daniela, *Thayaht: Futurista irregolare* (Milan, 2005).

Forster, E. M., *A Room with a View* (1808), ed. Malcolm Bradbury (Harmondsworth, 2000).

Franchetti, Giorgio, "Giorgio Franchetti in conversation with Germano Celant, Rome, 10 December 1992," in Germano Celant and Anna Costantini, *Roma-New York: 1948–1964: an art exploration*, trans. Joachim Neugroschel (Milan and New York, 1993), 132.

Fraser Jenkins, A. D., "Cosimo de' Medici's patronage of architecture and the theory of magnificence," *Journal of the Warburg and Courtauld Institutes* 33 (1970): 162–70.

Freud, Sigmund, "The Uncanny" (1919), in *The Standard Edition of the Complete Psychological Works of Sigmund Freud*, ed. James Strachey, 24 vols (London, 1955), 17:218–52.

Frick, Carole Collier, *Dressing Renaissance Florence: Families, Fortunes, and Fine Clothing* (Baltimore, MD, 2002).

Fumagalli, Edoardo, "I trattati di Fra Santi Rucellai," *Aevum* 51 (1977): 289–332.

Gadol, Joan, *Leon Battista Alberti: Universal Man of the Early Renaissance* (Chicago, IL, 1969).

Gamurrini, Eugenio, *Istoria genealogica delle famiglie nobili Toscane et Umbre* (1668–85; reprint, Bologna, 1972).

Garavaglia, Luca F., *Il Futurismo e la moda* (Milan, 2009).

Gennari Santori, Flaminia, "Renaissance *fin de siècle*: models of patronage and patterns of taste in American press and fiction (1880–1914)," in John E. Law and Lene Østermark-Johansen, eds, *Victorian and Edwardian Responses to the Italian Renaissance* (Aldershot, 2005), 105–20.

Giannarelli, Elena, "Donne a Palazzo," in Simonetta Bracciali, ed., *Restaurare Leon Battista Alberti: Il caso di Palazzo Rucellai* (Florence, 2006), 209–14.

Gilbert, Creighton E., "What did the Renaissance patron buy?" *Renaissance Quarterly* 51 (1998): 392–450.

Gilbert, Felix, "Bernardo Rucellai and the Orti Oricellari: a study on the origin of modern political thought," *Journal of the Warburg and Courtauld Institutes* 12 (1949): 101–31.

Goldthwaite, Richard A., "The Florentine palace as domestic architecture," *American Historical Review* 77 (1972): 977–1012.

——— "The building of the Strozzi Palace: the construction industry in Renaissance Florence," *Studies in Medieval and Renaissance History* 10 (1973): 97–194.

——— *The Building of Renaissance Florence: An Economic and Social History* (Baltimore, MD, 1980).

——— "The empire of things: consumer demand in Renaissance Italy," in F. W. Kent and Patricia Simons, with J. C. Eade, eds, *Patronage, Art, and Society in Renaissance Italy* (Oxford, 1987), 153–75.

——— "The economic value of a Renaissance palace: investment, production, consumption," *Annali di architettura* 2 (1990): 1–10.

——— *Wealth and the Demand for Art in Italy 1300–1600* (Baltimore, MD, 1993).

———— *The Economy of Renaissance Florence* (Baltimore, MD, 2009).

Grafton, Anthony, *Leon Battista Alberti: Master Builder of the Italian Renaissance* (New York, 2000).

Grayson, Cecil, "The composition of L. B. Alberti's *Decem libri de re aedificatoria*," *Münchner Jahrbuch der bildenden Kunst* 11 (1960): 152–61.

Greenfield, Amy Butler, *A Perfect Red: Empire, Espionage, and the Quest for the Color of Desire* (New York, 2005).

Guerzoni, Guido, "Servicing the casa," in Marta Ajmar-Wollheim and Flora Dennis, eds, *At Home in Renaissance Italy* (New York, 2006), 146–51.

Guicciardini, Francesco, *Storie fiorentine dal 1378 al 1509*, ed. Alessandro Montevecchi (Milan, 1998).

Gundle, Stephen and Lucia Rinaldi, eds, *Assassinations and Murder in Modern Italy* (New York, 2007).

Hanafi, Zakiya, *The Monster in the Machine: Magic, Medicine, and the Marvelous in the Time of the Scientific Revolution* (Durham, NC, 2000).

Hankins, James, "The Latin poetry of Leonardo Bruni," *Humanistica Lovaniensia* 39 (1990): 1–39.

Hatfield, Rab, "The funding of the façade of Santa Maria Novella," *Journal of the Warburg and Courtauld Institutes* 67 (2004): 81–128.

Hawthorne, Nathaniel, *Passages from the French and Italian Note-Books of Nathaniel Hawthorne* (Boston, MA, 1873).

Healy, Margaret, "'A most troublesome and dangerous ailment': 'encounters' with 'the stone' in early modern Europe," *Journal de la Renaissance* 3 (2005): 207–16.

Hellot, Jean, *The Art of Dying Wool, Silk, and Cotton. Translated from the French of M. Hellot, M. Macquer, and M. Le Pileur D'apligny* (Paris, 1785).

Henderson, John, *The Renaissance Hospital: Healing the Body and Healing the Soul* (New Haven, CT, 2006).

Hughes, Diane Owen, "Sumptuary law and social relations in Renaissance Italy," in John Bossy, ed., *Disputes and Settlements: Law and Human Relations in the West* (Cambridge, 1983), 69–99.

Jacoby, David, *Trade, Commodities and Shipping in the Medieval Mediterranean* (Aldershot, 1997).

James, Henry, *Italian Hours* (Boston, MA, 1909).

Jarves, James Jackson, "The ideal Florentine: a life story full of lessons for merchant princes," *New York Times*, 30 October 1881.

———— *Italian Rambles: Studies of Life and Manners in New and Old Italy* (New York, 1885).

Jones, Ann Rosalind and Peter Stallybrass, *Renaissance Clothing and the Materials of Memory* (Cambridge, 2000).

Kent, Dale V., "The importance of being eccentric: Giovanni Cavalcanti's view of Cosimo de' Medici's Florence," *Journal of Medieval and Renaissance Studies* 9 (1979): 101–32.

———— *Cosimo de' Medici and the Florentine Renaissance* (New Haven, CT, 2000).

Kent, Dale V. and Francis W. Kent, *Neighbours and Neighbourhood in Renaissance Florence: The District of the Red Lion in the Fifteenth Century* (Locust Valley, NY, 1982).

Kent, Francis W., "The Rucellai family and its loggia," *Journal of the Warburg and Courtauld Institutes* 35 (1972): 397–401.

——— "The letters genuine and spurious of Giovanni Rucellai," *Journal of the Warburg and Courtauld Institutes* 37 (1974): 342–9.

——— *Household and Lineage in Renaissance Florence: The Family Life of the Capponi, Ginori, and Rucellai* (Princeton, NJ, 1977).

——— "The making of a Renaissance patron," in Francis W. Kent et al., eds, *Giovanni Rucellai ed il suo Zibaldone, II: A Florentine Patrician and His Palace* (London, 1981), 9–95.

——— "Palaces, politics and society in fifteenth-century Florence," *I Tatti Studies in the Italian Renaissance* 2 (1987): 41–70.

Kent, Francis W. et al., eds, *Giovanni Rucellai ed il suo Zibaldone, II: A Florentine Patrician and His Palace* (London, 1981).

Kok, Annette, "A short history of the orchil dyes," *The Lichenologist* 3 (1966): 248–72.

Krohn, Deborah L., "Marriage as a key to understanding the past," in Andrea Bayer, ed., *Art and Love in Renaissance Italy* (New Haven, CT, 2008), 9–15.

Kuehn, Thomas, "Reading between the patrilines: Leon Battista Alberti's *Della Famiglia* in light of his illegitimacy," in *I Tatti Studies: Essays in the Italian Renaissance* 1 (1985): 161–87.

——— *Illegitimacy in Renaissance Florence* (Ann Arbor, MI, 2002).

——— *Heirs, Kin, and Creditors in Renaissance Florence* (New York, 2008).

Lacan, Jacques, *Écrits: A Selection*, trans. Alan Sheridan (New York, 1977).

Lasansky, D. Medina, *The Renaissance Perfected: Architecture, Spectacle, and Tourism in Fascist Italy* (University Park, PA, 2004).

Layard, Austen Henry, *Autobiography and Letters from His Childhood Until His Appointment as H. M. Ambassador at Madrid*, ed. William N. Bruce, 2 vols (New York, 1903).

Lazzaro, Claudia, *The Italian Renaissance Garden: From the Conventions of Planting, Design, and Ornament to the Grand Gardens of Sixteenth-Century Central Italy* (New Haven, CT, 1990).

Leach, Neil, "*Vitruvius crucifixus*: architecture, mimesis, and the death instinct," in George Dodds and Robert Tavernor, eds, *Body and Building: Essays on the Changing Relation of Body and Architecture* (Cambridge, MA, 2002), 210–25.

Lefaivre, Liane, *Leon Battista Alberti's Hypnerotomachia Poliphili: Re-cognizing the Architectural Body in the Early Italian Renaissance* (Cambridge, MA, 1997).

Leix, Alfred, "Dyeing and dyers' guilds in mediaeval craftsmanship," *Ciba Review* 1 (1937): 10–18.

Lepri, Nicoletta, "La 'Festa Labirintica' degli Orti Oricellari (1578)," *Medioevo e Rinascimento* 16 (2002): 333–77.

Levi, Donata, "'Let agents be sent to all the cities of Italy': British public museums and the Italian art market in the mid-nineteenth century," in John E. Law and Lene

Østermark-Johansen, eds, *Victorian and Edwardian Responses to the Italian Renaissance* (Aldershot, 2005), 33–53.

Levy, Allison, "The plastered female face in fifteenth-century Florence: a translation of Luigi Pulci's *Le galee per Quaracchi*," *Kritische Berichte* 45 (2017): 19–26.

Lillie, Amanda, *Florentine Villas in the Fifteenth Century: An Architectural and Social History* (Cambridge, 1995).

Lindow, James R., *The Renaissance Palace in Florence: Magnificence and Splendour in Fifteenth-Century Florence* (Aldershot, 2007).

Lucarelli, Carlo, "Alvise. Il 'caso Di Robilant,'" in *Mistero in Blu* (Turin, 1999), 95–109.

Machiavelli, Niccolò, *Le istorie fiorentine* (Florence, 1965).

—— *The Prince*, trans. Harvey C. Mansfield (Chicago, IL, 1985).

—— *Art of War*, trans. Christopher Lynch (Chicago, IL, 2003).

Macinghi Strozzi, Alessandra, *Selected Letters of Alessandra Strozzi*, trans. Heather Gregory (Berkeley, CA, 1997).

Manaugh, Geoff, *A Burglar's Guide to the City* (New York, 2016).

Marcotti, Giuseppe, *Un mercante fiorentino e la sua famiglia nel secolo XV* (Florence, 1881).

Masi, Bartolomeo, *Ricordanze di Bartolomeo Masi, calderaio fiorentino dal 1478 al 1526*, ed. Giuseppe Odoardo Carozzini (Florence, 1906).

McCuaig, William, "Bernardo Rucellai and Sallust," *Rinascimento* 22 (1982): 75–98.

Molho, Anthony, "The Italian Renaissance, made in the USA," in Anthony Molho and Gordon S. Wood, eds, *Imagined Histories: American Historians Interpret the Past* (Princeton, NJ, 1989), 263–94.

—— "Names, memory, public identity in late medieval Florence," in Giovanni Ciappelli and Patricia Lee Rubin, eds, *Art, Memory, and Family in Renaissance Florence* (Cambridge, 2000), 237–52.

Molho, Anthony et al., "Genealogy and marriage alliance: memories of power in late medieval Florence," in Samuel K. Cohn, Jr. and Steven A. Epstein, eds, *Portraits of Medieval and Renaissance Living: Essays in Memory of David Herlihy* (Ann Arbor, MI, 1996), 39–70.

Musacchio, Jacqueline Marie, *Art, Marriage, and Family in the Florentine Renaissance Palace* (New Haven, CT, 2008).

Najemy, John M., "Giannozzo and his elders: Alberti's critique of Renaissance patriarchy," in William J. Connell, ed., *Society and Individual in Renaissance Florence* (Berkeley, CA, 2002), 51–78.

Nardi, Jacopo, *Istorie della città di Firenze*, ed. Agenore Gelli, 2 vols (Florence, 1858).

Nerenberg, Ellen, *Murder Made in Italy: Homicide, Media, and Contemporary Italian Culture* (Bloomington, IN, 2012).

Nesti, Arnoldo, *Vita di palazzo: Vita quotidiana, riti e passioni nell'aristocrazia fiorentina tra Otto e Novecento* (Florence, 1994).

Newton, Isaac, "A letter of Mr. Isaac Newton, Professor of the Mathematicks in the University of Cambridge; containing his new theory about light and colors: Sent

by the author to the publisher from Cambridge, Febr. 6. 1671/72; in order to be communicated to the R. Society," *Philosophical Transactions of the Royal Society of London* 80 (1671): 3075–87.

Niccolini, Beatrice, *Olio di ricino a colazione* (Florence, 1992).

Nora, Pierre, "Between memory and history: *Les Lieux de mémoire*," *Representations* 26 (1989): 7–24.

Olsen, Christina, "Gross expenditure: Botticelli's Nastagio degli Onesti panels," *Art History* 15 (1992): 146–70.

Origo, Iris, "The domestic enemy: the Eastern slaves in Tuscany in the fourteenth and fifteenth centuries," *Speculum* 30 (1955): 321–66.

——— *The Merchant of Prato: Francesco di Marco Datini* (London, 1957; reprint 1992).

Panajia, Alessandro, *Lysine: Una "cossaca" amica di d'Annunzio* (Pisa, 2017).

Park, Katharine and John Henderson, "'The first hospital among Christians': the Ospedale di Santa Maria Nuova in early sixteenth-century Florence," *Medical History* 35 (1991): 164–88.

Passerini, Luigi, *Genealogia e storia della famiglia Rucellai* (Florence, 1861).

Pastore, Nicholas and Edward Rosen, "Alberti and the camera obscura," *Physis* 26 (1984): 259–69.

Paulicelli, Eugenia, *Fashion under Fascism: Beyond the Black Shirt* (Oxford, 2004).

——— "Fashion and futurism: performing dress," *Annali d'Italianistica* 27 (2009): 187–207.

Pedretti, Carlo, "La macchina idraulica costruita da Leonardo per conto di Bernardo Rucellai e i primi contatori d'acqua," *Raccòlta vinciana* 17 (1954): 177–215.

Pérez-Gómez, Alberto, "The *Hypnerotomachia Poliphili* by Francesco Colonna: the erotic nature of architectural meaning," in Vaughan Hart with Peter Hicks, eds, *Paper Palaces: The Rise of the Renaissance Architectural Treatise* (New Haven, CT, 1989), 86–104.

Perkins, Patricia, "Ecology, beauty, profits: trade in lichen-based dyestuffs through Western history," *Journal of the Society of Dyers and Colourists* 102 (1986): 221–7.

Pieraccini, Gaetano, *La stirpe de' Medici di Cafaggiolo: Saggio di ricerche sulle trasmissione ereditaria dei caratteri biologici*, 3 vols (Florence, 1986).

Pieri, Giuliana, "Between true crime and fiction: the world of Carlo Lucarelli," in Stephen Gundle and Lucia Rinaldi, eds, *Assassinations and Murder in Modern Italy* (New York, 2007), 193–203.

Pliny the Elder, *The Natural History*, trans. John Bostock and H. T. Riley, 6 vols (London, 1855).

Plutarch, *Plutarch's Lives of Romulus, Lycurgus, Solon, Pericles, Cato, Pompey, Alexander the Great, Julius Caesar, Demosthenes, Cicero, Mark Antony, Brutus, and Others, and his Comparisons: With Notes, Critical and Historical*, trans. John and William Langhorne (New York, 1889).

Pratesi, Mauro, "Thayaht e Ram. Un'idea universale di bellezza," in Mauro Pratesi, ed., *Futurismo e bon ton: I fratelli Thayaht e Ram* (Florence, 2005), 19–58.

BIBLIOGRAPHY

Preyer, Brenda, "The Rucellai loggia," *Mitteilungen des Kunsthistorischen Institutes in Florenz* 21 (1977): 183–98.

——— "The Rucellai Palace," in F. W. Kent et al., eds, *Giovanni Rucellai ed il suo Zibaldone, II: A Florentine Patrician and His Palace* (London, 1981), 155–225.

——— "Planning for visitors at Renaissance palaces," *Renaissance Studies* 12 (1998): 357–74.

——— "Florentine palaces and memories of the past," in Giovanni Ciappelli and Patricia Lee Rubin, eds, *Art, Memory, and Family in Renaissance Florence* (Cambridge, 2000), 176–94.

——— "The Florentine *casa*," in Marta Ajmar-Wollheim and Flora Dennis, eds, *At Home in Renaissance Italy* (New York, 2006), 34–49.

Pulci, Luigi, *Opere Minori*, ed. Paolo Orvieto (Milan, 1986).

Rainey, Ronald, "Dressing down the dressed-up: reproving feminine attire in Renaissance Florence," in John Monfasani and Ronald G. Musto, eds, *Renaissance Society and Culture: Essays in Honor of Eugene F. Rice, Jr.* (New York, 1991), 217–37.

Randolph, Adrian, *Engaging Symbols: Gender, Politics, and Public Art in Fifteenth-Century Florence* (New Haven, CT, 2002).

Read, Gray, "The play's the thing," in Marcia Feuerstein and Gray Read, eds, *Architecture as a Performing Art* (Farnham, 2013), 1–12.

Reist, Inge, ed., *A Market for Merchant Princes: Collecting Italian Renaissance Paintings in America* (University Park, PA, 2015).

Richardson, Carol M., Kim W. Woods, and Michael W. Franklin, eds, *Renaissance Art Reconsidered: An Anthology of Primary Sources* (Oxford, 2007).

Riello, Giorgio, "'Things seen and unseen': the material culture of early modern inventories and their representation of domestic interiors," in Paula Findlen, ed., *Early Modern Things: Objects and Their Histories, 1500–1800* (London, 2013), 125–50.

Roeck, Bernd, *Florence 1900: The Quest for Arcadia*, trans. Stewart Spencer (New Haven, CT, 2009).

Ross, Janet, *Florentine Palaces and Their Stories* (New York, 1905).

Rossi, Aldo, *A Scientific Autobiography*, trans. Lawrence Venuti (Cambridge, MA, 1981).

Rubin, Patricia Lee, *Images and Identity in Fifteenth-Century Florence* (New Haven, CT, 2007).

Rucellai, Bernardo, *De urbe Roma* (1496) (Florence, 1770).

——— *De bello italico commentarius* (London, 1773).

Rucellai, Giovanni, *Giovanni Rucellai ed il suo Zibaldone, I: Il Zibaldone quaresimale*, ed. Alessandro Perosa (London, 1960–81).

——— *Zibaldone*, trans. Gabriella Battista and Anthony Molho (Florence, 2013).

Rucellai, Lysina, *Souvenirs d'une cosaque* (Florence, 1929).

Ruskin, John, *Ruskin in Italy: Letters to His Parents, 1845*, ed. Harold I. Shapiro (Oxford, 1972).

Quintilian, *The Institutio oratoria of Quintilian*, trans. H. E. Butler, 4 vols (Cambridge, MA, 1920–2).

Saalman, Howard, "The Rucellai Palace," review of F. W. Kent et al., *Giovanni Rucellai ed il suo Zibaldone, II: A Florentine Patrician and His Palace*, London, 1981, in *Journal of the Society of Architectural Historians* 47 (1988): 82–90.

Salutati, Coluccio, *Colucii Salutati, De seculo et religione*, ed. B. L. Ullman (Florence, 1957).

Scalini, Mario, "The chivalric 'Ludus' in quattrocento Florence," in Cristina Acidini Luchinat, ed., *Renaissance Florence: The Age of Lorenzo de' Medici 1449–1492* (Milan, 1993), 61–3.

Schneider, Laurie, "Leon Battista Alberti: some biographical implications of the winged eye," *Art Bulletin* 72 (1990): 261–70.

Sframeli, Maria, *Il centro di Firenze restituito: Affreschi e frammenti lapidei nel Museo di San Marco* (Florence, 1989).

Small, Jocelyn Penny, *Wax Tablets of the Mind: Cognitive Studies of Memory and Literacy in Classical Antiquity* (London, 1997).

Smith, Graham, "Florence, photography and the Victorians," in John E. Law and Lene Østermark-Johansen, eds, *Victorian and Edwardian Responses to the Italian Renaissance* (Aldershot, 2005), 7–32.

Spezi, Mario, "Il caso di Robilant," in *Toscana Nera* (Florence, 1998), 181–90.

Stokes, Betty, "Betty Stokes and Robert Brown in conversation, May 2013," in *Christie's Post-War and Contemporary Art Evening Auction 25 June 2013, London*. Available at http://www.christies.com/lotfinder/sculptures-statues-figures/cy-twombly-untitled-5698856-details.aspx (accessed 1 August 2018).

Suetonius, *The Lives of the Twelve Caesars*, trans. Joseph Gavorse (New York, 1931), 262.

Tarr, Roger, "Giovanni Rucellai's comments on art and architecture," *Italian Studies* 51 (1996): 58–95.

Tavernor, Robert, *On Alberti and the Art of Building* (New Haven, CT, 1998).

Terpstra, Nicholas, *Lost Girls: Sex and Death in Renaissance Florence* (Baltimore, MD, 2010).

Theophrastus, *Enquiry into Plants*, trans. Sir Arthur Hort, 2 vols (New York, 1916).

Tóth, Gábor Mihály, "'Using culture'—Giovanni Rucellai's knowledge constructing practice in the MS Zibaldone quaresimale," *Annual of Medieval Studies at CEU* 16 (2010): 142–54.

Trachtenberg, Marvin, *The Campanile of Florence Cathedral: "Giotto's Tower"* (New York, 1971).

Trexler, Richard C., *Public Life in Renaissance Florence* (Ithaca, NY, 1980).

Tschumi, Bernard, *The Manhattan Transcripts* (London, 1994).

Twain, Mark, *The Innocents Abroad* (1869) (Herefordshire, 2010).

Vannucci, Marcello, *L'avventura degli stranieri in Toscana: Ottocento e novecento: fra cronaca e storia* (Aosta, 1981).

Vasari, Giorgio, *Lives of the Most Eminent Painters, Sculptors and Architects*, trans. Gaston du C. de Vere, 10 vols (London, 1912; reprint, New York, 1976).

Villa, Luisa, "Victorian uses of the Italian past: the case of Camilla Rucellai in George Eliot's *Romola*," in Alessandro Vescovi, Luisa Villa, and Paul Vita, eds, *The Victorians in Italy: Literature, Travel, Politics and Art* (Monza, 2009), 193–207.

Villani, Giovanni (d.1348), *Cronica di Giovanni Villani: A miglior lezione ridotta coll'ajuto de' testi a penna* (Florence, 1832).

Warburg, Aby, "Francesco Sassetti's last injunctions to his sons", in *The Renewal of Pagan Antiquity: Contributions to the Cultural History of the European Renaissance*, intro. Kurt W. Forster, trans. David Britt (Los Angeles, 1999).

Watkins, Renée Neu, "L. B. Alberti's emblem, the winged eye, and his name, Leo," *Mitteilungen des Kunsthistorischen Institutes in Florenz* 9 (1960): 256–8.

——— "L. B. Alberti in the mirror: an interpretation of the *Vita* with a new translation," *Italian Quarterly* 30 (1989): 5–30.

Watt, Jeffrey R., ed., *From Sin to Insanity: Suicide in Early Modern Europe* (Ithaca, NY, 2004).

Williams, Tennessee, *Collected Stories*, intro. Gore Vidal (New York, 1985).

Youssoupoff, Felix, *Lost Splendor: The Amazing Memoirs of the Man Who Killed Rasputin*, trans. Ann Green and Nicholas Katkoff (New York, 2003; first published in New York, 1953).

INDEX

Page numbers in *italics* reference illustrations within the text.

Academia, 1–2, 9, 30–1, 34, 35, 40, 76–7, 81–2, 84, 128–9, 132, 198, 203, 212, 228, 233–4
Accademia della Crusca, xx, 31–2
Acton, Sir Harold, xxiv, 174, 176, 179–80, *180*, 184, 193, 213, 250*n*
Adimari family, 89–90
adultery, 63–4, 105, 120, 122, 191, 212, 215, 215–16
Alamanno of the Oricellariis clan (later Rucellai), xvi, 19, 21, 26–8, 242*n*
Albania, 212–13, 220
Alberti family, 40, 43
Alberti, Leon Battista (plates 3, 4, 5, 6), xvii, xviii, xxiv, xxvi, xxvii, 2, 4, 7, 40–2, 48–56, 57–8, 64–7, 70, 72–5, 75, 76, 93, 98, 99–100, 103, 104–5, 113, 114–15, 123, 156, 172, 198–9, *199*, 234, 242*n*, 243*n*, 244*n*, 245*n*, 246*n*, 247*n*, 249*n*, 252*n*; and Palazzo Rucellai (plate 3), xviii, xxvii, 2, 7, 8, 12, 31, 42, 49–56, 60, 64, 66–7, 70, 76, 123, 135, 137, 139–40, 154–5, 158, 163, 172, 186, 199, 218, 220–1; personal emblem (plate 5) 42, 69–70, 75, *75*, 198, 243*n*; and Santa Maria Novella (plates 3, 6), xvii, 68–70, 152–3; and tomb for Giovanni Rucellai, 72–5, 75, 186, 197; *see also* Hypnerotomachia Poliphili (Alberti, presumed), *On Painting* (Alberti), xviii, *On the Art of Building* (Alberti), *On the Family* (Alberti), *Self-portrait* (Alberti), *Vita di Leon Battista Alberti* (Alberti, presumed)
Alinari (photography studio), 172, 219
American Girl in Italy (Orkin), xiv, *183*
amputation, 23, 43, 197, 217, 220
Anderlini, Pietro, 148
androgyny, 1, 187–9, *188*; *see also* crossdressing, effeminacy, hermaphroditism
Aristotle, 48, 141, 145
Arno River, xv, xx, xxii, 22, 27, 93, 104, 118, 120, 178, 196, 238; Valdarno (Arno valley), 118, 144, 166, 173; *see also* floods
Arte del Cambio (bankers' guild), xvii, 20, 45, 68
Arte della Lana (wool merchants' guild), xvi, 20, 21–2, 22
assassination, *see* murder
assault, xviii, xxviii, 17, 42, 86–8, 120, 123, 185–6, 196, 214
astrology, 79–81, 105

banking, *see* Florence: and banking
Baptistery, *see* Florence: Baptistery
Bargello, *see* Palazzo del Popolo
Berenson, Bernard, 81–2, 83, *83*, 170

INDEX

Bernardino of Siena, Saint, 26, 61, 244n
Bezzuoli, Giuseppe (plate 11), xi, 145
Bianchi, Marianna Rucellai de' (plate 11), xi, 145
Biblioteca Nazionale Centrale di Firenze (BNCF), 196, 227
Bingeri, *see* Rucellai, Berlinghieri (Bingeri) di Nardo
Bini, Lucrezia, 85, 88
birth salvers, *see* childbirth: birth salvers
Black Death, xvii, 28, 40, 159
blood, xxviii, 10, 15, 17, 23, 44–5, 69, 86, 88, 91, 128, 135, 145, 150, 159, 161, 167, 173, 177, 195, 205–7, 211, 216, 220, 231–2, 237
Boccaccio, Giovanni (plate 7), xvii, 86–8, 245n
bodily fluids, xxvii, xxviii, 87, 91, 118–20, 157, 174, 211, 237; *see also* blood, urine (as dye agent)
Bologna, 116, 145, 208
Bolsheviks, 185, 189, 193
Book of the Courtier (Castiglione), xix, 85, 98
bosom, 51–2, 58, 143, 190, 216, 244n
Botticelli, Sandro (plate 7), xi, xix, 85–6, 87–8, 128, 172, 245n
Brideshead Revisited (Waugh), 154, 179
Bronson, Edith, *see* Rucellai, Edith Bronson
Bronzino (Agnolo di Cosimo), 118
Brunelleschi, Filippo, xvii, xviii, 41, 45, 53, 68, 78, 96, 172, 173
Bruni, Leonardo, xxvii, 26, 40–1, 43, 91, 97, 243n, 246n
Burci, Emilio, xiii, 121
Byzantium, 17–18

Caffè Doney, xxiii, 182–4
calcio fiorentino (early form of football), *see* football
Campbell, Heather Anne, xiv, 238
Campi (suburb of Florence), 27, 113
cannibalism, 36–8, 37, 77
Caravaggio (Michelangelo Merisi da Caravaggio) (plate 16)

Carolingian period, xv, 72, 197
Carpeaux, Jean-Baptiste, xii, 37
cassone, *see* wedding chests (*cassone*)
Castiglione, Baldassare, xix, 85, 98
catasto (property tax survey), *see* taxes
catastrophe, 113, 116, 176, 182, 184, 220; *see also* Black Death, destruction, fires, Florence: floods, plagues
Caterina (Rucellai slave), 63–4
Catherine of Alexandria, Saint, xvii, 28, 68, 152
Cavalori, Mirabello, xii, 22
champagne, xxvi, 126, 134, 174–5
Charlemagne (Charles I, King of the Franks), xv, 27; *see also* Carolingian period
Charles VIII (King of France), xix, 101, 115
childbirth, 17, 36, 45, 51–2, 62, 63–4, 85, 87–8, 117–20, *119*, 123, 143, 176–7, 201, 222; birth salvers, 62; unexpected, 36, 63–4, 176; womb, 51–2, 201
Ciampolini, Count Aldobrando Rossi, 213
Cicero (Marcus Tullius Cicero), 48, 52, 105, 145
Circolo dell'Unione (Florentine club), 182–3, 205, 227
Clement of Alexandria, 17–18, 241n
clothing, *see* Arte della Lana (wool merchants' guild), fashion, silk, wool
coats of arms, *see* emblems, Rucellai family: coat of arms
Coffin, Clifford, xiv, 210
collecting, 10, 62, 64–5, 82–3, 129, 132, 140, 145, 166–73, *169*, 177, 192, 201, 209, 245n, 249n
Colosseum, 44, 49, 220
Colossus of Polyphemus (Burci), xiii, *121*, 122
confraternities, 23, 68
conspicuous consumption, xx, 17–18, 19–20, 24–7, 46, 49, 56, 64–6, 86, 88, 90, 92–8, 106–12, 113, 124–5, 127, 149, 161, 175, 189–90; *see also* collecting, drunkenness, fashion: dandyism, gluttony, sumptuary laws

INDEX

Constantinople, xviii, 17, 18, 19, 47, 73
Corriere della Sera (newspaper), 211, 214, 217, 220, 227
Corsi, Giovanni, 116
cosmetics, *see* fashion: cosmetics
Cossacks, xxvi, 176, 186, 189, 193
costume, *see* Arte della Lana (wool merchants' guild), fashion, silk, wool
crime (plate 15), 136, 196, 211–15, 217–18, 220, 227, 232, 251n; *see also* assault, cannibalism, forgeries, *giallo* (crime fiction), murder, prison, prostitution, punishment, sodomy, terrorism, treason
cross-dressing, 1, 181–2, 191; *see also* androgyny
currency, xvi, 15, 16, 18, 20–1, 45, 66, 89, 90, 92–3, 97, 113, 123, 126, 150, 163, 172, 187, 199, 202, 231

D'Annunzio, Gabriele, 32, 193–4, *194*
da Diacceto, Francesco, 116
da Maiano, Giuliano, 64, 169
da Peretola, Tommaso Masini ("Zoroastro"), 105, 114, 247n
da Settignano, Geri (workshop) (plate 2), xi
Daddi, Bernardo (plate 14), xii, 81–2, 84
Dalessio, Marc, xiii, 128, *129*
dancing, 35, 60, 174–5, 178–9, 181, 226
Dante (Durante degli Alighieri), xvi, 36–7, 86, 145
Dati, Gregorio, 44
De bello italico commentarius (Bernardo Rucellai), xix, 115–16
de Montaigne, Michel, 161
De urbe Roma (Bernardo Rucellai), xix, 115–16
death (plates 4 and 16), xvii, xviii, xix, xx, xxi, xxiii, xxvii, 37, 37, 39, 40, 51–2, 55, 69, 70, 72–5, 75, 76, 78, 80, 86–7, 100, 103, 114, 115, 116, 117, 118–21, 123–4, 125, 135–7, 143–5, 150, 158–60, 164–5, 184, 194, 201, 203, 205–7, 211–21, 226–32, 237, 244n; *also* Black Death, decay, destruction, English Cemetery (Florence), executions, funerary works, loss, melancholy, memento mori, murder, suicide, widows
Decameron (Boccaccio) (plate 7), xvii, 86–7
decay, xxviii, xxi, 17, 23, 28, 112, 150, 151–3, 164–5, 167, 178–9, 182–3, 186, 192, 213, 230
deconsecration, xxi, 166, 186, 197
decorum, xxvi, xix, xx, 9, 26, 43, 48, 60, 69, 77, 88, 98–101, 104–5, 106, 122, 134, 150, 177, 179, 180–3, 204; *see also Book of the Courtier* (Castiglione), *Galateo* (Della Casa)
del Benino, Conte Giovan Francesco, xx, 149–51
Delaney, abbi pazienza (Delaney, Be Patient!) (plate 15), xii
Della Casa, Giovanni, xx, 98–9, 180–1, 246n
della Robbia, Luca, 128, 172
delle Lanze, Conte Filippo Giordano, 212
desire, xxv, xxvi, xxvii, 12, 17–18, 21, 26, 30, 34–5, 37, 43, 50–2, 56, 78–81, 82, 84, 86, 91–2, 100, 127, 147, 148–51, 154, 167–70, 174, 191, 193, 210–11, 222, 234–8
destruction, xvi, xxii, xxiii, 33, 33, 44, 51, 71, 112, 119, 140, 153, 162, 185, 200, 208, 211, 218, 220, 224
di Neri, Francesco (called Sellaio), xiii, 118, *119*
di Robilant, Andrea, 209, 222
di Robilant, Conte Carlo Felice, 208–9
di Robilant, Conte Alvise (plate 15), xxiii, xxvi, 204, 205–14, *208*, 217–20, 221–4, 226–32, 251n
di Robilant, Conte Andrea, 208–9
di Robilant, Contessa Gabriella de Bosdari, 208–9, *210*
di Robilant, Elizabeth (Betty) Stokes, 208, 222, 251n
di Tomaso, Apollonio di Giovanni (plate 8), xi
diamonds, 94–5, 105, 121, 189–90, *190*, 192; emblematic use, 49–50, 59, 71, 97–8, 147, 246n
disaster, *see* catastrophe

INDEX

Discovery of Purple, The (van Thulden), xii, 15, *16*

disease, xvii, 32, 109, 114, 116, 121–2, 133, 144, 152, 159–61, 176, 178, 202, 235; *see also* Black Death, plagues

disguise, xxvi, 27, 50, 54, 55, 56, 76, 92, 168, 181–2, 191, 193–4, 207, 211, 221, 225, 233; *see also* secrecy

Dominic, Saint (plate 13), 166

Dominican order, xvi, 68, 102, 164

Donatello (Donato di Niccolò di Betto Bardi), xviii, 1, 41, 77, 128

dowries, 45, 89–90, 93–6

drunkenness, 78, 82, 86, 121–2, *121*, 124–5, 131, 132, 161, 175

Duomo (Santa Maria del Fiore), *see* Florence: Duomo (Santa Maria del Fiore)

effeminacy, 25, 98, 103, 179, 183–4

Egypt, 19, 23, 69

emblems (plates 4, 5, 6), xi, xii, xiii, 3, 32, 34, 35, 41–2, 49, 69–70, 71, 75, 88, 95, 97–8, 124, 133, 137, 147, 152, 166–7, 204; *see also* Alberti: personal emblem, diamonds: emblematic use, porphyry (emblematic use), Palazzo Rucellai: family emblems displayed, Rucellai family: coat of arms, Rucellai family: emblems, Rucellai, Giovanni: personal emblem

England, xx, xxi, 24, 28, 146, 190; English style, 21, 93, 132, 168, 175, 210

envy, 12, 43, 61, 65, 93, 116, 148–51, 167, 178, 192, 237

eroticism, 86, 91–2, 104, *104*, 121–2, 148, *121*, 194, *208*, 235–7, 251

excommunication, xix, 22–3, 113

executions, xix, 4, 28, 42, 103, 116, 190, 215

exile, xvi, xvii, xviii, 40, 41, 42, 46, 51, 86, 100, 113, 116, 123–4, 190, 192, 201

extinction, 19, 122–3, 193, 201

Fascism, xxvi, 184, 187, 201

fashion, xvii, 16–18, 23, 24–7, 93, 181–4, 186–9, *188*; cosmetics, 106–12; dandyism (plate 9), 25, 35, 65, 91, 93, 99, 106–12, 124, 126–7, 131–2, 178–9, 183–4, 190, 242n; ecclesiastical (plate 16), 17; "preppy," 1, 8, 35, 78, 132, 200, 233; significance of red (plates 9, 10, 11, 16), 18, 25, *25*, 26–7, 75, 84, 90, 93–4, 97, 99, 103, 131, 174–5; women's fashion (plate 11), xxii, 8, 25–6, 82, 89–90, 91, 93–7, 112, 121, 128–30, 132, 140, 149, 164, 175, 185, 189–90, 195, 222, 233; *see also* cosmetics, Gucci (fashion house), hairstyles, jewelry, purple (dye), Prada (fashion house), Pucci (fashion house), silk, sumptuary laws, wool

Ferretti, Gian Domenico (plate 12), xi, 147–8

Ferro, Messer (Nardo di Giunta d'Alamanno di messere Ferro), 72, 144

Ficino, Marsilio, 101, 103, 115, 145

fire, xvi, xix, xxii, 65, 69, 103, 120, 184, 186

floods, *see* Florence: floods

Florence, *x*, xv–xxiii, 2, 18, 19, 20, 26–9, 31, 35, 36, 39–45, 48, 50, 64, 72, 73, 81, 83, 84, 88, 97, 103, 104, 115–16, 117–20, 123, 124, 128–32, 134, 144, 146, 149–50, 163–4, 165–9, 170–7, 179–84, 187, 189, 193, 195–6, 201, 205, 207, 212–15, 219–21, 225–6, 233, *238*, 243n, 244n, 246n, 247n; and banking, xvi, xvii, xviii, xxiv, 20, 24–5, 27, 32, 40, 45, 47, 64, 68, 70, 102–3, 113, 130, 242n; Baptistery, xvi, xviii, 41, 53, 96; Duomo (Santa Maria del Fiore), xvi, xvii, xviii, xx, xxii, 29, 41, 43, 45, 48, 89, 96, 173, 198, 212, 215; floods, xvi, xvii, xx, xxi, xxiii, 32, *33*; governance, xv, xvi, xviii, xix, xx, 20, 28, 39, 97, 102, 103, 115, 116; Jewish population, xx, xxi, xxii, 26, 46, 173; libraries, 31–3, 33, 76, 81–2, 128, 156, 196, 227; and manufacturing, 20–4, 22, 25, 27, 28, 34, 40, 113–14; in medieval period, 3, 20, 22, 24, 27, 28, 42–3, 46, 69, 77, 137, 166, 169, 173

(*see also* Carolingian period); popular uprisings, xvii, xxii, 23, 44, 116, 124–5, 184; and sea trade, xvii, 19–21, 168; and tourism, 165–6, 168, 170–3, 249n; *see also* Arno River, Campi (suburb of Florence), Lion Rosso (Florentine district), Quaracchi (suburb of Florence)
Florentine Academy, 117, 120
forgeries, 73, 130, 145–6, 167, 207
fortune/Fortuna (luck), 41, 59, 77, 82, 84, 112, 113–14, 120, 134, 162
France, xxii, 28, 119, 189–90
Franchetti, Giorgio, 223, *223*
Freud, Sigmund, 30, 51–2, 137, 171
funerary works (plate 4), xviii, 2, 11, 52, 69, 72–5, 75, 78, 80, 128, 136, 150, 153, 159, 163–5, 167, 172, 184, 186, 194, 195, 197, 233, 245n
Futurism, xxi, 183–4, 188

Gabinetto Scientifico Letterario G. P. Vieusseux (Florence), 32, *33*
Gabriele D'Annunzio in the Nude (unknown), xiv, *194*
Galateo (Della Casa), xx, 98, 180–1, 246n
gardens (plate 10), x, *x*, 103, 105, 115–16, 119–21, *121*, 193; *see also* Orti Oricellari
Gendel, Milton, xiv, *208*
Genoa, xvii, 21, 40
giallo (crime fiction) (plate 15), xii, 82, 214, 251n
Giamberti, Marco del Buono (plate 8), xi
Giotto (Giotto di Bondone), xvii, 29, 172, 196
gluttony, 64, 86, 87, 90, 92–3, 99, 121, 161, 175; *see also* drunkenness
gossip, 2, 44, 91, 111, 177, 204, 208, 214; *see also* sensationalism
Gran Caffè Doney, *see* Caffè Doney
Grand Tour, 165, 195
Great War, *see* World War I
Grottaferrata, 222–3
Gucci (fashion house), 126, 130

Guelph faction (supporters of the papal cause), xvi, xvii, 40
guilds, xvi, 20–4, 22, 25, 34, 45, 68
Guzzi, Giuseppe, xiv, 199, *199*
gypsies, 176–7

hairstyles (plate 9), 75, 97, 106, 174, 184, 236
Habsburg-Lorraine dynasty, xx, 132, 147
Harvard University Center for Italian Renaissance Studies, *see* Villa I Tatti
heraldry, *see* emblems, personal
Hercules, 15–16, *16*
hermaphroditism, 23, 236–7
Holy Sepulchre (Jerusalem), xi, xviii, 72–5, 172, 186, 197
homosexuality, xvii, 179, 182, 191, 211–13; *see also* effeminacy, sodomy
Hungary, 131–3
hunting, 88, 122, 131, 133–4, 187, 202–3
Hypnerotomachia Poliphili (Alberti, presumed), 234, 251n, 252n

I Tatti, *see* Villa I Tatti
Il Giallo Mondadori (crime fiction series), *see giallo* (crime fiction)
il Vecchio, Boccardino (workshop), xii, 22
illegitimacy, 40, 42, 63–4, 100, 105, 119, 210, 215, 246n
illusion, 24, 52–5, 58, 142, 147, 225, 234, 237, 244n; *see also* Palazzo Rucellai: visual manipulation, perspective, invention and use, reproductions
Ingrisei, Rosa, 206, 227–9, 231
inheritance, xxvi, 11, 40, 42, 46, 58, 64, 66, 85–6, 98, 100–1, 103–4, 113, 122–4, 129, 132, 140, 143, 144, 146, 152, 167, 191–2; *see also* primogeniture
Inturrisi, Louis Blaise, 212
Italian Renaissance, xxv, 1, 29, 30, 40–1, 48, 53, 57, 63, 65, 69, 74–5, 81, 83, 84, 87, 88, 90, 99, 113, 128, 130, 140, 143, 145, 165–6, 168, 170, 172–3, 180, 186, 202, 214, 218–20, 233

INDEX

James, Henry, 32, 65, 165, 178
Jarves, James Jackson, 167–70, 249n
Jerome, Saint (plates 13, 16), 166, 207, 230
Jerusalem, xviii, 72–4, 146, 172, 197, 220
jewelry (plate 11), 66, 73, 82, 84, 89–90, 93–7, 99, 120, 133–4, 184, 189–92, 190, 233; see also diamonds
John the Baptist, Saint, 20, 42

kidney stones, 160–1, 233
Kingdom of Italy, xxi, 128, 166, 213
Kress, Samuel H. (plate 14), 83
Kunsthistorisches Institut, 128, 156

La Nazione (newspaper), xxi, 187, 220, 227
La Repubblica (newspaper), 227
Landucci, Luca, 44, 238
Layard family, xxi, 162–3, 165–6, 177
Layard, Sir Austen Henry, xxiv, 162, 165–6, 165, 249n
Lees, David, xiv, 223, 224
Leo X (Giovanni de' Medici, pope), xix, 116, 124
Leonardo da Vinci, xviii, 75, 105, 128
Levant, 16, 18, 21
Lion Rosso (Florentine district), 27, 39–40, 46, 50, 68, 70, 72, 152, 198, 242n
Lippi, Filippino (plate 13), xii, 64, 166, 169, 186
Lo Specchio (Rucellai estate), x, x, 104, 106, 112–13
Lodovigi, Rodolfo, 212
Loggia dei Lanzi, xvii, 130, 172
Loggia Rucellai, xiii, 70–2, 71, 75, 92, 138–9, 141, 172, 245n
London, 146, 166, 179, 212
Looking over the Arno (Campbell), xiv, 238
loss, 5, 36, 51, 57, 60, 65, 77, 91, 113, 131–2, 146, 151, 192, 198, 247n
lust, xviii, 17, 22, 34, 38, 78, 86, 91–2, 149–50, 161, 164, 191–3, 210–11, 215–16, 235–6; see also adultery, desire, sexuality
Luzi, Enrico Sini, 212–13

Machiavelli, Niccolò, xviii, xix, 39, 116, 126, 195, 242n
madness, 18, 105, 117, 136, 176, 194, 196, 207
Madonna and Child with Saints (follower of Bernardo Daddi) (plate 14), xii, 81
madrigals, xix, 116, 121
manners, *see* decorum
Marie Antoinette (Queen of France), 189–90, 190, 192
marriage (plates 7, 8, 11, 12), xvii, xviii, xx, xxi, xxii, 9, 15, 45, 46, 61, 85, 87–98, 104, 112, 120, 123, 135, 143–5, 147, 164, 177–8, 190, 208, 222, 231, 246n, 247n; see also wedding chests (*cassone*), widows
Masaccio (Tommaso di Ser Giovanni di Simone), 41, 128
masculinity, 21–2, 90–1, 98–101, 104, 130–1, 149–50, 177, 182–4, 183, 193, 205; see also *Book of the Courtier* (Castiglione), effeminacy, fashion: dandyism, *Galateo* (Della Casa), homosexuality
masturbation, 210–11
Medici family, xix, xxi, 92–3, 96–8, 106, 114, 116, 122, 125, 147, 163, 215, 246n; see also diamonds: emblematic use
Medici, Alessandro de' (Duke of Florence), xix, 215
Medici, Cosimo ("il Vecchio") de', xvii, xviii, 26, 44–7, 72, 92, 99, 144
Medici, Giovanni de', *see* Leo X (Giovanni de' Medici, pope)
Medici, Lorenzo ("il Magnifico") de', xviii, xix, 103, 105, 113, 115, 116, 126, 184, 186, 252n
Medici, Lucrezia (Nannina) de', *see* Rucellai, Lucrezia (Nannina) de' Medici
Mediterranean Sea, xvi, 15, 19, 21
melancholy, 86, 128, 136, 201, 209, 224
memento mori (plate 16)
Memmo, Andrea, 210–11
memory, v, xxv, xxvi, xxviii, 8, 11, 12–14, 28, 35, 51–2, 55, 72, 69, 74–5, 76, 77, 113, 119,

270

INDEX

130, 135, 140–2, 144–8, 162–3, 167, 176–7, 198, 209, 233–4; memoirs, 75, 144, 162–3, 166, 176–9, 209; memory palaces (mnemonic device), 141–2; *see also* funerary works, relics

Milan, 82, 95, 116, 131, 156

Mnemosyne with the Muses (Ferretti) (plate 12), xii

mollusks, 15–16, *16*, 19

Mona Lisa degli Oricellari, *see* Rucellai, Elizabeth (Lysina) Pilar von Pilchau

Mondadori crime fiction, *see* giallo (crime fiction)

Monster (Bronzino), 118

monsters (plate 10), xix, xxiii, 117–20, *119, 121, 122,* 123

Morgan, J. P., 168, *169*

murder, xvi, xviii, xx, xxiii, xxvi, 37, *37*, 86–7, 116, 121, 148–51, 158, 160–1, 163, 173, 185, 191–2, 195–6, 205–8, 211–19, 221, 224, 226–7, 228–32, 251*n; see also* poison

Murex (mollusk), *see* mollusks

Mussolini, Benito, xxii, 184, 186

mythological subjects, classical (plate 12), 12, 15–16, *16, 121, 122,* 130, 148, 235–6

Nardi, Jacopo, 115

National Gallery (London) (plate 13), 166

National Gallery of Art (Washington, D.C.), 83, 192

New Orleans, 1, 9, 12–14, 32, 83–4, 129

New Orleans Museum of Art, 83–4

New York (city), 83, 222

New York Times, 168, 212

Niccolini di Camugliano, Beatrice, 175

Nottiani, Piero, 213

Nuremberg Chronicle, x

occultic practice, 24, 31, 119–21, 136, 193, 201–2, 217, 225; *see also* astrology

On Painting (Alberti), xviii, 50, 53

On the Art of Building (Alberti), xviii, 48, 50, 66, 152, 247*n,* 249*n,* 251*n*

On the Family (Alberti), 50, 98, 246*n*

Onufrius, Saint, 23, 24

orgies, xxvi, 117, 121–2, 175–6, 193

oricella (*Roccella tinctoria,* "poor man's purple"), xvi, xxvi, 18–21, 23, 24, 26–7, 29, 128, 189

Oricellariis clan ("orchil dyers," later "Rucellai"), 19, 21, 28, 72, 115, 193

Orkin, Ruth, xiv, *183*

Orti Oricellari, x, *x,* xix, xx, 19, 115–17, 119–22, *121,* 123, 193, 247*n*

Ospedale di San Martino alla Scala, xiii, 118–19, *119*

Ospedale di Santa Maria Nuova, xvi, 123, 159–61; Cloister of Bones, 160

Ottavanti, Paolo di Giovanni, 63–4, 245*n*

Padre Pio (Saint Pio of Pietrelcina), 202, 227

Palazzo Corsi, 182, 228

Palazzo della Signoria, *see* Palazzo Vecchio

Palazzo Medici, xviii, 32, 42, 44, 96

Palazzo Mocenigo, 209–10

Palazzo Rucellai (plates 1, 3, 6, 12, 15), x, *x,* xix, xx–xxi, xxii, xxiii, xxiv, xxv, xxvi, xxvii, xxviii, 2–5, *3, 4, 5,* 6–8, *7,* 9–12, *13,* 29, 30–1, 32–3, 39–40, 42–3, 47, 49–65, *56,* 65–8, 70–1, 75, 76–7, 81, 82, 84, 85, 92, 96, 103, 104, 105, 114, 122–5, 127–8, *127,* 135–41, *136, 138, 141,* 143–8, 154–61, *155,* 162–3, 165, 170, 171, 172, 174, 176–9, 181, 184–90, 192–3, 195–200, 203, 205–7, 211–12, 214, 217–22, 226–7, 229–32, 233–4, 237–9, 244*n,* 245*n,* 246*n,* 248*n,* 249*n,* 251*n*; annex, 200, 218–20, *220*; archive, 101, 143–7, 219, 234; Archivio, xxv, 2, 8, 9–11, 77, 81, 156–8, 161, 219, 224, 229–32, 234; bedrooms, 2, 58, 61–4, 139, 163, 192, 207–8, 218, 229–30; bench (*banco*), 3, 4, 5, 50, *171,* 185–6, 198, 200, 225; chapel, 11–12, 164–5, 184–5; cornice, 3, *3,* 4, 50, 64, 139–40; courtyard, 7, *7,* 8, 58, 59, 123, 127, *127,* 135–7, *136,* 129, 139, 172, 197, 218–19;

INDEX

Palazzo Rucellai (*cont.*) elevators, 2, 8, 157, 159, 218–19, 229, 234, 237; facade (plate 1), xviii, xxiv, xxvi, xxviii, 2, 3, 3, 4, 4, 5, 6, 8, 31, 43, 44, 49, 50, 52–3, 55, 56, 59, 64, 65–6, 124, 138, 138, 147, 155, 171, 172, 184–5, 196, 218, 220, 230; family emblems displayed (plate 2), xi, 3, 3, 49–50, 55, 59, 97–8, 124, 137–8, 138, 147, 172; and ghosts, xxvi, 11, 55, 135–7, 157–9, 163, 228, 248n; glyphs on exterior, 154–6, 155, 158, 199, 249n; interior decoration (plate 12), xxvi, 9–12, 60–3, 62, 64–5, 140, 143, 146–8; "jagged edge," 66, 137, 172, 219, 220, 230; loggia, xviii, xx, 58, 59, 123, 172; *piano nobile* (plate 12), xxi, xxi, xxii, 4, 11, 60–1, 63, 96, 124, 139–40, 147, 165–6, 174, 177–8, 181, 190, 192, 219, 234, 249n; *piano terra*, 6–8, 60, 63, 67, 96, 124, 139, 172, 178; stable, 58–9, 63, 123–4, 184, 186, 219; stairways, 8, 11–13, 13, 60, 63, 67, 124, 139, 147, 158, 200, 218–19, 227, 234; terrace (*altana*), 64, 67, 70, 124, 147, 197–8, 218, 249, 233, 249n; visual manipulation, 52–6, 71

Palazzo Strozzi, xix, 32, 33, 42, 44, 45, 67, 172, 243n

Palazzo Vecchio, xvi, xx, xxiii, 20, 42, 43, 103, 172, 215

Palmieri, Matteo, 91

Pandolfini, Caterina, *see* Rucellai, Caterina Pandolfini

paranormal activity, xxii, 35, 201–2, 207

Paris, xxii, 126, 178, 187, 192, 193, 222

Passini, Ludwig Johann, xiv, 165

Paul II (pope), 74, 197

perspective, invention and use, xvii, xviii, 52–6, 252n

Petrarch (Francesco Petrarca), xvii, 119, 145, 195

Piazza della Signoria, 42, 130, 172

Piazza Rucellai (plate 8), 71, 92, 177, 184, 196, 200

Pisa, xvii, xviii, 21, 47, 79, 126, 149

Pisanella (lover of Cavaliere Giulio Rucellai), 149–51

plagues, xvii, 40, 144, 159, 176; *see also* Black Death

Pliny the Elder, 15, 17, 241n

Poggio a Caiano, 68, 113

poison, 121, 192, 135

Pollaiuolo (Antonio del Pollaiuolo), 64, 166, 169

Polyphemus, 121, 122

Pontormo (Jacopo da Pontormo) (plate 9), xi, 131

porphyry (emblematic use), 69, 115

Porta al Prato, 118–19

Portrait of a Youth in a Pink Coat (Pontormo) (plate 9), xi

Portrait of Allison Levy (Dalessio), xiii, 128–9, 129

Portrait of Alvise di Robilant (Gendel), xiv, 208

Portrait of Bernard Berenson (Seymour), xiii, 83

Portrait of Countess Gabriella di Robilant (Coffin), xiv, 208

Portrait of Cy Twombly with patron Giorgio Franchetti (Lees), xiv, 223

Portrait of Cy Twombly (Lees), xiv, 224

Portrait of Giovanni di Paolo Rucellai (attributed to Salviati) (plate 3), xi

Portrait of Leon Battista Alberti (Guzzi), xiv, 198–9, 199

Portrait of Lysina Rucellai (unknown), xiv, 174

Portrait of Marianna Rucellai (Bezzuoli) (plate 11), xi

Portrait of Palla Rucellai (attributed to Torrigiano) (plate 10), xi

Portrait of Sir Austen Henry Layard (Passini), xiv, 165

Portrait of Sir Harold Acton (Wright), xiv, 180

Prada (fashion house), 126, 129, 228, 233

Prato, 114, 118–19, 122, 146

INDEX

primogeniture, 124, 129, 132
Prince, The (Machiavelli), xix, 126, 195
prison, xvi, 35, 37, 150, 192, 230
privacy, xxiv, xx, xxiv, 2, 6, 14, 22, 33, 43, 48–50, 56–8, 59, 60, 63, 65, 71, 90, 91, 118, 162, 198, 211; *see also* secrecy
prophecy, 11, 64, 164, 202, 224
prostitution, 18, 22, 26, 27, 149, 213–14, 220
Pucci, Giannozzo, 85, 88
Pulci, Luigi, 102, 106–12
punishment, 43, 86, 87, 136, 150, 177, 212, 214, 216–17; *see also* amputation, executions, exile, prison, torture
purple (dye), xvi, xxvi, 15–20, 21, 24, 26, 27, 29, 39, 75, 76, 93–4, 96, 115, 119, 126, 128, 179–80, 242n; *see also* oricella (*Roccella tinctoria*, "poor man's purple"), *The Discovery of Purple* (van Thulden), Tyrian purple ("royal" or "imperial" dye)

Quaracchi (suburb of Florence), 45, 104–5, 106, 112–13, 186, 247n
Quintilian (Marcus Fabius Quintilianus, Roman rhetorician), 142, 248n

Rasputin, Grigori, 191–2
Ravenna, 86, 88, 118
Red Week, xxii, 184, 186
relics, 157, 164–5, 167, 233–4
Renaissance, *see* Italian Renaissance
reproductions, 72, 84, 129, 134, 172–3
restoration, 116, 124, 127, 152–3, 200, 213, 220
Roccella tinctoria, *see* oricella (*Roccella tinctoria*, "poor man's purple")
Rome (ancient), xv, xvi, xix, xxii, 16–17, 44, 52, 69, 71, 75, 115, 135, 141–2, 220
Romanov dynasty, 190–2
Rome (city), xviii, xix, xxii, 18, 35, 47, 49, 64, 79, 103, 177, 207, 212, 215, 220, 222
Rosamund, Queen of the Lombards (Sandys), xiii, 116, 117
Rosmunda (Giovanni di Bernardo Rucellai), xix, 116, 117

Rosselli del Turco, Marchese Niccolò, 208
Rossellino, Bernardo, 76, 158, 172, 245n
Rucellai, Abbate Filippo, 139–40
Rucellai, Alamanno, *see* Alamanno of the Oricellariis clan (later Rucellai)
Rucellai, Annibale, xx, 98, 180–1
Rucellai archive, *see* Palazzo Rucellai: archive
Rucellai, Barbara, 205–6, 229
Rucellai, Bencivenni (Cenni di Nardo), xvii, 28, 68, 152
Rucellai, Bernardo (Nardo) di Giunta, xvi, 28, 145
Rucellai, Bernardo (son of Giovanni) (plate 8), xviii, xix, xxiv, xxvi, 57, 69, 92–3, 96–8, 100–1, 103–6, 104, 112, 114–17, 122–5, 144, 147, 247n, 248n; marriage to Lucrezia (Nannina) de' Medici, 92–8, 101, 104–5, 104, 106–12, 114, 147
Rucellai, Bianca, xx, xxvi, 135–7, 140, 157
Rucellai, Camilla (later Lucia), xix, 46; embalmed corpse, 164–5
Rucellai, Caterina Pandolfini 57, 61, 72
Rucellai, Cavaliere Giulio, xx, 148–51
Rucellai, Conte Niccolò, 206, 229, 231
Rucellai, Conte Paolo, 151–3
Rucellai, Cosimo di Cosimo (Cosimino), 116, 247n
Rucellai, Cosimo (husband of Edith Bronson), xxii, 8, 178, 188
Rucellai, Edith Bronson, xxii, 146, 178, 188, 250n
Rucellai, Elizabeth (Lysina) Pilar von Pilchau, xxiv, xxvi, 174–87, 174, 189–90, 192–4, 250n; personal style, 174–6, 189–90, 193
Rucellai family (plates 2, 13, 14), xvi, xvii, xviii, xx, xxi, 18–20, 23, 24, 26–9, 39–40, 56–8, 61–4, 68, 69, 72–3, 82–3, 92–3, 96–7, 101–3, 113–14, 119–20, 123, 137–8, 143–8, 151–3, 160, 162–5, 177–8, 186, 220, 242n, 245n; coat of arms (plate 2), xi, xvii, xiii, 3, 28–9, 41, 50, 59, 69, 137–8, 138, 166–7, 172;

273

INDEX

Rucellai family (*cont.*) emblems (plate 4), 3, 3, 41, 49, 55, 59, 71, 124, 147, 152; patron saint, *see* Jerome, Saint; patronage (plates 3, 4), x, xviii, xix, 29, 42, 68, 82, 152–3, 166 (*see also* Alberti: and Palazzo Rucellai, Alberti: and Santa Maria Novella); discovery of *Roccella tinctoria* ("poor man's purple"), xvi, xxvi, 18–20, 21, 29, 39; *see also* Oricellariis clan ("orchil dyers," later "Rucellai"), Palazzo Rucellai, Palazzo Rucellai: archive

Rucellai, Francesco Maria, 139–40

Rucellai Gardens, *see* Orti Oricellari

Rucellai, Giovanni di Bernardo, xix, 72, 114, 116

Rucellai, Giovanni di Paolo (plates 3, 4), xvii, xviii, xxiv, xxvi, 28, 39–42, 45–8, 50–2, 55, 57–75, 73, 76–7, 85, 92–3, 97–8, 100–1, 104–6, 112–14, 122–3, 137–40, 144–6, 147, 152, 160, 162, 168–70, 186, 196, 198, 218, 242*n*, 243*n*, 245*n*, 246*n*, 247*n*, 248*n*; banking career, xvii, xviii, xx, 45–7, 64, 68, 143, 245*n*; marriage to Iacopa Strozzi, xvii, 45, 57, 61–2, 114, 145; patronage, xviii, xx, 42, 48, 50–2, 64–5, 66, 68–70, 72–5, 169, 245*n*; personal emblem (plate 4), 41, 49, 59, 69, 71, 73, 98, 114; tomb, 72–5, 75, 104, 104, 172, 186, 196

Rucellai, Giulio, xx–xxi, 140, 147–8, 151, 178

Rucellai, Giulio (Cavaliere), *see* Rucellai, Cavaliere Giulio

Rucellai, Giuseppe, xxi, 151, 162, 166, 177–8

Rucellai, Iacopa Strozzi, xvii, 45, 57, 62, 114, 145

Rucellai, Jacopoantonio (Iacopo Antonio), 66, 123, 218

Rucellai Loggia, *see* Loggia Rucellai

Rucellai, Lucia, *see* Rucellai, Camilla (later Lucia)

Rucellai, Lucrezia (Nannina) de' Medici (plate 8), xviii, xxiv, 92–8, 101, 104, *104*, 106–12, 114, 140, 144, 147, 184, 186, 215, 246*n*

Rucellai, Lysina, *see* Rucellai, Elizabeth (Lysina) Pilar von Pilchau

Rucellai, Marianna, *see* Bianchi, Marianna Rucellai de'

Rucellai, Marietta, 57, 123

Rucellai, Nannina (daughter of Cosimo Rucellai), 188–9

Rucellai, Nannina (wife of Bernardo), *see* Rucellai, Lucrezia (Nannina) de' Medici

Rucellai, Niccolò (Conte), *see* Rucellai, Conte Niccolò

Rucellai Palace, *see* Palazzo Rucellai

Rucellai, Palla (plate 10), 114, 117, 119

Rucellai, Pandolfo (son of Giovanni, later Fra Santi), xviii, xxvi, 57, 100–3, 114, 123–4, 144, 164

Rucellai, Paolo (Conte), *see* Rucellai, Conte Paolo

Rucellai, Paolo (father of Giovanni), xvii, 42, 45, 46, 55, 64, 69, 74, 77, 113

Rucellai, Paolo (son of Pandolfo), 96, 114, 124–5, 146

Rucellai, Ugolino di Francesco, 70–1

Ruskin, John, 32, 168, 173, 178

Russia, xxvi, 132, 173–4, 176, 185, 190, 192; *see also* Cossacks, Saint Petersburg

Russian Orthodox church, xxii, 173–4, 178

Russian Revolution, 189, 191–2; *see also* Bolsheviks

Saint Jerome Writing (Caravaggio) (plate 16)

Saint Petersburg, 191–2

Salutati, Coluccio, 43

Salviati, Francesco (plate 3), xi

San Marco (convent), 103, 123–4, 164

San Pancrazio (church), x, x, xxi, 27, 29, 59, 72, 82, 92, 166, 172, 186, 197

Sandys, Frederick, xiii, 117

Santa Croce (church), xvi, 40, 171, 196, 220

INDEX

Santa Maria del Fiore, *see* Florence: Duomo (Santa Maria del Fiore)
Santa Maria Novella (church) (plates 3, 6), x, *x*, xvi, xvii, xviii, xxi, 8, 27, 28, 68–70, 72, 75, 150–2, 152, 160, 233, 245*n*
Sargent, John Singer, 32, 129, 178
Savelli, Giovanni Battista, 215–17
Savelli, Ludovico, 216–17
Savelli, Troiano, 215–17
Savelli, Vittoria, 215–17
Savonarola, Girolamo, xix, 83, 102–3, 116, 123, 164
Scarampi, Aleramo, 206
secrecy, xxv, 11, 13, 19, 21, 24, 26, 57, 60, 61–3, 65, 72, 77, 78, 112, 119, 128, 143, 147, 149–50, 155–6, 160–1, 185, 195, 199, 207, 211, 214, 215–19, 227, 231, 232; *see also* disguise, privacy
Self-portrait (Alberti), xiii, 75, *75*
Sellaio, *see* di Neri, Francesco (called Sellaio)
sensationalism, 90, 189, 196, 205, 213–15, 217, 227, 251*n*
Seymour, David, xiii, *83*
sexuality, xxviii, 22, 23, 24, 42, 45, 61, 63–4, 78, 81, 85, 88, 89, 91, 98, 118–19, 131, 133, 149–50, 161, 191–3, 209–13, 215–16, 236–7, 246*n*; *see also* adultery, eroticism, childbirth, hermaphroditism, orgies, sodomy, virginity
Ship of Fortune, The (unknown), xiii, *104*
Siena, xvii, 26, 28, 61
Signoria, xvi, 20, 28
silk, 19, 20, 44, 47, 84, 90, 93, 95–7, 113–14, 131, 163, 166, 203, 233, 246*n*
sin, 14, 17, 18, 25, 27, 62, 68, 88, 120, 122, 136, 149, 214; *see also* adultery, drunkenness, envy, gluttony, lust, murder, occultic practice, orgies, prostitution, sloth, sodomy, suicide, usury, vanity
Singer, Bant (plate 15), xii
slavery, 47, 57, 63–4, 114, 176
sloth, 74, 89, 121, 122, 127, 133, 179, 184
snobbery, 6, 9, 17–18, 19, 23, 24, 25–6, 65, 67, 78–9, 86, 88–9, 97, 116, 122, 147, 161, 170, 175–7, 179–83, 186, 189–90, 192, 205, 226
sodomy, xvii, 88, 211–14
Spain, 21, 220
Stokes, Elizabeth (Betty), *see* di Robilant, Elizabeth (Betty) Stokes
Story of Esther, The (Giamberti and di Tomaso) (plate 8), xi, *93*
Story of Nastagio degli Onesti, The (Scene II) (Botticelli) (plate 7), xi, 85–6
Strozzi, Alessandra Macinghi, 89, 90, 92, 144, 246*n*, 248*n*
Strozzi, Caterina, 89, 90
Strozzi family, xix, 97–8, 146
Strozzi, Filippo, 45, 89, 90
Strozzi, Iacopa, *see* Rucellai, Iacopa Strozzi
Strozzi, Palla, xviii, 45–6, 64
suburbs, 9, 12–14, 45, 114; *see also* Campi (suburb of Florence), Quaracchi (suburb of Florence)
Suetonius (Gaius Suetonius Tranquillus, Roman historian), 17, 241*n*
suicide, xx, xxvi, 51, 86, 135–7, 248*n*
sumptuary laws, xvii, 17–18, 25–6, 97, 242*n*

taxes, xvii, 20, 44, 48, 57, 65, 68, 70, 113, 143
Thayaht (Ernesto Michahelles), xiv, xxi, 187–9, *188*
theater, xvi, xix, xx, xxi, xxvii, 36, 116–17, 214–15; *see also* madrigals
Theophrastus (ancient Greek philosopher), 19, 241*n*
tombs, *see* funerary works
Torrigiano, Pietro (plate 10), xi
torture, xix, 87, 103, 120–1, 138, 214–15
Trattato di Aritmetica (Calandri), xii, 25
trauma, 39, 42–3, 51
treason, 4, 37, 216
Tuscany, xv, xx, xxi, 10, 20, 22, 30, 35, 69, 131–2, 146, 154, 168, 193, 196, 201, 203, 213; *see also* Arno River, Prato, Siena

INDEX

tuta (Thayaht), xxii, 187–9, *188*, 250n
Twain, Mark (Samuel Langhorne Clemens), 32, 170
Twombly, Cy (Edwin Parker "Cy" Twombly, Jr.) 222–4, *223*, *224*
Tyrian purple ("royal" or "imperial" dye), 15–17, *16*, 19

Uccello, Paolo 64, 140, 169, 197–8
Ugolino and His Sons (Carpeaux), xii, 37
Ugolino of Donoratico, 36–8, 37
urine (as dye agent), 18–19, 23–4, 242n
usury, 27, 68, 103, 242n; *see also* Florence: and banking

Valdarno (Arno valley), *see* Arno River: Valdarno (Arno valley)
Van Thulden, Theodoor, xii, *16*
vanity, 17, 26, 106–12, 176, 191; *see also* fashion: cosmetics, fashion: dandyism
Varchi, Benedetto, 117–20
Veneziano, Domenico, 64, 140, 169
Venice, xxii, 94–5, 116, 120, 142, 168, 173, 178, 208–9, 212, 234
Verrocchio, Andrea del, xviii, 64, 140, 169
Via dei Palchetti, 39, 46, 53, 56, 59, 122, 219
Via della Vigna Nuova (plate 1), xvii, 2, *5*, 6, 39, 46, 49, 52, 55, 58, 59, 60, 64, 66, 71, 76, 92, 96, 101, 113, 122, 137, 140, 147–8, 163, 166, 172, 175, 184, 186, 188, 196–8, 211, 217–19
Via Tornabuoni, 32, 96, 182–3, 198, 205
vice, 17, 211; *see also* adultery, cross-dressing, desire, drunkenness, envy, gluttony, gossip, homosexuality, lust, masturbation, murder, occultic practice, orgies, prostitution, sexuality, sin, sodomy, snobbery, sumptuary laws, usury
Villa I Tatti, 81–3, 128, 233

Villa La Pietra, 128, 179, 213
Villani, Giovanni, 20, 25–6, 118
Virgin and Child with Saints Jerome and Dominic, The (Lippi) (plate 13), xii, 166, 186
virginity, 23, 61, 63, 86, 91–2, 161
Vita di Leon Battista Alberti (Alberti, presumed), 54, 74
von Pilchau, Elizabeth (Lysina) Pilar, *see* Rucellai, Elizabeth (Lysina) Pilar von Pilchau
voyeurism, xxvii, 131, 182–3, *183*, 197

Waugh, Evelyn, 154, 179
wedding chests (*cassone*) (plate 8), 62, 90, 91–2, 93, 166
weddings, *see* marriage
widows, xv, xxvi, 22, 39, 40, 56, 57, 61, 66, 70, 77, 90, 123, 128–9, 174, 215; widowers, 114, 123, 145, 231
wine, 10, 15, 30–1, 33–4, 35, 36, 60, 71, 77, 79, 82, 93, 99, 113, 116, *117*, 122, 124, 131, 133, 158, 160–1, 175–6, 192, 198, 201, 203, 204, 207, 212–13, 226, 229; *see also* champagne, drunkenness
womb, *see* childbirth: womb
wool, 20–3, 22, 25, 26, 27, 45, 46, 47, 62, 93, 97, 113–14, 133, 246n; *see also* Arte della Lana (wool merchants' guild)
Wool Factory, The (Cavalori), xii, 22
World War I, xxii, xxvi, 176, 184
World War II, 186–7, 193
Wright, George, xiv, *180*
Wunderkabinette (cabinets of curiosity), 10, 77, 233–4
Wynne, Giustiniana, 210–11

Yusupov family, 190–1
Yusupov, Prince Felix Felixovich, 189–92